Ferdinand Bauer's Remarkable Birds

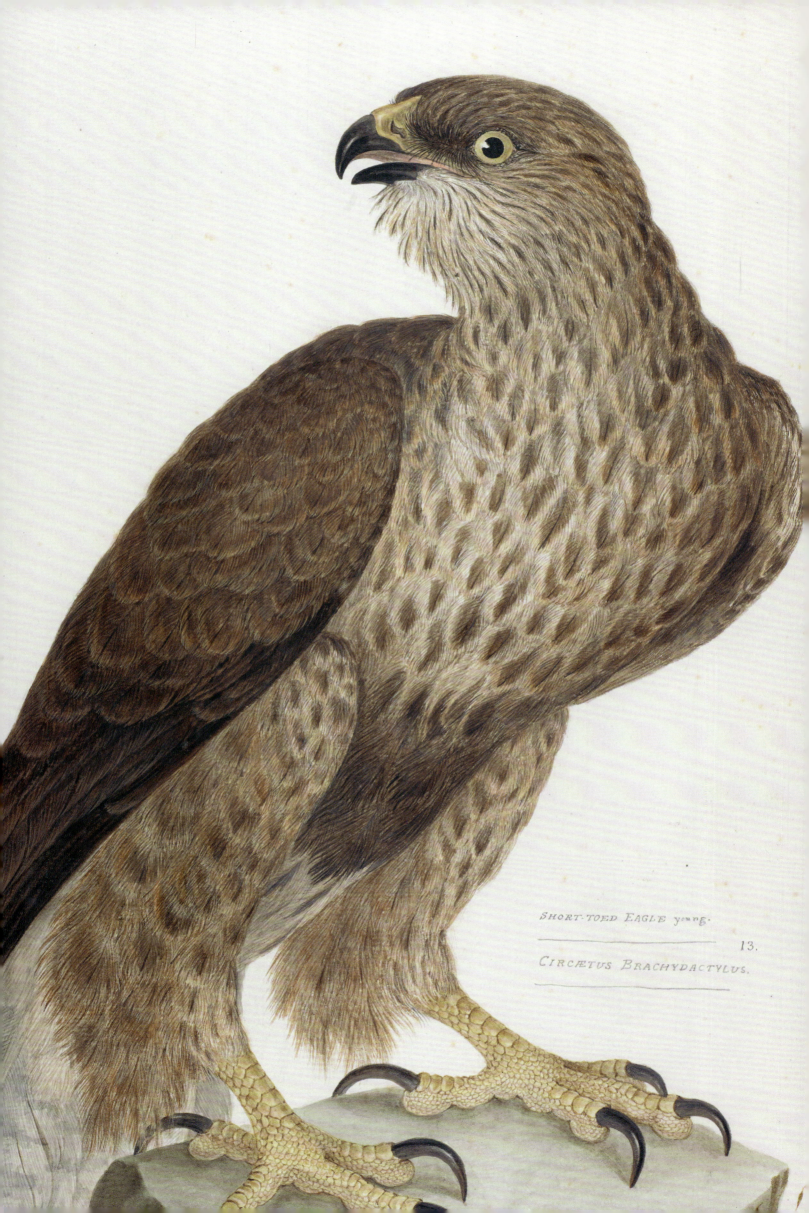

Short-toed Eagle young.
13.
Circætus Brachydactylus.

Ferdinand Bauer's Remarkable Birds

Jonathan Elphick

BODLEIAN
LIBRARY
PUBLISHING

*In loving memory of my wife Melanie (1952–2016), and with
love and thanks to my wonderful children Becky, Alys and Tom,
my grandsons Callum and Jacob, and my little great-grandson Sunny*

First published in 2024 by Bodleian Library Publishing
Broad Street, Oxford OX1 3BG
www.bodleianshop.co.uk

ISBN 978 1 85124 625 0

Text © Jonathan Elphick, 2024
This edition © Bodleian Library Publishing, University of Oxford, 2024

All images, unless specified on page 235, are from 'Fauna Graeca Sibthorpiana, or Drawings of the Animals of Greece and the Levant, executed by Ferdinand Bauer for Dr. John Sibthorp but never engraved.' Oxford, Bodleian Library, Sherardian Library of Plant Taxonomy, MS. Sherard 240, vol. 3.

Jonathan Elphick has asserted his right to be
identified as the author of this Work.

All rights reserved.

No part of this book may be reproduced, stored in a retrieval system, or transmitted in any form or by any means, electronic, mechanical, photocopying, recording, or otherwise, without the written permission of the Bodleian Library, except for the purpose of research or private study, or criticism or review.

Publisher: Samuel Fanous
Managing Editor: Susie Foster
Editor: Janet Phillips
Picture Editor: Leanda Shrimpton
Cover design by Dot Little at the Bodleian Library
Designed and typeset by Lucy Morton of illuminati
in 10.3 on 15 on Baskerville
Printed and bound in China by C&C Offset Printing Co., Ltd
on 157 gsm Matt Art paper

British Library Catalogue in Publishing Data
A CIP record of this publication is available from the British Library

Contents

Introduction
1

Painting by numbers
25

BAUER'S BIRDS
33

Appendix
227

Further reading
234

Acknowledgements
235

Indexes
236

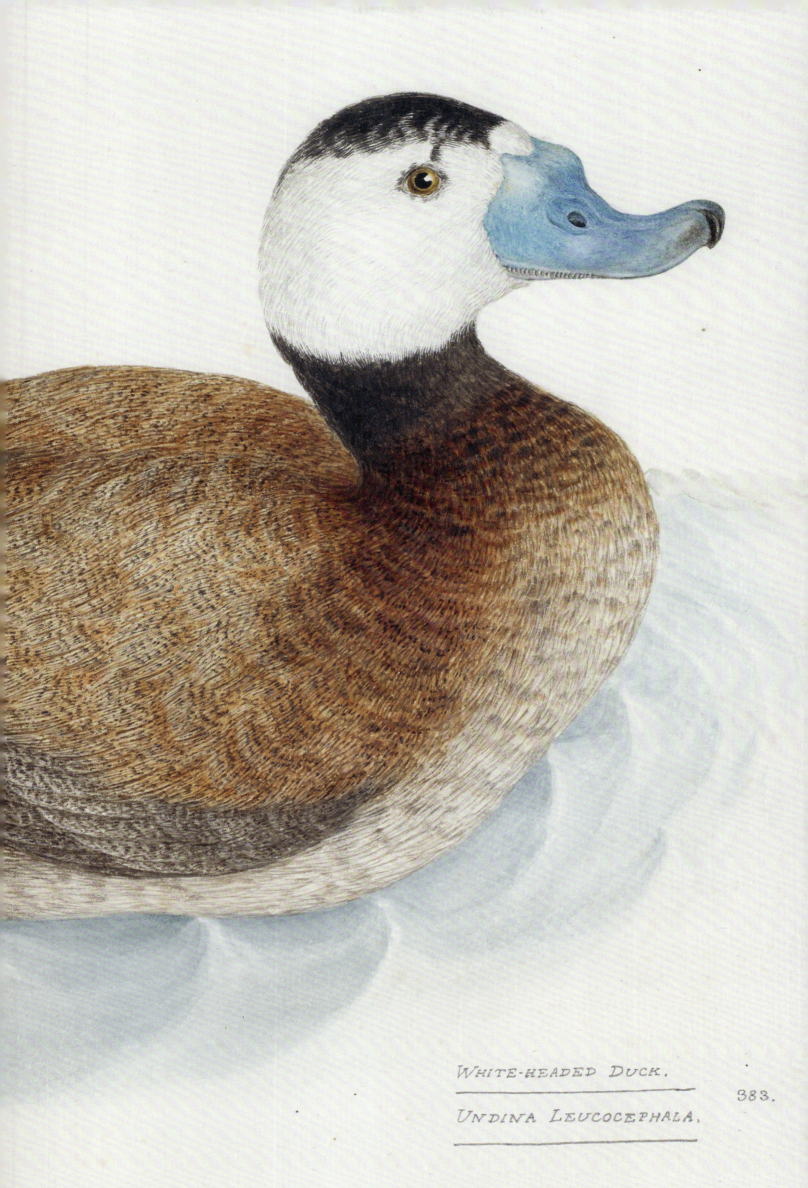

WHITE-HEADED DUCK.
UNDINA LEUCOCEPHALA.
383.

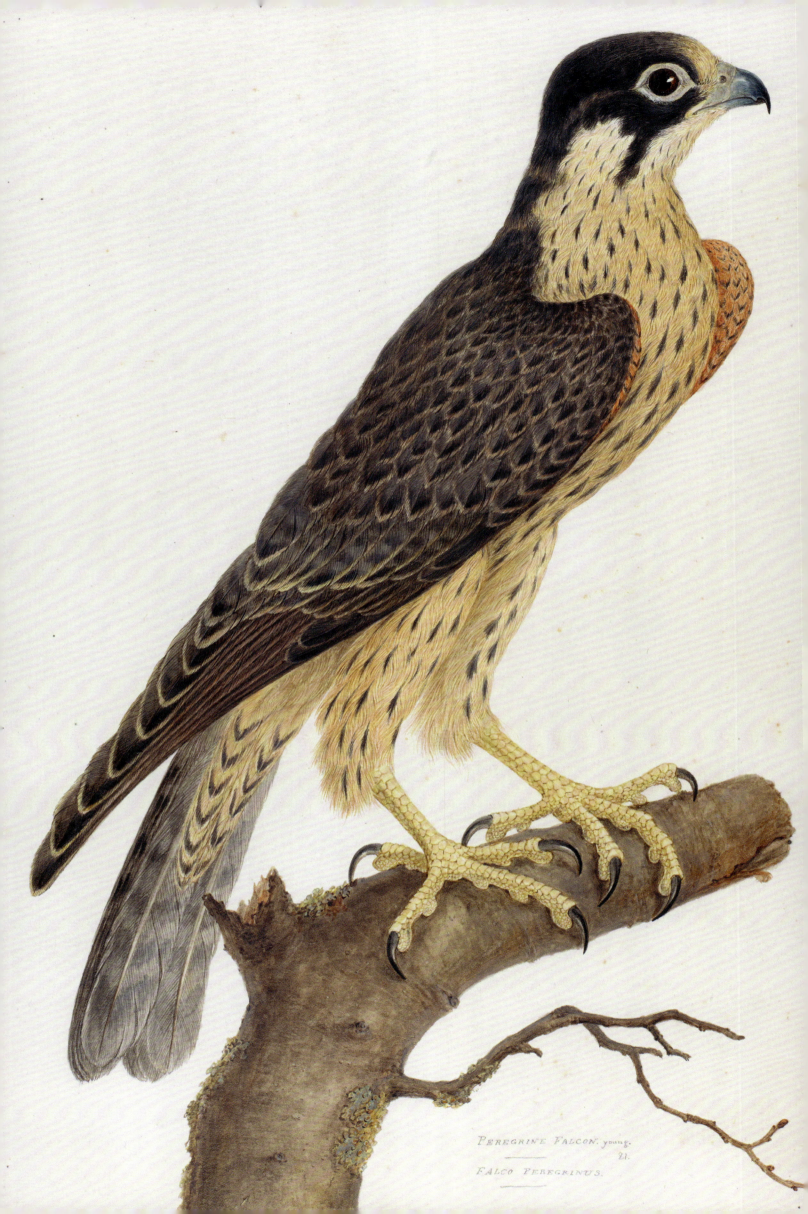

PEREGRINE FALCON, young.
21.
FALCO PEREGRINUS.

Introduction

On 6 March 1786 two highly gifted young men of very different backgrounds, nationalities and social classes set off together on a voyage that would have a profound effect on the rest of their lives. They were the wealthy English botanist John Sibthorp (1758–1796) and the far less privileged Austrian artist Ferdinand Bauer (1760–1826).

Ferdinand Bauer

Ferdinand Bauer is best known today for being regarded by many authorities as the finest of all botanical artists who have ever lived. He has even been called 'The Leonardo of botanical illustration'. The towering testament to the greatness of his work is that which he was commissioned to create for John Sibthorp to illustrate the *Flora Graeca*, one of the scarcest and most beautiful of all the world's floras. But he was also a consummate painter of vertebrate animals, from fish, amphibians and reptiles to mammals and birds, including those encountered by the two young travellers in their exploration of the Levant (the area bordering the eastern Mediterranean). The bird paintings are reproduced in this book in their entirety for the first time since they were painted towards the end of the eighteenth century. Had these been published and widely circulated, Bauer would also have been ranked among the great bird painters of the time, such as John James Audubon. Sibthorp intended the 293 animal paintings to be published as a separate *Fauna Graeca*, which was to contain 11 of Bauer's paintings of mammals; 114 of birds; 34 of 'amphibians', of which only three would now be classed as amphibians, the remaining 31 being reptiles; and 134 of fishes. These were to be divided between three volumes, the first containing mammals, amphibians and reptiles, and 49 of the fishes, the second the rest of the fishes, and the third the birds. Sibthorp also hoped to publish a commentary on the writings of the Greek physician, botanist and 'father of pharmacology' Dioscorides from the first century CE, but neither project was realized, due to a combination of factors, not least Sibthorp's early death.

Ferdinand was born on 20 January 1760 in the little border town of Feldsberg, about 65 km north of Vienna. It was then in Austria (remaining so until 1919, when it was annexed by the newly created state of Czechoslovakia and named Valtice). He was one of seven children, the first-born and only daughter dying at 18, and two boys surviving only seven and eight days. Their father, Lucas Bauer, was employed by the powerful Prince Joseph Wenzel I of Liechtenstein (1696–1772) as his court painter, tasked

FIG. 1 A fine example of Ferdinand Bauer's superbly detailed and accurate watercolours for the never published *Fauna Graeca*, this depicts an immature Peregrine Falcon (*Falco peregrinus*). It is clearly distinguished from adults by its streaked rather than barred breast, and belly and brownish upperparts.

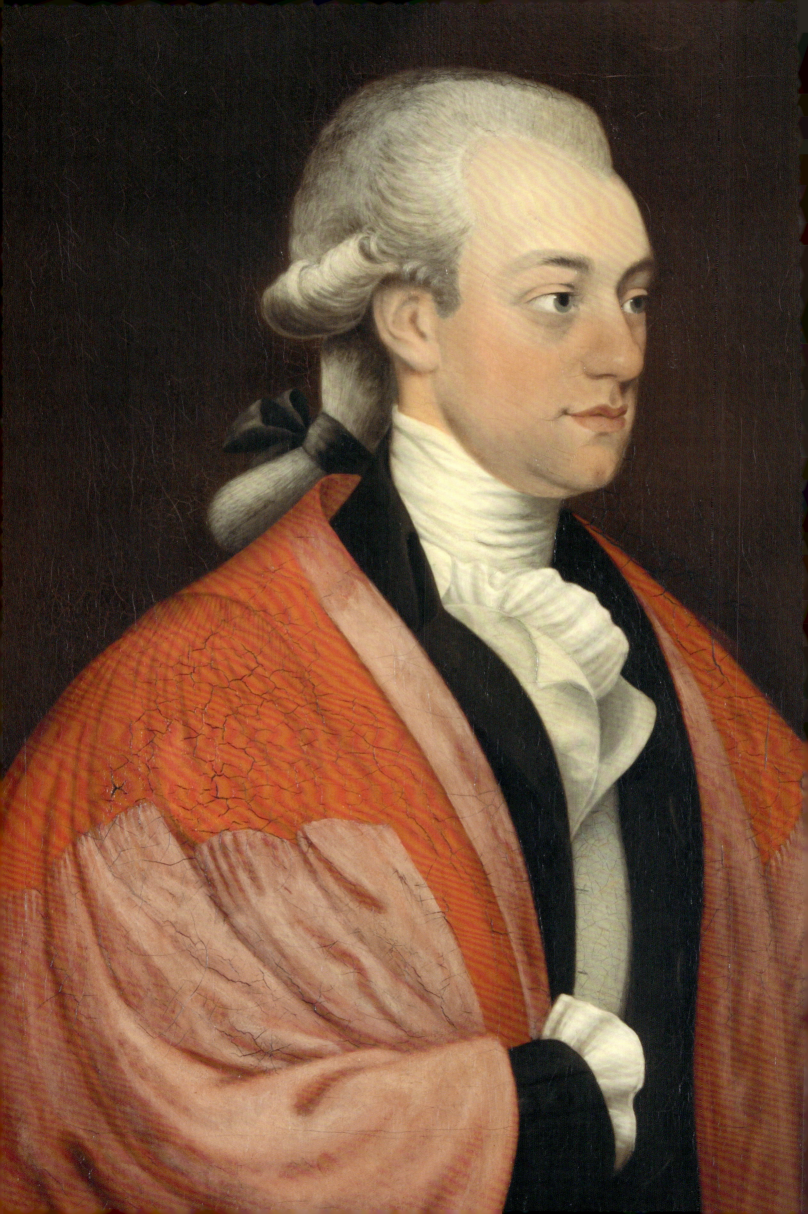

with creating intricate floral compositions, church altarpieces and hunting scenes. The Liechtenstein family spent their winters at their palace in Vienna, and summers in their splendid castle in Feldsberg, near where they also had another residence with a huge and splendid orangery.

Lucas's sudden death at the age of just 54 left his wife Theresa to bring up their four surviving sons alone. She encouraged them all to practise art from early childhood, getting them to copy their father's illustrations of plants and birds. Their aptitude was already apparent and proved to be lasting, as three of the four, Josef, Franz and Ferdinand, went on to make their living as artists. Indeed, the last two brothers became among the greatest of all botanical artists, while Josef succeeded his father and became the Liechtenstein family court painter, and later was appointed director of the family's art gallery in Vienna, one of the world's greatest private art galleries. Their first rung on the ladder was working for Norbert Boccius (1731–1806), the physician, pharmacist and botanist who had become prior of the Feldsberg monastery of the order known as the Barmherzige Brüder (Brothers of Mercy), and was physician to the Liechtensteins. The motto of the order was 'Do good, and do it well!' and the brothers certainly lived up to that dictum in their artistic prowess. For Boccius's part, he also did good by taking the Bauer brothers under his wing while still children, following the death of their father, and educating them as well as encouraging their artistic prowess. A keen field botanist, he amassed a herbarium collection of plants found in the Feldsberg area and employed the Bauers to prepare scientifically accurate drawings of them for his fourteen-volume work entitled *Liber regni vegetabilis retinens plantas ad vivum pictas* (Book of the plant kingdom containing plants painted from life). Due to Boccius giving a copy of this important work to the princes of Liechtenstein, mainly in exchange for their donations to the monastery, this became better (and more concisely!) known as the Codex Liechtenstein. It took from soon after 1770 to 1805 to complete, and the paintings in the first six volumes were exclusively the work of the Bauers, those in volumes seven to nine mainly by them, leaving just a few that they painted for the later volumes, together with the work of at least three other artists. Many of the paintings were direct copies of those in other books, suiting the Bauers as their father had trained them so well in extremely precise copying.

John Sibthorp

John Sibthorp was the younger son of Humphrey Sibthorp (1713–1797), the second Sherardian Professor of Botany at Oxford University, and his second wife, Elisabeth née Gibbes (1727–1780). The first to hold the professorship was the German botanist Johann Dillenius (1684–1747), who was appointed by the endowment of the British botanist William Sherard (1659–1728). John's family were wealthy landowners, with estates in Lincolnshire and, through his mother, at Instow in north Devon. He was brought up first in the official apartment of the Sherardian professor, near the university's Magdalen College and Physic Garden, now known as the Oxford Botanic Garden, which is England's oldest botanic garden. From there the family moved to a grand dwelling that his father had arranged to be built, called Cowley House (now part of St Hilda's College). Humphrey, who had been elected to his position by nepotism without having published a single word, had the dubious distinction of being the most ineffectual holder of the professorship, a mark of this being that in the thirty-six years he held the post he made no advances in science and was reputed to have delivered only a single lecture.

FIG. 2 This oil painting of John Sibthorp in academic dress, by an unknown artist, is inscribed 'J. Smith & Sons 1850'.

John Sibthorp was educated first at Magdalen College School and then at Lincoln Grammar School. In 1773, at the age of 15, he was admitted to study medicine at Lincoln College, Oxford, from where he graduated as a BA in 1777. He left Oxford in 1779 to further his medical studies at Edinburgh University, after which he returned to Oxford, where he was awarded his MA in 1780, the year of his mother's untimely death. There followed his first tour abroad, funded by his considerable private income. Already wealthy, young John had inherited the beautiful Instow estate from his mother. Furthermore, as well as the considerable rents from the land, in June 1781 he had been awarded the Radcliffe Travelling Fellowship, which paid him handsomely at the rate of £300 per annum for a period of ten years. The stipulations of this award were that he had to be a Master of Arts, have studied medicine and should travel for five years 'in part beyond sea' (that is, abroad) to improve his education. This last requirement suited the ambitious young botanist perfectly, as the extremely generous endowment (worth about £60,000 today) enabled him to journey at his leisure and in as much style as possible, as befitted a gentleman of the day. John returned from his first Continental tour in October 1783, having studied at the famous botanical institutions of the Jardin du Roy in Paris and Montpellier University on the Mediterranean coast. This gave him the opportunity of studying the herbarium specimens that had been collected in the Levant by the renowned French botanist Joseph Pitton de Tournefort (1656–1708) and the illustrations by his painter Claude Aubriet (1665–1742).

In December 1784 his father resigned his post and John was elected third Sherardian Professor of Botany at the age of just 25. The following winter he travelled to Vienna, arriving sometime in early November 1785. There he was introduced to Ferdinand by the renowned Dutch-born botanist, chemist and mineralogist Nikolaus Joseph von Jacquin, director of the Vienna University Botanical Garden, for whom Ferdinand and Franz were making drawings for a multi-part work von Jacquin was publishing, titled *Icones Plantarum Rariorum*. Sibthorp was immediately impressed with the quality of Ferdinand's work, and commissioned him to serve as his painter and to accompany him on his planned tour of the Levant to record the plants he planned to collect. It is likely that Sibthorp also visited Feldsberg, describing in his travel diary the Bauers' illustrations in Boccius's *Liber Regni Vegetabilis*, and commenting (including his only mention of Ferdinand by name): 'His Collection of painted Plants amounting to upwards of two thousand done by le[s] Frères Bauer and principally my Painter Ferdinand is the most splendid work of this kind that perhaps exists.'

Sibthorp was an outstanding botanist and very competent at identifying plants in the field, passionate about his subject and intensely driven, both in tracking down new species and in making a name for himself that would assure his place in posterity. A primary motive for making his two expeditions to the eastern Mediterranean was that this northern part of the great Ottoman Empire was relatively little known and he would have the opportunity of advancing botanical knowledge, not only by discovering many plants that were new to science, but also by giving already known species Linnaean scientific names. He would also advance knowledge of the wild distribution of plants already known from cultivation, including trees such as Horse Chestnut, *Aesculus hippocastanum*, and Lilac, *Syringa vulgaris*, as well as collecting living material such as seeds, bulbs or other plant parts of others that would be valued as new garden plants, such as the Twin-flowered Daphne, *Daphne pontica* and the Yellow Crocus, *Crocus flavus*. Sibthorp planned to follow the route taken by Tournefort and Aubriet on their expedition to the Levant (and further east) between 1700 and 1702. Tournefort had published a

...for Negropont the Torrent Bed which we had lately passed quite dry was now considerably swollen. On our Arrival we sent to Procop... to pay our compliments & thank ... for our kind Reception at Atepi requesting the further favour of ... Bospordin or Firman as we expected to touch at diff.t Parts of the Island in our way to Mount Athos, being informed ... were Pirates in the Gulph of Negropont.

Plants observed in Negropont on mount Delphi not noticed in the Flora Græca.

792. Galium cinereum
793. Asperula cubœnse
794. Campanula uniflora ?
795. Physalis somnifera
796. Athamanta cubœnse
797. Laserpitium trilobum
798. Bubon cubœnse
799. Ionanthus europœus

800. Saxifraga cæspitosa
801. Saponaria cubœnse
802. Dianthus cubœnse
803. Silene cubœnse
804. Phytolacca decandra
805. Euphorb. cubœnse
806. Rosa cubœnse
807. Potentilla cubœnse ?
808. Geum cubœnse
809. Helleborus cubœnse
810. Teucrium cubœnse
811. Sideritis cretica
812. Phlomis cubœnse
813. Origanum syryleum
814. Genista candicans
815. Hypericum cubœnse
816. Crepis cubœnse
817. Hieracium Pilosella
818. Carduus eriocephalus
819. Tussilago Farfara
820. Bellium Bellidioides
821. Fagus cubœnse
822. Celtis australis
824. Polypodium Lonchitis

FIG. 3 This page from the diary Sibthorp kept somewhat haphazardly during his travels in the Levant shows how researchers studying the expedition have had their work made much more difficult due to his often almost illegible notes written using poor-quality ink and paper.

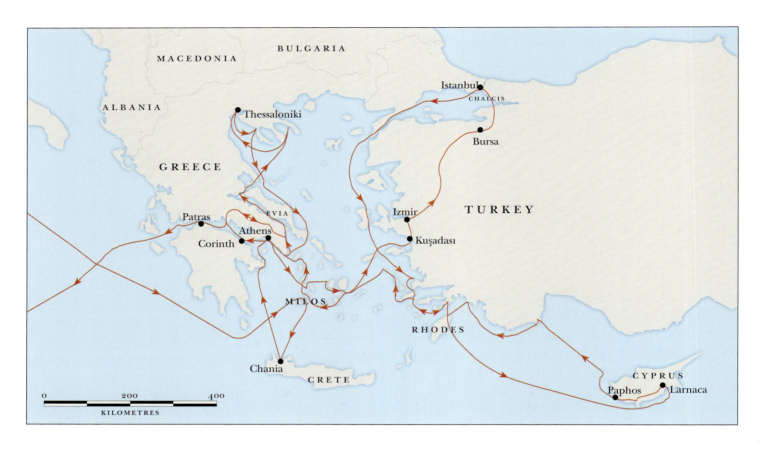

FIG. 4 Map showing the route taken by Ferdinand Bauer and John Sibthorp in 1786.

huge amount of information in two major works and Sibthorp probably took copies with him on the expedition, along with a set of printed illustrations of plants from the early-sixth-century works of the Greek botanist and pharmacist Dioscorides, which were still critical sources of knowledge of eastern Mediterranean plants. With the vital bonus of Bauer's superlative illustrations, Sibthorp intended to become famous as the 'second Tournefort'.

Sibthorp and Bauer left Vienna on 6 March 1786, travelling in Sibthorp's barouche (a shallow, two-horse, largely open coach) in heavy snow and driving winds to Italy via the Austrian town of Graz, then to Trieste, where Ferdinand would have had his first ever view of the sea. From there they sailed to Venice on 21 March, and continued overland by hired coaches and on horseback via Bologna, Florence, Pisa, Livorno, Siena and Rome. They then moved on south to Naples, where they stayed for several weeks, managing to fit in a five-day visit to Capri at the end of April 1786. From Naples, the party set sail in late May or early June for Crete, making brief stops en route at Messina, in Sicily, and at Milos, the south-westernmost island of the Cyclades group of Aegean islands. On Milos, Bauer and Sibthorp had arrived at the western fringe of the declining but still very powerful Ottoman Empire and much was unfamiliar to them. Sibthorp's account makes grim reading: suffering from the intense summer heat compounded by seasickness, he writes that he 'could scarcely crawl' to the town 'two Mile from the Beach'. And once there he found ruined houses and learned that most of the inhabitants had succumbed to disease. So 'with Horror & dismay' the party returned to the shore, to find that the ship had already departed. There they slept for two nights in a hollow among the rocks. After securing further passage, they arrived by the end of June on the large island of Crete at the port of Chania, the first major Ottoman settlement they had encountered. They were soon busy botanizing, beginning

in the Akrotiri peninsula where they stayed in a Greek monastery and made collections of plants, including rarities, which Bauer sketched. Escaping the punishing heat of the plains, they then headed for the Lefka Ori mountain range (then known as Sfaccia) where they found previously unrecorded endemic plants, but also notorious bandits, which necessitated arranging protection by guards.

Due to the haphazard nature of Sibthorp's diary entries, some of which may have been lost, it is not certain when the party left Crete to travel to Constantinople (present-day Istanbul) or the precise route that they took on this lengthy journey. Using the evidence of Bauer's chronological landscape drawings, titled 'Views of Mediterranean Scenes' (FIG. 5), it appears that the party sailed through the Aegean via the islands of Hydra, Aegina, Sifnos, Antiparos, Amorgos and Samos. From Samos they proceeded north up the west coast of Anatolia (Turkey), making landfall at the little port of Kuşadası on 1 August (known to them at the time as Scala Nova). Evidence for this visit comes from Bauer's sketch (worked up later into no. 40 in his series of Mediterranean scenes) which depicts the town's impressive fortifications and mosques from the sea. The following view (no. 41) shows a nearby coffee house, as well as a large ring of horses and another of camels that provided the traditional caravan route to Istanbul for travellers in the region. This is likely to have included stops at various towns, including the large city and major international port of Izmir (then called Smyrna), and the major cultural and trade hub of Bursa. Near Bursa they made a detour lasting three days to climb the mountain now known by its Turkish name of Uludağ, which means 'great mountain'. Its tallest peak reaches 2,543 m (8,343 ft), making it the highest in north-west Turkey. The range of which it forms a part was then known by its Latin name of Olympus, confusingly the same as that given to the better-known mountain of the same name (now Olymbos) in Greece, which they later hoped to climb but were unable to due to the danger from plague in the region.

The travellers finally arrived in Istanbul, capital of the Ottoman Empire, in early September 1786, and doubtless were pleased to find respite from the rigours of travel and the strenuous ascent of Uludağ. The great city became their base until early March the following year. They must have marvelled at its size, since at the time it was by far the largest city Bauer and Sibthorp had ever encountered, far larger than Vienna, Naples or even London. Sibthorp found very congenial lodgings at the British Embassy as the guest of the ambassador, Sir Robert Ainslie, and it is possible that Ferdinand stayed there too. We cannot know for sure, as there is no evidence of any diary entries by Sibthorp for their entire six-month stay or near the city, and just some of his letters and Bauer's topographical sketches to go on. Sibthorp probably busied himself with improving his knowledge of modern Greek, visiting the impressive bazaars in the city to study plants on sale there that had medicinal and economic importance. As well as seeking out new plants for Sibthorp to identify and Bauer to draw, they made an excursion in November to stay on the island of Heybeliada (Greek Halkis, referred to by Sibthorp as Chalcis), second largest of the Princes' Archipelago (Prens Adalı) in the Sea of Marmara. Here, Sibthorp researched and compiled lists of the local names of plants and animals, especially fishes (some of which were obtained by Sibthorp paying fishermen for their entire catch), while Bauer made drawings of them as well as of landscapes. As always, he helped his employer greatly by preserving herbarium specimens.

As the winter advanced, Sibthorp was eager to plan the rest of the journey, starting with a trip to Cyprus as soon as possible in the new year, to ensure they would arrive in time to collect spring flowers. He had met a Scottish army officer, military engineer and geologist based in Gibraltar, Captain Ninian Imrie,

who was to join the expedition, bringing with him not only a knowledge of local contacts but also great agility in climbing, enabling him to secure specimens of mountain plants. They were further delayed by having to await the arrival of Sibthorp's friend John Hawkins, a particularly valuable member of the party, who had been delayed travelling from Vienna to Istanbul. He finally arrived on 30 January, after a gruelling journey via Belgrade and Sofia. In sharp contrast to Bauer, whom Sibthorp unfortunately regarded as of inferior station, John Hawkins (1761–1841) was a gentleman of considerable means, indeed being richer than Sibthorp. The youngest son of a wealthy Cornish landowner, he inherited the Trewithin Estate and owned many lucrative mines. After studying law at Cambridge University, he went on to become a knowledgeable geologist, mineralogist and archaeologist, and also had a keen interest in botany. Sibthorp had met Hawkins in Germany during the summer of 1785, and the two became good friends. A great advantage to having Hawkins accompany the party was that he was by far the most experienced traveller in the region. Sibthorp had hoped to depart by the end of January, so as to arrive in Cyprus during the short flowering time of plants, but the late arrival of Hawkins and further delays meant that the expedition did not embark on the ship *Bethlehem* until 13 March. Soon they were battling through driving sleet and treacherous currents. Three days later they reached the Dardanelles, the famous straits that played such an important strategic part in the history of the region. Unsurprisingly, Imrie in particular was especially interested in studying the fortifications and Bauer was tasked with making drawings of them from various viewpoints. The *Bethlehem* then followed the coastline south, and within a few days the party found themselves in the midst of a violent storm that forced the captain to seek safe anchorage in the bay of Karabaglar. After spending several days on the mainland collecting plants, catching fish and observing

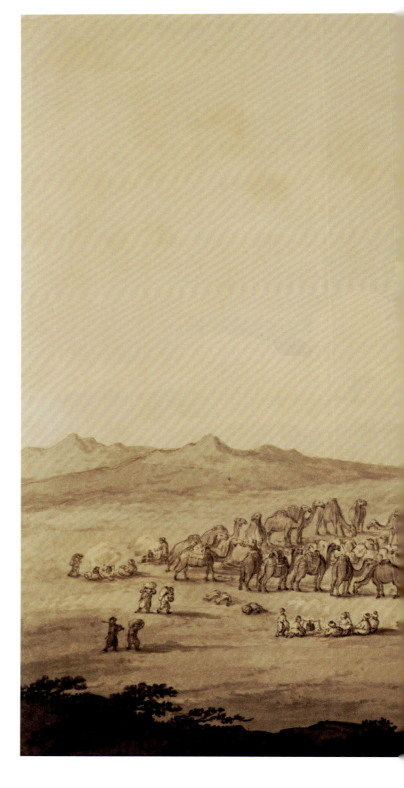

FIG. 5 One of Bauer's 123 surviving 'Views of Mediterranean Scenes', this one, titled 'The Caravan at rest by the Coffeehouse near Scala nova in Asia', gives an idea of the method of travel adopted by his and Sibthorp's party during their long journey up the western coast of Anatolia in early August 1786. It shows the travellers' baggage and saddles protected by a ring of camels on the left and another surrounded by horses.

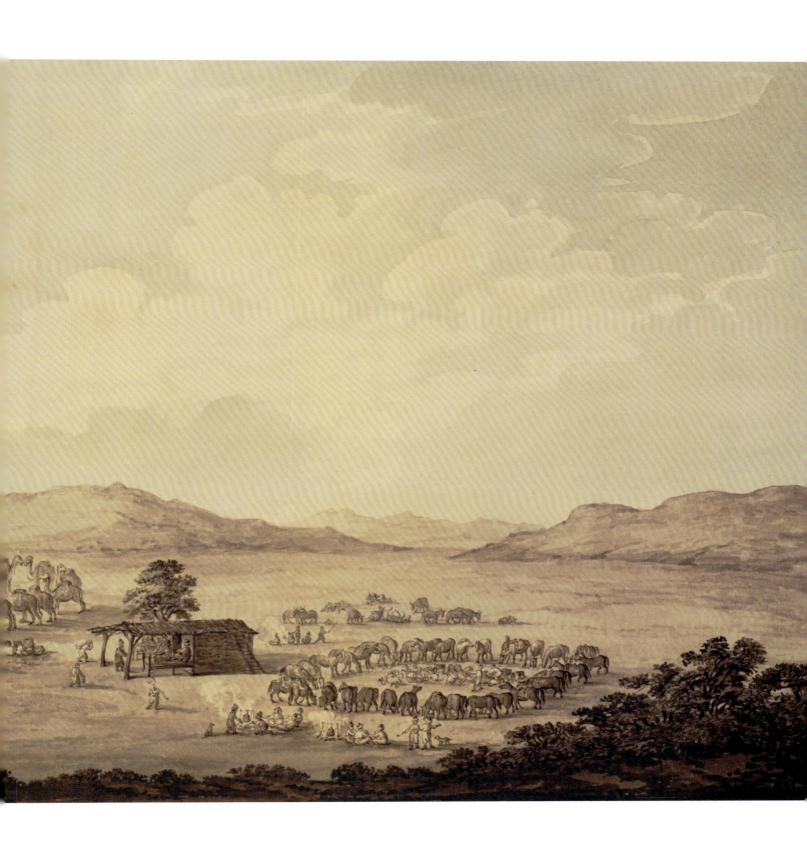

tortoises, they set off again on 31 March and crossed the harbour to the island of Rhodes, where they explored before sailing the next day for Cyprus. They reached their destination a week later, but on arrival at the port of Larnaca on the south coast on 8 April they were forced to wait for several days until the winds allowed them to reach the harbour. Over the next month they visited various parts of the island, including the impressive central Troodos mountains, the northern area around Nicosia, and Famagusta, in the east, where Sibthorp writes of his disappointment in finding 'the remains of a fine city now scarcely containing 200 inhabitants who are all Turks'. They observed and collected many new plants, birds and fishes, and Bauer was kept very busy in making drawings.

A major purpose of Sibthorp and Bauer's visit to Cyprus was to find new species, as the island had been little explored by naturalists previously. They spent just over five weeks on the island from 8 April 1787 to 14 May 1787. One reason for making the trip from Sibthorp's competitive viewpoint was to better his old rivals, the French: Tournefort had never visited the island, where the flora and fauna were little known and included endemics. Although Cyprus was home to considerably fewer plant species than Crete, due, as Sibthorp observed, to its more arid conditions and thin soil, he was able to list 616 species, representing roughly a third of those identified there today, including several new to science, some of which proved to be endemic to the island.

As an exception to his generally slapdash attitude to recording detail, Sibthorp produced a useful list of the birds of Cyprus, containing eighty-one species. Although he prepared this in 1787, it was not published until 1818, along with extracts from Sibthorp's diaries and notes, by the Whig politician, writer and art historian Horace Walpole. The leading authority on the birds of Cyprus in the early 1900s, Sir John Bucknill, considered it 'the foundation of all subsequent publications relating to the ornithology of Cyprus'. The bird life of Cyprus proved particularly rich in migrants, as it is to this day. As Sibthorp wrote, 'The naturalist … is surprised on observing the great variety of birds which migrate to Cyprus … Great numbers of Grallae pass over in spring from Egypt and Syria.' (The obsolete term 'Grallae' was then used for the fourth Order of birds in the Linnaean system of classification to include not only birds that we now call waders or shorebirds, but also other wetland birds such as herons, spoonbills and flamingos.) The birds also included endemic races of a variety of species and three endemic species: the Cyprus Warbler, *Sylvia melanothorax*; the Cyprus Wheatear, *Oenanthe cypriaca*; and the Cyprus Scops Owl, *Otus cyprius*. Two of these, the wheatear and the warbler, feature as paintings by Bauer (see pp. 200 & 180). The warbler is of particular interest in that it was not known to ornithologists until Canon Henry Baker Tristram (1822–1906) found it as a winter migrant in Palestine and described it scientifically in 1872, yet a male was accurately painted by Bauer eighty-five years earlier.

The travellers left Cyprus from the harbour of Paphos on the west coast on 14 May 1787, this time on a ship called *Providence*. Calm weather meant sailing to their destination of Rhodes was slow, to Sibthorp's irritation, and they put in twice to land on the Turkish mainland. These visits made up for the delay by producing interesting plants and stunning scenery, as well as the discovery by Sibthorp's faithful servant Joseph Ganzarowitz of a tame Eurasian Lynx kept by villagers, which Bauer lost no time in drawing. After a few days on Rhodes, the travellers changed their means of transport from the *Providence* to

FIG. 6 This is one of the very attractive watercolour frontispieces Sibthorp had planned to introduce each of the ten volumes of *Flora Graeca*, combining a garland showing a selection of plants (originally planned to reflect those in each volume, but not always achieving this) with a landscape view of one of the major locations on the Levant expedition, based on one of Bauer's watercolours. Only seven were finished, including this one with a view of Athens.

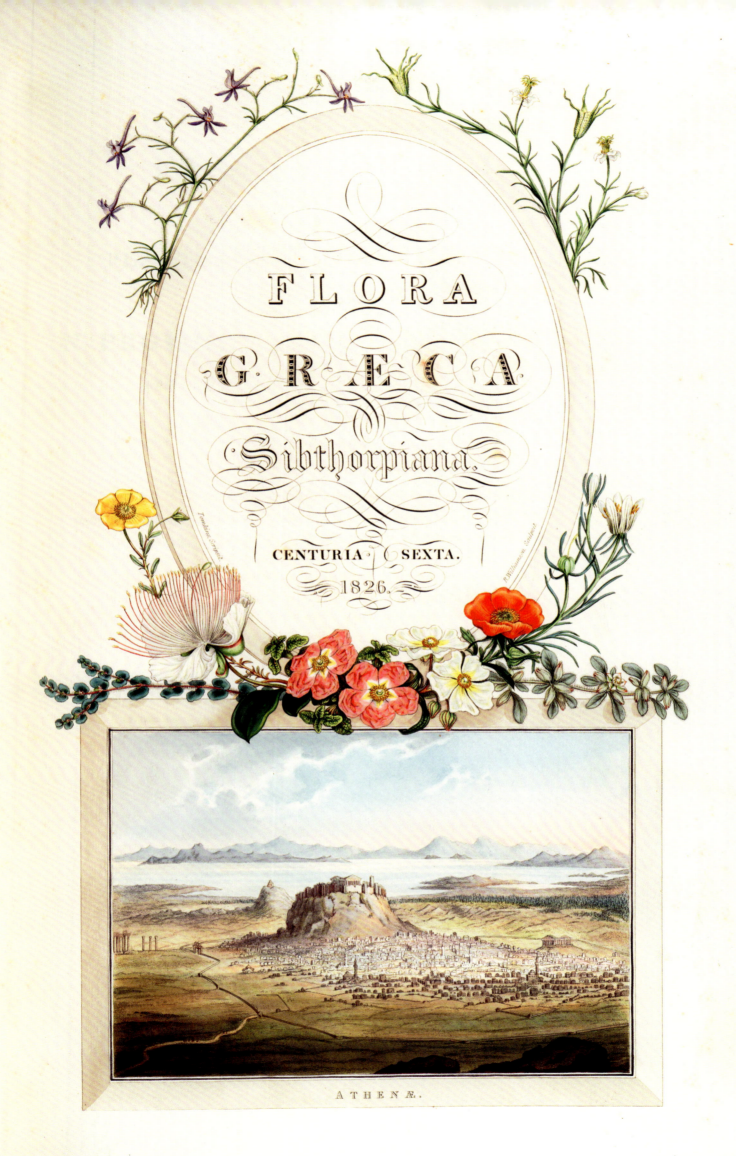

ATHENÆ.

a small traditional sailing vessel known as a caïque. They proceeded across the Aegean Sea, initially intending to head south-west and pay a second visit to Crete, but unfavourable winds meant that the hired boatmen often had to alternate periods of strenuous rowing with sailing in a westerly direction instead, making frequent stops on various islands. The intense heat of summer meant that most plants were reduced to dead, dry, brown skeletons, while others had been devoured by goats, so there was little plant collection apart from seeds. While heading south again towards Crete, they had landed on the small island of Sikinos, when Sibthorp was afflicted with a bout of fever and diarrhoea. His diary entry for 11 June records that while visiting the island of Kimolos (Argientera) the entire group succumbed to sickness. At this point they abandoned the plan to travel to Crete and on 15 June decided to make for Athens. They ended up briefly visiting as many as ten islands on the more than month-long journey from Rhodes to reach the peninsula on the Greek mainland then known as Attica, near the end of which lay Athens.

Arriving on 19 June at the port of Phaleron, east of the present-day major port of Piraeus, the party had to traverse a marsh before proceeding to Athens, but were greatly relieved to be on dry land, and lost no time in exploring the famous classical destination. At that time it was not the major city it is today, having a population of only about 6,500, and being under the control of the Ottoman Turks. The parched land with few plants that had not dried up convinced Sibthorp to concentrate his searches at high altitude where it was cooler. So, on 24 June, the party travelled north-east from the city to climb Mount Parnassus and visit the famous classical site of Delphi, together with a dozen armed Greek guards for protection against bandits. They were apparently the first modern European travellers to have reached the summit, which stood at 2,457 m (8,061 ft). During the descent Sibthorp was rewarded by discovering many new plants, including rarities. They had returned to Athens by 9 July, but stayed less than a week before setting off again, this time to visit the town of Marathon (famous for the Ancient Greek legend of the messenger who ran the 40 km (25 miles) from the town to Athens with news of the Greek victory over the Persians in 490 BCE). On 17 July Sibthorp's servant, Joseph Ganzarowitz, succumbed to what Sibthorp described as a 'violent fever' due to 'marsh effluvia', which may have been malaria. This caused the party to return to Athens. Nevertheless, they set off again just a week later, sailing for Thessaloniki, or, as it was then known, Salonica. On their way there they called at the offshore island of Evia, so that Sibthorp could search once again for mountain plants, but the atrocious weather they encountered on 3 August as they climbed Mount Delphis proved challenging. As they were battered by a hailstorm and were 'shivering with cold and distress', Bauer panicked and Ganzarowitz 'dragged him by force down the mountain'. Travelling north-west up the coast via the island of Skopelos, they arrived on 10 August at Athos, a rugged peninsula dominated by Mount Athos, whose densely forested slopes tower to a height of 2,033 m (6,670 ft). It is famous to this day for its community of twenty monasteries, housing some 2,000 Orthodox monks from Greece and elsewhere, and also notable for its ban on allowing entry to women and female animals (except for mouse-hunting cats). The party explored the mountain over four days, before sailing on 16 August to Salonica, where they studied the plants, fish and birds of marshes to the north of the city. After bidding farewell to Hawkins, they left near the end of August on a boat bound for the ancient port of Kenchreai, at Korinthos (Corinth). By 8 September they had anchored halfway along the Gulf of Corinth at Antikira, to make another ascent of Mount Parnassus, but they had to abandon the journey because of the cold and mist. A week later they set out again by boat towards Patras, at the western end of the gulf, with a detour to explore one

more mountain, Erimanthos. Shortly after they had installed themselves in the port of Patras, ready to return to England, Joseph Ganzarowitz suddenly died, perhaps weakened by the fever he had suffered during the trip to Marathon. After arranging the burial of 'my poor Joseph', Sibthorp left with Bauer the same evening. The voyage, on the *Pomona*, took ten weeks, and they did not reach Bristol until 5 December. Soon they were on their way to Oxford, and the next stage of the endeavour.

The hardships of travel

Compared with the experience of many of today's naturalists, artists and photographers who journey to distant lands, Bauer and Sibthorp faced many privations and perils. They were frequently given primitive accommodation, often inhospitable due to filth or infestation with rats or noxious insects, sometimes so bad that they were forced to sleep outdoors. On this aspect Sibthorp commented: 'it may be usefull to any future traveller in Greece to know before hand what he has to expect from Gnats and Bugs, If he sleeps under tents he is assailed by the one, if in chambers he is beset by the other and if he can obtain a sound nap in either case good Lord! What must be the texture of his hide?' The travellers also faced a far greater risk of injury or disease. This last proved tragically true for Sibthorp, for whom the experience contributed to his early death from tuberculosis at the age of just 37, since he had been weakened on his second Levant expedition by an affliction that may well have been malaria. Robbery or worse was also a frequent risk. Sibthorp records in his diary how he and his fellow travellers were often fearful of attack by bandits on land and pirates by sea. He mentions in a letter to his father during his time in Crete that 'Tomorrow ... I set off for the snowy Mountains of Sfaccia ... I now botanize always with loaded Pistols in my Pockets.'

Artistic brilliance, social inferiority

Bauer must have suffered many tribulations in coping not only with extensive travel at a time when conditions of comfort were often primitive and safety an issue, but also with being treated by Sibthorp as a social inferior and a servant to the greater glory of an ambitious master whose motivations were largely concerned with personal advancement. A measure of this is that his employer only once referred to him in his diaries and letters by name (and then just by his first name), instead calling him 'my Painter' or 'my Draughtsman'. It is tempting to regard 'Sibthorp as sinner and Bauer as saint', in the words of Stephen Harris (in *The Flora Graeca Story*), but there is much to be said for the notion that such a judgement would be an example of historical relativism. As a privileged upper-class gentleman as well as a very ambitious and driven academic wishing to establish his name for posterity, Sibthorp was typical of his class and background and the time when he lived.

Ferdinand Bauer's relative illiteracy was in contrast to his artistic brilliance. He probably never learned to write much more than basic German, and acquired only a limited knowledge of English, with much misspelling. He left behind very little written record, apart from a few letters. For this reason, it has proved difficult to know what kind of a man he was, apart from tantalizing glimpses gleaned at second-hand from occasional comments by Sibthorp and others for whom he worked.

Although Sibthorp was often dismissive, arrogant or downright rude to Bauer, he did genuinely regard his artistic talents very highly, and praised him on several occasions, albeit in combination with his refusal to mention him by name. For instance, in a letter from Naples to his father in Oxford during the early part of their trip he wrote: 'I am particularly fortunate with a Draughtsman – his good Temper and honest Countenance endear him to me much ...

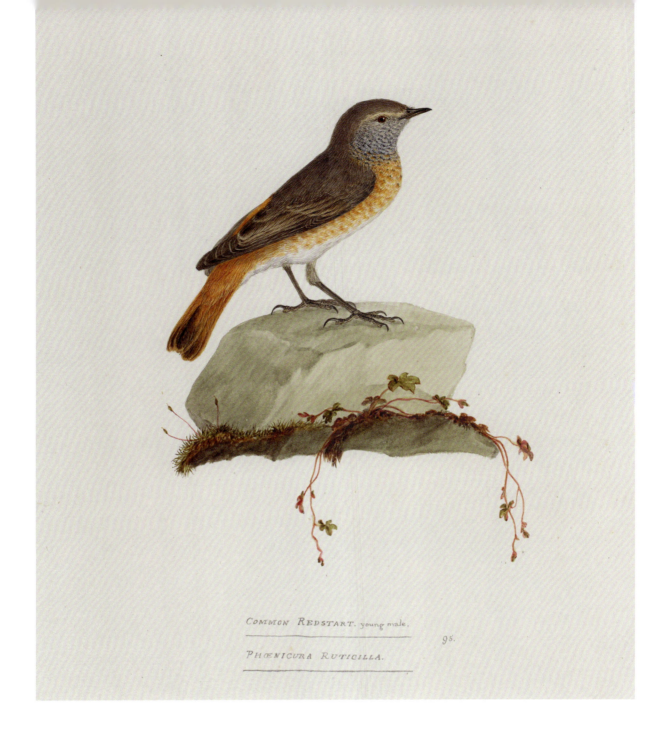

FIG. 7 In many cases, Bauer illustrated both a male and a female of various bird species and also occasionally a juvenile male. Common Redstart female and young male are shown here. The adult male is shown on p. 192.

he has made more than a hundred Designs of different Plants found about Florence, Rome and Naples … I never saw Beauty and Accuracy so fully combined.' Notwithstanding this, he had personal motives for choosing such an outstanding artist, revealed to his father when he wrote: 'The Superiority of my Draughtsman will fence me what I shall publish … & will entitle me to a Place in the Petersburg or to our Academy [the Royal Society] with just Pretensions.' It is also fair to say that choosing Bauer for such an important project meant that his work would be appreciated far beyond Vienna, and lead to further commissions.

On their return from the Levant in 1788, Sibthorp instructed Bauer to begin the mammoth task of painting the watercolours based on his meticulous field sketches. He began with the plants, then went on to paint the animals (only vertebrates were included): the mammals, amphibians, reptiles, fishes

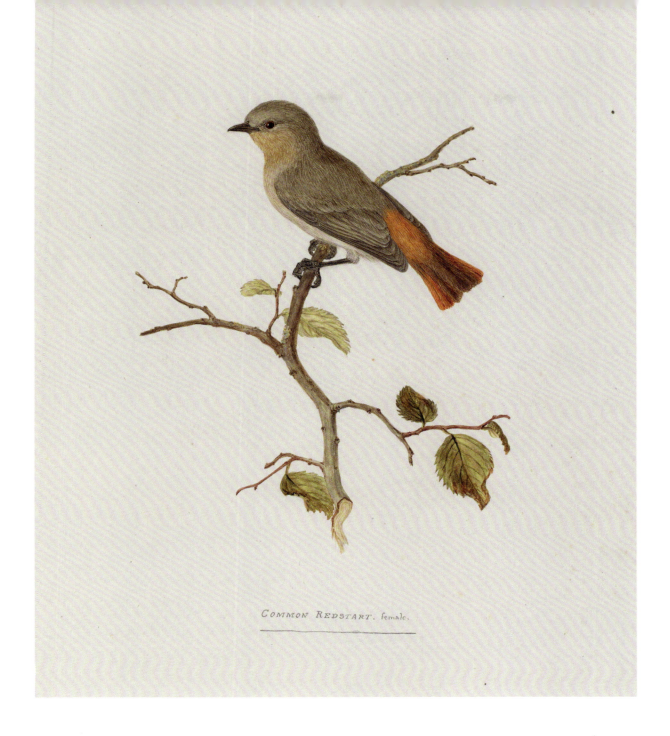

COMMON REDSTART. female.

and birds. There was a great contrast between Sibthorp's more leisurely time after returning from the Levantine adventure and Bauer's huge workload. For Sibthorp, his return after being away for three years saw him welcomed by his wealthy family and benefiting from his many social connections. He continued to be assiduous at self-promotion, gaining considerable kudos by becoming elected in March 1788 as a fellow of the Royal Society. He also became a founding member of the Linnean Society of London, the world's oldest continuously active natural-history society. Sibthorp was also busy lecturing to students, promoting the Oxford Physic Garden and visiting his family's estates.

Bauer, by contrast, must have found it difficult to cope with the long periods he spent working up his sketches into paintings in Oxford as an outsider (having never visited Britain before and knowing no one apart from Sibthorp) – a foreigner belonging to neither town nor gown. His English was poor (in contrast to his brother Franz, whose long residence at Kew near London helped him speak and write the language fluently), which must have exacerbated his isolation. Furthermore, his working conditions were trying, especially with regard to light – the overcast skies combined with small windows in his cramped quarters. According to Hans Walter Lack, he probably dwelt 'in a way

similar to most servants – under the roof of his master at Cowley House, or in Sibthorp's other place, the Professor's House opposite college', and Lack adds that he most likely 'sat at the servants' table'.

Bauer's output was phenomenal, especially considering that he consistently retained his high standards of accuracy. For *Flora Graeca* he painted almost a thousand illustrations, completing, on average, one (generally life-sized) watercolour of plants every one and a quarter days. Bauer dissected flowers and fruits in the field and used a powerful lens to draw details of tiny plant parts, which added to the scientific value of the paintings but also to the toll on his eyesight during long days without the benefit of modern lighting. And soon after he had completed that immense task, in June 1792 he started work on painting the animal specimens collected on the Levant expedition, completing at least 300 watercolours for the planned *Fauna Graeca* in just eighteen months. These still exist in all their glory, but unfortunately few of Bauer's meticulously colour-annotated pencil drawings, done in the field on thin paper, have survived. To produce the paintings, he probably copied the outlines onto watercolour paper using a lightbox, and then coloured them in precisely using a numerical colour code, as described on p. 25.

As with the rest of his natural-history work, Bauer's bird paintings are not only exquisite but also generally very accurate. They have been praised by many authorities for their great impression of solidity, the three-dimensional effect contrasting with much of the depictions by other contemporary artists. In most cases Bauer has succeeded in capturing the character (known to birders as 'jizz') of each species. Furthermore, as Stephen Harris comments, 'The quality of the animal watercolours is all the more impressive given that they were started up to seven years after the sketches were made and Bauer was working so rapidly.'

In contrast to the work of many artists of his day, Bauer has captured the birds in lifelike, natural poses. This suggests he spent time watching the birds before, or while, sketching them. He followed the general style of the day for scientific natural-history illustration in placing his subjects isolated from their surroundings on rather formalized branches or rocks, but often added appropriate lichens and mosses or other plants. Occasionally this led to some very unlifelike portraits, such as the highly aerial Alpine Swift (p. 64) inappropriately perched on a rock, or the Little Bittern (see p. 76), a generally very secretive bird well hidden among dense freshwater reedbeds or other vegetation, on a rock with seaweeds (although migrants may rarely turn up on coasts on migration). Some of the waterbirds Bauer chose to portray, such as the Great Crested Grebe (*Podiceps cristatus*) on p. 52 or the White-headed Duck (*Oxyura leucocephala*) have been shown swimming, with very attractive and skilfully rendered ripples. The rest of the ducks, as well as the gulls, terns and Great Cormorant (*Phalacrocorax carbo*) are shown together with various accurately portrayed seaweeds. A few of the illustrations among the waders and warblers are difficult to assign to a particular species, and there is a small number of errors such as the exact size of a bill or length of legs, for example as with the Egyptian Vulture (*Neophron percnopterus*) on p. 122.

His accuracy and attention to detail are not only commendable but can also provide

FIG. 8 Although almost all of the bird specimens Bauer painted are clearly recognizable, in a few cases their identity is uncertain. Despite the annotation (not by Bauer; made over fifty years later by the ornithologist Hugh Edwin Strickland), this is not likely to have been an immature Green Sandpiper (*Tringa ochropus*): its legs are far too long and yellowish as opposed to greenish; as Strickland notes as a query in smaller writing below, it may be a Wood Sandpiper (*Tringa glareola*), with its longer pale stripe over the eye, browner upperparts and yellowish legs. There is also a chance that it may have been a juvenile Marsh Sandpiper (*Tringa stagnatilis*) with its much longer yellowish legs, although that has a finer, needle-like bill.

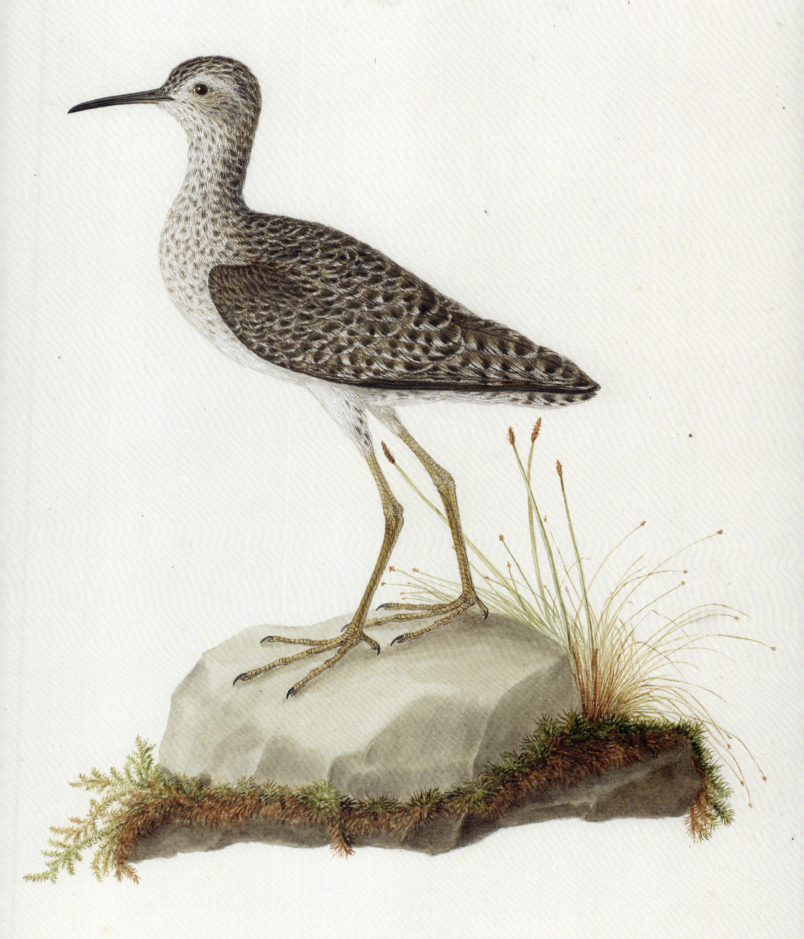

GREEN SANDPIPER. immature.

315.

TOTANUS OCHROPUS.
or glareola ? H.C.S.

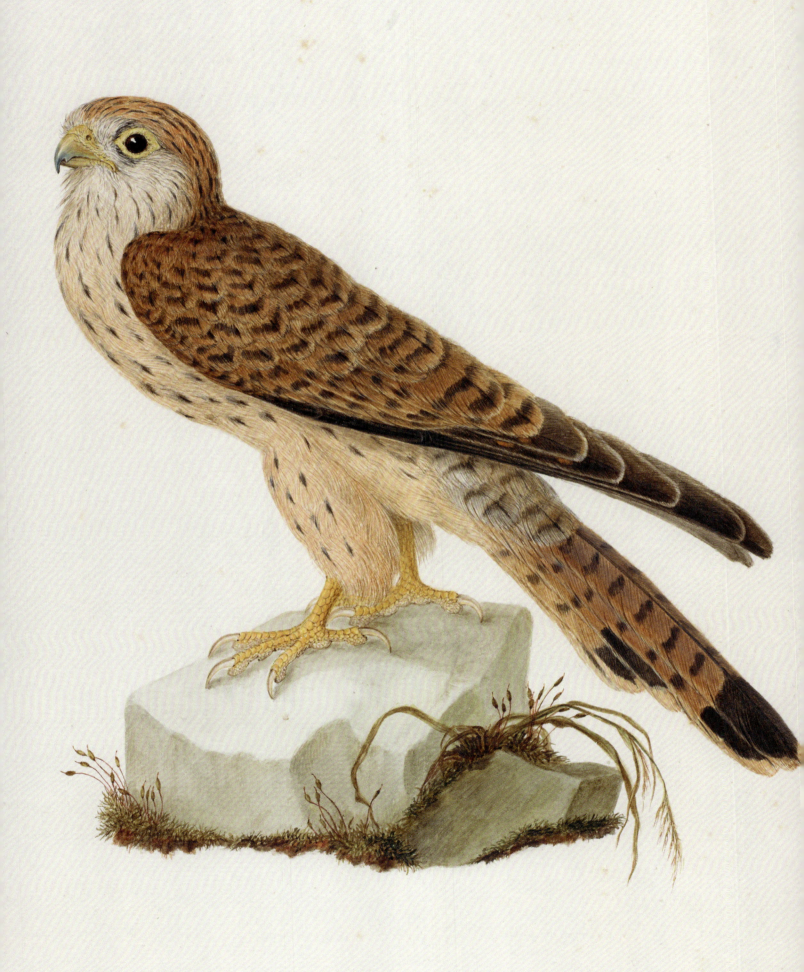

LESSER KESTRIL. female.

valuable information missing from Sibthorp's sparse and unsystematic records. For instance, in his painting of the Coal Tit (*Periparus ater*, see p. 160), the usually very obvious white nape is very narrow. This is a feature of the Cyprus race of the species, along with more black on the head and breast, details that Bauer has included in his painting. Another instance of his precise detail is seen in his painting on p. 140 of the scarcer relative of the Common Kestrel (*Falco tinnunculus*), the Lesser Kestrel (*Falco naumanni*), in which Bauer has correctly shown the pale-coloured claws as opposed to the Common Kestrel's black ones.

The handwritten comments that appear on most of the illustrations were added more than fifty years after Bauer had completed them and are by three well known ornithologists who examined the watercolours. The first was John Gould, the famous publishing impresario; the second Hugh Edwin Strickland, a geologist and systematist as well as ornithologist; and the third Frederick Holmes, a tutor at Corpus Christi College, Oxford. These addenda are usually accurate, but there were occasional misidentifications, as in the plate on p. 112, when Holmes referred to an immature Common Gull (*Larus canus*) as a Kittiwake (*Rissa tridactyla*), or the Rock Dove (*Columba livia*) on p. 54 mislabelled as a Stock Dove (*Columba oenas*).

Concerning the *Flora Graeca*, although Sibthorp was an outstanding botanist, he was a lamentably poor record keeper, as those tasked with sorting out his material after his untimely death found to their cost, causing exasperation and adding to the time it took to produce this superlative work. He wrote no formal descriptions of the plants he collected and failed to label his specimens or sketches. According to Hawkins, 'he trusted to his memory and dreamed not of dying'. The diaries he kept of his travels, too, have proved exasperating to researchers, since he wrote them using cheap, poor-quality ink in a near-illegible, spidery hand, and failed to give a clear account of where his observations were made.

He did make a useful list of the birds seen and sometimes collected on the expedition, as well as referring to them in a sporadic manner in his diary. Even so, the list, as with his diary, does not give any kind of precise detail, merely dividing them into 'birds seen' 'in Thessaly', 'in (other) parts of Greece' and 'in Cyprus', where many of the bird specimens were procured. Most of these are relatively common birds that are familiar to ornithologists and birders travelling in the area today, but there are some interesting exceptions: for example, two high-altitude specialists, the Ring Ouzel, *Turdus torquatus*, and the White-winged Snowfinch, *Montifringilla nivalis*.

In addition to the huge numbers of paintings of plants and animals created by Bauer, his 'Views of Mediterranean Scenes', which he methodically numbered chronologically 1–141 (with some missing), and comprising 123 in total, are of great value in establishing at least some idea of the chronology of the journey by Sibthorp and Bauer. These pencil, ink and wash drawings, painted on thick card or a couple of sheets of paper glued together, are also of great interest in that they are rare depictions of landscapes and architecture made at a time before the invasion by Napoleon's army had taken its toll. They look like sepia drawings and are sometimes erroneously described as such. In fact, Bauer first added a grey wash to his pencil or ink drawings, and then a thinner, transparent yellowish, brown or pale red wash. He completed the painting

FIG. 9 The Lesser Kestrel is a slightly smaller Mediterranean relative of the far more numerous Common Kestrel (see p. 142). The two species are very similar, but in this plate and that of the male (see p. 140) Bauer has clearly and skilfully illustrated the subtle differences from its relative, such as the pale not blackish claws and elongated central tail feathers (though the latter feature is exaggerated).

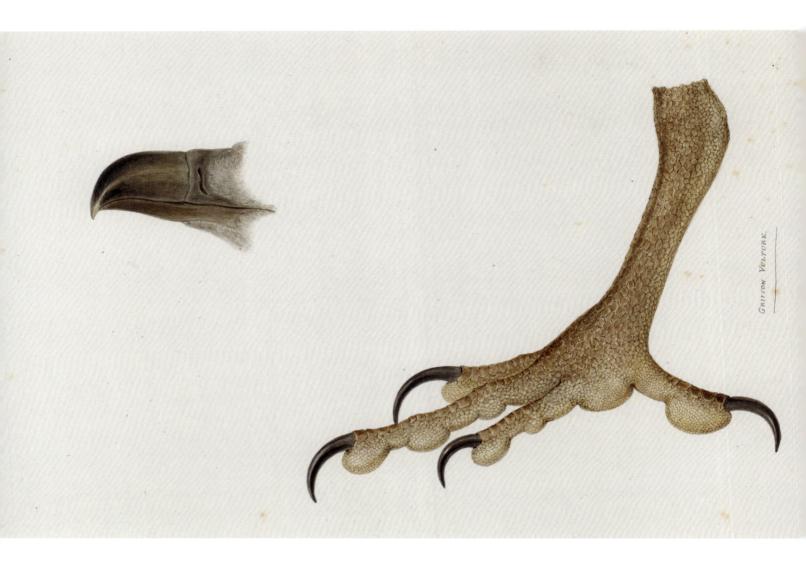

FIG. 10 For several of his bird illustrations, Bauer added details of bills and feet, as here with the Griffon Vulture obtained as a captive bird from a *caloyer* (Greek Orthodox monk). They show clearly the large, deep, hooked bill used for tearing meat from a carcass as fast as possible in competition with the usual pack of rivals and also pecking at them during scrummages for food; as for the feet, these are flatter and rather less powerful than their raptor relatives such as eagles and hawks that use them to seize, subdue and carry live prey.

by creating a frame consisting of three close parallel lines in black ink, with a second line at the bottom marking off a rectangular box in which Bauer has added a description of locality.

It is interesting that although Sibthorp describes entering the village of 'Castri or Delphos' during the descent of Mount Parnassus, and seeing 'on terraces the foundations of the ancient town', he also notes that they saw no antiquities; furthermore, Bauer did not make one of his drawings of the site. However, it was not until much later that the Ancient Greek site we now know as Delphi became famous as a mecca for scholars and tourists. Compared to the extremely high standard of Bauer's plant and animal drawings and paintings, landscape was clearly not his forte. The scenic drawings, though valuable in serving as useful

records of the journey, helping to fix its chronology, contain various inaccuracies, such as the misplacement of landscape features, though this is probably due to the fact that Bauer did not work up the views from his original sketches until long after he had visited the places depicted and returned to England, and also he may have reproduced errors by copying other artists' drawings.

Sibthorp collected huge amounts of plant material, including whole plants, seeds and bulbs, as well as animal specimens. In contrast to his herbarium specimens, all of which (over 2,500) are still housed in the Oxford University Herbaria, and the seeds that he carefully amassed to be sown in the Botanic Garden (providing valuable additional reference material for Bauer), none of the animal specimens which were brought back to Oxford has survived, due to poor preservation techniques after they were collected. This adds greatly to the importance of the paintings of the bird and other animal paintings as they are the sole representatives of the expedition's findings in this respect.

Sibthorp's second expedition

After returning from abroad, John Hawkins encouraged Sibthorp to realize his plans for a second trip to the Levant. He also hoped that Bauer would join them, but when he contacted him the Austrian was understandably wary of committing himself to another greatly demanding journey, especially as he felt that Sibthorp had not treated him with respect and had underpaid him for such a huge volume of work over so long a time. Despite their friendship, and his respect for Sibthorp's dedication and brilliance as a botanist, Hawkins was at times critical of his treatment of Bauer. Moreover, he had considerable sympathy for Bauer's complaints, and relayed them to Sibthorp by letter, saying 'He [Bauer] assured me that he had been greatly deceived in terms of the engagement having no idea that it could continue so long, otherwise he should have stipulated for much more his present income not being more than he had earned in Vienna.' Sibthorp's reply was typically brusque and firm: 'I am highly satisfied with his Drawings & Sensible of their Beauties. but like a prudent Man with a beautiful Mistress I must not suffer myself to be intoxicated with the Beauty. & run throu lengths which Prudence cannot approve. More than I pay Him at present neither can I afford nor am I willing to give.' Bauer's strong disinclination to accompany Sibthorp on this second Levant expedition is perfectly understandable. He had devoted eight long years of his life to producing outstanding work for Sibthorp, often under trying conditions. He wrote a letter, dated 31 July 1794 (one of very few of Bauer's letters that have been found), responding to Hawkins's entreaty that Bauer should accompany him and Sibthorp once more. In it he outlined his feelings in no uncertain terms: 'I think Dr Sibthorp will beging His tour quite in the oldstyle never come to a determination before the last day. then at ones all in haste which is most unblessent ... I must big pardon if I shall Egus myself to acconpeng Dr Sibthorp.'

Despite this setback, which meant that Sibthorp would have none of Bauer's drawings to bring back to Oxford, and unwisely given the state of his health, he set off from London on 20 March 1794, but soon fell seriously ill, probably with malaria, while in Bucharest. All the members of the party except for Hawkins appear to have contracted the disease during the course of the expedition. By the middle of May, Sibthorp had arrived at the British Embassy in Constantinople, but he was still suffering from illness and required convalescence for several months. After Hawkins joined him in Constantinople on 8 August, and a brief return to the mountain of Uludağ they had climbed on the previous voyage, they travelled extensively across Greece, including a two-month exploration of the Morea, as the Peloponnese peninsula was then known. Sibthorp's return home was particularly taxing, as he decided not to take the direct

boat from Greece to Bristol as he and Bauer had done on their first voyage, but to follow a circuitous route across sea and land. After bidding farewell to Hawkins on the island of Zakinthos on 1 May 1795 he left with the crew on an open boat to Corfu, and after a short convalescence then reboarded it on 19 May. After being stranded for two weeks on a nearby islet, they crossed the Strait of Otranto and made the long journey up the east coast of Italy to Venice. Sibthorp still had another four months of overland travel ahead of him. He did not arrive in Bristol until 8 October 1795, and now gravely ill made haste to reach Oxford and home. Despite being bundled off to Bath in the hope of a cure, this failed to alleviate his symptoms, and he died there only a few months later on 8 February 1796, aged only 37.

Compared to Sibthorp and to the other protagonists in the Levant explorations, Hawkins lived into old age, dying at 80, just after the final, tenth, volume of the *Flora Graeca* was published. Sibthorp, by contrast, died before a single page of this great work appeared. It had a remarkably long gestation, not helped by the fact that at his death he had, in the words of Stephen Harris, 'left a chaotic mixture of unlabelled herbarium specimens, completed and half-completed drawings and manuscripts, and field notes in his execrable handwriting.' The task of making sense of this huge jumble of material fell to James Edward Smith (1759–1828), a renowned botanist and author. He was well equipped for the task, being a founder member and first president of the Linnean Society of London, whose family wealth had enabled him to buy Linnaeus's botanical library, manuscripts, herbarium and other natural-history items, an invaluable resource for the Herculean task of making sense of Sibthorp's material. In this, he was ably assisted by John Hawkins and the administrator, lawyer and accountant Thomas Platt. As well as being one of the most sumptuous and important of all floras, the *Flora Graeca* is both the most expensive and one of the rarest. The first printing numbered only twenty-five copies, though a second one numbered about forty. Many of the copies surviving today are an amalgam of the two printings.

Franz and Ferdinand

By contrast with Ferdinand, his older brother Franz Bauer had a far more stable and well-rewarded employment. He had left Vienna in 1788 and travelled across Europe via Prague, Germany and the Low Countries to London. There he remained, enjoying a settled and comfortable life working for the renowned English botanist and patron of science Sir Joseph Banks (1743–1820) in London as resident botanical artist for the Royal Botanic Gardens in Kew for 52 years until his death at the age of 82, and never travelled abroad again. This was in striking contrast to Ferdinand, who, after making long and arduous journeys across Europe and Australia, returned to his native land in 1814, where he remained until 17 March 1826. Another difference between the brothers was that, despite having a regular source of income, Franz died a pauper, for reasons unknown, whereas Ferdinand, who seemed to have been careful with money, became comfortably off in later years.

London, Australia and then home

After he had finished the work on the *Flora Graeca* and *Fauna Graeca* illustrations in 1794, and was no longer working for Sibthorp, Bauer moved from Oxford to London, where he stayed until 1801, after which he spent four years in Australia. On engaging him as his artist on the first Levant expedition, Sibthorp had paid Bauer £80 per year; later he increased that to £100 per year. However, this compared very unfavourably to the salary of £300 per annum for life his brother Franz received from Sir Joseph Banks while working for fifty years at the Royal Botanic Gardens at Kew. It also was

dwarfed by the remuneration of 300 guineas per annum Ferdinand himself received after refusing to go on Sibthorp's ill-fated second expedition to the Levant, when he was chosen in 1801 by Banks as the official artist on an expedition to Australia (then known as New Holland). This expedition was tasked with the accurate surveying and mapping of the island continent's entire coastline for the first time, as well as the investigation of its remarkable flora and fauna, which were almost totally unknown to science, though of course familiar to the indigenous Aboriginal inhabitants for at least 65,000 years. Under the command of 27-year-old Lieutenant Matthew Flinders, Ferdinand's fellow expedition members were the naturalist Robert Brown, with whom he worked closely and amicably; William Westall, landscape and figure draughtsman; Peter Good, gardener; and John Allen, miner.

Ferdinand Bauer's tour of the Levant with Sibthorp had begun in Vienna on 6 March 1786 and ended in Bristol on 5 December 1787, spanning a period of twenty-one months. By comparison this later, far longer, voyage to Australia involved not only the circumnavigation of Australia, but, to reach that faraway land and return, the circumnavigation of the world. This took up fifty months of Bauer's life, from the embarkation of the expedition ship *Investigator* on 18 July 1801 to the return to Liverpool on 13 October 1805. It is a mark of Bauer's supreme achievement that his paintings from the Levant tour were eventually published as the sumptuous and superlative *Flora Graeca*, while the illustrations he made of Australian plants remain to this day the best of any drawn in the field. He also made many fine pencil drawings of Australian birds and other animals, as with the plants including species new to science.

He had further developed his highly effective colour coding, with the number of different individually numbered colours increased to well over 1,000. In contrast to the situation with the Levant pencil drawings, only a small proportion of the Australian ones were chosen for Bauer to work up as watercolours: just 236 of the 1,534 drawings of plants, and 52 of the 176 drawings of animals.

Doubtless weary from his long sojourn on the other side of the world, Ferdinand returned in 1805 to London. Virtually nothing is known of his life there for the next nine years, though it is likely that he spent most of it working with his usual diligence on the watercolours of Australian plants and animals, in close cooperation with Robert Brown, who provided accompanying text of their scientific names, descriptions and information about distribution.

In 1814 Bauer left England for Vienna, with fourteen large cases of possessions, including his extensive herbarium collection and various paintings. There he lived in a single-storey cottage in the Viennese district of Hietzing, near the grand Schönbrunn Palace. Following a period of illness in 1825, he died in 1826 at his home, aged 66, the causes being recorded as dropsy (an old name for oedema) and gout. Little is known about Ferdinand's personality and temperament, apart from a few tantalizing references from others, such as Matthew Flinders's commenting that he was 'polite and gentle', but then qualifying this by saying 'I fear there is a dreadful disposition at the bottom.' No portraits of him have ever been found, although a few letters and other documents exist. It seems likely that though very single-minded he was not overly concerned with self-promotion. Sadly, this helped to account for his relative obscurity until quite recently.

1. 2. 3. 4. 5. 6. 7. 8. 9. 10. 11. 12. 13. 14. 15. 16. 17. 18. 19. 20.
21. 22. 23. 24. 25. 26. 27. 28. 29. 30. 1. 2. 3. 4. 5. 6. 7. 8. 9. 40.
41. 2. 3. 4. 5. 6. 7. 8. 9. 50. 1. 2. 3. 4. 5. 6. 7. 8. 9. 60.
61. 2. 63. 4. 5. 6. 7. 8. 9. 70. 1. 2. 3. 4. 5. 6. 7. 8. 9. 80.
81. 2. 3. 4. 5. 6. 7. 8. 9. 90. 1. 2. 3. 4. 5. 6. 7. 8. 9. 100.
101. 2. 3. 4. 5. 6. 7. 8. 9. 10. 11. 12. 13. 14. 15. 16. 17. 18. 19. 20.
21. 2. 3. 4. 5. 6. 7. 8. 9. 30. 1. 2. 3. 4. 5. 6. 7. 8. 9. 40.
141. 142. 143. 144. 145. 146. 147. 148. 149. 150. 151. 152. 153. 154. 155. 156. 157. 158. 159. 160. 161.
162. 163. 164. 165. 166. 167. 168. 169. 170. 171. 172. 173. 174. 175. 176. 177. 178. 179. 180. 181. 182.

Painting by numbers

As anyone can attest when attempting to describe the colours of a plant's leaves and flowers, or a bird's plumage – or to match a colour when decorating a room – precise hues are notoriously difficult to describe. Colour charts employed by fine artists have a long history, dating back at least to their use by the great German painter Albrecht Dürer (1471–1528), and by the close of the eighteenth century were in common use in central Europe. Ferdinand and his brother Franz appear to have been well versed in the use of a colour chart from an early age, when working on the Codex Lichtenstein for the physician, pharmacist and botanist Norbert Boccius, who had become prior of the convent at Feldsberg, as described earlier (see p. 3).

Ferdinand in particular used his system of numerical colour coding to great advantage to achieve his subtle and remarkably precise rendition of plants, birds and other animals. He is thought to have been unique in his regular use of such a complex system in the field when making his preliminary drawings. This involved his remembering each colour by a system of number codes assigned to each and every one of at least 300 colours during his Levant expedition with Sibthorp – a remarkable feat that was eclipsed when he devised a far more complex system of up to 1,000 colours for the later expedition with Flinders to Australia. His memory for colour must have been phenomenal and very unusual. As one of Bauer's two major biographers, David Mabberley observes: 'Bauer must have been able to recall the number–colour link in many instances – it is possible that he had the capacity to remember colours in the way a musician remembers notes.' Such a method had the great advantage that it saved him from the encumbrance of being weighed down with carrying stocks of paints and watercolour paper while making long and arduous journeys, often in challenging terrain.

In 1999 Hans Walter Lack, who has spent over forty years carrying out extensive research on Bauer and his work, found what is apparently a painted colour chart of 140 colours prepared by either Ferdinand or Franz Bauer in the archive of the Real Jardín Botánico in Madrid. The evidence for this is that the numbering of the colours matches that on some of the early sketches made by the two brothers. Nevertheless, there is no further evidence that Ferdinand Bauer used a painted colour chart during either his expedition with Sibthorp or the longer one with Flinders to Australia.

Bauer left very little trace of his industrious and adventurous life save for the huge number of magnificent and meticulous watercolours and some (regrettably few) of the precise and accurate pencil sketches on which these were based. The latter bristled with lines leading from all over the drawings to the constellations of colour numbers, reminiscent of an acupuncturist's chart.

As for producing the colours themselves, it is very likely that for the Levant tour Bauer would have had to purchase his pigments from his own salary, and grind and mix them himself. (By the time he joined the expedition to Australia, he would have been able to buy ready-prepared boxes of watercolours in pans, tubes or pots, as one can today.)

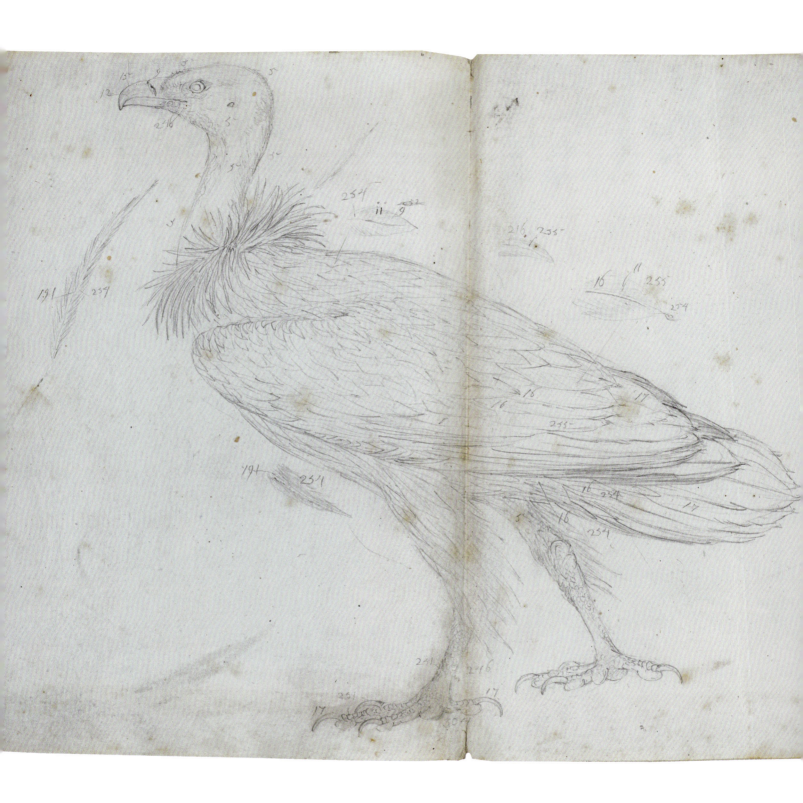

FIG. 11 This preparatory pencil drawing of the Griffon Vulture shown in the final watercolour is one of only very few surviving preparatory colour-coded pencil drawings that Bauer made.

FIG. 12 This pencil drawing of the foot of the Griffon Vulture with its scribbles and paint marks gives an idea of the maximum use to which Bauer put his limited supply of poor-quality paper.

FIG. 13 This preparatory drawing of a female Northern Wheatear, bristling with lines leading to a constellation of numbers, gives an idea of just how many subtle and precise colours Bauer was able to portray – and quite possibly to recall without recourse to a chart, in a similar way to a musician remembering notes.

FIG. 14 The finished watercolour corresponding to the pencil sketch of the Northern Wheatear, complete with the usual addition of a rock perch and appropriate vegetation.

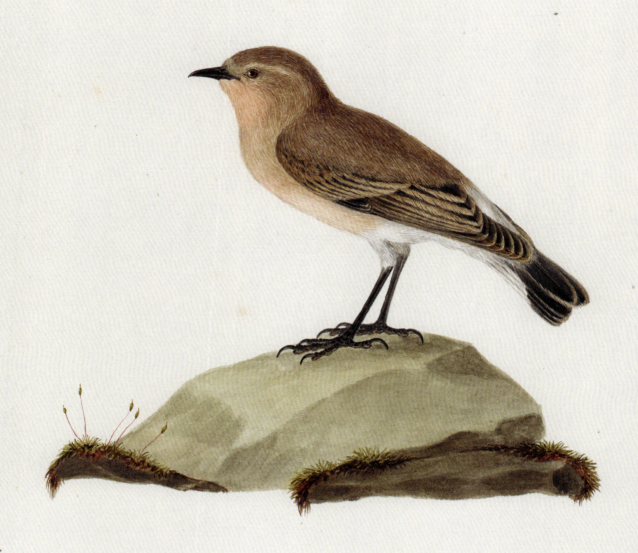

WHEAT-EAR young.

90.

SAXICOLA ŒNANTHE.

FIG. 15 Even with a bird having apparently uniformly coloured feathers, such as this Red-billed Chough, Bauer distinguished subtle variations in the appearance of its plumage, and also distinguished between the different shades of red between the bill and legs. The finished watercolour is shown on p. 158.

FIG. 16 This colour chart was discovered by chance by Hans Walter Lack, who has made a close study of the Bauer brothers over many years, in the archive of the Real Jardín Botánico in Madrid. It was bound into a manuscript owned by the estate of a Czech botanist, Thaddeus Haenke. After he worked for Jacquin in Vienna, he left in June 1789 to join a major expedition of the Spanish possessions in the Pacific. Amazingly, the chart survived a shipwreck in the Rio de la Plata and further adventures in California, Alaska, Kamchatka, Australia and some ten years in the region that became Bolivia before arriving in Madrid. The 140 colours are each identified by a numeral, and the handwriting is identical to the Bauers' pencil drawings for the Codex Lichtenstein. Although this may be that of Joseph or Franz Bauer, it is most likely to have been written by Ferdinand.

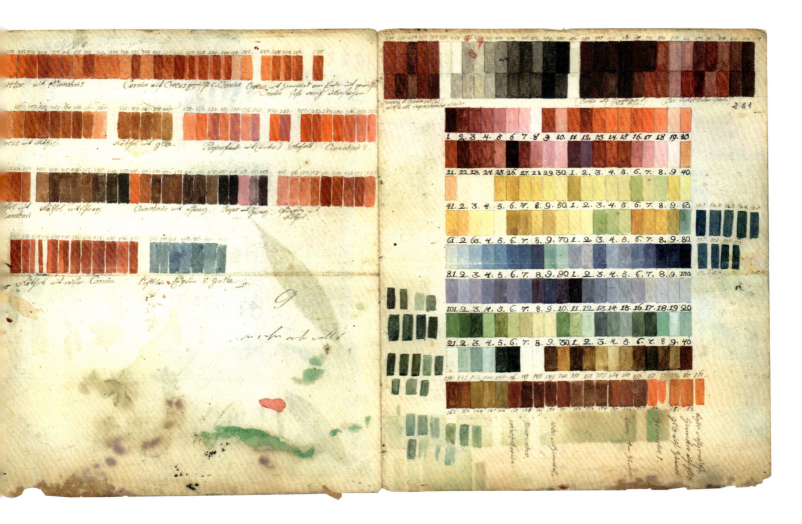

Until relatively recently, little attention has been paid to Bauer's remarkable adoption of a such complex colour codes, his colour palette, or the precise analysis of the pigments he used. In 2017, as part of a research project at the Bodleian Library, the technical art historian and conservator Richard Mulholland and colleagues used portable bespoke imaging apparatus and techniques to analyse the pigments used in both the *Flora Graeca* and the *Fauna Graeca* without damaging the delicate and valuable watercolour paintings. The results showed that Bauer's colour palette was more limited than had previously been thought and, though generally similar to that used by contemporary artists, differed in some respects. Sibthorp's refusal to increase his remuneration was likely to have contributed to Bauer's choice of pigments, such as ultramarine for blue colours and cochineal for red ones. Another factor was the immense number of detailed paintings he had to produce in a remarkably limited time. Despite these constraints, it is a mark of his dedication to quality and sheer hard work at a rate that caused deterioration of his eyesight that Bauer could achieve an astonishing degree of colour accuracy for both his plant and his animal paintings. As for the paper, he used expensive high-quality white laid watercolour papers from the Dutch paper mill of C. & J. Honig in Amsterdam.

AUTHOR'S NOTE

The order in which the following plates appear is determined by the evolutionary relationships of the different species of birds. The sequence and the common and scientific names follow the taxonomy used in the HBW and BirdLife International (2022) *Handbook of the Birds of the World* and BirdLife International digital checklist of the birds of the world, Version 7. The full world list is available online at: datazone.birdlife.org/userfiles/file/Species/Taxonomy/HBW-BirdLife_Checklist_v7_Dec22.zip.

Bauer's Birds

Black Francolin *Francolinus francolinus*

EUROPEAN FRANCOLIN *FRANCOLINUS VULGARIS*

This partridge-sized gamebird is one of a number of species that share the word 'francolin' as part of their common name. In origin this is related to the Italian word for the bird, *francolino*, meaning 'little hen'. In the first scientific description of this bird, in 1766, Linnaeus had placed it in the genus *Tetrao*, but the use of this name became restricted to the world's largest grouse, the two species of capercaillie. Later, as in the annotation provided by Frederick Holmes to Bauer's illustration, the Black Francolin was included in the genus *Francolinus*, along with all the other francolin species. This was the case until the 1990s, when taxonomists suggested that differences among them merited division among several genera, reserving *Francolinus* for the Asian species; members of the other genera were all African.

The specimen Bauer has painted is a young male. His plumage is very similar to that of the female, a subtly beautiful melange of mottled and barred brown, buff and cream feathers with a reddish nape and black outer tail. The male is very striking, with his black head bearing a contrasting white cheek patch, a broad reddish-brown band encircling his neck, and a black body with white spots on his back and hindneck and white V-shaped markings on his flanks and belly. These are shy and retiring birds, spending much time hidden among tall grass, crops and shrubs, often near water. Attention is drawn to their presence during much of the year by the distinctive loud rhythmic grating calls uttered by the males to advertise themselves to females, consisting of seven syllables. Rather fanciful transcriptions of the sounds include the mnemonic 'fixed bayonets, straight ahead' and 'be quick, pay your debts'. They are repeated at 10- to 15-second intervals and usually delivered from an elevated perch on a mound or ridge or in a bush so that they carry as far as possible. The male stretches his neck upwards, and ends the performance with a bout of up-and-down tail wagging. At the start of spring, they are usually heard only before sunrise, but during the mating period can be heard all day long, though usually with a peak at dawn and dusk.

At one time the Black Francolin's range extended westwards across the Mediterranean to Portugal, Spain and the Balearic Islands (partly as a result of introductions for hunting by the Saracens and Moors), and also including Sardinia, Sicily, parts of Italy, and Greece. It has disappeared from all these places, although there have been recent attempts at reintroduction to the Algarve in Portugal and Tuscany in Italy, which have only been partially successful. To the east, the range extends across southern Turkey, parts of the Middle East, southern central Asia and eastwards to Pakistan and northeast India. Sibthorp and Bauer would have encountered this bird in Cyprus. There and in Turkey it was at risk from overhunting, as well as by habitat destruction and degradation, but there have been welcome increases in numbers recently.

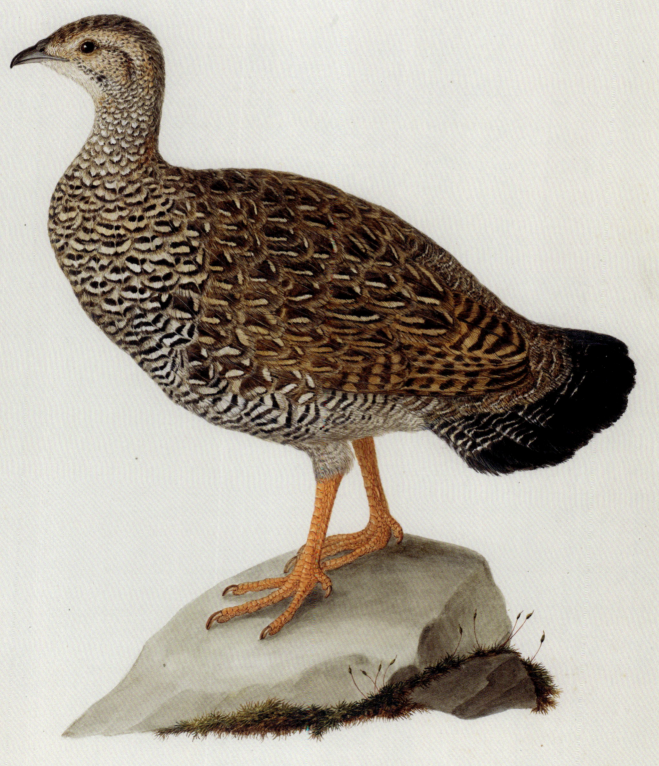

EUROPEAN FRANCOLIN. immature male.

259.

FRANCOLINUS VULGARIS.

Fer. Bauer del.

Rock Partridge *Alectoris graeca*

Greek Partridge *Perdix saxatilis*

This attractively plumaged, plump gamebird is one of only twenty-one bird species endemic to Europe, where it breeds in the Alps, the Apennine range in Italy, Sicily, and the Balkan Peninsula, the last area holding the largest numbers today. It is a close relative of another endemic, the Red-legged Partridge (*Alectoris rufa*), whose natural range was across the south-west Mediterranean, in northern Italy, France, Spain and Portugal. This species was first introduced for hunting to land near the Royal Parks at Windsor and Richmond on the orders of King Charles II in the late seventeenth century, but that and various other early attempts at establishing the species failed, and it was not until 1770 that a successful much larger scale introduction was made by the Marquis of Hertford in Suffolk. Following that, further imports by other landowners over many years saw the species spread throughout much of Britain, and numbers were massively topped up by artificial rearing. Currently, more than 5 million of these birds are released annually in Britain (and several million each year in France and Spain).

Sibthorp may have encountered the 'Red-leg', 'French' Partridge, or 'Frenchman' as the Red-legged Partridge was usually known (the last two names referring to the origin of the imported eggs that were incubated under domestic hens) during his travels in Italy with Bauer, but that species does not occur in the Levant. However, a third species, the Chukar, *Alectoris chukar*, extremely similar in appearance to the Rock Partridge, is widespread in Greece and many of its islands, including Crete, as well as in Cyprus, and it breeds right across Turkey. Confusingly, in his diary, Sibthorp records that on Cyprus the 'red partridge reside(s) throughout the year', but this must refer to the Chukar, as neither the Red-legged nor the Rock Partridge occurs on the island. The specimen Bauer has painted shows distinctive facial, breast and flank markings that indicate that it is a Rock Partridge, so it was presumably obtained somewhere in Greece. The reference in the annotation to the specific name *saxatilis* is puzzling, though, as this is the name for the subspecies (*Alectoris graeca saxatilis*) that breeds in the Alps from France to Austria and farther east to western Bulgaria; the subspecies that occurs in Greece and elsewhere in the Balkans is the nominate one, *Alectoris graeca graeca*.

Both the Rock Partridge and the Chukar were introduced to the UK from the 1970s onwards by gamebird-shooting interests in the hope that they might be easier to breed than the Red-legged Partridge and the endangered and greatly diminished indigenous British species, the Grey Partridge, *Perdix perdix*. The Chukars, however, though easy to breed, failed to thrive and maintain viable populations outside their native range. Moreover, they were able to hybridize with both Red-legged and Rock Partridges, producing viable offspring, which has posed a problem of further contributing to the decline of wild Rock Partridges. In Britain, releasing Chukar or hybrids between Red-legged Partridges and Chukar has been banned since 1992.

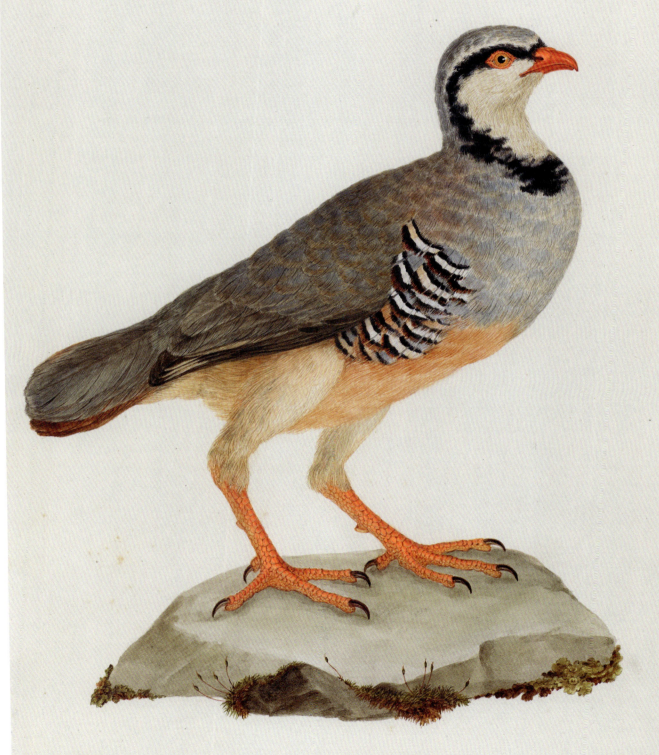

Greek Partridge, male.
261.
Perdix Saxatilis.

White-headed Duck *Oxyura leucocephala*

WHITE-HEADED DUCK *UNDINA LEUCOCEPHALA*

As with his painting of the seabird Scopoli's Shearwater, *Calonectris diomedea* (see p. 68), Bauer deviated from his usual practice of situating birds on a standard rock or perch, instead portraying this unusual little duck swimming. This is very apt, as the White-headed Duck and its relatives in the small subfamily Oxyurinae of ducks, commonly known as the stifftails, are highly aquatic, rarely leaving the water except when on the nest, either a platform of dead reed stems and leaves, or the old nest of another duck or a coot. They are mostly reluctant fliers that have to beat their short, broad wings rapidly and patter over the water surface to achieve lift-off. Instead, they prefer to escape from danger by diving underwater, when they use the long narrow tail as a rudder.

The White-headed Duck is the only species of stifftail native to Europe and Asia, the other eight species being indigenous to Africa (one species), Australia (two species), South America (four species) and North America, Mexico and the Caribbean (one species). In recent years, the last of these relatives has proved of crucial importance for the fate of the White-headed Duck in a manner that could not have been foreseen. This species is the closely related Ruddy Duck, *Oxyura jamaicensis*, and the story begins in 1948, when three pairs were imported to the Wildfowl & Wetlands Trust centre at Slimbridge, Gloucestershire, two years after the trust's foundation by the great conservationist Sir Peter Scott with the aim of captive breeding of wildfowl species from many parts of the world. Some of the Ruddy Ducks escaped from the wildfowl collection there and soon established self-sustaining breeding populations elsewhere. Twenty-four years after their introduction, there were twenty-five breeding pairs, and by 1991 a census counted 3,400 individuals. By the year 2000 this had increased to 5,000, spread throughout much of the UK. They posed no problem and were appreciated by many who watched them, due in no small part to their unusual and endearingly comical and rather toy-like appearance, with their big bright blue bills that looked as if they had been fashioned from plastic, and their spiky black tails cocked up at a jaunty angle. The trouble began when they spread to continental Europe, colonizing the Netherlands, France and Belgium in the 1970s, and especially when they arrived in Spain, where the White-headed Duck had a small remnant population of just twenty-two birds. This was a serious concern as the species is threatened throughout its range in Spain, north-west Africa, Turkey and central Asia by habitat destruction and hunting. Unfortunately, the male Ruddy Ducks lost little time in interbreeding with their female relatives, and producing hybrid young. The risk that the dominant interlopers would cause the extinction of the White-headed Ducks by swamping them with their genes was deemed great enough for conservationists to set up a cull of Ruddy Ducks to eradicate both the small number in Spain and the much larger population in the UK, the source of the problem. This has been almost entirely effective, and hopefully the White-headed Duck's future is assured, though this is by no means certain.

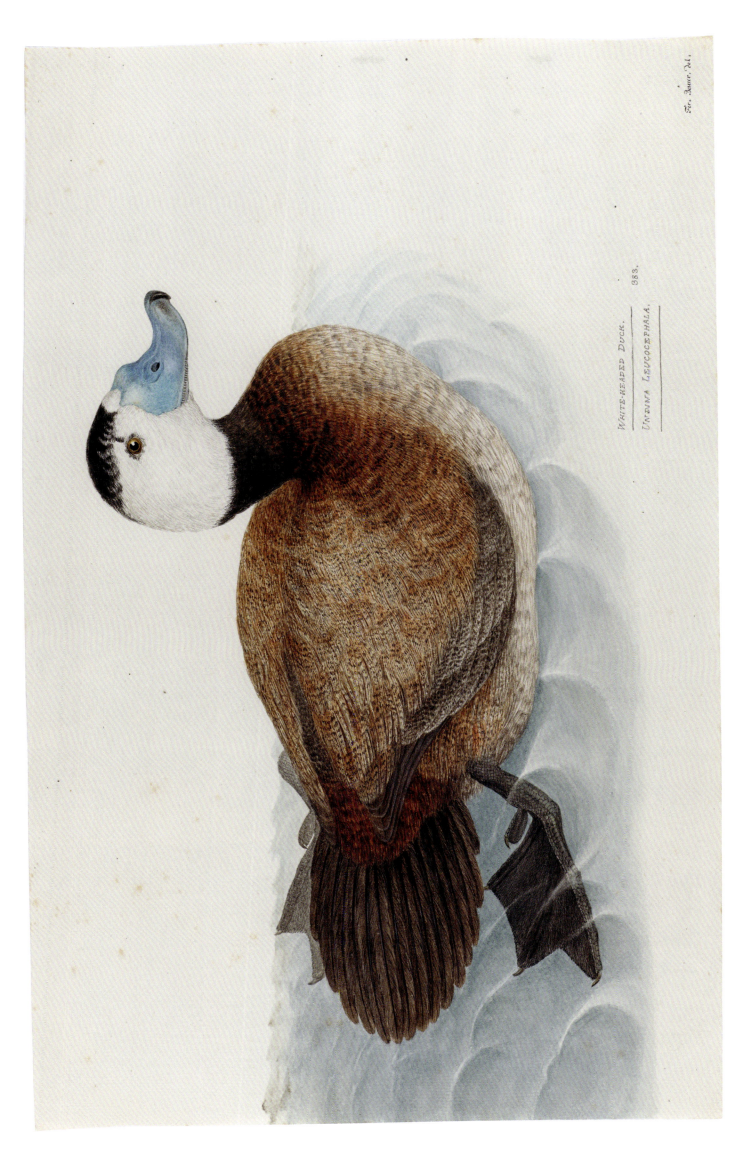

Smew *Mergellus albellus*

SMEW *MERGUS ALBELLUS*

The pattern of the drake's plumage is exquisite: its mainly dazzlingly white head and body contrasting strikingly with a black 'panda' patch around the eye that extends to the base of the bill, a black stripe higher up on the rear half of the head, and a black central stripe down the back. At close range, it is possible to make out two very thin black stripes curving down the side of the breast and the fine grey pencilling pattern on the flank. Usually, when swimming or resting ashore the wings are tucked away neatly, and the back below the central black stripe is white apart from a narrow horizontal black line bordering the grey flanks, but Bauer has painted his specimen with the left-hand wing held slightly away from the body, revealing it to be mainly black apart from a white panel. This is also apparent when a male takes off, shooting up suddenly off the water with very fast wingbeats.

The pied plumage pattern and the cowl-like shape of the crown feathers account for the old English name of White Nun (or simply Nun) for the male Smew; other dialect names were Magpie Diver and Pied Diver, reflecting both its appearance and the frequency with which this little duck dives, to catch its food (small fish and invertebrates) and to escape danger. The name Smew is related to Dutch and German words (*smeeente*, *Schmeiente*) for this and other small ducks.

The drake is only a little bigger than a Teal, *Anas crecca* (see p. 50). The slightly smaller female (see p. 233), and also immature birds of both sexes and males after moulting in autumn into an eclipse plumage (the cryptic female-like plumage adopted by many male ducks when flightless after their post-breeding moult, to help hide them from predators), were known as Redheads, Red-headed Smew or Weasel Duck, all names referring to the rich chestnut colour of the upper part of the head and the hindneck, contrasting with the white chin and foreneck and the grey body. Because of these differences, the male and female were originally thought to belong to different species. The Smew is a member of a small group of ducks known as sawbills, which are distinguished by the sharp toothlike serrations of the cutting edges of their bills, an adaptation to grasping and holding on to their slippery, wriggling fish prey.

Smew breed in the far north of Eurasia, mainly in northern Scandinavia, Finland and Russia, extending right across Siberia. There are small isolated populations in Lithuania and Belarus. All populations winter farther south: those from Scandinavia, Finland and western Russia to north-west and central Europe; birds from farther east to the eastern Mediterranean (where Sibthorp and Bauer presumably found this male) and the Black Sea; and Siberian breeders to the Caspian Sea and south-west Asia.

They are birds of nutrient-rich (eutrophic) lakes and rivers in the great northern coniferous forest belt known as the taiga. Here, they nest in tree holes (and also nestboxes provided by conservationists), from which the chicks must make a prodigious leap to the ground far below, their soft, fluffy, down-covered bodies cushioning them as they land.

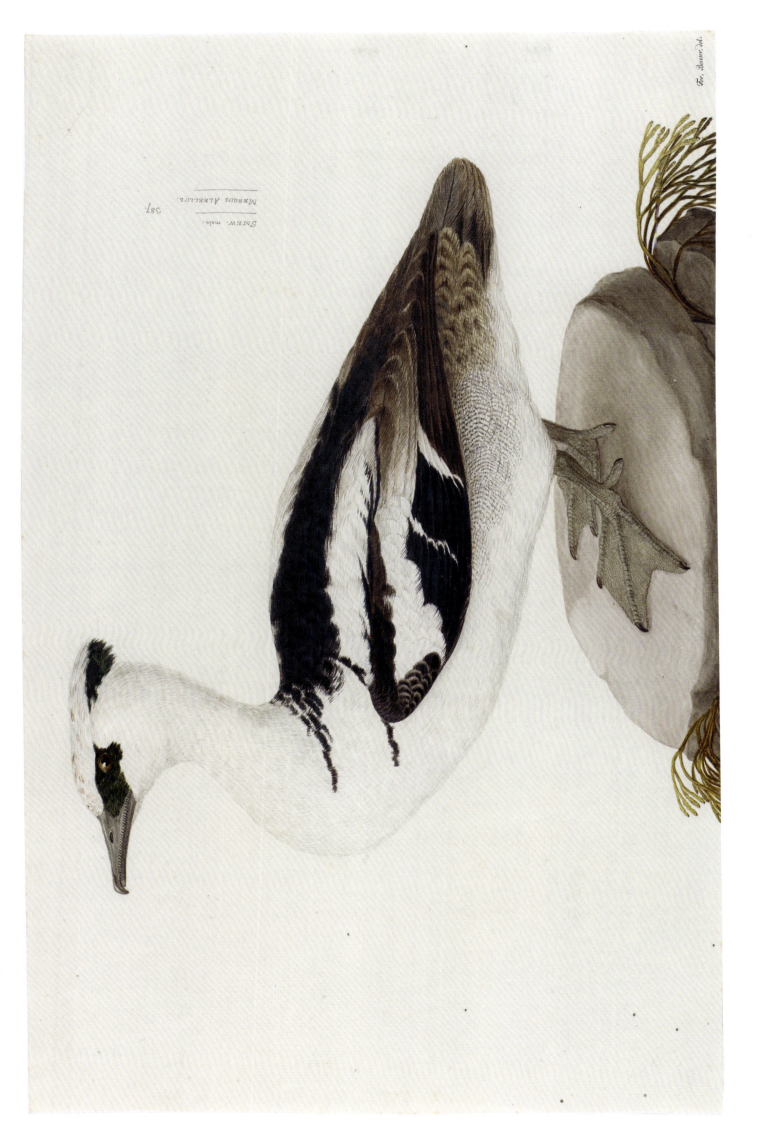

Tufted Duck *Aythya fuligula*

TUFTED DUCK *FULIGULA CRISTATA*

This jaunty little waterfowl is one of a group of ducks known as diving ducks, from their habit of obtaining most of their food by diving from the surface and swimming underwater, rather than finding food at the surface or upending to obtain it, as do the dabbling ducks. They mostly have rather shorter (and in some species less pointed) wings, so are unable to spring straight up into the air. Instead they need to run, pattering their feet along the surface of the water before they can gain enough lift to be airborne. Some species, like this one and the pochards, live mainly on freshwaters, while others, such as eiders, scoters and the Long-tailed Duck, *Clangula hyemalis*, are marine, and hence often known as sea ducks. The prominent bunch of feathers at the back of the head that Bauer has portrayed in this otherwise accurate portrait is not typical for this autumn eclipse plumage male. Such a long, drooping crest is a distinguishing character of the drake in his dapper black-and-white breeding plumage, though not always apparent when lying close to the rear of his head. The female's crest, by contrast, is a far shorter adornment, more fitting of the name of a tuft.

The breeding range of the Tufted Duck spans right across Europe and Asia, mostly at upper middle latitudes, between 70 N and 45 N. Populations in Britain and Ireland and across much of eastern Europe are mainly resident all year, whereas those from the rest of their breeding range migrate south annually, mainly to France and the Mediterranean region. Although there have been declines in parts of northern and eastern Europe, it is a successful and abundant bird in the west that has shown a steady increase in numbers and range over a long period. It has benefited greatly from the construction of lowland reservoirs and flooded gravel pits with relatively deep water for diving, as well as ponds and lakes in parks, even in the middle of large cities such as London. But it is also at home throughout its range in other fertile freshwaters, including lakes (as long as they are not acid) to slow-flowing rivers, canals, sheltered coastal waters and tundra pools in the far north. For breeding, it favours small islets that give it protection against most predators, and often for extra safety it nests among dense colonies of gulls. It will also readily take to nest boxes. Tufted Ducks prefer waters with depths of 3–5 m, but will also thrive where the water is as deep as 15 m. Most dives last 14–17 seconds, but they can stay under for up to 40 seconds. They feed mainly on molluscs, crustaceans and insects, supplemented with seeds.

In Britain and Ireland, Tufted Ducks had only been present as winter visitors until the middle of the nineteenth century: they were first recorded breeding in England in 1849. Their spread thereafter was assisted by the accidental introduction via ships of two molluscs that came to be of great importance in their diet. These were the Zebra Mussel, *Dreissina polymorpha*, from the mid-1820s, and then, from 1883, Jenkins' Spire Snail, *Potamopyrgus antipodarum*.

Tufted Duck
Fuligula Cristata
370.

Garganey *Spatula querquedula*

GARGANEY TEAL *QUERQUEDULA CERCIA*

As with most of his other birds, Bauer has posed this handsome little drake Garganey on a rock, and as with almost all the other ducks, except the swimming White-headed Duck, *Oxyura leucocephala* (see p. 38), he has chosen for his characteristic rather stylized decorations seaweeds, despite this being essentially a freshwater bird. It only occasionally visits coastal waters in its European range, though it may do so more often in Asia. Also, as with the other wildfowl Bauer portrayed, the bill is a rather odd shape, with the upper mandible abruptly concave, and in this case far too thick as well. The plumage though is beautifully rendered, bringing out the striking head pattern, and the detail of the fine white markings on the rich reddish-brown face and neck, the black barring and chevrons on the bronzy breast and the fine grey vermiculations on the flanks. Females – and males during their female-like 'eclipse' plumage when, like other wildfowl, they moult all their flight feathers after breeding and become temporarily flightless – have a camouflaging pattern of streaked and mottled brown and buff, as with other dabbling ducks. Both sexes are distinguished by a pale grey forewing, most prominent and with a blueish cast in males. Slightly larger than the more familiar Common Teal, *Anas crecca* (see p. 50), the Garganey is a quieter and generally more unobtrusive bird, which is easily overlooked.

The Garganey's scientific name was changed recently when it was moved from the large genus *Anas*, which contains many of the surface-feeding (or dabbling) ducks, reflecting genetic research that indicated it is more closely related to the shovelers and various species of teal in the genus *Spatula*, a name referring to the huge shovel-shaped bills of the shovelers. Like the common name, which is related to an Italian name for the bird, *garganella*, the specific name *querquedula* is imitative of the male's curious breeding display call, a dry, wooden rattling sound that has been likened to the sound of cracking ice, the noise of a fingernail running across the teeth of a comb, or the sounds made by crickets. The last comparison accounts for the old English name of Cricket Teal. Other old dialect names in English include Summer Teal, referring to the Garganey's unique position as the only wildfowl species that is a summer visitor to Britain, which constitutes the western outpost of its vast distribution across much of Europe and Asia, to as far east as the Pacific coast of Russia. Indeed, all populations are migratory, travelling thousands of kilometres each year. Those breeding in Europe winter mainly in Africa, right across that continent in a narrow belt south of the Sahara, while Asian breeders fly to the Persian Gulf, India, southern China and South East Asia. In Europe, the Garganey is most common in the east, with about 90 per cent of the total in Ukraine, Belarus and southern Russia.

GARGANEY TEAL. *Querquedula Circia.* 864.

Northern Shoveler *Spatula clypeata*

SHOVELLER DUCK *RHYNCHASPIS CLYPEATA*

This is one of four very similar species of distinctive ducks, with an extremely wide distribution across much of Europe, northern Asia and North America; the other three are the Cape Shoveler (*Spatula smithii*) from southern Africa, the Australasian Shoveler (*S. rhynchotis*) and the Red Shoveler (*S. platalea*) in South America. Northern Shovelers are in many parts of their range rather sparsely distributed, breeding by shallow, food-rich lakes or in marshes with areas of open water. Although some are year-round residents, as in England, the Low Countries and France, most populations are migratory, travelling south to winter from western France, Spain and the Mediterranean, Africa, southern Asia and southern USA, Central America and the Caribbean.

The boldly patterned male Bauer has painted and the far plainer female with her mottled brown plumage are distinguished from other dabbling ducks at considerable range by the strikingly long and broad-ended bill, both as they cruise low in the water, their bills almost touching the surface, and in flight, when it makes them look oddly front-heavy.

The Northern Shoveler's generic name *Spatula* roughly describes the shape of the huge bill. Its specific name, *clypeata*, was derived from the Latin word meaning 'shield-bearing', while the formerly used generic name *Rhynchaspis* is the Greek equivalent. Viewed from above, the bill does have the shape of a shield, the front half being expanded so that it is twice as wide at the tip as at the base. Shovelers have a varied diet. They are more carnivorous than most other dabbling ducks, feeding mainly on small aquatic invertebrates, such as insects and their larvae, molluscs and planktonic crustaceans. They also eat smaller amounts of seeds and other plant matter. Like other dabbling ducks, they are filter feeders, sifting out their prey and seeds with a meshwork of fine serrations along the inner edges of the bill. The common name refers to the somewhat shovel-shaped bill and to another method of feeding, in which its owner scoops it through liquid mud to extract food. They sometimes exhibit a curious and distinctive method of obtaining food. Swimming in pairs or small groups, they rotate in tight circles, each following closely behind its neighbour, benefiting from the cloud of tiny creatures and plant food it disturbs. Versatile feeders, they also swim along with head and neck outstretched, sweeping the surface from side to side with their bill or immersing their heads and necks; upending with head and neck submerged, or making brief shallow dives.

It was the great seventeenth century naturalist John Ray who distinguished the two species that were, confusingly, both called by wildfowlers 'spoonbills'. He referred to the duck as the Shoveller, reserving the name Spoonbill for the other, unrelated white bird – a member of the ibis family – with a far longer and more truly spoon-shaped bill, which it also uses for filter feeding.

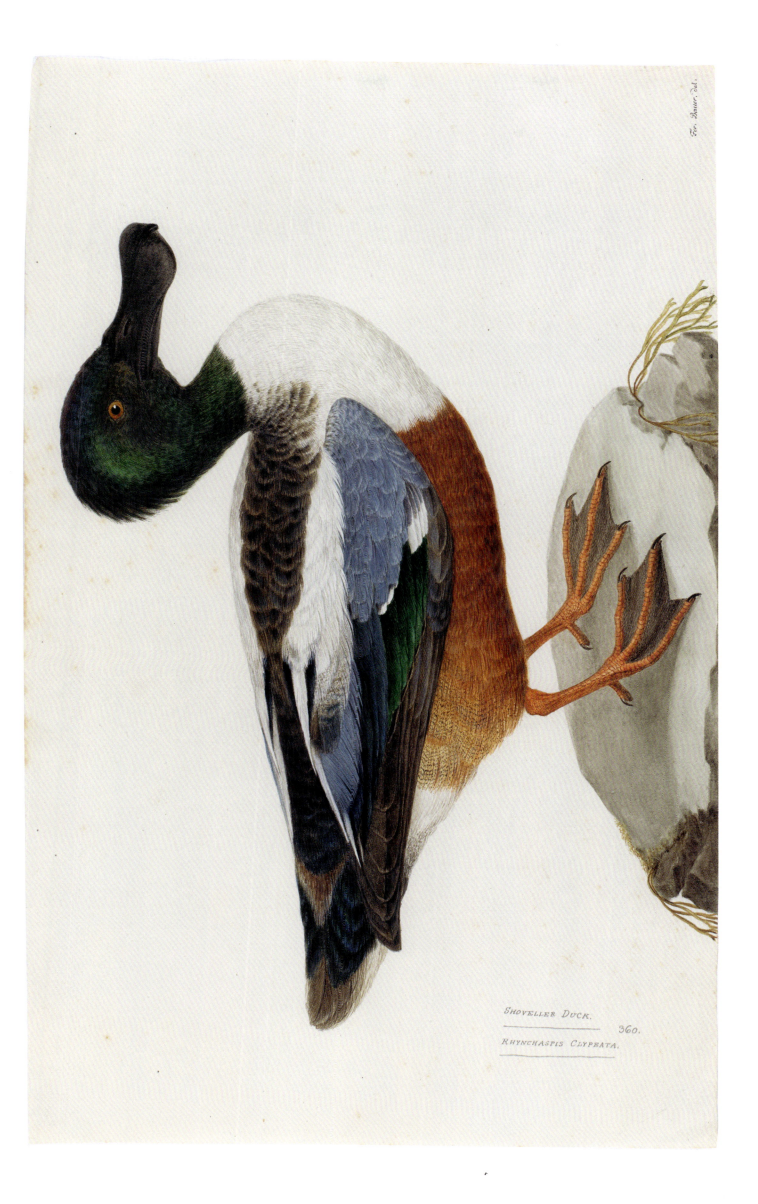

Shoveller Duck.
360.
Rhynchaspis Clypeata.

Eurasian Wigeon *Mareca penelope*

WIGEON *MARECA PENELOPE*

In his painting of a handsome drake of this short-necked, small-billed surface-feeding duck, Bauer has created an accurate portrayal of the particularly lovely pattern of colours, with a yellowish cream forehead and crown, rich chestnut brown head and neck, delicate pinkish breast and pale grey body contrasting boldly with the white and black rear. In flight, the big white wing patch is visible at long range. The Wigeon is a duck with a whistle rather than a quack. More specifically, the male has a loud, far-carrying, musical whistling call. This is particularly dramatic when, as often, a flock all call together, so that the whistles overlap in a delightfully complex fashion. It also accounts for many local English names, such as Whistler, Whew and perhaps also Wigeon from its first element *Wi* (and its antecedents, such as Widgeon, Wigene and Wegyons, derived from Old French *Vigeon*). Females, which have variable dark reddish-brown or greyish-brown plumage, have deep, three-note growling calls, but do not quack like many other female ducks.

Adult Wigeon are almost entirely vegetarian, their diet including leaves, stems, rhizomes and some seeds of a variety of plants, although the ducklings eat insects or other invertebrates. Wigeon sometimes feed like the ubiquitous Mallard, *Anas platyrhynchos*, by dabbling at or just below the surface of the water, or upending to reach deeper items, as when pulling saltmarsh plants by the roots. But, like geese, they specialize in grazing: along coasts on marine grasses, especially eelgrasses, *Zostera*, and also inland on grassland, especially since the decline of eelgrass and during winter.

Appropriately, this is one of the species for which Bauer chose to include a pencil drawing of an anatomical detail, in this case the short, narrow bill of the Wigeon. This shows clearly the numerous small, hard spines called lamellae that line the insides of the lower bill; these work together with lamellae in the upper bill during feeding. They vary considerably in their shape and function in different groups of ducks, depending on their diet, from fine and comblike for filter feeding in the Mallard, Northern Shoveler, *Spatula clypeata* (see p. 46) and many other dabbling ducks, to sharp, toothlike, backward-pointing serrations for seizing and holding slippery fish in the Smew, *Mergellus albellus* (see p. 40), and other 'sawbills'. The shape of the Wigeon's bill, the arrangement of the transverse lamellae, the spikes on the tongue and the hard 'nail' at the tip of the upper mandible are well suited for grasping grass shoots and shearing off their tops, in a similar way to that seen in geese such as the little Brent Goose, *Branta bernicla*, and Canada Goose, *Branta canadensis*, alongside which Wigeon flocks often feed.

Wigeon are very widespread, breeding across northern Europe, from Iceland, Britain and the Netherlands, through Scandinavia, Finland and the Baltic Republics and east in Belarus and northern Russia to the Pacific coast of Siberia. They favour shallow freshwater lakes and marshes and also nest in tundra and bogs. Most migrate south in winter, with about half of those from north-west Europe spending winter in Britain and Ireland.

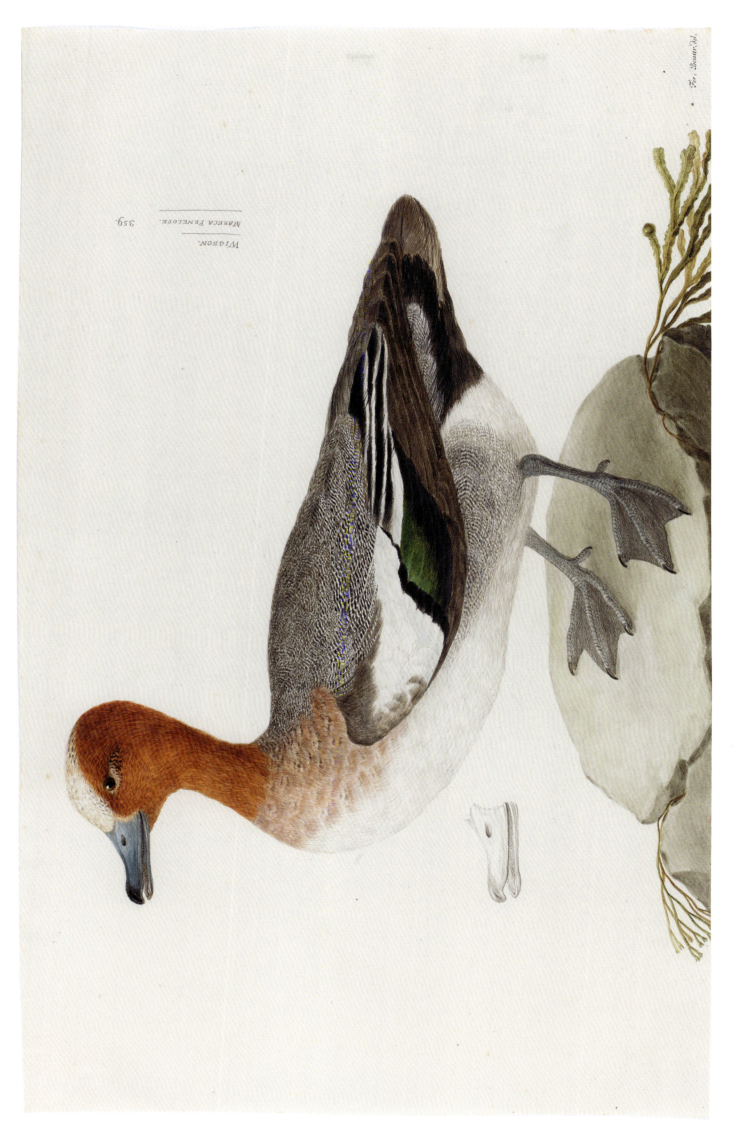

WIGEON.
MARECA PENELOPE. 359.

Common Teal *Anas crecca*

TEAL *QUERQUEDULA CRECCA*

This is the smallest of all the European ducks, little larger than a town pigeon and weighing only about one-third as much as the commonest European duck, the Mallard, *Anas platyrhynchos*. Wildfowlers and game dealers used to refer to it as a 'half-duck' for this reason. The male, shown here, has exquisite plumage with a complex pattern.

The female, as in some other surface-feeding ducks in the genus *Anas*, is more soberly attired in an intricately streaked and mottled plumage that helps camouflage her from predators when on the nest.

Bauer has chosen to portray this little drake Common Teal with its bill open, calling. It is one of a number of duck species in which the drakes at least have some most 'unducklike' calls, including a mellifluous, high-pitched piping call that, though not very loud, is far-carrying. They are particularly vocal in winter and spring when displaying in groups to threaten rival males and attract females to mate with them. Females make more typical quacking sounds, higher pitched, quieter and less vigorous than those of larger relatives among the dabbling ducks, such as the Mallard and Pintail.

The name 'teal' used for this species – and by extension for twenty-three other species of small ducks that are found in various parts of the world – is of great antiquity, dating back to the thirteenth century or earlier. It is probably imitative of the male's attractive call. The specific name *crecca* is also onomatopoeic, having been derived from the Swedish common name of the bird by Linnaeus, and again refers to this distinctive call, which is sometimes transliterated as *crick crick*.

Common Teal are abundant winter visitors to Cyprus, Greece and Turkey, but it must have provided a challenge to procure the specimen Bauer has painted, as they have always been justly renowned by wildfowlers and birders alike for their extremely fast and agile flight. When alarmed, a flock will rocket off the water almost vertically and, bunching close together, twist and turn with very rapid wing beats in a similar fashion to that exhibited by many waders. This dramatic take-off led to the group name for the birds as a 'spring of Teal'.

They have an immense breeding range across northern Europe and Asia, where they nest in bogs, marshes, moorlands and forests by ponds, lakes and riversides, as well as in saltmarshes along estuaries. In Britain and Ireland they are on the western margin of their breeding range and are generally scarce nesters, with most found in northern England, Scotland and western Ireland. As they do throughout their range, they choose sites among dense vegetation for nesting to help them avoid detection by predators. They are far more widespread as winter visitors, seeking out various types of wetlands, including wet meadows and freshwater marshes as well as tidal mudflats and saltmarshes.

TEAL.
QUERQUEDULA CRECCA. 362.

Great Crested Grebe *Podiceps cristatus*

CRESTED GREBE *PODICEPS CRISTATUS*

This is the largest European member of the grebe family, Podicipedidae, and the fourth largest of the total of twenty species worldwide. It has a huge range: as well as occurring in much of Europe, smaller populations live in Africa, southern Asia, Australia and New Zealand. Until recently, grebes were thought to be close relatives of the divers (family Colymbidae) – like them, they catch fish underwater with dagger-like bills (shown in the sketch Bauer has included beneath the bird), swim similarly low in the water, propelled by legs far back on the body (*Podiceps* means 'arse-foot'), and have very short tails, but DNA research into avian evolution has shown they are not related. Surprisingly, their closest relationship is likely to be with flamingos (Phoenicopteridae)!

The grebes' low profile and the ease with which they slip below the water is due to their heavier, more solid bones that have few hollows and air sacs compared with those of many other waterbirds, such as ducks. Once submerged, grebes keep their wings tightly closed for a streamlined profile as they propel themselves fast with powerful thrusts of their big feet. Their large, strong legs are equipped with flexible joints, allowing them to make sudden twists and turns when chasing the small fish that form most of their prey. They are also compressed from side to side to offer minimal resistance to the water. The toes bear lobes that are expanded on the backstroke to serve as broad paddles.

The bird Bauer has painted so beautifully is wearing its flamboyant headgear, indicating that this specimen was in breeding plumage and thus obtained in spring or summer, its finery being moulted for winter. Of all the grebes, this species has the most spectacular head plumes, which it uses during courtship in an elaborate series of rituals. These include the pair facing one another, with their chestnut and black head plumes expanded into a circle and their black head tufts erected, and culminate in the weed ceremony, in which they rise right up, treading water, and, breasts touching, shake their heads as they hold beakfuls of waterweed they have gathered.

Although the species is widespread and relatively common across Europe today, with expansion in range northwards and increases in populations, its fortunes were not always so promising. During the nineteenth century, these beautiful birds were nearly exterminated in England and other parts of Europe. The Victorian craze for adornments to women's clothing saw huge numbers slaughtered for their feathers to supply the fashion trade. A Great Crested Grebe has a total of about 20,000 feathers compared with the 7,000–10,000 counted in ducks. Especially valued were the fine, dense, lustrous white feathers of the underparts. A mark of how soft and warm they are is that they were called 'grebe fur' by traders selling strips of grebe skin to costumiers to be used as trimmings on hats, collars and cuffs on dresses, and to make muffs, stoles and boas, with the head plumes often added as adornments.

Rock Dove *Columba livia*

STOCK DOVE, *COLUMBA ŒNAS*

Although Bauer's plate of this member of the large pigeon family is labelled as a Stock Dove, *Columba oenas*, it does not show that species, but instead a Rock Dove, *Columba livia*, probably a wild one, although maybe one of the semi-wild types known as Feral Pigeons (also called Town Pigeons and Common Pigeons), which were originally derived from escaped or deliberately liberated domestic birds. Their differences from a Stock Dove are clearly visible in the illustration: far larger black wing bars, an all-dark bill compared to the Stock Dove's pale-tipped reddish bill, and red eyes. It is not surprising that the confusion arose, because the two species were not distinguished from one another until the late eighteenth century, and some ornithologists still conflated them well into the early years of the nineteenth century. The Stock Dove, so called because it nests in tree holes ('stock' is from an Old English word referring to a tree trunk), had been scientifically described by Linnaeus in 1758, but the Rock Dove had to wait until 1789, some two years after Sibthorp returned from Greece to Oxford with Bauer.

There is a stark contrast between the original wild Rock Dove and the Feral Pigeon, the former being wary and pushed by human development to nest in more remote natural habitats such as sea cliffs. Rock Doves were among the first birds to be domesticated, along with chickens and geese, and were bred in captivity at least 5,000 years ago by Ancient Egyptians for sacrificial rituals and in huge numbers for their tasty meat, available year round because of their fecundity. Homing pigeons were bred from at least as early as Roman times for carrying messages, and have many devotees worldwide to this day for racing. 'The pigeon fancy' is an apt collective term for the devotees of those who keep and exhibit the myriad breeds that have been developed for a wide range of traits relating to shape, size, feathering, colour and behaviour. There may be as many as 800 or more different breeds today; Charles Darwin corresponded with a worldwide network of fanciers and bred some varieties himself in connection with his studies on variation within species.

It is difficult even for experienced ornithologists familiar with the species to distinguish individuals of the wild form from feral birds that readily breed with them, using subtle details of appearance and behaviour. Today, suspected pure (or nearly pure) Rock Doves do still occur along some relatively wild and less-visited coasts of Ireland, northern and western Scotland, Portugal, Spain, France, Corsica, Italy, Slovenia, Greece and Turkey. Sibthorp and Bauer doubtless encountered truly wild Rock Doves; in his diary, Sibthorp records having seen 'the rock pigeons' around the ruins of Delphi, as well as on the westernmost cliffs on the coast of Cyprus.

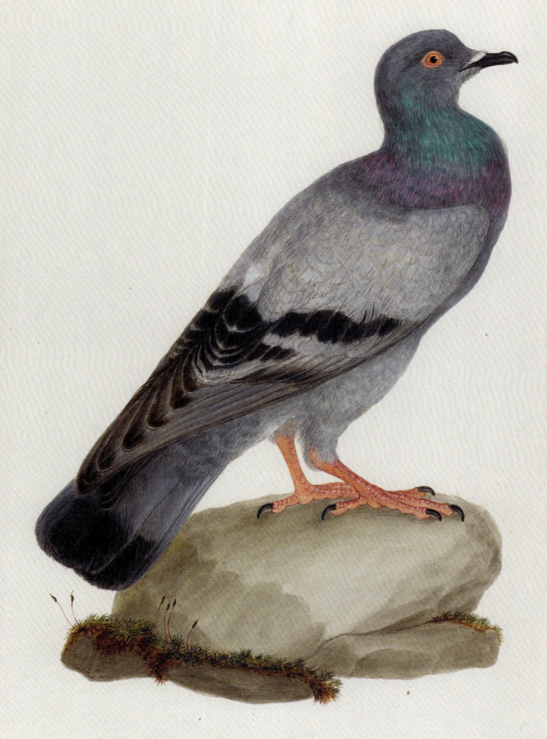

STOCK DOVE.
COLUMBA ŒNAS. 244.

Ferd. Bauer. del.

European Turtle Dove *Streptopelia turtur*

TURTLE-DOVE *COLUMBA TURTUR*

This is simultaneously one of the most admired members of the pigeon family Columbidae and the most persecuted. No bird sound is more evocative of hot summer days then the male's throaty, purring song, which, although not very far-carrying, fills the air around those privileged to hear it at close quarters. He often delivers this soporific sound from deep within dense cover, such as a tall, overgrown hedge. It has a ventriloquial quality, so that it is hard to discern exactly where it is coming from. The English common name has nothing to do with turtles, although this misconception was common: it is pure coincidence that the beautiful bright chestnut and black chequer pattern on the bird's upperparts resembles the shells of some marine turtles. Instead, the name is a corruption of the more accurately onomatopoeic French name for the bird, *Tourterelle*, which can in turn be traced back to the Latin *turtur*, used as the specific scientific name.

Although spending time hidden when singing or when the pair are incubating their clutch of two white eggs in their flimsy nest of twigs, itself concealed in a hawthorn or other shrub, this exquisite bird often ventures out in the open, as when feeding in fields on a variety of weed seeds and grain. It is also fond of perching on overhead wires. The Turtle Dove has relatively long, pointed wings suited to fast flight, which it flicks backwards in an abrupt, jerky fashion. It also has a very distinctive habit of tilting its body from side to side as it makes brief glides between bursts of wingbeats.

The breeding range extends across Europe and into south-west and central Asia to as far east as north-west China, and also in Madeira, the Canaries, North Africa and at oases in the Sahara. This is a bird mainly of warmer climates, favouring open woodland and cultivated agricultural country. In Europe, the largest breeding populations are in parts of central Europe, such as Hungary and Romania, and around the Mediterranean. This is the only long-distance migrant among Europe's pigeon species, all populations making long journeys to winter immediately south of the Sahara. It is at this already stressful time for these beautiful birds that, despite a 2021–2 ban in France, Spain and Portugal, they still face peril in the shape of a barrage of hunters in Mediterranean countries, especially in Portugal, Spain, France, Italy, Greece, Malta and Cyprus. This is one of the most threatened of all European birds, experiencing a 78 per cent decline across the continent since 1980.

In addition to the toll taken by unsustainable and often illegal hunting, Turtle Doves are very sensitive to habitat destruction, which affects breeding success. These losses have been especially acute in Britain, which lies at the north-western edge of its range. Before the mid-nineteenth century it was largely restricted as a breeder to East Anglia and the south-east of England. Then its fortunes improved and it gradually spread north and west into much of England and the southern fringes of Scotland, and across Wales. Today, following a decline of 94 per cent since 1995, it only just hangs on in small and dwindling numbers, almost all in east and south-east England. It has suffered the greatest decline of any UK bird over the last fifty years.

TURTLE-DOVE.
COLUMBA TURTUR.
246.

Barbary Dove *Streptopelia risoria*

C O L U M B A R I S O R I A

Unlike all the other birds in the *Fauna Graeca* collection, this is a purely domestic form. Over the centuries this attractive pigeon has been the subject of convoluted debate as to its nomenclature and origin. Following a variety of names given to it by various naturalists from the seventeenth century, Linnaeus described it as *Columba risoria* in 1758. It was then moved from the major pigeon genus *Columba* to a previously used genus *Turtur* in 1885 and finally to *Streptopelia* in 1855. Some authorities considered that its wild ancestor was the Eurasian Collared Dove, *Streptopelia decaocto*, but it is now generally accepted that it was a close relative, the African Collared Dove. Both this species and the domestic form have been known to ornithologists by the scientific name *Streptopelia roseogrisea*, while aviculturalists referred to it as *Streptopelia risoria*. Recently, though, many authorities have considered that the name should have preference for both wild and domesticated forms. The specific name *risoria* is from the Latin word meaning 'a laugher', referring to the harsh laughing sound uttered by the male when greeting a female. This is very different from the male's two-note cooing that is his advertising call for attracting mates.

Dealers and aviculturalists often refer to Barbary Doves as ring-necked doves. Other names include Domestic Ringdove, Domestic Collared Dove and, for the white mutant form, Java Dove (the latter because birds of that attractive variety had been introduced to Java and parts of China by Dutch colonists during the early seventeenth century). The 'official' common name of Barbary Dove refers to its supposed origin in the area that was once known as the Barbary Coast, including Morocco, Algeria, Tunisia and Libya. It has been a very popular cagebird for centuries and, although the date of its domestication is not known, it is most likely to have been in Egypt, perhaps as long as 2,000 to 3,000 years ago.

There is no biological distinction between the names 'pigeon' and 'dove'. Both are members of the same large family Columbidae, but the latter word is usually restricted to the smaller species. This is one of fifteen species of doves in the Old World genus *Streptopelia* from the Greek words *streptos*, collar, and *peleia*, dove. Many of them do have a collar of white-bordered black feathers at the base of the hindneck. These are all small to medium-sized, mostly no more than half the size of a Feral Pigeon, *Columba livia*, and more slender, with longish tails. They include the four species of turtle doves, including the European Turtle Dove, *Streptopelia turtur* (see p. 56).

This attractive dove has long been a popular cagebird worldwide, with the advantage of being easy to keep, long-lived (up to twenty years or more) and very tame, generally showing no fear of humans. Various different colour forms have been bred by pigeon fanciers. The white form is often used for acts performed by magicians. They have also been used in biological research, especially into the hormonal aspects of breeding behaviour.

COLUMBA RISORIA

Black-bellied Sandgrouse *Pterocles orientalis*

SAND-GROUSE *PTEROCLES ARENARIUS*

This exquisitely patterned pigeon-sized bird is one of a family of birds that look like a cross between a pigeon and a partridge or other game bird. At various times they have been thought to be most closely related to pigeons, game birds or waders, but recent DNA studies suggest that they represent a very old lineage that is closest to a group of varied bird families that include pigeons, grebes, flamingos and a little known family of birds called mesites that are endemic to Madagascar. The sixteen species of sandgrouse live mainly in Africa and Asia, with most of them in Africa, where thirteen species occur. Just two, the Black-bellied Sandgrouse, *Pterocles orientalis*, a female of which is portrayed here, and the Pin-tailed Sandgrouse, *P. alchata*, are found in Europe, although by far their largest populations are in Asia. Both breed in Spain in declining numbers and marginally across the border in Portugal, as well as in Morocco, Algeria and (Black-bellied only) the Canary Islands.

In his diary entry for 3 May 1787 Sibthorp writes that when in Cyprus on salt flats between Larnaca and Famagusta, 'our chasseur shot a very rare bird of the Tetrao kind, *T. alchata*' (now *Pterocles alchata*), but it is likely that this may have been a case of mistaken identity.

Sandgrouse are all found in warmer areas of the Old World, where they are highly adapted to life in arid habitats, including dry grasslands, semi-deserts and deserts. Despite this, and unlike some birds adapted to such habitats, they need to drink every day because their diet consists almost entirely of dry seeds. Surprisingly, they generally live far from sources of water such as rivers or oases, and are often seen as much as 75 km away from the nearest one, which means they have to make round trips daily of 150 km. They are very social birds and flocks of up to several hundred birds usually set off soon after dawn, when it is cooler. They are very fast flyers, thanks to their broad-based, pointed wings powered by big flight muscles. As they travel, they keep in touch with one another with loud chuckling, churring and whistling sounds that carry a long way in the still desert air, so that a big flock is heard well before it is seen.

Although they have long been thought to drink in a different manner from most birds by sucking water up while immersing their bills, as pigeons do, it now appears that they take in beakfuls of water and raise their heads so that it flows into their stomachs, in the usual avian fashion. During the breeding season, sandgrouse need to provide water for their chicks. This duty falls to the males, who have evolved special adaptations for the purpose. Their breast feathers are highly absorbent, and act like a sponge to soak up the water. When they return to the young, they stand over them so that they can sip the water that runs down a vertical groove in their breast feathers.

SAND-GROUS. male.
257.
PTEROCLES ARENARIUS.

Fer. Bauer. del.

European Nightjar *Caprimulgus europaeus*

GOAT-SUCKER *CAPRIMULGUS EUROPÆUS*

Regarding the name 'goatsucker' that is written on Bauer's illustration, Sibthorp mentions in his diary that 'the goatsucker retains its ancient name, and still lies under the accusation brought against it by Aristotle of sucking the goats.' The generic name *Caprimulgus* for this and for many of the world's ninety-eight species of nightjar also refers to the goatsucking myth, being created from two Latin words, *capra*, for the female (or nanny) goat, and *mulgere*, to milk. The bird was accused of seeking out lactating goats in order to suckle their milk and injuring their udders in the process, as well as making the animals go blind.

The nightjar is crepuscular – that is, most active at dusk and dawn – though it also hunts for food on moonlit nights. It has a large, flattened head, a slim body, long pointed wings and a long tail. Its flight is silent, the sound damped by soft feathers like those of owls, reducing the chance of their insect prey detecting their approach. It is a fast, buoyant flier, with few flaps and long glides on stiff wings, and is superbly aerobatic, side-slipping, dipping and hovering as it pursues its prey. When trawling for or chasing insects, the nightjar opens its tiny, weak-looking bill, suddenly transforming it into a huge, almost circular, bright pink gape for trapping the large beetles and moths that are its main prey. This is fringed by a battery of very long, possibly tactile rictal bristles that may detect the prey and prevent it escaping. Like the unrelated owls, nightjars have big eyes, aiding vision in dim light. Along with cats, dogs, deer and many other mammals, as well as some fishes, but probably uniquely among birds, nightjars have a reflective surface behind the retina, called the tapetum (or tapetum lucidum). This increases the amount of light detected by the eye, as the photons are detected once as they pass inwards through the retina tapetum and then a second time as they are reflected back out. The nightjar's intricately marbled and mottled plumage provides superb camouflage by day, as it sleeps stretched out lengthwise along a tree branch, while those roosting – and incubating eggs or brooding chicks – can be virtually invisible to human eyes at least. Bauer has also painted details of the two pectinate (comb-like) middle toes (see also pp. 78, 80, 82 & 84). The specimen Bauer has painted is a male, distinguished from a female by the white marking just visible on its closed wing and the white corners to the tail. These are prominent visual signals in the male's courtship display, when he glides with his wings raised in a deep *V* shape and tail spread wide. He also claps his wings together loudly over his back and gives nasal, frog-like *koo-ick* calls. His song is an extraordinary churring sound, resembling that of a distant two-stroke motorbike.

This is a summer visitor to much of Europe and Asia to as far east as Mongolia. It breeds in a wide range of open country habitats with bare ground or minimal cover for nesting, including lowland heaths, moors, sand dunes and young conifer plantations. All populations migrate to winter in Africa.

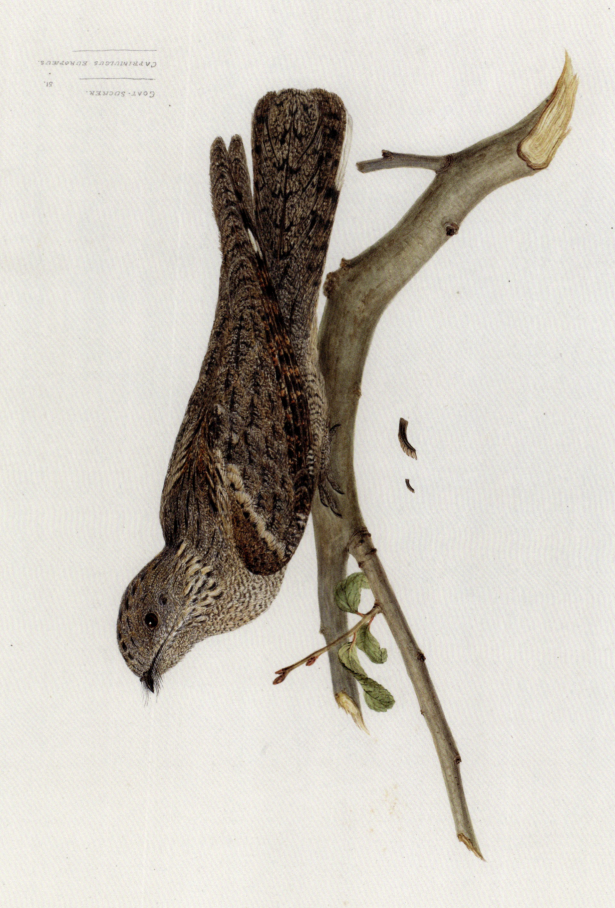

Alpine Swift *Tachymarptis melba*

WHITE-BELLIED SWIFT *CYPSELUS ALPINUS*

The Alpine Swift is one of the largest of all the world's hundred or so species of swift. Its most usual call – a long, sharp, twittering sound – is distinctive and quite unlike the high-pitched, penetrating screams of the Common Swift. Alpine Swifts are far larger too, and in their dashing flight, with their long, narrow sickle-shaped wings (spanning about half a metre) and relatively short tail, can even be mistaken at a distance (and when no other birds are nearby to compare with) for a small falcon, such as a Lesser Kestrel (*Falco naumanni*).

Alpine Swifts are widespread in mountainous country, from southern Europe east to the Himalayas, and to the south in parts of northern, eastern, south-western and southern Africa, Madagascar, eastern India and Sri Lanka. European populations are migrants, travelling many thousands of kilometres each year between their alpine breeding quarters and the wintering areas in Africa.

Like other swift species, they are consummate aeronauts which spend most of their lives in the air, feeding, drinking, mating, gathering nest material and even sleeping in flight after the breeding season. Research by scientists at the Swiss Ornithological Institute, using tiny, ultra-lightweight electronic tags to log the birds' movements, have proved that they can remain aloft above a West African wintering area for 200 consecutive days, alternating flapping flight with gliding. Like all swifts they feed on aerial insects, chasing and catching them in their bills, which are very short but with a wide gape. They cover astonishing distances in search of their prey, up to 1,000 km (600 miles) in a single day.

These striking birds nest in cracks (usually vertical) in cliffs or old stone buildings in towns and villages. It is breathtaking to watch one career through the air towards the narrow entrance, and a split second before it looks as though it might dash itself to pieces against the rock suddenly fold up its long curving wings and disappear within. Their busy colonies can contain as many as 170 pairs. They are relatively long-lived among smaller birds, with a maximum age of 26 years old recorded.

The current name for the genus, *Tachymarptis*, is from the Greek words *takhus*, meaning 'fast', and *marptis*, 'a seizer'. And they are indeed speedy, among the fastest of all birds in level flight, attaining speeds of up to 110 km/hr (66 mph).

Bauer may have encountered these striking birds in his native Austria, and together with Sibthorp must have seen them at various points on their travels, both at their cliff colonies in remote country but also in villages and towns, where they nest in old buildings. Indeed, Sibthorp mentions them several times in his journals, as for example when visiting Didascalo, one of the islands in the Gulf of Corinth, recording that 'the melba we found twittering in immense numbers ... where it lives with the large bat in the holes of the rocks.' He also notes that he saw it flying over the summits of Parnassus.

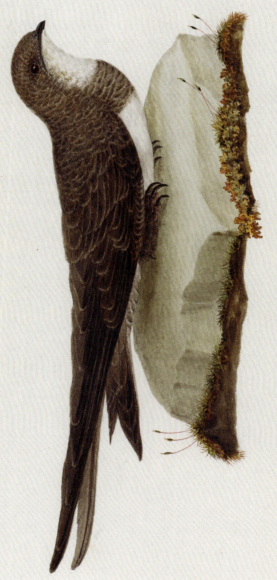

White-bellied Swift. 53.
Cypselus Alpinus.

Great Bustard *Otis tarda*

The males of this striking, turkey-sized species are among the world's heaviest flying birds. Standing over a metre tall, they average about 10 kg in weight, while the largest may reach at least 18 kg. They also exhibit one of the greatest size differences between the sexes of any bird: males weigh on average two and a half times as much as females, while the largest individuals can attain six times the weight of a small female. Viewed at a distance, a gathering of these imposing and gregarious birds can easily be mistaken for a flock of sheep or goats, due both to their size and to the dense, almost wool-like plumage. This accounts for the traditional English collective noun for bustards as a 'drove'.

In its ornithological usage, the word 'bustard' dates from the fifteenth century, but it appears earlier as a surname. Perhaps deriving from Anglo-Norman, it represents a blending of Old French *bistarde* and *oustarde*. The genus name *Otis* was originally an Ancient Greek name for a bird mentioned by Pliny the Elder in his *Natural History*, and thought to be of this species; he also gave the Latin name as *avis tarda*, meaning 'slow bird'. This refers to the stately, deliberate progress of bustards when walking. They spend much of their lives walking across extensive, treeless, grassland plains and arable farmland searching out food. Their diet consists mainly of grasses, clover, thistles and other plants, as well as invertebrates such as grasshoppers and beetles. They often raise their head at an angle, and are constantly on the alert for danger in the shape of predators, especially humans. They may evade detection by pressing themselves close to the ground and relying on the camouflage of their barred brown upperparts, but if pressed will take to the air, with powerful beats of their long, broad wings.

In the breeding season, males assemble at traditional display sites, or leks, where they seek to impress visiting females. Their extraordinary performance involves each male burying his head and neck into his back and then appearing to turn his plumage inside out, shaking it about so that he resembles a huge, white, vibrating powder puff. Bauer's fine portrait of this imposing male includes the detail of the long, narrow feathers spreading like a moustache from the base of the bill. He has also included a pencil detail of the bill itself.

In a diary entry, Sibthorp mentions that 'Bustards, I was assured, visited the plain of Athens during the winter in abundance.'

Along with most of the other twenty-five species of bustard, Great Bustards are suffering serious declines across much of their range, from Iberia across central Europe and east to Mongolia. Renowned for the excellence of their roast meat, they have been hunted for centuries, while other threats are intensive agriculture and collision with power lines. About 80 per cent of those remaining in Europe live in Portugal and Spain, the latter being their major stronghold. They became extinct in the UK by the 1840s. A reintroduction programme began in 2004 on one of its former strongholds, Salisbury Plain, and currently there is a small population, although this is not yet truly self-sustaining.

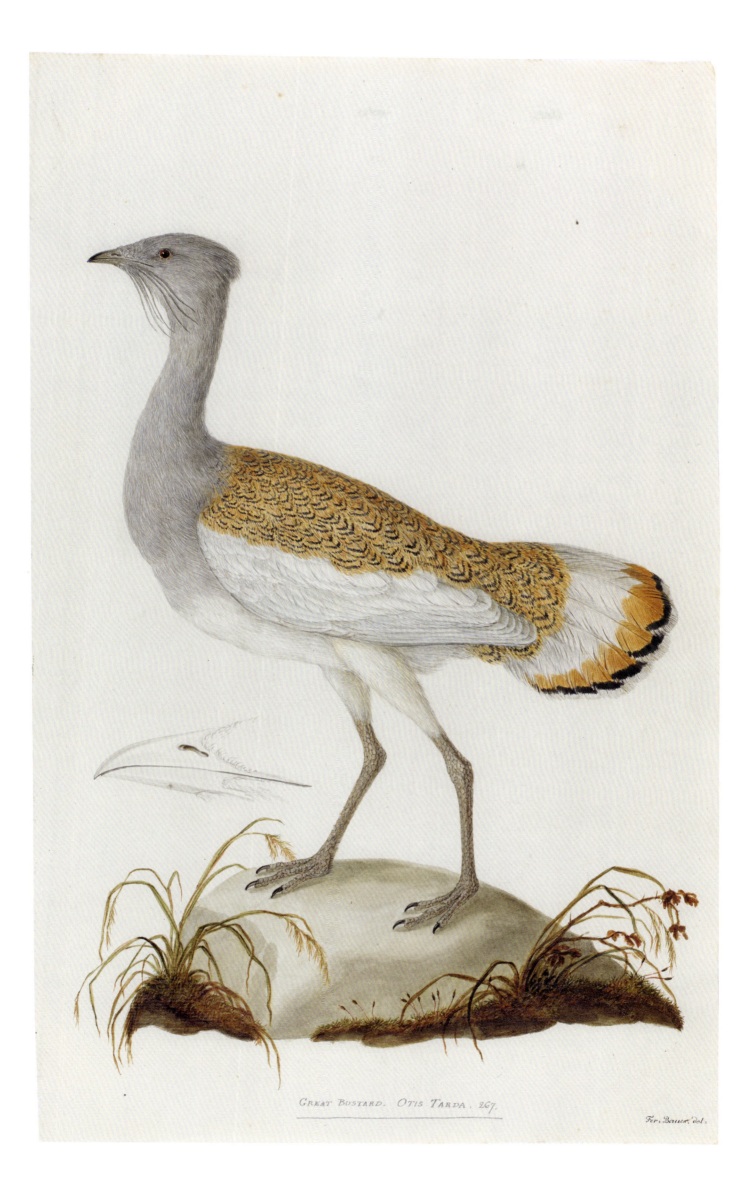

GREAT BUSTARD. OTIS TARDA. 267.

Fer. Bauer, del.

Scopoli's Shearwater *Calonectris diomedea*

CINEREOUS SHEARWATER *PUFFINUS CINEREUS*

At almost the size of a Herring Gull, *Larus argentatus*, this is one of the largest members of the group of seabirds known as shearwaters, whose name describes well their buoyant flight in which their stiffly held wings almost touch the waves as they bank and turn, riding the wind. Bauer and Sibthorp would have been likely to encounter them in summer or early autumn at one or more of their various breeding colonies on steep coasts or rocky islands in Greece and off the west coast of Turkey. They also breed elsewhere on islands or coastal cliffs around the Mediterranean, including southern France, the Spanish Balearic islands, Italy and Gozo, Malta. Currently, the biggest colony is at Zembra Island, Tunisia. Some of these breeders remain at sea in the Mediterranean, but most travel much farther, to winter in the South Atlantic Ocean off the west coast of Africa, where upwelling currents bring small fish, crustaceans and cephalopods to the surface on which they can feed. Overall, the species is declining, due to predation by rats or cats, human disturbance and death as a result of being drowned when they are caught on the hooks of long-line fishing boats, euphemistically known as by-catch.

Shearwaters are like miniature albatrosses, to which they are related in the seabird order Procellariiformes, popularly known as tubenoses, in reference to the tube-shaped external nostrils set atop their long, sharply hooked bills. These are associated with their owners' excellent sense of smell, which allows them to travel many thousands of kilometres across featureless open oceans and return unerringly to the same breeding colony, and even to the same burrow, cave or rock crevice. The current generic name *Calonectris* for this and three other species of shearwater means 'good swimmer' and these birds live up to this description, although they are most highly adapted to energy-efficient flight on their long, flexible wings. Although they are very impressive in flight, low above the sea with long glides on bowed wings interspersed with a few leisurely flaps, these ocean-goers are ungainly and vulnerable on land, due to their legs and feet being set right back at the end of their bodies so that they can only shuffle along. This has made them an easy target for predators such as cats and rats. Humans, too, have exploited this bounty since prehistoric times, accounting for huge numbers of eggs and plump chicks (the latter killed for their valuable oil, feathers and meat).

Today, several shearwater species are still subject to this traditional harvest. This can be sustainable, as with the catch by Maori people of Sooty Shearwaters, *Ardenna grisea*, in New Zealand. A salutary tale, however, relates to a very close relative of Scopoli's Shearwater, Cory's Shearwater, *Calonectra borealis*. This nearly saw the extinction of its largest known colony on the uninhabited island of Selvagem Grande in the Atlantic near the Canaries. There had been a sustainable harvest there by Portuguese fishermen for centuries, but the arrival of poachers and their wholesale plunder of adults as well as eggs and young threatened the birds with extinction. Thankfully, the islands were declared a national nature reserve by Portugal and the species was saved.

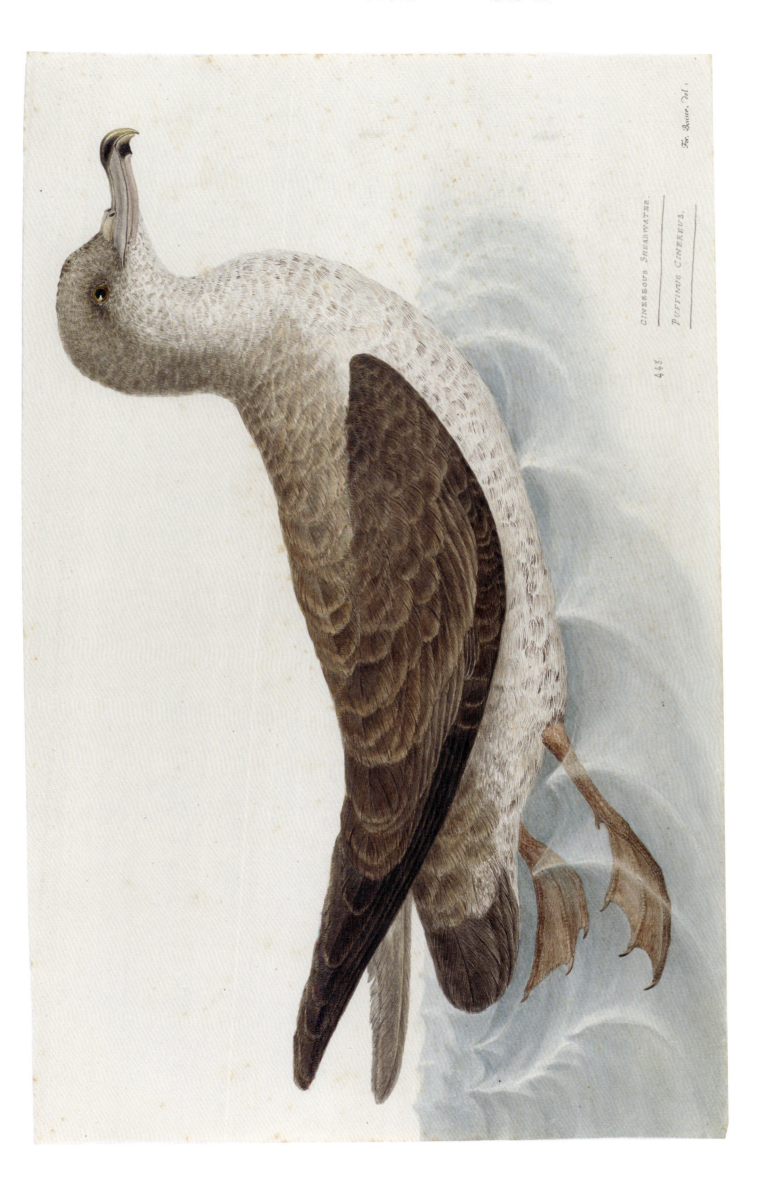

Yelkouan Shearwater *Puffinus yelkouan*

MANKS SHEARWATER *PUFFINUS ANGLORUM*

This is one of a group of twenty-nine seabird species known as shearwaters (for a general description, see Scopoli's Shearwater, p. 68). The annotation on this fine painting refers to its former status as a race of the Manx Shearwater, whose scientific name was later changed to *Puffinus puffinus*. 'Manks' is an earlier spelling of the word Manx, referring to the Isle of Man. This is the only shearwater to breed in Britain and Ireland; indeed, almost all the world population of 350,000 or so pairs nest on a few small islands off their coasts. It was given its name because it used to breed in considerable numbers on the islet known as the Calf of Man off the south coast of the Isle of Man, but few now remain there.

The shearwater depicted by Bauer was at the time considered as being a Manx Shearwater, but that species is an Atlantic bird that does not occur in the Mediterranean. Then, in 1827, an Italian naturalist, Giuseppe Acerbi, formally described what was then called the Levantine Shearwater as a new species, *Puffinus yelkouan*, based on specimens collected in the Bosphorus, Turkey. The very apt and delightful name that he chose for it, *yelkouan*, is Turkish for 'wind-chaser' or 'spirit of the wind'. At the beginning of the twentieth century this was then demoted to being a race of the Manx Shearwater, *Puffinus puffinus yelkouan*. Another race, *Puffinus puffinus mauretanicus*, was described in 1921 from a specimen from Algeria. Its breeding grounds in Europe were discovered in 1930, in Spain's Balearic Islands, and thus it was given the common name of Balearic Shearwater. Later, both races were for a long time considered as subspecies of the Yelkouan (or Mediterranean) Shearwater, *Puffinus yelkouan*. Most recently, they have generally been regarded as deserving full species status.

As for the confusing generic name, *Puffinus*, this was derived from the English word 'puffin' for the cured carcases of plump nestling Manx Shearwaters, regarded as a gastronomic delicacy. This became transferred as a vernacular name to the also plump young of the completely unrelated seabird (a member of the auk family, Alcidae) that we know and admire as the Puffin, *Fratercula arctica*. The Latinized scientific name *Puffinus* was retained for the shearwaters.

The breeding colonies of the Yelkouan Shearwater are confined to central and eastern islands of the Mediterranean, with the largest colonies being off the west coast of Italy and in the Greek Aegean islands. In contrast to the Manx Shearwater, the Yelkouan Shearwater does not make such prodigious migrations after breeding, finding richer feeding grounds mainly in the Black Sea, where most individuals spend the winter months. The total population is far smaller than that of the Manx Shearwater, estimated at no more than 30,000 pairs and perhaps as low as 20,000 pairs. Its close relative the Balearic Shearwater is far less numerous still, with fewer than 3,000 breeding pairs, and it is arguably Europe's most threatened seabird. In both cases, the main threats come from continued plunder of the young for eating, predation by cats and rats, and accidental 'by-catch' by fishing vessels.

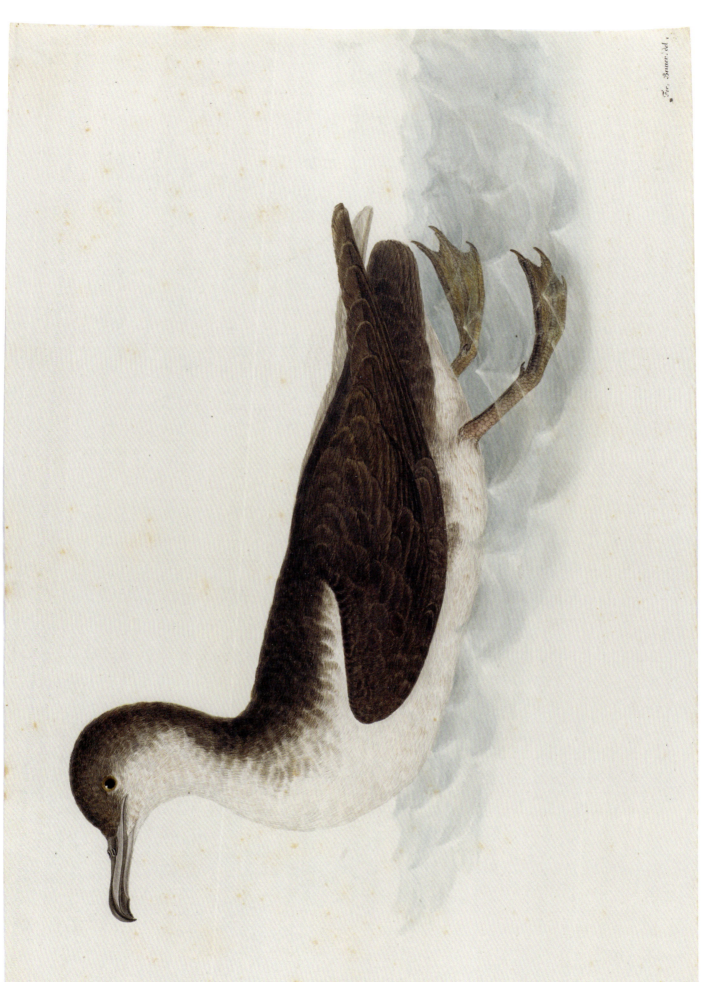

MANKS SHEARWATER.
443.
PUFFINUS ANGLORUM.

White Stork *Ciconia ciconia*

WHITE STORK *CICONIA ALBA*

This huge, imposing bird, with a formidable long bill and long legs, is far larger than the Grey Heron, *Ardea cinerea*. The White Stork has one of the longest and most intimate associations of any bird with human society. This has resulted in a rich mythology focused on their symbolizing spring renewal and fertility. The best-known legend is of course that of the stork as a bringer of human babies. This probably originated in north Germany, and was widely popularized by the nineteenth-century Danish author of children's tales, Hans Christian Andersen.

To this day the return of the storks in spring from their winter quarters in Africa is eagerly awaited. Their arrival on the rooftops in town and country across much of Europe sees them celebrated anew each year as cherished guests and bringers of good luck, as pairs arrive at their traditional nest sites on houses, churches, cathedrals, water towers, telephone poles or other artificial structures. It is remarkable and heartening that their very obvious presence so close to people is welcomed, let alone merely tolerated, especially considering that the huge piles of sticks (often lined with large clods of turf, earth or dung) that are their nests can be up to three or even four metres deep and weigh as much as two tonnes. Despite being essentially voiceless (apart from making the occasional weak hissing sounds), they are very noisy at the nest, as they perform ritual courtship and greeting ceremonies to the accompaniment of loud bill clattering. Sibthorp relates in his diary that 'The domestic stork, a privileged bird, arrives regularly at Athens, sometimes in the month of March, and leaves it when the young are able to support the fatigues of a long flight, about the middle of August.'

The White Stork is the best known of the nineteen species of storks in the family Ciconiidae. Both family and genus names are from the Latin word for stork. The name 'stork' is derived from the Proto-Germanic word *sturkaz*, and may also be connected with the word for 'stick', referring to the bird's upright posture and habit of standing on one leg.

During Sibthorp and Bauer's time, White Storks would have been far more abundant. Following a huge decline between the late nineteenth century and the 1980s, they have increased substantially in numbers in Europe, especially in the breeding strongholds in Spain and Portugal. However, there have also been recent declines in other areas, including another stronghold in Poland. They continue to face a variety of threats, such as habitat loss, collision with power lines and drought in their African winter quarters. It is ironic that another of the threats affecting storks is the reduction in their food supply resulting from pesticides, considering that they eat large numbers of agricultural pests such as rodents and many insects, including locusts and armyworms in their African wintering range. On a more positive note, a few White Storks have started to breed again in southern England after a hiatus of more than 600 years, thanks to a project involving birds introduced from Sweden and France.

White Stork.
Ciconia Alba. 283.

Glossy Ibis *Plegadis falcinellus*

GLOSSY IBIS *IBIS FALCINELLUS*

This striking wetland bird is the only one of the twenty-eight species of ibises in the world to breed in Europe in recent times, since its relative, the now extremely rare and globally threatened Northern Bald Ibis, *Geronticus eremita*, became extinct on the continent sometime before the seventeenth century. The ibises are classified in the family Threskiornithidae, together with the six species of spoonbills. The most obvious difference in appearance between these two groups of wetland birds is that whereas ibises have long decurved bills, spoonbills live up to their name, with bills of spatulate shape. This dramatic difference within a single family is evidence of the effects of feeding habits on evolution, the ibises being probers into mud or soil for invertebrates and the spoonbills sieving similar prey and small fish from shallow water by sweeping their bills from side to side.

Until recently, taxonomists considered these birds' closest relatives to be herons, storks and other members of the order Ciconiiformes. Genetic research has, however, revealed that they belong with pelicans, cormorants, gannets and relatives in the order Pelecaniformes. Furthermore, the results of DNA studies challenge the division of the family into two neatly separated subfamilies, ibises and spoonbills, suggesting instead that the spoonbills are a discrete group but that the ibises constitute two separate groups: the first containing many widespread, mainly Old World, species of ibises, together with all the spoonbills. Closest to the spoonbills are the seven species of *Threskiornis*, which include the African Sacred Ibis, *T. aethiopicus*, revered – and mummified – by the Ancient Egyptians as an incarnation of their god of wisdom and the moon, Thoth. (The name 'ibis' derives from their language via Greek and Latin transliterations.) The most widespread of all ibises, the Glossy Ibis and two other *Plegadis* species from the Americas are included in this group. The second group contains the rest of the ibises endemic to the New World.

Although at a distance it can look like an all-dark Curlew, *Numenius arquata*, a closer view in good light reveals that the Glossy Ibis lives up to its name: the blackish brown plumage of its head, back, wings and tail are enlivened by a brilliant purple and green gloss. The neck, upper back, shoulders and underparts are rich chestnut brown. In winter the head and neck are densely streaked with white. When it flies it is readily distinguished from a Curlew by its far longer, thinner neck, long legs trailing out far behind its short tail, and its shorter, broader wings.

The Glossy Ibis nests in reeds or trees in often dense colonies, usually mixed with herons, cormorants or other waterbirds, in southern Europe, Africa, south-west, central and southern Asia, Australia, the east coast of North America and the Caribbean. Most populations are migrants, wintering far to the south of their breeding range. In Europe its breeding colonies are scattered from Portugal, Spain, France and northern Italy to the Balkans, western Turkey and around the Black Sea. Most European breeders migrate to winter in tropical Africa.

301. *Glossy Ibis.*
Ibis Falcinellus.

Little Bittern *Ixobrychus minutus*

Little Bittern *Botaurus minutus*

During the time of Bauer and Sibthorp's travels, this member of the heron family Ardeidae would have been far more abundant, before reedbeds and other marshland habitats were drained. In recent years, and especially between the late 1960s and mid-1990s, it suffered major declines due to a combination of factors. Chief among these were the destruction, degradation and fragmentation of its preferred reedbed habitat, water pollution affecting its food supply, and the effects of severe droughts in its African wintering range and on migration.

This is a notoriously difficult bird to see, as it is very wary and spends most of its life hidden within reedbeds or other dense vegetation. In addition, it is crepuscular – that is, especially active in twilight at dawn and dusk. True to its common name, this is a diminutive bird, especially compared to relatives such as the Great Bittern, *Botaurus stellaris*, three times as long, and with less than half its wingspan. It is the smallest European heron, and only three species from the New World and one from Africa are smaller. It feeds on fish, amphibians, crustaceans, spiders and insects, standing still and waiting for them to appear or stalking them slowly in the typical manner of other members of the heron family.

The genus name *Ixobrychus* can be loosely translated from the Greek as 'reed-bellower', and refers to the male's spring song, which has been likened to a cross between a frog's croak and the deep, muffled bark of a large dog. It is far-carrying and for anyone within earshot hard to ignore, as the male produces it monotonously every couple of seconds without pause for long periods, especially at night, but sometimes during the day.

The Little Bittern has a vast global range, spread across much of central and southern Europe, in Asia to as far east as western Siberia and north-east India, and in much of sub-Saharan Africa and Madagascar. A close relative, formerly regarded as a subspecies of the Little Bittern, breeds in eastern and southern Australia, New Guinea and New Caledonia; another race from New Zealand is now extinct. The European and Asian breeders all migrate to spend winter in sub-Saharan Africa. The largest numbers breeding in Europe are in Russia, Ukraine and Romania, in the huge deltas of rivers flowing into the Black and Caspian seas. It breeds in Greece, including Crete, in Turkey, including the east, and in Cyprus. It also occurs in the region as a migrant en route between breeding sites farther north and its African winter range. Also, small numbers, mainly immature birds, can be found wintering in the Balkans and other parts of southern Europe.

Bauer has painted this bird (a male, with a black back, rather than a brown, streaked one) in his usual formal manner, standing on a rock, but it is interesting that he chose to include two seaweeds, a species of brown wrack and one of the filamentous red seaweeds, because this is a denizen of freshwater lakes and swamps, although some migrants may turn up in coastal marshes – but not on rocky coasts with seaweeds.

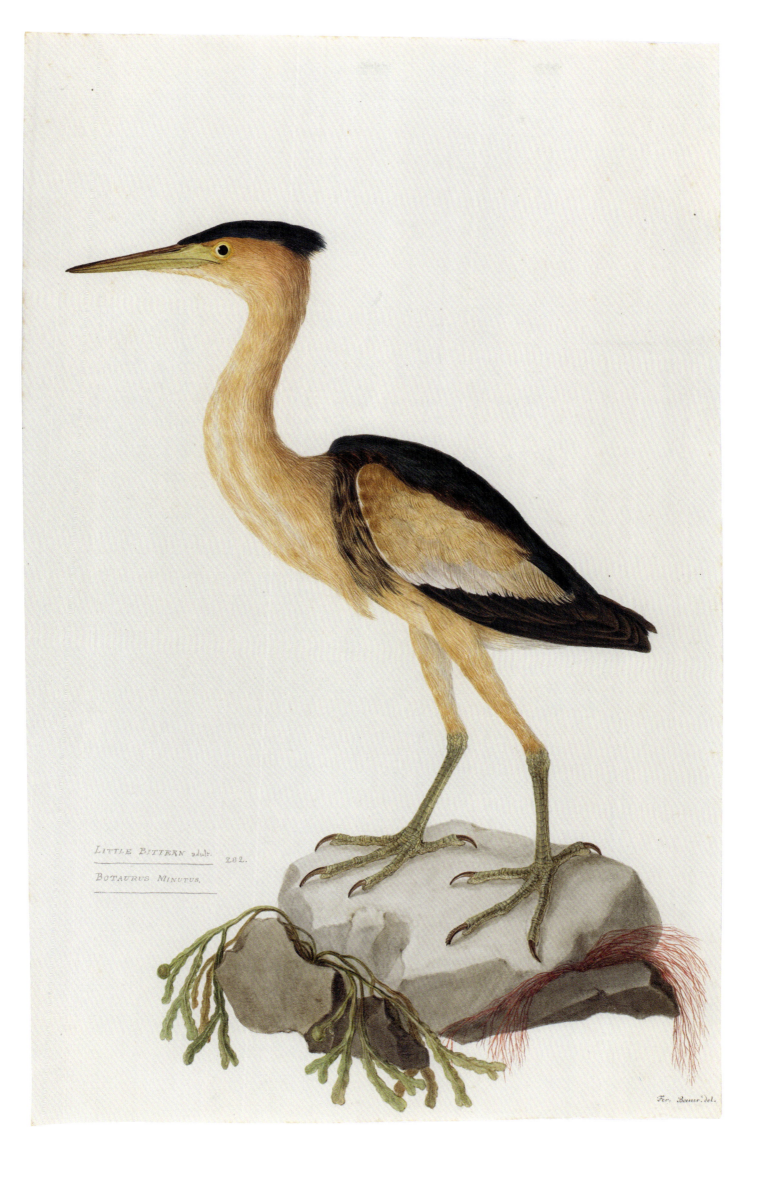

Grey Heron *Ardea cinerea*

COMMON HERON *ARDEA CINEREA*

Its considerable size – approaching that of a Golden Eagle (*Aquila chrysaetos*) – helps to make this a bird that most people notice, whether poised motionless in the shallows of a lake or estuary ready to make a lightning strike at a fish, hunched in repose on a river bank or in a field, or in flight with slow, heavy beats of its broad, arched wings. From the wildest Scottish lochs to the lakes in crowded city-centre parks, the Grey Heron is a familiar sight.

Nevertheless, the fortunes of this charismatic bird have fluctuated greatly over the centuries. From medieval times to the early nineteenth century, it received protection from the nobility because it was highly valued for food and as an important quarry to test the skills of falconers, both in England and on the European continent. Grey Herons often featured in banquets; for instance, in 1465, four hundred were served at a single lavish banquet in honour of the appointment of Lord Neville as Archbishop of York. But during the Victorian era – with the decline of falconry and the increase in firearms, and the popularity of egg collecting and taxidermy, as well as the rise of angling as a popular sport, which saw the birds as rivals for fish stocks – this persecution resulted in major declines. Numbers reached a nadir by the late 1960s, following dramatic losses during hard winters, when prolonged freezing conditions affecting the shallow waters the birds favour for feeding made it difficult for them to find food. In more recent times, legal protection helped their fortunes improve in the UK and continental Europe.

Although they eat mainly fish and other aquatic creatures, Grey Herons have a wide-ranging diet, and often forage on land, too. There they catch small mammals, including rats, voles and other rodents, and even fierce predators such as stoats and weasels, amphibians, small reptiles and insects, and birds and their young, especially aquatic birds such as ducks and coots. They prey on a wide range of fish, from little minnows to large eels and flatfish.

The pencil drawings accompanying Bauer's watercolour show details of the powerful dagger-like bill and the distinction between the claw of the middle toe of each foot, with its comb-like (pectinated) edge contrasted with the plain surface of one of the claws on the other toes. Suggested functions for this adaptation are that the heron uses it to remove parasites, or for feather maintenance (see p. 80).

The Grey Heron has a very wide global range. It breeds widely right across the middle latitudes of Europe (with smaller numbers and a much patchier distribution in the north and south), across central and southern Asia east to Japan, and in southern Africa and Madagascar. Grey Herons are communal nesters that usually breed in tall trees. Thanks to their habit of nesting colonially in early spring, when their bulky, untidy nests of sticks are easy to see in the bare leafless branches, the colonies are easy to find and census. In the UK, nests have been counted annually for the British Trust for Ornithology by volunteers since 1928: this is the longest running single-species nest census in the world.

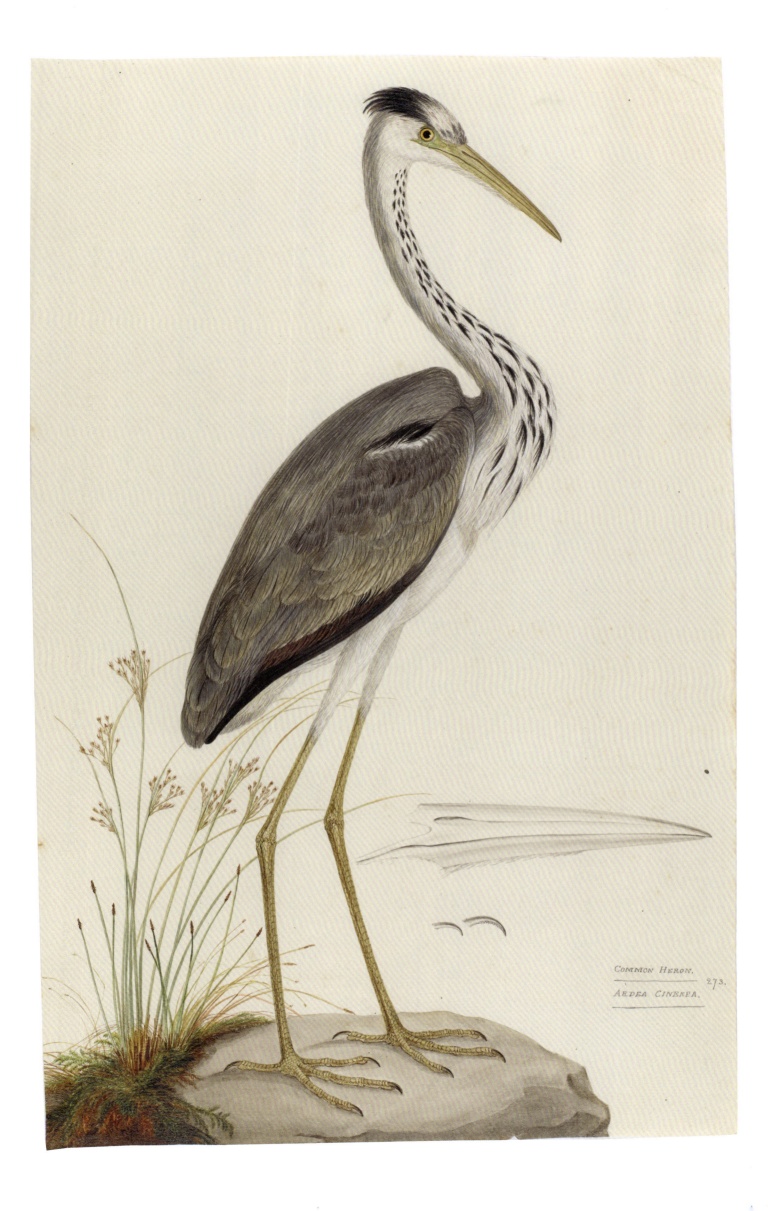

Common Heron.
Ardea Cinerea. 273.

Purple Heron *Ardea purpurea*

PURPLE HERON *A. PURPUREA*

This far less well-known relative of the familiar Grey Heron, *Ardea cinerea* (see p. 78), is the epitome of gauntness. Everything about it is slender, from its narrow head and stiletto of a bill, down its greatly elongated snakelike neck, to its long, slim body and long legs and feet. Bauer's fine painting has this striking bird in a dramatic pose, with one leg raised to show clearly the especially long toes. These are splayed out to enable the heron to walk about on floating vegetation without sinking. When it takes flight, the disproportionately large feet are apparent as its legs are splayed out behind it. Although distinctly smaller and slighter than the Grey Heron, it is an imposing bird, standing up to 90 cm tall and with a wingspan of up to 1.5 metres. It is far more richly coloured than its well-named relative. At long range it looks all dark, but a closer view reveals the rich reddish-gold head and neck sides, adorned with narrow black stripes; the grey back and wings have a purplish cast, most prominent in males.

This is one of several of Bauer's bird paintings in which he has included pencil details, in this case of the bill and, below it, the comblike claw that tips the middle of the three forward-facing toes. Known as a pectinated (or pectinate) claw, its serrations may be adaptations enabling this heron (and other members of the heron family) to remove prey remains, such as fish scales or amphibian slime, from its plumage when preening. Herons are among several unrelated families and individual species of birds, including nightjars (see p. 62) and the Barn Owl, *Tyto alba*, that have evolved these natural combs. They also have specialized feathers called powder down, whose tips disintegrate to form the avian equivalent of talcum powder. The heron may gather this in its bill, then wipe it onto the pectinated claw before preening so that it absorbs the sticky prey remains.

The world breeding range of this species is very wide, taking in much of southern and central Europe, Africa (mainly in the east) and central and South East Asia. European and north-east Asian breeders are migratory, wintering in sub-Saharan Africa, but those in Africa and southern Asia remain there year-round. Purple Herons are restricted as breeders by their need for shallow wetlands with reedbeds or other dense vegetation. They are generally patchily distributed in Europe, with the great majority in Spain, France, Italy, Ukraine and Russia. Sibthorp refers in his diary to this species frequenting the marshes of Boeotia in central Greece. Today, small numbers breed in that country, but on Cyprus the Purple Heron occurs only in autumn and spring as a passage migrant. There has been speculation that the effects of global warming may push the Purple Heron to colonize the UK from its nearest colonies in the Netherlands and northern France. However, to date it has remained a very scarce wanderer to Britain, apart from a handful of nesting attempts and a single pair that bred successfully in Kent.

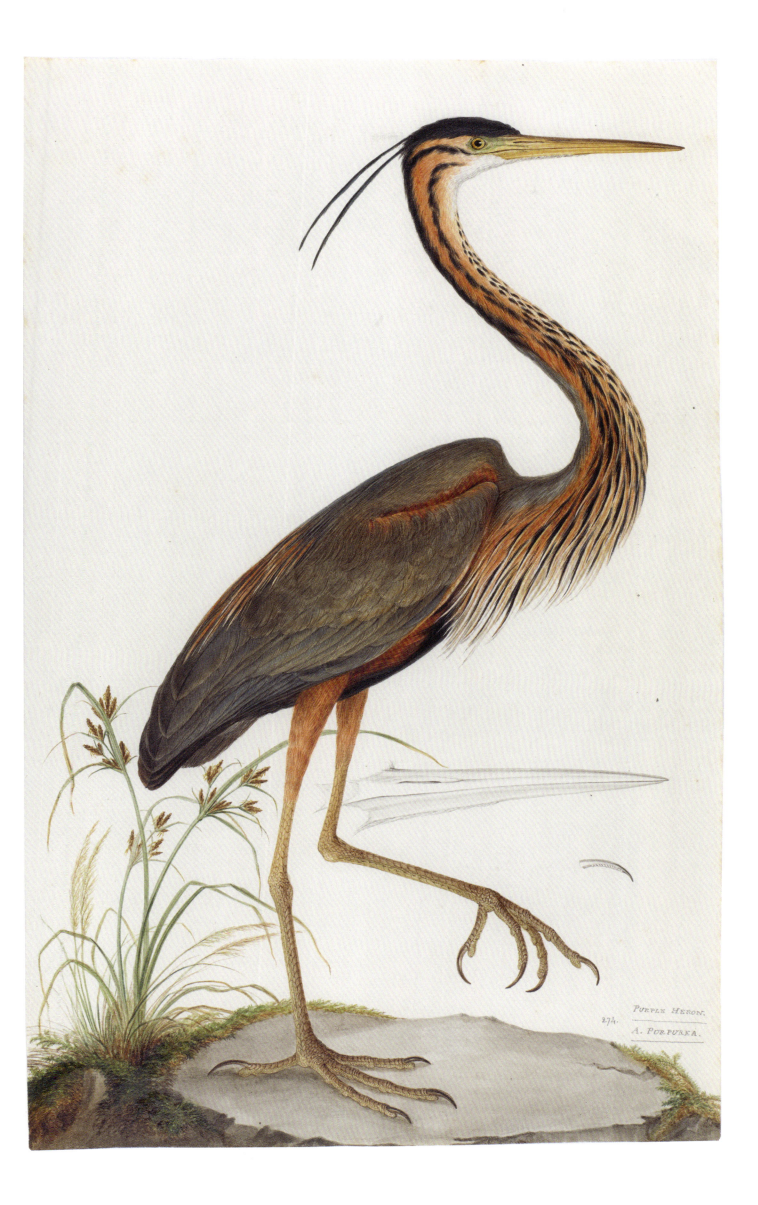

Great White Egret *Ardea alba*

Great Egret *Ardea alba*

This imposing member of the heron family Ardeidae is a far bigger version of its relative, the equally aptly named Little Egret, *Egretta garzetta* (see p. 84). At about one and a half times the size of the latter, the Great White Egret is almost the size of the more abundant and more familiar Grey Heron, *Ardea cinerea* (see p. 78). It was for a long time included with the Little Egret in the genus *Egretta*, but has recently reverted to being classified with most other herons in *Ardea*. Apart from the immediately obvious difference from that species of its all-white plumage, it has longer legs and a longer neck, often held in a more pronounced S shape (sometimes with a very abrupt and almost right-angled kink). Its resting pose, by contrast, is with the head and neck sunk into the breast and wings.

Compared with its smaller counterpart, it occupies an even vaster range in the world's temperate and tropical regions, breeding in scattered locations in Europe, in Africa, right across Asia and in Australasia, and also in southern North America, the Caribbean, Central America and most of South America. Within Europe, it occurs in colonies of varying sizes scattered across the continent. The great majority of breeding Great White Egrets and the largest colonies are in the east of the continent. More than 85 per cent of the total is in Hungary, Belarus, Ukraine and Russia. Nevertheless, over the past thirty-five years or so this impressive bird has undergone a major expansion into northern and western Europe, including as far north as the Baltic republics and westwards to thirteen other countries, including small breeding populations in Sweden, Germany, Belgium and the UK.

Bauer's beautiful composition places this striking bird on his standard rock but also among appropriate vegetation, including the delicate clump of flowering rush. The Great White Egret's favoured habitats are the marshy fringes of large, shallow lakes, especially where there are reeds and low shrubs or trees, but it has also colonized reservoirs, flooded gravel pits, ricefields, wet meadows and other agricultural land. Bauer and Sibthorp must have seen this individual when it was wintering in Greece or Turkey, or passing through on its way to winter farther south in the Middle East, as its bill is yellow (in the breeding season it becomes almost entirely black) and it lacks the nuptial plumes that will develop for springtime courtship displays. These thirty to fifty long barbed white feathers cascade in a filmy filigree up to 50 cm beyond the short tail, and often trail in the water. Their beauty was appreciated not only by their owner's partners, but also during the Victorian era by the creators of fashionable hats for women, which nearly led to the species' extinction in Europe, along with the Little Egret. As with his portraits of the other herons and egrets, Bauer has included in his portrait sketches of the bill, which is heftier than that of the Little Egret, and the pectinated claw from the middle toe of the foot (see also pp. 78, 80).

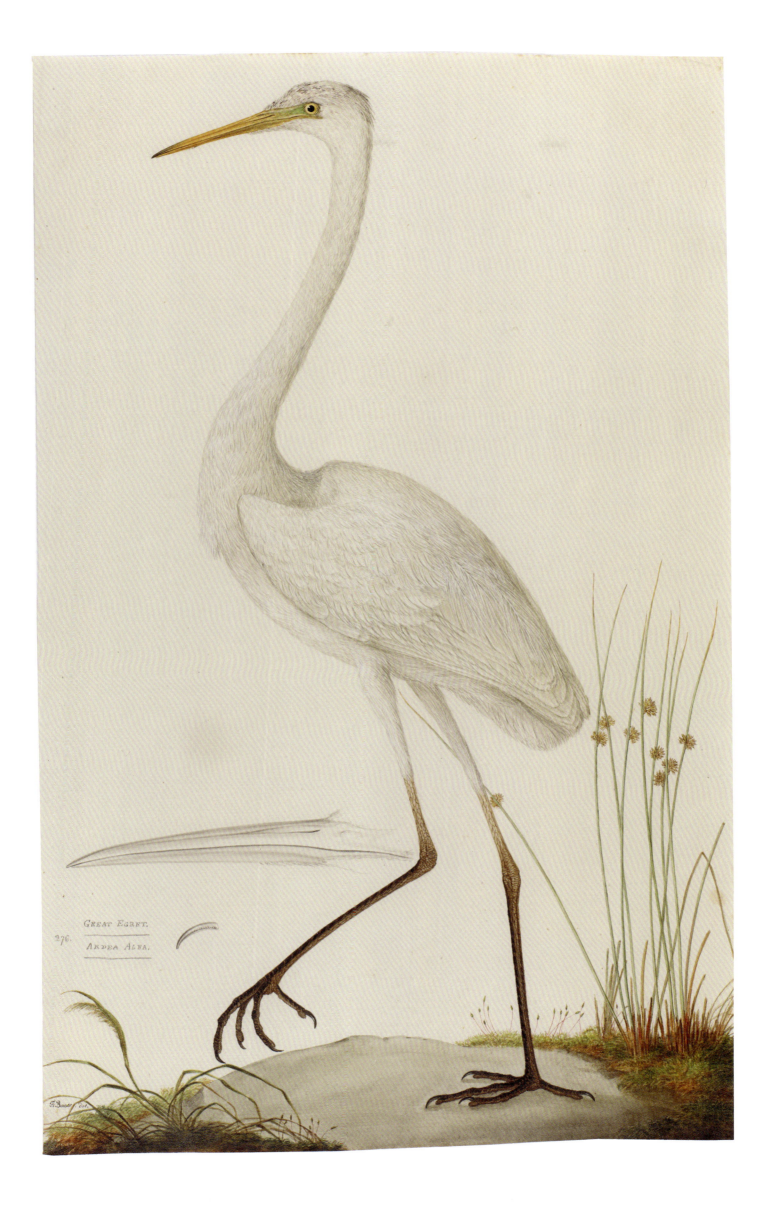

Little Egret *Egretta garzetta*

LITTLE EGRET *ARDEA GARZETTA*

As its common name suggests, this is by far the smaller of the two stunningly white species of egrets that Bauer painted: the other one, the Great Egret, *Ardea alba* (see p. 82), is twice its size, and has proportionately longer legs that make it appear even taller. The name 'egret', used for mainly smaller members of the heron family, Ardeidae, has a somewhat convoluted origin. Although it sounds different from 'heron', it actually has a similar origin. The Old English *hragra*, Old High German *heigir* and the Provençal *aigron* all referred to 'a heron', and the last is clearly related to the diminutive form *aigrette*.

The Little Egret is found in a wide variety of wetland habitats, from freshwater lakes, riversides, marshes and wet grassland to estuaries and sea coasts, and feeds mainly on small fish. Other prey include insects, crustaceans, molluscs and worms, as well as small reptiles, amphibians, birds and mammals. Little Egrets nests in colonies, often with other species of herons or other waterbirds. They usually select groups of tall trees, dense shrubs or reedbeds where they can hide their nests of sticks or reeds among the vegetation. Their world range is huge, extending across western and southern Europe, tropical Africa, southern Asia, Australasia and various Pacific islands, and the increase in records in the Caribbean (where breeding has been recorded) and along the US Atlantic coast suggests that it may even spread to North America. Sibthorp refers in his diaries to encountering this graceful bird in the region of Thessaly, northern Greece. At the time of his sojourn with Bauer, the Little Egret was restricted in Europe to the warmer south of the continent, but there it would likely have thrived at a time before large-scale drainage of wetlands. However, this state of affairs was sadly not to last. The egrets' downfall lay with the beautiful filigree of pure white nuptial plumes that graced the rear of their heads, the breast and the upper back during the breeding season. These had long been valued for ornamenting headgear, but it was in the late nineteenth and early twentieth centuries that there was an explosion in the plume trade supplying the millinery establishments of Europe and America. The huge demand for fashionably ornamented women's hats led to the slaughter on an industrial scale of both this species and the Great Egret. In the nick of time, the threat to their survival was averted, thanks to the establishment of a pioneering bird protection organization by a group of women conservationists, which later became the Royal Society for the Protection of Birds.

Although Bauer has added a small sketch of the bill to his painting, he did not also include a drawing of the comblike (pectinate) claw of the longer middle toe, a feature of members of the heron family, as he did with the other species illustrated in *Fauna Graeca* (see also pp. 78, 80, 82). It is also worth noting that the serrations that are characteristic of this claw are visible on the middle toe of the left foot only. This may be because this individual bird had its 'comb' on only one foot.

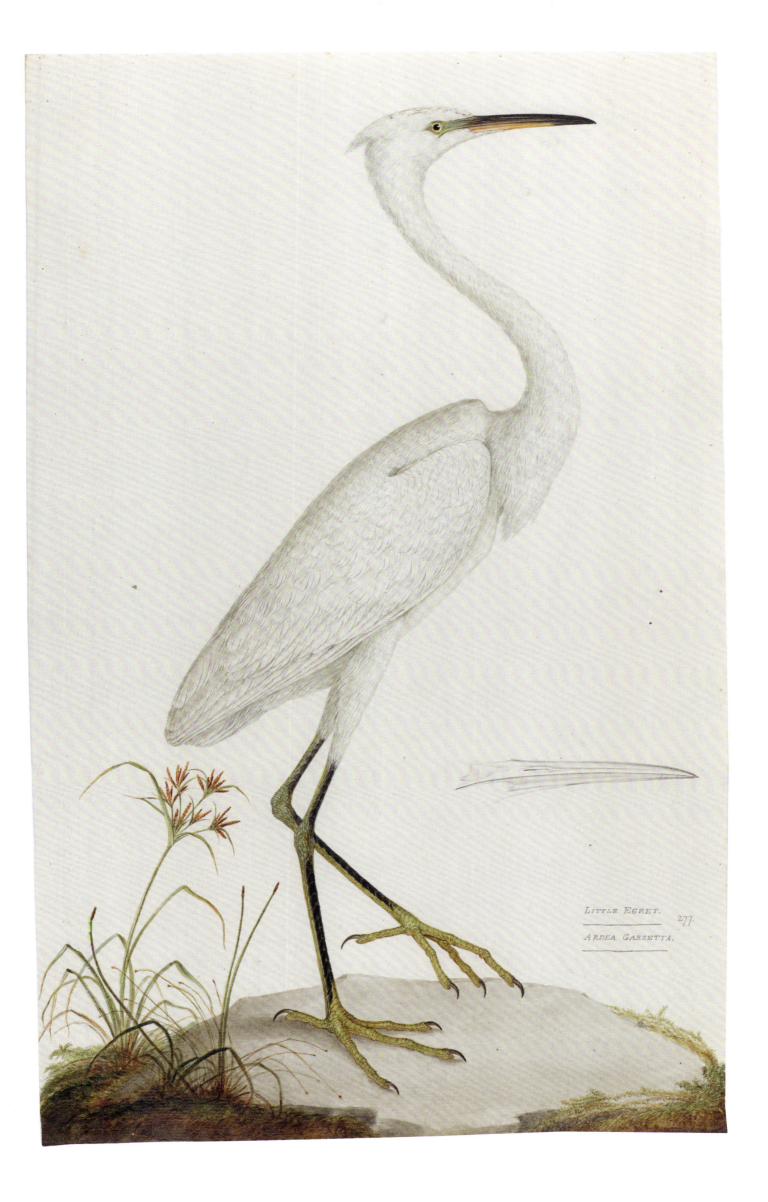

Little Egret.
Ardea Garzetta. 277.

Great Cormorant *Phalacrocorax carbo*

Black Cormorant *Phalacrocorax graculus*

As its name suggests, this is the largest of all the world's thirty-four species of cormorants, a family of duck-sized to goose-sized waterbirds that feed mainly on fish, which they catch by diving, propelled by big, powerful, fully webbed feet. Most have black plumage, often with blue, green, purple or bronze iridescence. The long, strong bill is adapted for seizing the slippery, wriggling prey and has a hooked tip that helps prevent it escaping. Great Cormorants prey on a great variety of fish (over eighty species have been recorded), and can tackle large eels and flatfish, which can put up a spirited and prolonged struggle. The bill has a special hinge allowing it to raise the upper mandible and they have a greatly distensible gular (throat) pouch that helps the cormorant accommodate such prey.

Great Cormorants are among the most efficient of all marine fish-eating birds at catching prey, despite having low visual acuity underwater, so that the fish appears only as a blur beyond about a metre distance. A hunting individual will probe about underwater into spaces among rocks or into sand or mud to frighten any fish hiding there into attempting an escape. Then it can shoot out its long neck to seize its target. By detecting movement rather than detail it can gain an advantage by being able to find fish in turbid water. Its hunting technique also allows it to catch well-camouflaged as well as hidden prey, such as flatfish resting on the seabed. The pencil detail accompanying Bauer's painting shows the bill with its hooked tip and the eye set high on the side of the head. This allows the cormorant to look down its bill to get a good view of the fish it has caught when it surfaces, so that it can identify its prey and if necessary reposition it for swallowing.

The subspecies of Great Cormorant indigenous to Britain, Ireland and north Atlantic coasts of Europe is the race *Phalacrocorax carbo carbo*. This also breeds in Greenland, and along the eastern seaboard of Canada. While travelling on their Levant expedition Bauer and Sibthorp would have encountered a different race, *sinensis*, which breeds right across Europe and central Asia, and winters in parts of south Asia. This smaller race more frequently lives by freshwaters inland, nesting in trees, in contrast to *carbo*, which breeds mainly on sea cliffs. It has increased greatly in numbers and range across Europe in recent years, and forms part of the British inland breeding population. The two races occur together and have hybridized. The four other races extend the species' vast range to Japan, Africa, Australia and New Zealand.

Unlike most aquatic birds, cormorants have relatively poorly waterproofed plumage, and after a period of foraging they need to find a sandbank, tree branch, boat or other dry perch on which to dry their broad wings, facing the wind as they adopt their characteristic heraldic pose. When they resume fishing, the wettened plumage is heavier, helping them sink with little effort. Another adaptation for reducing buoyancy is having heavier bones containing fewer air spaces than those of most other birds.

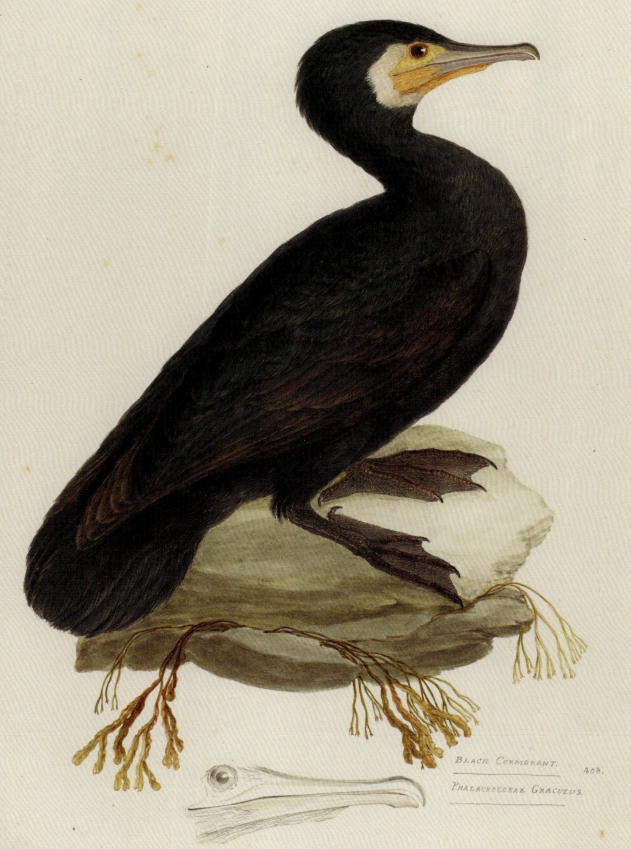

Black Cormorant. 408.
Phalacrocorax Graculus.

Fer. Bauer del.

Eurasian Thick-knee *Burhinus oedicnemus*

STONE PLOVER *ŒDICNEMUS CREPITANS*

This is a striking and strange-looking bird, with its long, heavy body set on long, sturdy, yellow legs and its big, staring yellow eyes, that give it an angry, glaring look. In life, this is emphasized by the eyes being ringed in black and the prominent white eyebrows, but Bauer has not shown this. It may be that he painted a juvenile, since the diagonal pattern on the wing, boldly black-and-white in adults, is far more muted.

It also has a strange vernacular name. It is one of ten species of thick-knees with a worldwide collective distribution, whose group name refers to the swollen 'knee' joint (actually the tibio-tarsal joint, more analogous to our ankle joint). An alternative name, still often used, is Stone-curlew. The reference to one of its favoured habitats, stony arid land, is apt, but the second part of the word is misleading, because this is not a member of the curlew genus, *Numenius*, and is not closely related to them. There is, though, a similarity between some of the calls of the Eurasian Thick-knee and the Eurasian Curlew, *Numenius arquata*. The flight call is a loud, wailing *krrrooor-lee* sound, with a curious rippling quality, shriller than the Curlew's *cooour-li* and with the accent on its second, not first, syllable. The Eurasian Thick-knee is particularly vocal at dusk and into the night, when groups join in chorus with a range of wild, eerie-sounding wailing, yelping, quavering and whistling sounds.

The Eurasian Thick-knee stands tall on its long legs, but often adopts a hunched posture, or remains still for long periods squatting on the ground. If danger threatens the chicks, the parents utter a special call that prompts them to press themselves flat against the ground so that their dark streaked brown down feathers camouflage them by breaking up their outline. When it takes flight, its long wings make it appear to grow in size.

The Eurasian Thick-knee is a relatively scarce bird that is patchily distributed across Europe. In the west, the largest populations are in France and Spain (including both the mainland and the Canary Islands), with the greatest abundance in dry grassland and arable farmland in central Spain. Europe contains about one-third of the total world population, which extends south into North Africa and as far east as south-east Russia and South East Asia. Except in Spain, North Africa and southern Asia, it is a summer visitor, wintering in Africa.

During Sibthorp's and Bauer's lifetimes, this was a more numerous and widespread European bird, both within its southern and eastern strongholds and in its far more fragmented range farther north, including in southern Britain. There it has always been at the extreme north-west of its range, and was confined to the warmer, dryer southern and eastern counties, from east Yorkshire in the north to Dorset in the south. Today, most pairs breed on the sandy heaths of Breckland in Suffolk and Norfolk, and on Salisbury Plain in Wiltshire. This is a bird adapted to life in lowland heaths, dry grasslands, steppe, large areas of sand dunes and semi-deserts. As these habitats became reduced, this wary bird has adapted to living on arable farmland, as long as the crops do not grow high or have space between the plants, as with carrots, sugar beet, maize or sunflowers, so that it can detect any approaching predators or other threats at long range.

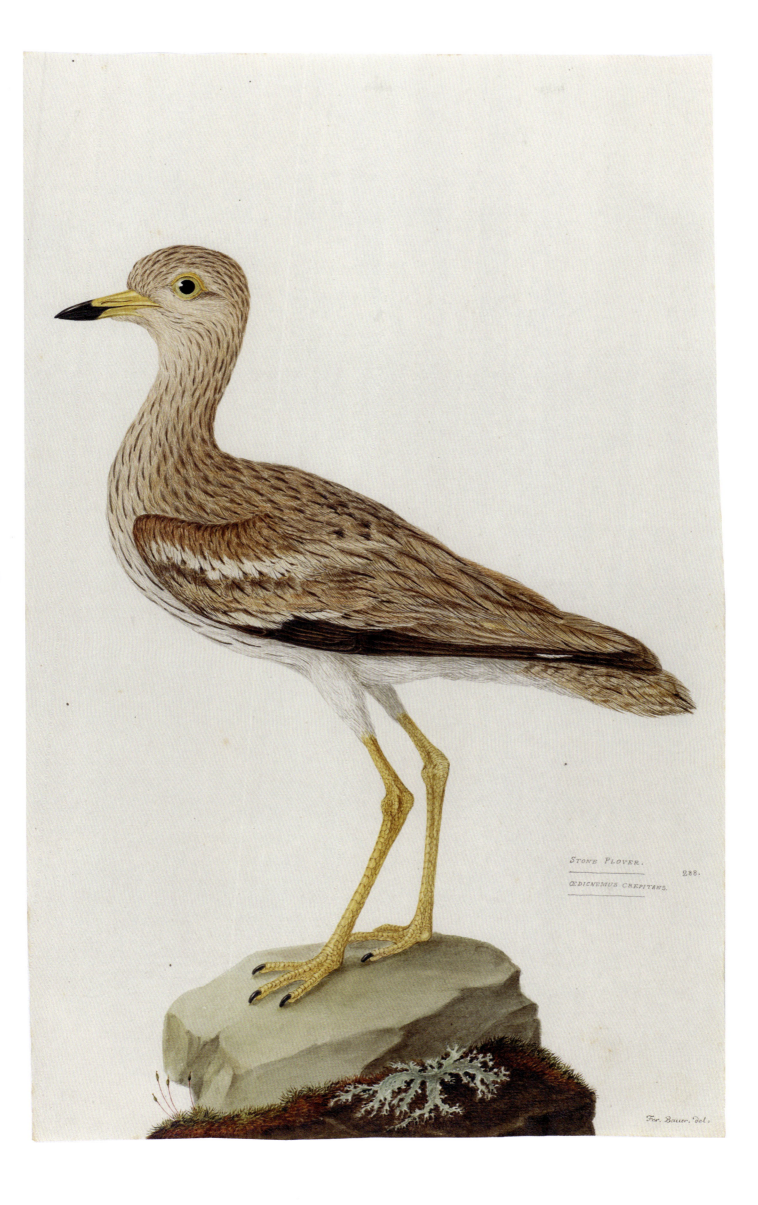

Stone Plover.
Œdicnemus crepitans.

Eurasian Oystercatcher
Haematopus ostralegus

OYSTER-CATCHER *HAEMATOPUS OSTRALEGUS*

Its combination of strikingly pied plumage and long, blade-like, bright orange-pink to orange-red bill make this large, stout-bodied wader unmistakable. Bauer's painting shows an adult in breeding plumage in an alert posture. In winter it acquires a white chinstrap.

Despite its common name, which is echoed in the specific scientific name *ostralegus*, from the Latin for 'oyster-gatherer', it does not often eat oysters, at least in Europe and nowadays. The common name was first bestowed on the bird in 1731 by an émigré for fourteen years to North America, the English naturalist Mark Catesby (1683–1749), after he had observed an American relative of the Eurasian species feeding on oysters, as they still commonly do today. In 1843 the English naturalist William Yarrell (who established many of the preferred English names of birds) chose Catesby's name over the long-established one, Sea Pie – the second word referring not to any culinary use, but to the pied plumage, with a link to the name for the landbird that is the Magpie. Other local names for this charismatic bird, such as Scolder, from Orkney, and Kleeper, from northern England, relate to the loud, shrill and far-carrying *kleep* flight calls of this very noisy bird. The genus name *Haematopus*, for this and the other ten surviving species of oystercatcher spread across the world, from the Greek for 'blood-foot', refers to the legs, although they are pink rather than blood red. The 'catcher' part of the name is another inaccuracy, implying as it does a chase after mobile prey. Across its wide range, the prey selected varies with locality, time and individual, but on coasts the most often targeted are mussels, cockles and other bivalve molluscs, while earthworms are favourite prey inland.

Oystercatchers are remarkably efficient at dealing with bivalves. The upper and lower mandibles of the bill have a triangular cross section, with the corners strengthened to withstand longitudinal stress. Individual birds specialize in one or other of two methods of opening the two halves of the shell to get at the soft body within. 'Hammerers', with blunt bill tips, break one of the shells using several forceful blows before cutting the adductor muscles that hold the shells shut, while 'stabbers' insert their pointed or chisel-tipped bill into the gap between the shells to sever the muscle. The birds learn their specific technique from their parents.

The Eurasian Oystercatcher has a vast range, breeding discontinuously from Europe across Asia. This is a very scarce breeder in the Mediterranean, with only a few hundred pairs today scattered along its northern coasts, from Spain, southern France and north-east Italy to Albania, northern Greece and Turkey. Sibthorp records seeing one on 17 April 1787 on Cyprus, where it is a rare visitor; this is said to be the first record for the island.

As is the depressing case with so many birds today, it is shocking that such a familiar and relatively abundant bird is now in steep decline in western Europe, despite former range increases as northern and central European populations spread from the coast inland along rivers.

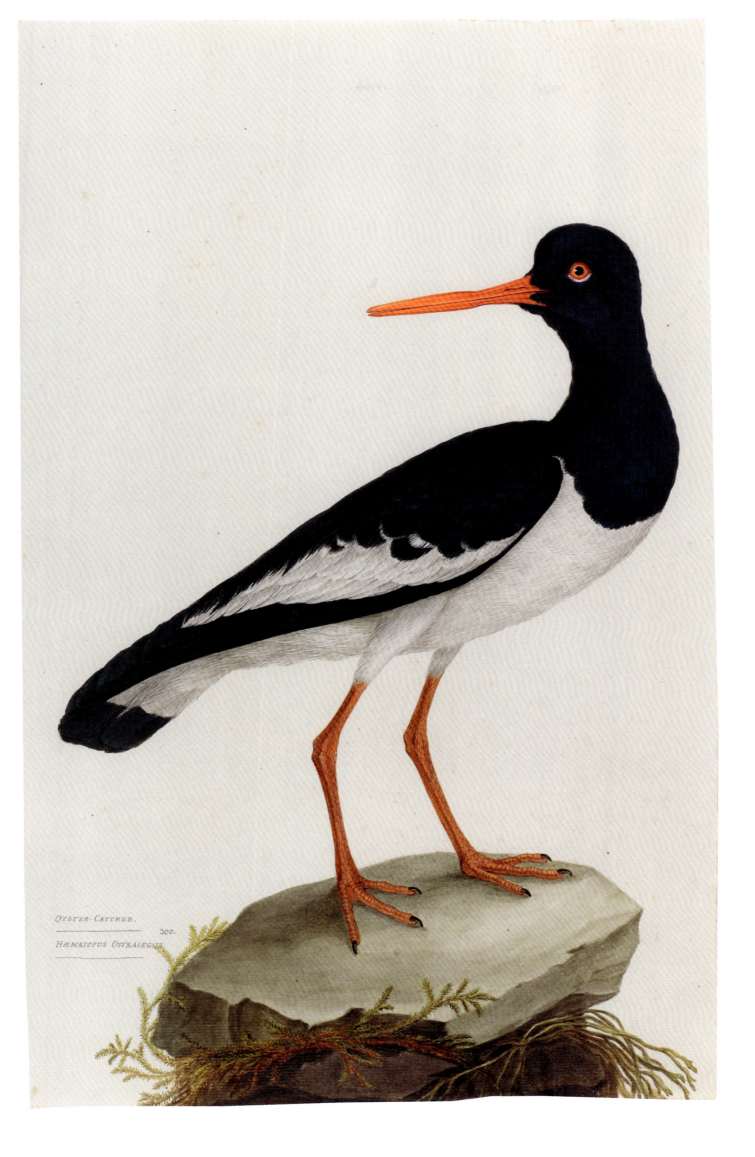

Oyster-Catcher.
Hæmatopus Ostralegus.
300.

Black-winged Stilt *Himantopus himantopus*
Long-legged Plover *Himantopus melanopterus*

Relative to its overall size, this elegant wader has the longest legs of any of the world's 10,000 or so bird species. This is celebrated in its English common name: it was first recorded as having been applied to especially long-legged birds in 1597, long after its original use for describing the long wooden extensions used to make people taller. And it is said by the *OED* not to have been used for this species and its relatives until 1813. In his lists of birds seen on the Levant expedition, Sibthorp includes it as having been encountered in Cyprus; he also mentions in his diary seeing it near Marathon, about 40 km north-east of Athens. As the note on Bauer's illustration indicates, the Black-necked Stilt was known as the Long-legged Plover at the time he and Sibthorp collected their specimen. It is not in fact a plover but a member of another bird family, Recurvirostridae, which includes both the two species of stilts in the subfamily Himantopodinae and the four species of avocets and a single Australian species of stilt more closely related to them than to the other stilts.

Black-winged Stilts live in a variety of shallow fresh, brackish or salt-water wetlands, including marshes, saltpans and estuaries. The extravagantly long reddish-pink legs give them a competitive advantage over other wading birds by enabling them to feed in deeper water, and thus to obtain invertebrate prey denied to the rest. The needle-thin, sharply pointed black bill works like a pair of fine tweezers to snatch aquatic insects either from the surface of the water or beneath it, and also as the birds leap up to catch them in flight. They sometimes also eat molluscs, crustaceans and other invertebrates, as well as small fish. In flight, Black-winged Stilts present an even more extreme appearance, with the bill held out straight in front and the long legs trailing far behind the tail.

This is a bird that often nests in ephemeral wetland habitats that are prone to drying out, with the result that its populations undergo quite dramatic fluctuations in breeding success between years. If their breeding site dries up, they will either not nest, or move elsewhere. The nest is on the ground, and ranges from a simple scrape with minimal lining to a more substantial construction of vegetation. Incubating birds look very ungainly as they fold up their legs.

This is one of the most widespread of all birds, breeding on every continent except Antarctica. There are only five subspecies (or geographical races), with minor differences in plumage, within this vast area. The one found in Europe, and also across Africa and southern Asia, is the race *himantopus*. Major populations are around the Mediterranean, especially in Spain and Portugal, and in the east around the Black and Caspian seas, with smaller numbers in between these two areas, including in Greece and Turkey. There has been a large expansion towards the northern parts of its range, including France and the Netherlands, which has been linked to the effects of climate change.

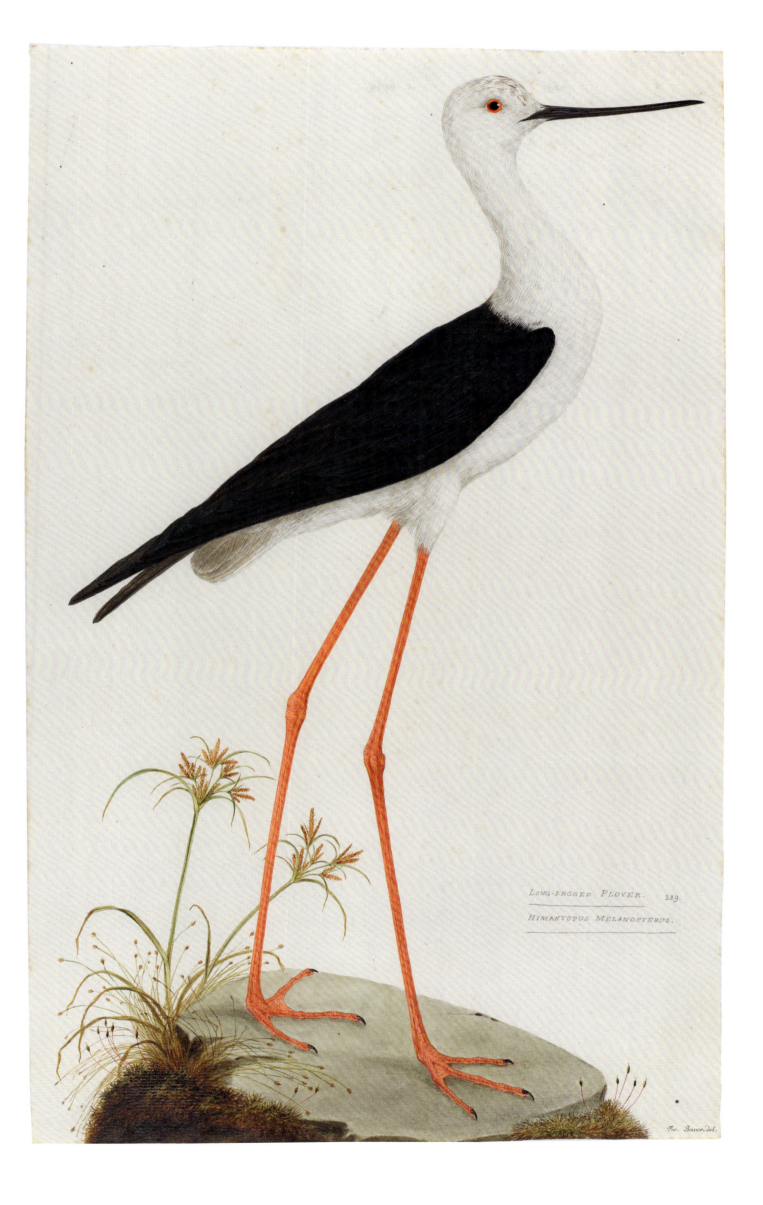

Kentish Plover *Charadrius alexandrinus*

KENTISH PLOVER *CHARADRIUS CANTIANUS*

Despite its common name, this attractive little wader last bred in the English county of Kent in about 1831. It was first scientifically described and named by Linnaeus in 1758, who described the habitat of the type specimen as the Nile in Egypt (hence its specific name of *alexandrinus*). Sadly, though, considering its name, Britain was one of the first countries on the north-western fringes of its range to lose the Kentish Plover as a breeding bird.

Although it is today a widespread, mainly coastal, breeder across Europe, northern Africa and Asia, it was not recognized and named as a British bird until 1787, when the English ornithologist, artist and physician John Latham examined specimens collected at Sandwich Bay on the Kent coast and realized they differed from the more abundant Ringed Plover, *Charadrius hiaticula*. By the early 1800s, the Kentish Plover was found to be breeding along other coastal sites in Kent and also in the adjacent county of Sussex. Its scarcity there proved to be its undoing, for as its presence became more widely known, it attracted the attention of specimen collectors eager to obtain skins for preparing mounted trophies that commanded good prices from a ready and growing market during Victorian times. In addition, the nesting colonies were plundered by egg-collectors, who took whole clutches to sell or add to their own collections. A vicious spiral ensued, as the scarcer and more desirable the trophies became, the more the birds were targeted. After a decline to just twelve breeding pairs at the surviving Dungeness breeding colony by 1903, full-time protection led to a brief increase with a peak of forty-four pairs by 1906. However, this was not to last, as a new threat arose when the nesting area was invaded by the building of a railway and roads which brought visitors to newly constructed holiday homes. By about 1931, breeding had stopped altogether. There was occasional nesting after that until 1979, when the last pairs nested in Lincolnshire. Now it is just a rare passage migrant to England, with almost all records from the south-east, especially in Norfolk, and mainly in spring with just a very few in autumn.

Until 2011 the world range of the Kentish Plover was thought to extend to the American continent, where they bred in the USA, the Caribbean and the coasts of Peru and Chile. But as a result of genetic research, it became apparent that the birds there were not just distinctive subspecies, but deserved to be regarded as a distinct species. Reflecting its appearance, with much paler and greyer upperparts than its relatives, this took the common name of Snowy Plover and the specific name *nivosus* (from the Latin for 'snowy') that had already been given to the subspecies. In addition, the research showed that another race, *dealbatus*, breeding in eastern China and Japan, also merited promotion to full species status.

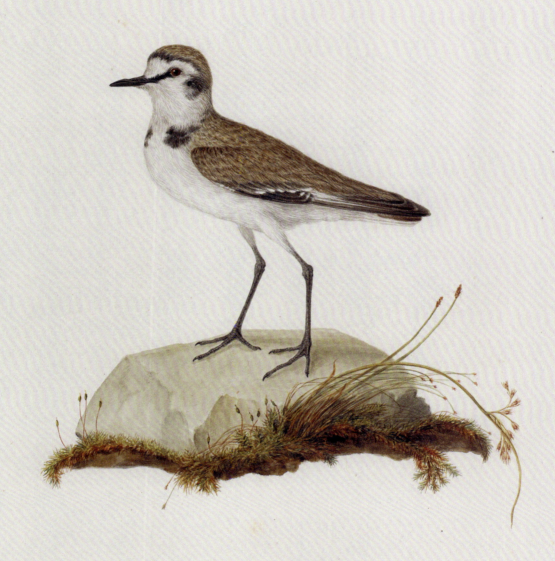

KENTISH PLOVER.
298.
CHARADRIUS CANTIANUS.

Spur-winged Lapwing *Vanellus spinosus*

SPUR-WINGED PLOVER *PLUVIANUS SPINOSUS*

This strikingly plumaged wader was formerly known as the Spur-winged Plover, but because it belongs in the distinctive subfamily (Vanellinae) of the plover family (Charadriidae) called lapwings it was renamed. The word 'Lapwing', originally given to the more familiar Northern Lapwing, *Vanellus vanellus*, derives from an Old English word, *læpewince*. Various sources (including the *OED*) aver that it represents a combination of the word for 'leap' and that meaning 'wavering or winking'. This might refer to its distinctive winking appearance in flight, as the dark upperwings alternate with the white underwings, but more likely to the dramatic and unignorable springtime display flight of the males, as they make sudden dramatic ascents, tumbles, swerves and headlong dives accompanied by shrill calls, adding to the loud humming from their wingbeats. Yet another alternative suggestion is that it derives from two Anglo-Saxon words referring to the waving of the prominent wispy crest.

The Spur-winged Lapwing, which is somewhat smaller than its northern relative, lives up to the first part of its common name in that it has a little spur on each wing, visible in Bauer's painting. The specific name *spinosus*, from the Latin word meaning 'thorny', also celebrates this feature. Spurs are sharp conical projections of bone surrounded by a horny sheath that are found on the legs or wings of various birds. Wing spurs grow from the carpal (wrist) joint of cassowaries, screamers, jacanas and other birds, including many lapwing species (though not the Northern Lapwing), and are clearly visible when protruded. In the Spur-winged Plover, at least, the horny covering is moulted along with the wing feathers annually. The function of these appendages is as weapons, used in fights between rivals and perhaps also in defence against predators. This is one of several species of wader that have been associated by various naturalists with the generally discredited assertion that they have a symbiotic relationship with Nile Crocodiles, flying or leaping into these formidable reptiles' mouths to clean them of parasites or food remains. This belief originated with the Ancient Greek historian Herodotus, who claimed to have encountered it on a visit to Egypt, though he did not specify which bird was involved. The bird most often mentioned is the beautiful little Egyptian Plover, *Pluvianus aegyptius*, which is neither a plover (now classified in a family of its own) nor any longer found in Egypt.

The Spur-winged Plover is a bird of wetlands, including saltmarshes, lakes, riverbanks and rice paddies and other irrigated agricultural land. It is probably increasing in numbers in the Middle East and is also a widespread and common bird across northern sub-Saharan Africa and along the Nile valley. By contrast, it is a very scarce breeder with a restricted range in the eastern Mediterranean, where it is a summer visitor only, migrating south to spend winter in Africa to join resident birds there. In Greece small numbers breed along northern mainland coasts and the island of Kos, and it has recently colonized Cyprus, while the larger Turkish population, where it occurs at many inland sites, is suffering a decline, in part due to the conversion of wetlands to agriculture.

Spur-winged Plover.
Pluvianus Spinosus.

Ruff *Calidris pugnax*

RUFF *MACHETES PUGNAX*

This is one of the most remarkable of all waders in several ways. The specimen that Bauer has painted would have been most likely to have been a passage migrant en route between its winter quarters in Africa and breeding grounds in northern Europe, as the Ruff does not breed in the Levant or the rest of southern Europe. The annotation indicates a bird in winter plumage, but this looks more like a juvenile, probably a male. It is the only bird species in which the male and female have different common names. Ruff is the name for the far larger male, which came to be adopted for the species as a whole, while the female was referred to as a Reeve. After moulting into his breeding plumage, the male is transformed into a veritable dandy, with an extravagant ruff of feathers girdling his neck and head. The bird was named from the elaborately fluted lace collar worn in Tudor and Stuart times, and not the other way round. Uniquely, due to the great range of permutations of several colours and patterns on the ruff and ear tufts, no two males look the same.

The males gather at traditional communal mating grounds (called 'hills') to attract and mate with watching females. Unlike most other waders, which perform aerial displays accompanied by trilling or piping sounds, this performance is strangely silent, apart from the rustling of feathers as the rival males leap and joust, aiming kicks at their rivals' heads. There are two main types of male. Most are 'resident', or 'independent', males, with bright black and chestnut or orange ruffs. These are the most aggressive and dominant ones that secure their own display 'court' and the most mates. The others are 'satellite' males, with pale, mottled or white ruffs. They wait on the edges of this sexual solar system, then sneak onto a court and mate with a female. A very few males are runtish individuals, their size and plain plumage mimicking females so they can mingle with them unnoticed. As the females crouch, indicating they are ready to mate, they quickly copulate with them.

The Ruff occupies a huge breeding range from northern Europe to far-eastern Asia. All populations migrate south or south-west on a broad front to winter in Africa and southern Asia. The western population, from Britain across northern Europe to western Siberia, traverses Europe to winter in West Africa. Two other populations across north-eastern Asia travel to winter in eastern and southern Africa and in southern Asia respectively. The Ruff breeds sparsely in Britain and Ireland, the Netherlands, northern Germany, Denmark, and in dwindling numbers across eastern Europe, including northern Scandinavia, Finland, the Baltic states, Belarus, Ukraine and Russia. While the Siberian populations have shown recent increases, the Ruff has suffered huge losses in both range and numbers in the western parts of its breeding range over a period of thirty to forty years. These include a 70 per cent decline in Sweden and 90 per cent in Finland. A major driver of these catastrophic downturns is habitat loss and degradation, not only on the nesting grounds but also at migratory stopover sites and in the winter quarters.

RUFF. winter plumage.
325.
MACHETES PUGNAX.

Fer. Bauer. del.

Curlew Sandpiper *Calidris ferruginea*

PYGMY CURLEW *TRINGA SUBARQUATA*

As is so often the case, the names of this attractive little wader – both vernacular and scientific – have changed over time. Its modestly decurved bill led to its being known as the 'Pygmy Curlew', though it is not a close relative of the much larger true curlews of the genus *Numenius*, which have far longer and more noticeably curved bills. Moreover, in this painting, the normally scrupulously accurate Bauer has made the bill strongly decurved abruptly towards the tip, rather than more shallowly and smoothly curved overall. Given its scientific name by the Norwegian naturalist (and bishop of Bergen) Erik Pontopiddan in 1763, the Curlew Sandpiper was formerly placed in the genus *Tringa* along with the Redshank, *T. totanus*, Greenshank, *T. nebularia*, and relatives, but later transferred to the large genus of smaller sandpipers *Calidris*.

Bauer was seeing this bird on its transit through the Mediterranean region, while it was making a prodigious journey, for it breeds far away in Arctic Russia. The impressive migration of this Starling-sized bird constitutes a round trip of some 17,700 km (11,000 miles) between its breeding grounds in the vast expanses of treeless tundra in north-central Siberia, mainly on the great Taimyr Peninsula, and its wintering quarters in Africa. If, as is likely, he and Sibthorp encountered the species in spring on the shore of a Cyprus lagoon or estuary, it would have been stopping briefly to refuel on invertebrates living in the mud before heading off as fast as possible to arrive on the distant breeding grounds ready to take advantage of the short but food-filled Arctic summer to raise a family. The bird Bauer has painted is already handsomely adorned in its bright breeding plumage, with a rich brick-red head, neck and breast.

In comparison with its close relative the Dunlin, *Calidris alpina*, the most abundant small wader in Europe, the Curlew Sandpiper is distinctly scarcer, nesting regularly only on the high Arctic coastal tundra fringing the coast of Siberia; the Dunlin breeds over a vastly greater area, from Greenland and Scandinavia, northern Britain and Ireland, and across northern Siberia and also in Alaska and central Canada, and in a wide variety of habitats, from tundra to moorland and salt marsh. The two species differ also in structure and feeding habits, reducing competition when, as often, they feed in the same area. The slightly larger Curlew Sandpiper regularly selects bigger invertebrates than the Dunlin, and its longer legs allow it to wade into shallow water and its longer more decurved bill enable it to probe more deeply.

PYGMY CURLEW. *male in summer plumage.*
328.
TRINGA SUBARQUATA.

If it be T. subarquata, the beak is too short & too curved

Geo. Bauer del.

Greenshank *Tringa nebularia*

GREENSHANK *TOTANUS GLOTTIS*

A member of the largest family of waders, Scolopacidae, this is the biggest and most elegant species in the genus *Tringa*, known to ornithologists as 'shanks'. This word is an old name for legs (as in the humorous expression 'shanks's pony' for walking, or the nickname Edward Longshanks given to King Edward I of England). Its origin appears to be the Old English word *scanca*, which means 'leg-bone', and is related to the German word for ham, *Schinken*. Close relatives of the Greenshank whose names include reference to their leg colour are the Common Redshank, *Tringa tetanus*, and the Spotted Redshank, *Tringa erythropus*, which breed in northern Eurasia, and the North American Greater Yellowlegs, *Tringa melanoleuca*, and Lesser Yellowlegs, *Tringa flavipes* (both formerly known as Yellowshanks). The legs in Bauer's portrait are greyish; they range from greenish grey to olive green.

Greenshanks often wade deeply, up to the waist or even almost immersing their bodies, striding along on their long legs, and darting about energetically in pursuit of small fish and mobile invertebrates such as crabs. They are fast and very agile, often abruptly changing direction when chasing their prey. They also probe into mud with their long, slightly upcurved bills or sweep them from side to side to detect prey. During the breeding season, these versatile hunters delicately tweezer flies or other insects, which then form the main prey, from vegetation or the ground, and seize flying insects in mid-air.

Greenshank breed across northern Europe and Asia, their vast range extending from Scandinavia, Finland and right across northern Russia, where they live to the south of the tundra, mainly in the immense taiga forest zone, with some extending to the steppe regions. There is also an isolated population in northern Scotland, with the largest numbers on the huge treeless expanse of blanket bog in the Flow Country.

On their lonely breeding grounds, those lucky enough to see them may be treated to the thrilling sound and spectacle of the male's song-flight. Ascending to a considerable height, he may follow an undulating course, uttering his rich, fluting two-note song on each downward phase of his flight path, before gliding down to join the female, who may join in to perform a sublime duet.

In the rest of Europe they are enjoyed by birders as passage migrants, to estuaries, lakes and reservoirs, usually singly or in small groups. They are often first detected by their distinctive alarm call – a far-carrying, ringing, three-note whistle, with all notes on the same pitch. Some remain for winter but most are just passing through in spring and autumn on their long migrations to and from their main winter quarters. European breeders winter mainly on the coasts and wetlands of sub-Saharan Africa, especially in the south-west of the continent, with small numbers in the Mediterranean. The eastern European and Asian breeders migrate south to southern Asia and Australasia.

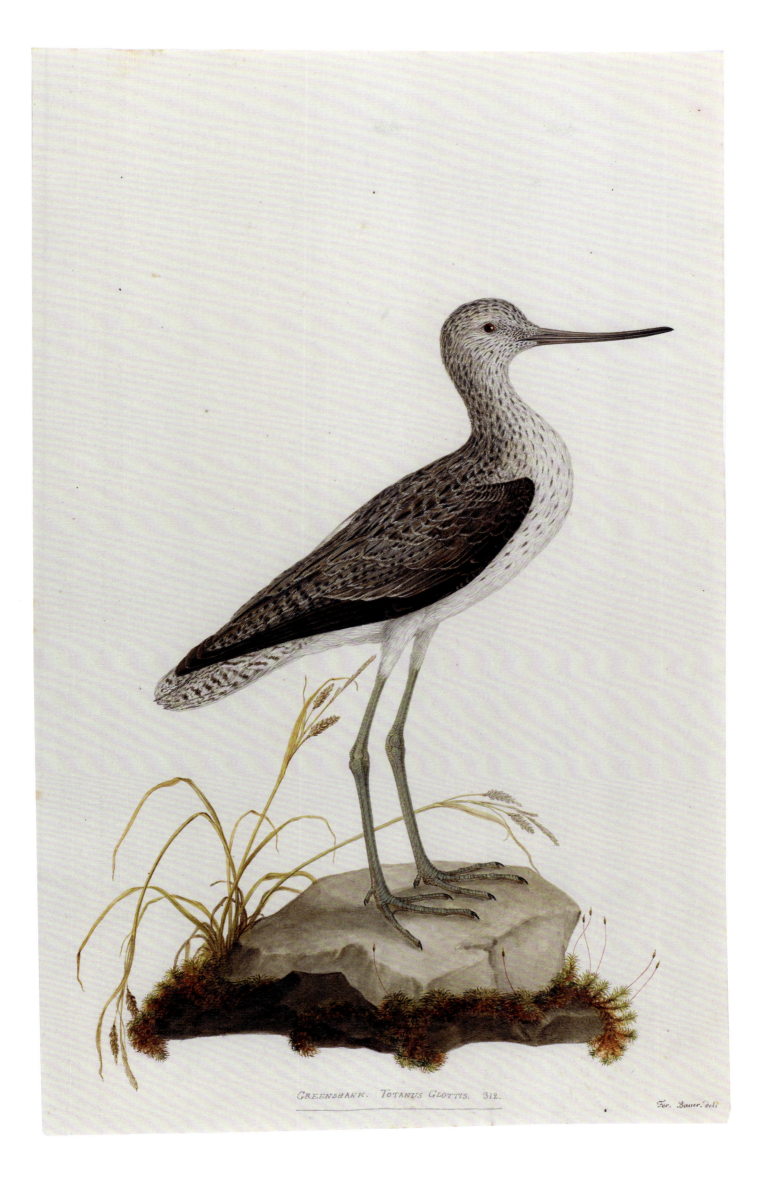

GREENSHANK. TOTANUS GLOTTIS. 312.

Collared Pratincole *Glareola pratincola*

PRATINCOLE *GLAREOLA TORQUATA*

The eight species of pratincoles resemble in appearance the elegant sea and marsh birds called terns, with long, pointed wings and forked tails, but with shorter bills, rather longer legs, and only partially webbed feet. In flight they also recall oversized swallows, as they hawk for grasshoppers, beetles and other flying insects with graceful, buoyant flight on their long, pointed wings, snapping them up in the wide gape of a short, strong bill. To catch their prey, they make sudden swooping manoeuvres, steered by a pair of fine streamers projecting from the corners of their tails. This resemblance led them to be classified with the swallows. Indeed, Sibthorp's first mention in his diary refers to observing in Greece 'Of the swallow tribe … all the European species, except the Pratincola.' The travellers did manage to see – and collect a specimen of – the Common Pratincole in Cyprus, and again in his diary Sibthorp lumps this bird in with "the swallow, the martin, the swift and 'the Melba' (the Alpine Swift, *Tachymarptus melba*). German vernacular names, which Bauer may have known, include *die Wiesenschwalbe*, 'meadow swallow'.

The scientific name *pratincola*, from the Latin words meaning 'dweller in meadows', was not applied to these birds until 1756, by a rather obscure Austrian naturalist, Wilhelm Kramer. Then in 1773 it was first used as a common name by the prolific Welsh writer on natural history and travel, Thomas Pennant; the birds had up to then been referred to as *hirundo marina*, or sea swallow (the latter also being an old name for terns!). The modern name for the genus, *Glareola*, is from the Latin word for gravel, and refers to the pratincole's nest, a mere scrape, often in gravel.

Pratincoles breed in open habitats, such as expanses of dried mud, gravel and salt marsh. They are very sociable: feeding, resting, bathing and migrating in flocks and usually breeding in colonies. Outside the breeding season, some flocks may number many hundreds of birds or even thousands, especially in the past.

As well as feeding on the wing, they sometimes chase insects on the ground, in a very similar go–stop–go manner to plovers, alternating running with a brief pause to seize prey. This helps to account for an old name of 'swallow plover'. They often feed at dusk or dawn, when insects are more sluggish and easier to catch. They are summer visitors to Europe, wintering in Africa.

Worldwide, the Collared Pratincole is patchily distributed across parts of Africa, western Asia and southern Europe. The European population suffered declines in both range and abundance during much of the twentieth century. Censusing and measuring fluctuations in numbers are difficult because pratincoles tend to change breeding sites from one year to the next. At the time of Sibthorp and Bauer's sojourn in the Levant, a very similar close relative, the Black-winged Pratincole, *Glareola nordmani*, was common in south-east Europe, and it is possible that they encountered it. However, the bird Bauer has painted with great accuracy has a much larger red area at the base of the bill, indicating that it is a Collared Pratincole.

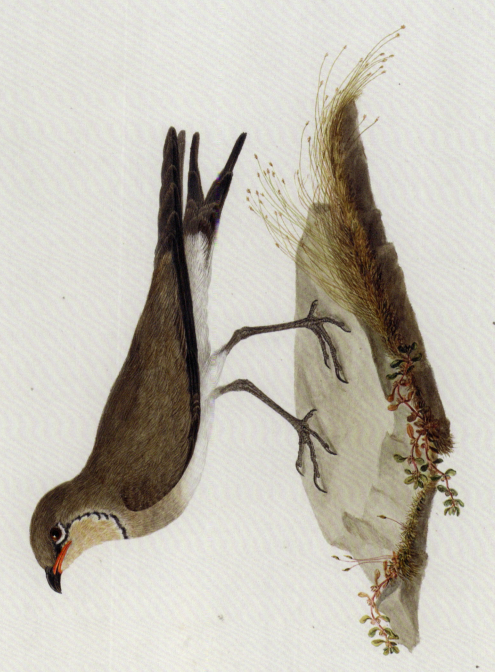

PRATINCOLE.
GLAREOLA TORQUATA.
265

Gull-billed Tern *Gelochelidon nilotica*

GULL-BILLED TERN *STERNA ANGLICA*

As the note on Bauer's painting indicates, this is an immature bird. It is in its second summer and on its way to acquiring the solid black crown and nape of the adult breeding plumage, which it loses in autumn. As its English name indicates, it has a thicker and blunter bill than almost all other terns, resembling that of smaller species of their close relatives the gulls. The Gull-billed Tern was first scientifically described in 1789 by the German naturalist Johann Friedrich Gmelin, one of the most prolific of all describers of bird species new to science. The German common name is *die Lachseeschwalbe*, the 'laughing sea swallow' (the old name 'sea swallow' for terns combines the habitat of most of these birds with their similarity in appearance and grace in flight to the unrelated swallows). The first part of the German name refers to the Gull-billed Tern's distinctive, rapid laughing alarm call. They also have deeper, two-note, nasal flight calls and rattling or bubbling sounds at breeding colonies.

Most terns breed in large colonies on seashores and islands and fish in inshore waters, although several species nest on oceanic islands, and many others make long migrations to their wintering quarters (the Arctic Tern, *Sterna hirundo*, being the world's champion migrant, from pole to pole). Although they have webbed feet, their plumage is not very waterproof, and they do not swim. They feed mainly by plunge diving to catch fish and invertebrates, patrolling at moderate height above the water, then, when they have spotted prey, hovering above the water to establish its exact location before plunging just below the surface to seize it in their sharp bills. A few species, including this one, live inland on freshwaters as well as along coasts, and regularly feed over land. Instead of being specialist fish-catchers, they are opportunistic hunters that feed mainly on insects, but also take other prey, including small fish, crabs, voles and other small mammals, frogs, lizards and the eggs and young of a wide variety of birds. Gull-billed Terns often fly slowly into the wind, dipping down gracefully to seize prey from the ground, vegetation or water, and, like oversized swallows, they also chase flying insects, such as dragonflies and locusts, in the air.

The breeding range of the Gull-billed Tern is vast, scattered across six continents. It is a bird of warmer areas in southern North America, South America, Africa, southern Europe, central and southern Asia, and Australia. Furthermore, the Australian Gull-billed Tern, *Gelochelidon macrotarsa*, formerly regarded as a race of this species, breeds across much of the Australian continent and is also found along the south of New Guinea outside the breeding season. Breeding sites with suitable conditions are limited and they may not be used every year, so that numbers fluctuate considerably and include declines over many decades. In Europe, they used to breed widely in northern and central Europe until the nineteenth century, but are now restricted mainly to the Mediterranean, Black Sea and Caspian regions. In Ukraine, where estimates suggest that a quarter of the entire European population breed, there have been declines since the 1980s.

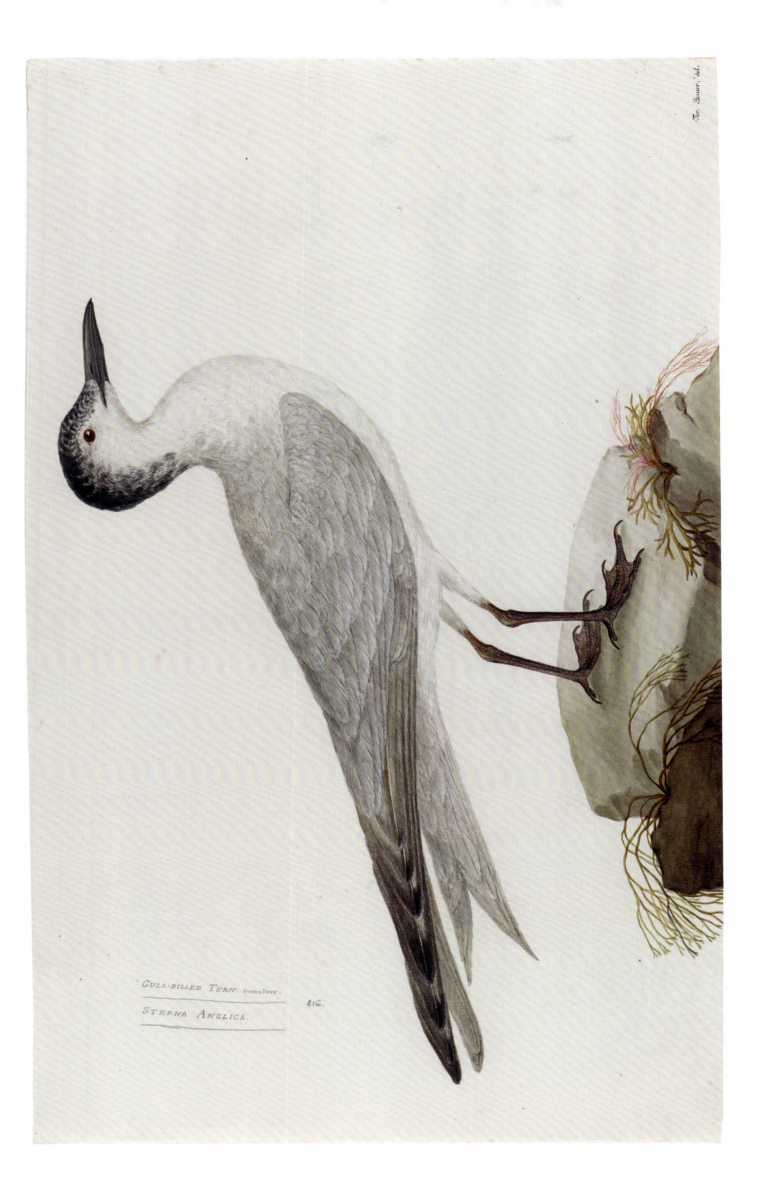

GULL-BILLED TERN. *immature.*
STERNA ANGLICA. 416.

Black-headed Gull *Larus ridibundus*

LAUGHING GULL *XENIA RIDIBUNDA*

The bird known to Sibthorp and Bauer as the Black-headed Gull is nowadays called the Mediterranean Gull, *Larus melanocephalus* (see p. 110). A more accurate name for this attractive gull would have been the Brown-hooded Gull, as the colour on its head in its breeding plumage is not black but dark chocolate brown, and this is restricted to an area extending only part way on the head. And in further twists in the convoluted story of naming, the name Laughing Gull was used for the Black-headed Gull during Sibthorp and Bauer's time, and is still referenced in its species name, *ridibundus* (and earlier *ridibunda*, the feminine form to accord with the gender of the old genus name, *Xenia*), from the Latin word for 'laughing'. That name is now given to an American species, *Larus atricilla*, which deserves it more, as some of its most often heard calls do really sound like raucous, high-pitched human laughter. Furthermore, the specific name *atricilla* is from the Latin 'black-tailed', evidently an error when applied to this white-tailed gull, introduced by Linnaeus when he bestowed it, mistaking his shorthand note for the intended *atricapilla*, Latin for 'black-headed'.

The Black-headed Gull is a beautiful bird, more delicate in proportions than the larger gulls such as the Herring Gull, *Larus argentatus*, Yellow-legged Gull, *Larus michahellis* and Lesser Black-backed Gull, *Larus fuscus* (see pp. 116 & 114). It has a proportionately smaller head and a longer neck than other commonly seen European gulls, and more pointed wings. Bauer has painted an adult in winter plumage, when he and Sibthorp would have seen it, as it is a regular passage migrant and winter visitor to Mediterranean Europe, including Greece, Cyprus and Turkey, but does not breed there, except at a few places in central Turkey. At this time of year the dark chocolate hood the bird wore in summer is reduced to a few smudged markings above and behind the eyes, and the normally all-crimson bill has a blackish tip. One of its best distinguishing features at all times of year, visible at long range and especially in flight, is the white leading edge to the outer wing. All these features Bauer has accurately rendered in his portrait.

Gulls are not noted for mellifluous voices, and the calls of the Black-headed Gull are especially harsh, with shrill, sharp or rasping notes. A single bird can make a lot of noise, but the chorus of loud calls from a large colony can be deafening. And some colonies that benefit from access to plentiful food sources nearby can be huge, containing tens of thousands of birds. These gulls are always found near shallow water. Their breeding sites include both coastal and inland marshes, among dunes, at lakes with extensive reedbeds, and on bogs in moorland. They also visit agricultural land, where they follow the plough to snap up invertebrates disturbed by it, as well as urban areas and landfill dumps, and will hawk in the air for flying ants and other insects. They are widespread and abundant over huge breeding and wintering ranges, across much of Europe and Siberia east to the Pacific coast.

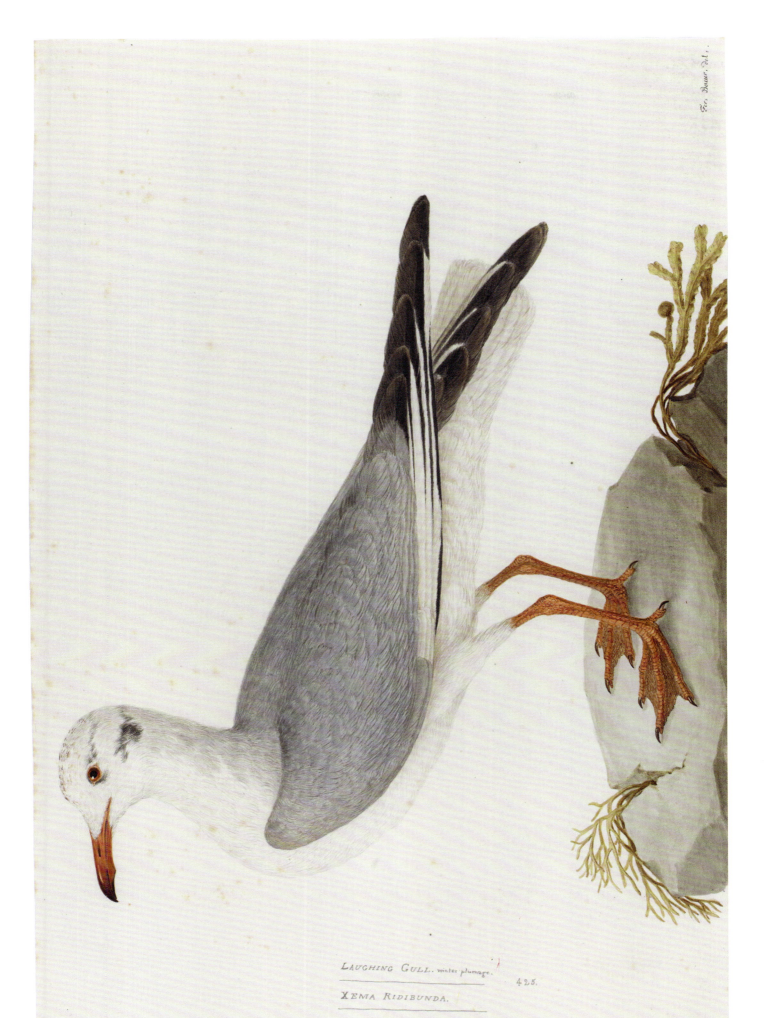

LAUGHING GULL. winter plumage.
425.
XEMA RIDIBUNDA.

Mediterranean Gull *Larus melanocephalus*

BLACK-HEADED GULL *XENIA MELANOCEPHALA*

The annotation to this illustration refers to this species as the Black-headed Gull. Although it is now known as the Mediterranean Gull, the common name ascribed to it on Bauer's painting is in fact a better name for this species than the one we now call Black-headed Gull, *Larus ridibundus* (see p. 108), as the latter has a dark chocolate brown hood in its breeding plumage rather than a black one (although it does often look black at long range). The modern name is also a geographical misnomer: the main breeding area is centred around the Black Sea rather than the Mediterranean.

Whatever it is called, this is a medium-sized gull, stockier than the more familiar Black-headed Gull, with which it often associates, and with a larger, thicker neck and a flatter, less rounded head. It has paler grey upperparts and, apart from its head, often appears all white at a distance. It also has a distinctly heavier, less pointed bill (also shown in the pencil detail). This is bright red (often with a blackish band near the tip), as are its longer legs (a Black-headed Gull's bill and legs are much darker red). Both bill and legs are faded in Bauer's specimen. In flight, its wings appear broader and have translucent, all-white tips (apart from the very thin partially black leading edge on the outer flight feather, usually not visible) rather than the black tips of the Black-headed Gull. In its summer plumage, shown in this painting, white crescent-shaped eyelids above and below the eye stand out against the black of its hood, which reaches farther down its hindneck than that of the Black-headed Gull. It is odd that Bauer hasn't painted them in this portrait, but he has included a few white feathers elsewhere on the head.

Mediterranean Gulls feed on insects, both aquatic and terrestrial, and also other invertebrates, including crustaceans, molluscs and worms, as well as small fish, frogs, lizards, small mammals, other birds' eggs and chicks, offal, fish scraps and discard from fishing boats. As with other gulls, the parents feed their chicks on a regurgitated mush of partially digested food from their stomachs. Also like other gulls, they are colonial breeders, sometimes among colonies of other gulls, including Black-headed Gulls. Over most of their range they prefer dry, warm steppe habitats and Mediterranean zones, where they live on coasts, river deltas, estuaries, marshes, lagoons and by lakes, rivers and other wetlands inland.

The species increased considerably from the 1950s, when estimates of its total world population indicated there were fewer than 40,000 breeding pairs; by the mid-1990s there were between 300,000 and 370,000 pairs, almost 99 per cent in the former USSR, mostly in Ukraine, with smaller numbers in scattered colonies elsewhere, in south, central and northern Europe, including Britain and Ireland. The expansion in range has, however, been accompanied by declines in many areas, due mainly to predation by larger gulls and crows, as well as humans taking eggs and causing disturbance.

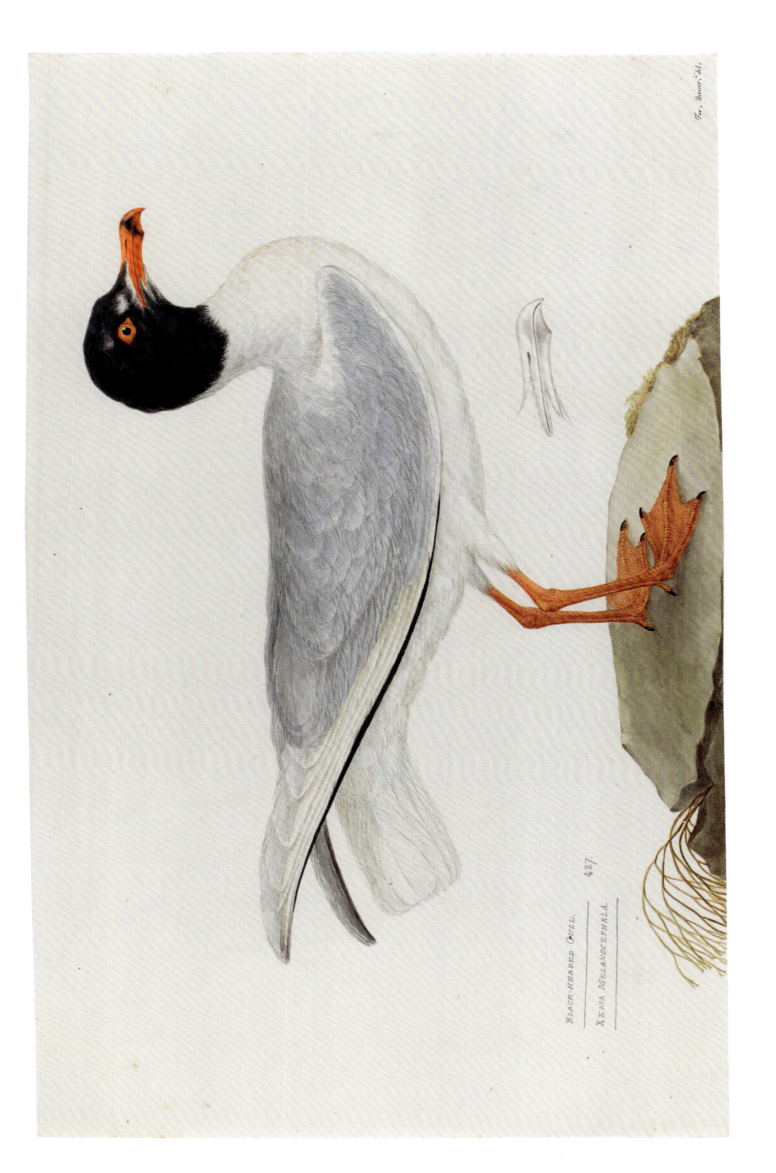

Common Gull *Larus canus*

Kittywake *Larus rissa*

The annotation by Frederick Holmes on this portrayal of a gull by Bauer is incorrect: it is not a Black-legged Kittiwake (then spelled Kittywake), *Rissa tridactyla*, but an immature Common Gull, *Larus canus*. The bill and leg colour are wrong for a Kittiwake, which is only a rare wanderer to the south-eastern Mediterranean, but right for an immature Common Gull in its first winter plumage, as indicated by the broad black band at the end of its tail, which is lost by the following year. The comment written on the plate, 'hind toe incorrect', would have been generally true had this bird been a Black-legged Kittiwake, as in this species it is often completely lacking. But while the Common Gull, like all gulls, has a greatly reduced hind toe compared with that of many birds, it is clearly visible. Also, Bauer has painted the right wing in an odd position, as if broken. Compared with the larger grey-and-white gulls such as the Herring Gull, *Larus argentatus*, and Yellow-legged Gull, *Larus michahellis* (see p. 116), with their thicker more formidable bills, and menacing pale eyes, it has a more 'benign' appearance with its dark eyes set in a softly rounded head.

This is as good a place as any to point out that the popular name 'seagull' used by most people for members of the gull family, Laridae, is never employed by birders and ornithologists. True, these birds are often found by the seaside, and regularly feed in coastal waters, but apart from relatively few truly ocean-going species, including the two species of kittiwake (the other being the Red-legged Kittiwake, *Rissa brevirostris*, endemic to the far northern Pacific region) and Sabine's Gull, *Xema sabini*, most of the world's species of gulls are largely restricted to waters of the continental shelf. Many also occur inland, and some are not marine at all.

This medium-sized gull has a vast range, with three of its four subspecies breeding from Britain and Ireland right across northern Europe and Asia as far as the Bering Strait. The fourth subspecies, known as the Mew Gull, breeds across Alaska and eastwards as far as central Canada. Most populations migrate south for winter, generally not very far, though some reach the Mediterranean, including Greece, where they are regularly seen between November and March. In his diary, Sibthorp refers to having seen it in the Aegean. The name Common Gull is a misnomer in the sense that it is not at all the commonest gull in Europe, though the epithet may have been given in the alternative sense of the word, meaning 'having no marked distinguishing features'. The alternative Mew Gull (often used for the Eurasian birds as well as the North American ones) is from an Old English word *meaw*, referring to a gull. This often appeared as 'sea-mew', sometimes applied to this species in particular, or in Scotland, where most of the British population breed, 'maa' or 'maw'. And 'mew' relates in turn to the wailing cries of this and other gulls (as well as cats and other creatures of course).

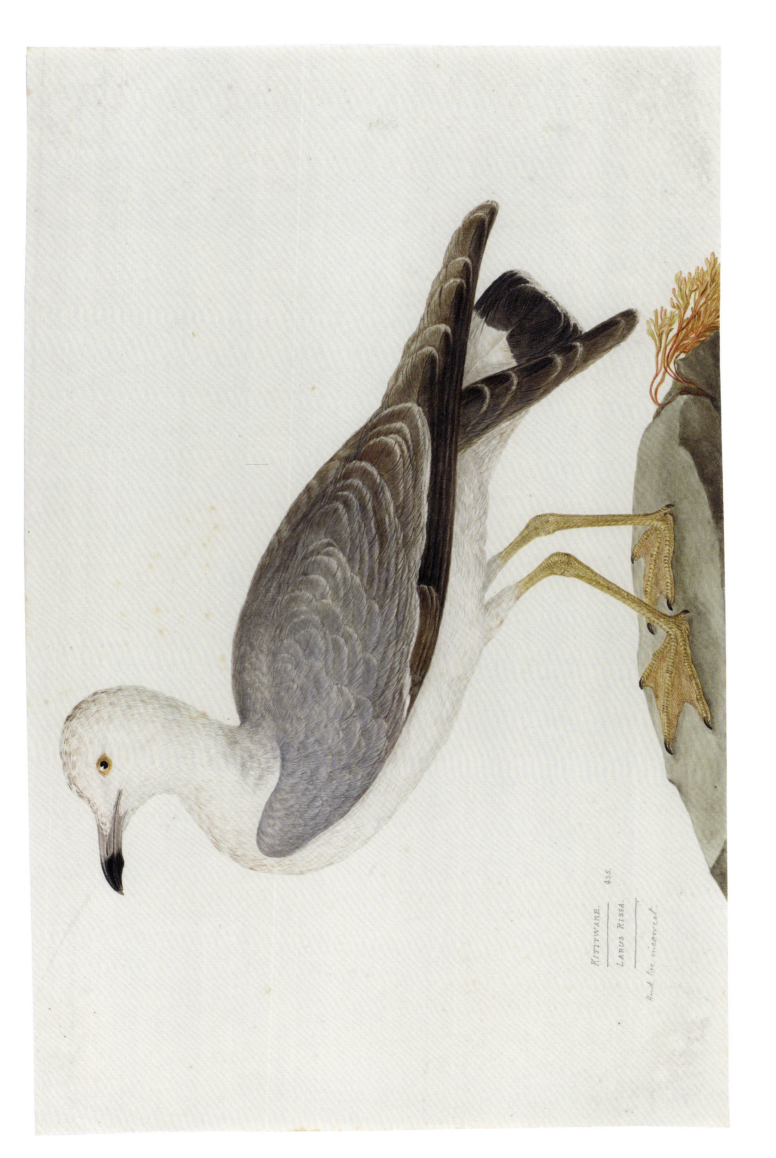

KITTYWAKE.
LARUS RISSA. 435.
Hind toe incorrect.

Lesser Black-backed Gull *Larus fuscus*

LESSER BLACK-BACKED GULL *LARUS FUSCUS*

This handsome gull has a breeding range that is almost entirely confined to Europe (the exceptions being a few pairs that have been recorded nesting in the Canary Islands and some birds from the increasing numbers of winter visitors to eastern North America that have paired with Herring Gulls, *Larus argentatus*, and produced hybrid young). The overwhelming majority of breeding colonies are in northern and north-western Europe, with the greatest numbers in Britain and Ireland.

This is a relatively large member of the fifty or so species in the widespread gull subfamily Larinae, only a little smaller than its close relative the Herring Gull or its more southerly one the Yellow-legged Gull, *Larus michahellis* (see p. 116). These are all exceeded in size by the far stockier, longer winged and more powerful Great Black-backed Gull, *Larus marinus*, the world's largest gull. (Sibthorp lists this impressive bird, which has similar plumage to the Lesser Black-back, in his account of the Levant expedition as having been found in Cyprus, but there are very few definite records of it ever having been seen there or in any other parts of southern Europe or Turkey, since it is far less migratory than the Lesser Black-backed Gull.)

The specimen of Lesser Black-back Bauer has painted belongs to the race *fuscus* (from the Latin for 'black'), which breeds in north-east Europe, mainly in Sweden, Finland and Russia, and has sometimes been regarded as a separate species, called the Baltic Gull. Compared to other races this has far darker upperparts, which are velvety black with little or no difference in tone between the back and the wings. Bauer and Sibthorp would have most likely encountered this bird as a winter visitor or passage migrant, especially as the race *fuscus* is (like two other Russian races) a long-distance migrant, in the case of *fuscus* wintering widely around the Mediterranean region (including in Greece, Crete, Cyprus or Turkey) or travelling farther across it to reach the Middle East or East Africa.

The palest race of Lesser Black-backed Gull, *graellsi*, which breeds in north-west Europe, including in Britain and Ireland, experienced a dramatic increase in numbers during the twentieth century, and together with the north European race *intermedius* extended the breeding range of the species to Iceland, France, Denmark, Germany and the Netherlands and later to Spain and Portugal. This expansion, especially in its stronghold of Britain and Ireland, has been largely due to its colonization of urban areas, often well inland. Here (like Herring Gulls, with which it competes, often favourably) it finds a ready supply of breeding sites on the roofs of buildings and a ready supply of easily accessible food resulting from human profligacy, from the remains of lunches at outdoor cafes or the sandwich snatched from someone's hand to the piles of waste food on nearby landfill sites. By contrast, the race *fuscus* in Scandinavia and Finland have been experiencing serious declines, with breeding failures at many sites, some of which researchers have shown to result from the build-up of toxins in the food the birds have eaten in their winter range.

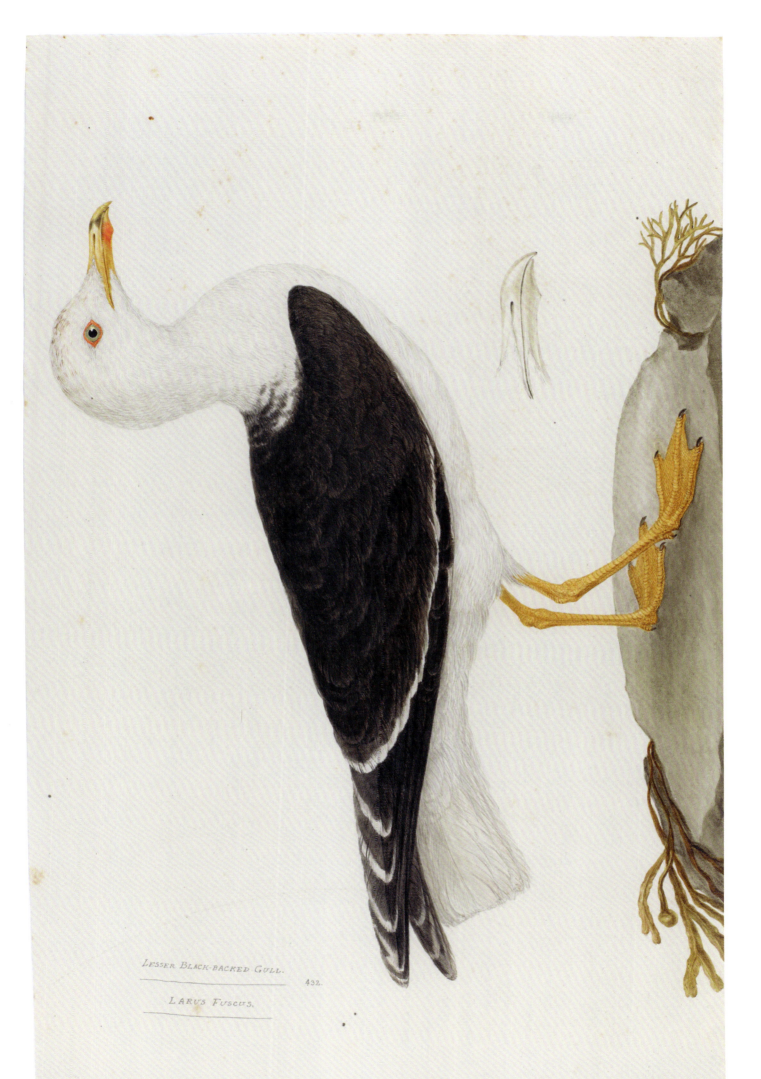

Lesser Black-backed Gull.
432.
Larus Fuscus.

Yellow-Legged Gull *Larus michahellis*

Herring Gull *L. argentatus*

This large gull was recognized as a distinct subspecies of the Herring Gull in 1840 (fourteen years after the death of Bauer and forty-four after that of Sibthorp) when the German Johann Friedrich Naumann (1780–1857), described it scientifically. He was the younger son of Johann Andreas Naumann (1744–1826), a farmer who lived to the southwest of Berlin, and the older brother of Carl Andreas Naumann (1786–1854). Although poorly educated and without any formal scientific training, the whole family were passionate bird hunters and trappers, who by careful study of the birds they found greatly advanced the knowledge of ornithology. Naumann Senior wrote an important and highly influential guide to birds of Germany, which Johann Friedrich updated. Furthermore, like Ferdinand Bauer, Johann Friedrich had great talent as an artist from a young age, and from the age of 15 produced extremely good and accurate illustrations for the time to illustrate his father's seminal work and later his major updates. He eventually received recognition internationally and was given a professorship and honorary degrees. The subspecies name *michahellis* was conferred in honour of a German naturalist and physician, Karl Michahelles, who travelled widely in Croatia, where he identified several new species, including the Western Rock Nuthatch, *Sitta neumayer* (p. 184), and the race of the Western Yellow Wagtail known as the 'Black-headed Wagtail', *Motacilla flava feldegg* (p. 212).

The Yellow-legged Gull has sometimes been regarded as a race of a different gull, the Caspian Gull, *Larus cachinnans*, itself formally subsumed as a subspecies of the Herring Gull, but recently elevated to full species. The recent recognition of the Yellow-legged Gull as a separate species from both Caspian and Herring Gulls is fully supported by modern genetic research, unavailable to earlier ornithologists. The differences in its appearance from its relatives are numerous but very subtle: gull identification is renowned as a difficult art. The distinctive feature implied in the bird's common name is not always any help, since it is shared with other species, including the Caspian Gull and Lesser Black-backed Gull. Bauer's painting shows the red spot on the yellow bill extending into the upper mandible, a distinguishing mark of the Yellow-legged Gull.

Whereas the Herring Gull breeds in northern Europe (with a sister species, the American Herring Gull, across the Atlantic), the range of the Yellow-legged Gull is concentrated mainly in the Mediterranean Basin and eastwards to the shores of the Black Sea, with a separate subspecies, *atlantis*, on the Azores, Madeira and the Canary Islands. At the time Bauer and Sibthorp encountered this bird, it was a coastal species, and remained so until the 1990s. Since then it has greatly expanded its breeding range inland, colonizing much of central Europe. This spread follows a longer-term substantial population increase throughout its range, due to a number of factors. These include a reduction in persecution and the taking of eggs for human consumption, the huge increase in readily available food from fisheries' discards at sea, landfill sites containing much edible waste, and the adoption of roof nesting in towns and cities.

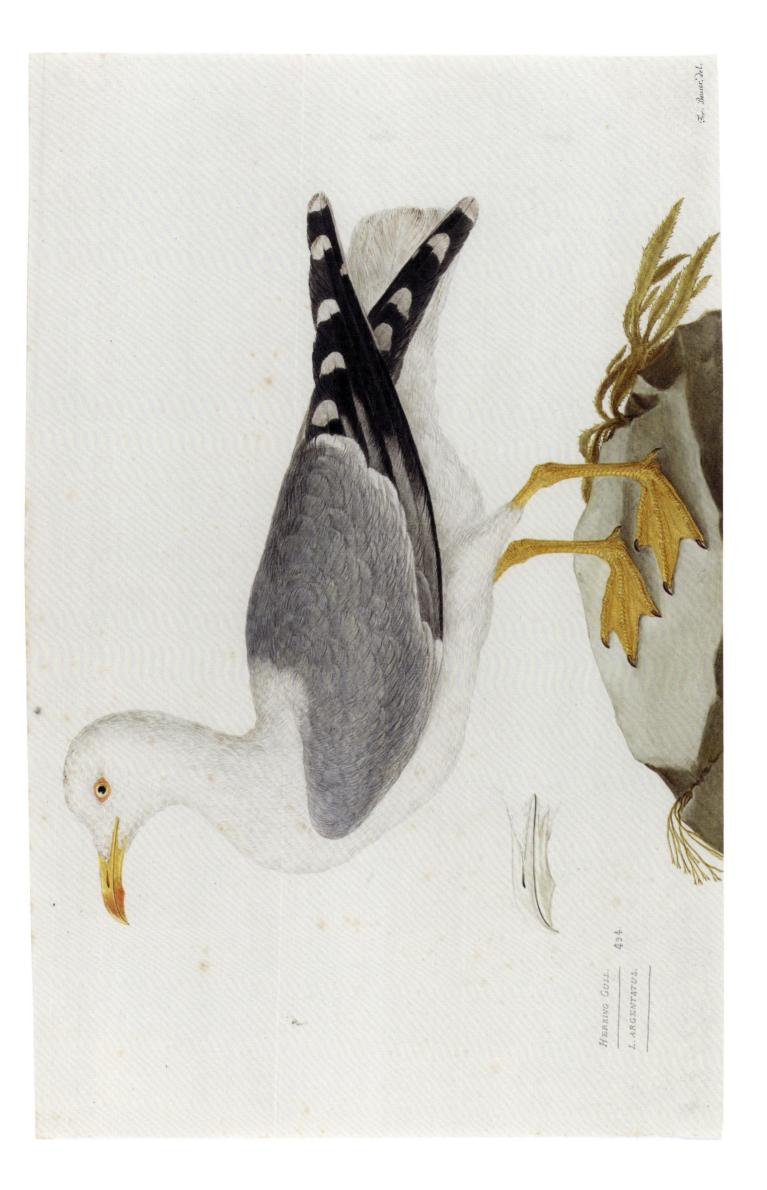

Little Owl *Athene noctua*

LITTLE OWL *NOCTUA NUDIPES*

The image created by Bauer is not a particularly good likeness of an adult Little Owl, though it could represent a fledgling of that species. As there are no surviving specimens of any of the birds shot on the expedition to examine, it is only possible to glean further evidence from Sibthorp's poor record-keeping of the identity of the bird that Bauer painted. The only other owl that looks at all similar is the far smaller (starling-sized) Eurasian Pygmy Owl, *Strix passerina*. Sibthorp wrote in his diary that 'The little owl, Strix passerina, is the most common species [of owl] in Greece, and abounds in the neighbourhood of Athens.' However, the scientific name he gives here is that Linnaeus gave to the Eurasian Pygmy Owl, which was used until 1826. But that species is a dweller in coniferous or mixed forest and has only rarely bred in Greece, whereas the Little Owl is indeed an abundant breeder.

Sibthorp's observation that 'The little owl, though a nocturnal bird, flies frequently by day among the rocks' is also accurate, and it is a frequent experience where this diminutive owl is common to encounter one in daylight, as it perches completely exposed on a tree branch, telegraph pole, wall or the roof of a building, in contrast to other owls. At such times, this squat, thrush-sized owl can have a very comical appearance, as its angled, white eyebrows (not at all apparent on Bauer's painting) give it a severe, frowning expression, made all the more amusing as it bobs its whole body up and down.

The genus name *Athene* refers to the Greek goddess Athena, patron of the city of Athens, for whom the Little Owl was a sacred bird and an embodiment of wisdom. This is an example of a positive view of owls in contrast to their many traditional associations with witchcraft, evil and death. The specific name is from the Latin word for night.

Little Owls do much of their hunting at dawn, and then again from dusk until midnight, although they will also hunt in daylight when they have hungry chicks to satisfy. They take a wide range of prey, including mammals, especially mice, voles and shrews, but sometimes as large as rats or young rabbits; and, less commonly, small lizards, frogs and small birds. But their main prey, constituting up to 90 per cent of diet by number, and as much as a third by weight, are invertebrates, especially large insects, such as beetles, earwigs and crickets, and other invertebrates such as earthworms, scorpions and slugs.

The Little Owl is widespread with a range that extends from Iberia and across most of Europe, except for most of the north and parts of central Europe and Russia, and right across central and eastern Asia to the Pacific coast, as well as in much of northern Africa, including parts of the Sahara, and the Middle East. Imported birds were released in England in various places from the mid-nineteenth century onwards, but none of these introductions resulted in viable populations until the closing years of that century. By the late 1950s, much of England and parts of Wales had been colonized. Recently, there have been marked declines.

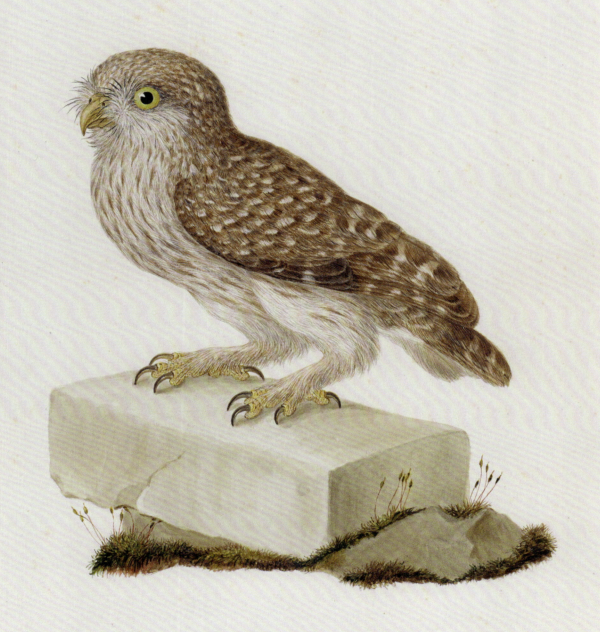

LITTLE OWL.
NOCTUA NUDIPES.

Eurasian Scops Owl *Otus scops*

SCOPS OWL *SCOPS ALDROVANDI*

This exquisitely plumaged little owl, distinctly smaller even than the species called the Little Owl, *Athene noctua* (see p. 118), is one that Bauer and Sibthorp are likely to have encountered at many places on their travels, as its range includes Italy, Greece, Cyprus and Turkey. It is strictly nocturnal and usually very hard to detect by day when roosting in a tree close to the trunk or a branch, not emerging until after dusk to hunt for insects and other invertebrates. Its intricately mottled, streaked and barred greyish-brown plumage provides it with superb camouflage against the similarly patterned, often lichen-covered bark. It is easily mistaken for the end of a small branch. By contrast, it becomes impossible to ignore at night in spring and summer when rival males utter penetrating calls to advertise their presence and pairs duet with one another. These short, mellow whistling sounds are uttered with remarkable precision every two to four seconds, sometimes for hours on end. This sound, reminiscent of the BBC radio time signal (the 'Pips'), is penetrating and far-carrying, being often audible for up to a kilometre. Bauer and Sibthorp would likely have been kept awake by this owl, just as campsite holidaymakers are today, although their strenuous exertions may have helped them fall asleep before long.

The owl's posture in Bauer's portrait is not its typical one, perched upright, and he has made the top of the head look like a rounded cap rather than a flat crown with a bump on either side formed by the retracted ear-tufts. He has conveyed the appearance of the intricately streaked, barred and vermiculated cryptic plumage with his customary skill, although he has not shown one of its distinctive features: the row of white or buff spots formed by the fringes of the 'shoulder' feathers that combine to give the appearance of a pair of braces. Also, the eyes should be bright yellow, although rarely individuals have been seen with duller, greenish eyes as Bauer has shown here. The pattern of the plumage varies little across the species' range, which extends from the Iberian Peninsula and parts of North Africa across southern Europe and beyond to Turkey and Central Asia and as far east as the Lake Baikal region of southern Siberia. As with many other species of owl, the colour does vary, from brownish-grey to warm brown.

Like more than 40 per cent of the world's 250 or so owl species, the Scops Owl has ear tufts on its head. Despite their name, these feather tufts have nothing to do with hearing, being used in various displays. In Scops Owls, they appear when the bird is relaxed like small bumps at the corners of the crown. When disturbed, they are erected by muscles into longer, ear-like tufts as the owl sleeks its plumage and adopts a thin, bolt upright stance as it remains motionless to avoid detection.

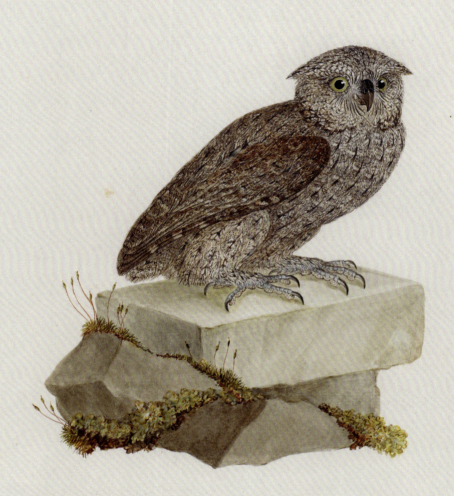

Scops Owl.
41.
Scops Aldrovandi.

Fer. Bauer. del.

Egyptian Vulture *Neophron percnopterus*

EGYPTIAN VULTURE *NEOPHRON PERCNOPTERUS*

This bird is by far the smallest of the four vulture species that breed in Europe. That said, it is still a big bird, roughly the size of an Osprey or a Red Kite, and with a 1.5–1.7 metre (5–5.6 ft) wingspan. When perched on a crag or seen on the ground, adults are easy to distinguish, as they appear almost entirely white, with just a patch of black in the closed wing and a black tail. The nape and lower neck are adorned with a mane of long, lance-shaped feathers. The white is often sullied with brownish or reddish staining from the soil. Also distinctive is the bright canary yellow bill with a black tip and an area of wrinkled naked yellow skin extending around the eye. Seen from below as one soars overhead, the black flight feathers contrast dramatically with the white of the rest of the wing and the relatively short wedge-shaped tail. At greater heights, they can be mistaken for White Storks and White Pelicans, which both share a similar wing pattern.

Sibthorp refers in his diary to having encountered this species 'near Liacoura', referring to it by its most common Greek name, Asproparos (also spelled Aspoparis). Its current English name refers to the bird's cultural importance to the Ancient Egyptians. Unlike the Griffon Vulture (see p. 126) it did not feature in their mythology but it was protected by law (hence its old name of Pharaoh's Chicken) and represented as a hieroglyph. Liacoura (now Liakoura) is, at 2,457 m (8,061 ft), the highest of the peaks of Mount Parnassus (or Parnassos), in central Greece. The handwritten comment beneath the species names on the watercolour, reading 'Bill too short and thick', is correct. It should be distinctly longer and more slender.

The Egyptian Vulture is strongly associated with humans, and will eat an astonishing range of waste at abattoirs, rubbish tips and middens, including meat, fish, eggs, rotting fruit and vegetables – and faeces, both human and from animals, especially carnivores. It is also one of the few birds known to use a tool to obtain food, picking up a stone in its bill and throwing it at an egg to break it. This occurs in Africa, where it is used with great success to break into Ostrich eggs.

Unfortunately, while the fortunes of the three other European vulture species (Bearded Vulture, Griffon Vulture and Cinereous Vulture) have improved in recent years, this is a bird facing a grim future. It has declined throughout its global range, which as well as southern Europe includes parts of Africa, Arabia, Turkey, south-west and central Asia and the Indian subcontinent. Only about 1,500 pairs are left in Europe, with about 80 per cent in Spain and Portugal. The picture is especially grim in Italy, where only thirteen or so pairs survive, and in Greece, where there are only five documented pairs.

Major threats include collisions with electricity cables causing electrocution; changes in agriculture and hygiene that deprive the birds of carrion; and poisoning, both deliberate and accidental from pesticides and lead shot in carcasses. Also, most of the European breeders migrate to Africa for winter, and they face illegal shooting on their long journeys.

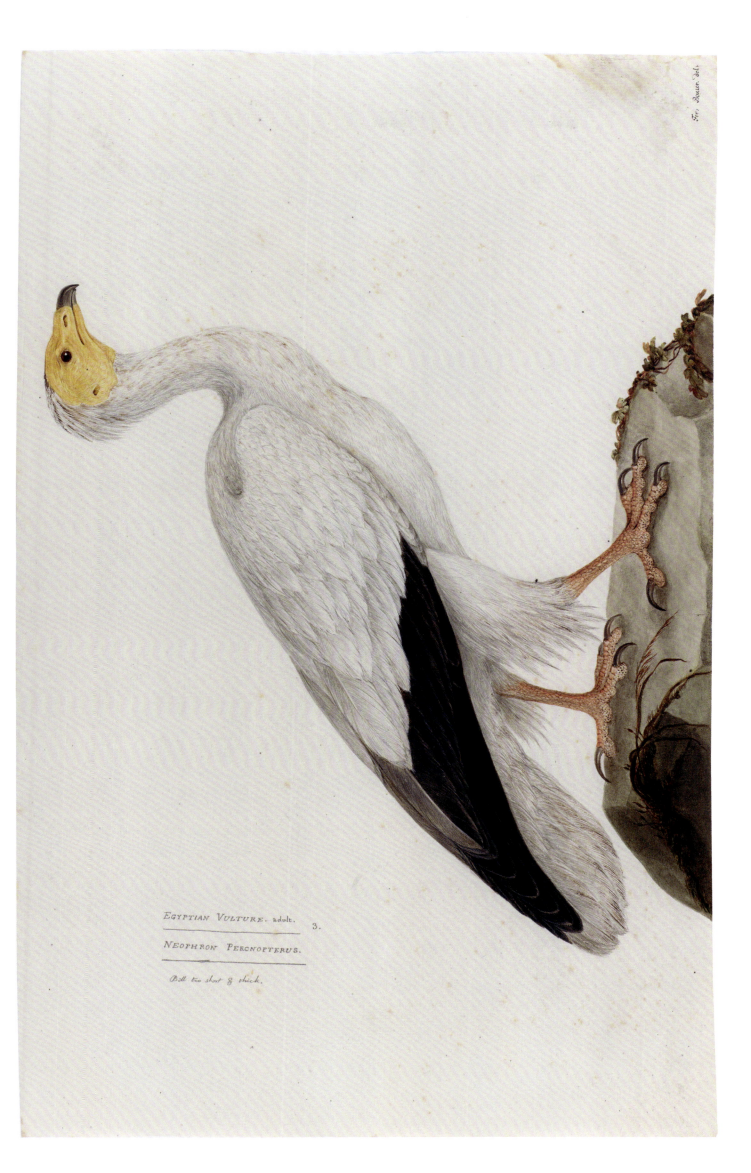

Common Buzzard *Buteo buteo*

Short-toed Eagle *Circætus brachydactylus*

This is one of the most puzzling of all the bird plates Bauer produced for the proposed *Fauna Graeca*. Although the annotation indicates that it portrays a young Short-toed Eagle, *Circaetus gallicus*, it bears no resemblance whatsoever to that raptor. Although somewhat variable in plumage between individuals, with a few paler or darker, it is very distinctive, with a clearly defined dark grey head and breast and pale, almost white, underparts bearing rows of dark spots across the belly. Juveniles are very similar to adults. Although smaller than many eagles, they are still distinctly larger and longer-winged compared to buzzards, and have a short neck with a wide head, giving them an almost owl-like appearance. Clearly this is nothing like the plumage of the bird in Bauer's dramatic painting, which does however look like that of a juvenile Common Buzzard. Also, the Short-toed Eagle has a very different tail pattern, with just three dark bars (and in some birds a trace of a fourth), in contrast to Bauer's bird, with six or more bars visible. This accords with the pattern in the juvenile Common Buzzard, even though that species is very variable, from pale individuals to almost black ones and intermediates in between. Another difference from the Short-toed Eagle is that the Common Buzzard has 'trousers', elongated feathers covering the upper part of the unfeathered legs, well shown in Bauer's painting; these are lacking in the eagle.

Perhaps the most likely reason for this apparent misidentification was due to the failure of Sibthorp to organize or care for the collection of skins of birds they shot – or to keep regular and reliable written records of their identity or where they were obtained. This was true even for the labelling of his botanical specimens, and it is even more likely to be the case with the zoological ones. It is also important to note that none of the many bird skins, preserved fish, reptiles or other zoological specimens collected on the Levant expedition has survived. This loss makes Ferdinand's outstanding collection of paintings of even greater importance, since this visual trove provides the only reliable record of the animal life encountered in the region at that time.

Whatever the cause, it is still surprising that the ornithologists tasked with adding the names of the birds to Bauer's paintings got this identification so wrong. Common Buzzards were among the best known of all raptors, widespread across western Europe from Britain and Iberia east to the Balkans. Persecuted for centuries by gamekeepers and landowners, they later faced further threats from the introduction of myxomatosis, and more recently RHD (rabbit haemorrhagic disease), which caused a dearth of their major prey. Nevertheless, the species has greatly expanded its range since it received legal protection from persecution and it has been able to adapt its diet to include more voles and other mammals. Nowadays this handsome bird is our commonest bird of prey, having replaced the Common Kestrel in top spot since that much-admired member of the falcon family has recently suffered steep declines.

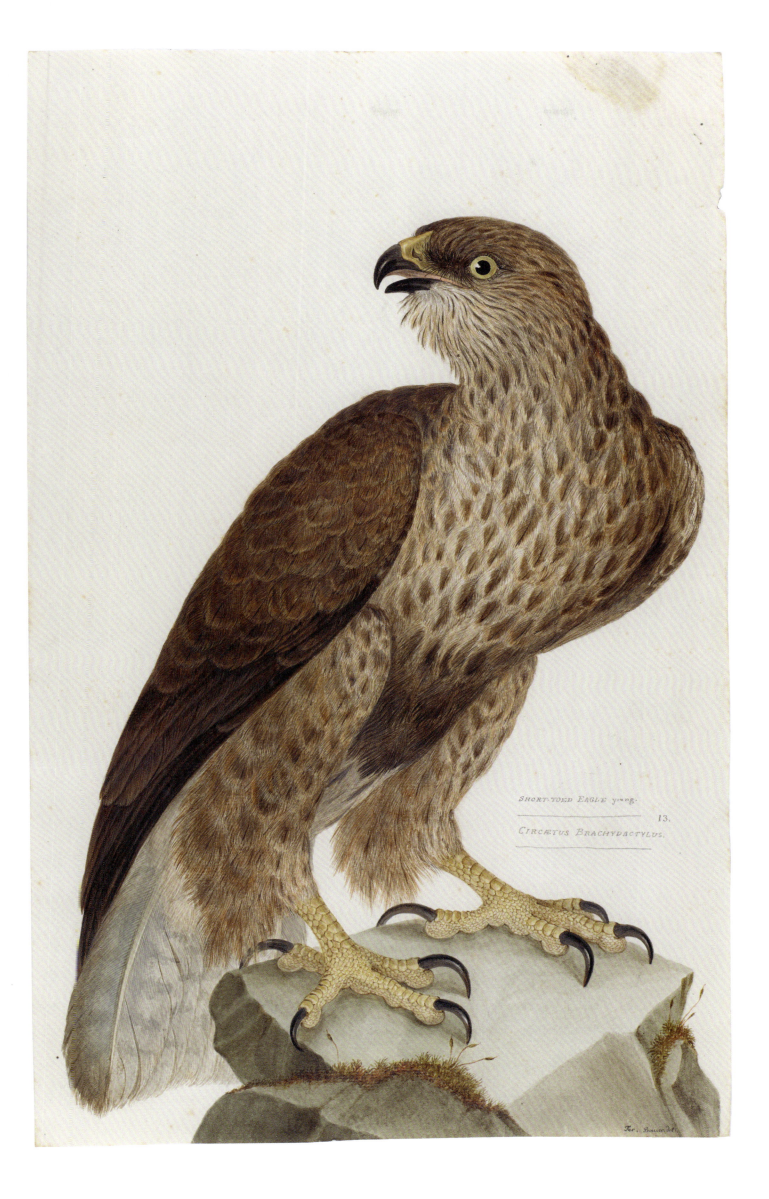

Griffon Vulture *Gyps fulvus*

GRIFFON VULTURE *VULTUR FULVUS*

Of the four species of vulture that breed in Europe, this is one of three huge species, the other two being the slightly bigger Eurasian Black (or Cinereous) Vulture, *Aegypius monachus*, and Bearded Vulture (formerly known as the Lammergeier), *Gypaetus barbatus*. The fourth species is the much smaller Egyptian Vulture, *Neophron percnopterus* (see p. 122). The individual Griffon Vulture that Bauer painted was not shot but kept in captivity, most likely after having been taken from a nest. Sibthorp was keen for Bauer to paint such striking or unusual animals, and also persuaded local people to obtain them in exchange for money. He recorded that this impressive bird measured approximately 3 ft 9 in (1.1 m) from the tip of its deep hooked bill to the end of its tail. It is an immature bird (the bill is grey rather than yellowish as in an adult, and the ruff of feathers at the base of the neck brown rather than white).

Vultures are beautifully adapted for their lives as some of the most accomplished gliders of all birds. Utilizing spiralling thermal air currents produced in hot climates once the sun warms the ground, they can soar to great heights and cover vast areas of land in their search for large animal carcasses, such as those of deer, horses and cattle. Amazingly, they use only a little more energy in soaring and gliding than if they were resting on the ground or perched on a tree or a cliff completely inactive. If they had to travel by flapping flight, they might use as much as thirty times more energy. These are huge birds, measuring a metre or slightly more in length from bill tip to tail tip. Their great broad wings, spanning up to 2.7 metres and ending in long, upwardly tilted feathers, generate maximum lift, enabling them to sail through the air with minimal effort. Far from being a drawback, their considerable weight of up to 11 kilograms acts to help them glide faster (like ballast in gliders) and so travel more efficiently. They are constantly scanning the terrain below, as well as keeping an eye on any others nearby. As soon as one bird spots a carcass, they descend fast and the corpse is soon covered with a mass of jostling birds.

These are by far the most numerous of the four European vulture species, with some 35,000–43,000 breeding pairs. About 90 per cent of that total are in Spain. Other areas that have seen moderate increases include southern France, Italy and, in Greece, Crete and the Cyclades. Much of this success is due to captive breeding and reintroduction programmes, coupled with education altering public opinion and the establishment of viewing sites at 'vulture restaurants', where the great birds can feed safely on healthy carcasses. Nevertheless, all vultures worldwide still face many threats, from eating carcasses laced with poison, either deliberately or accidentally; being electrocuted when they hit overhead power lines or killed by striking wind turbines; starvation resulting from hygiene regulations clearing away carcasses; and the major problem of poisoning by diclofenac and other non-steroidal anti-inflammatory drugs used to treat livestock.

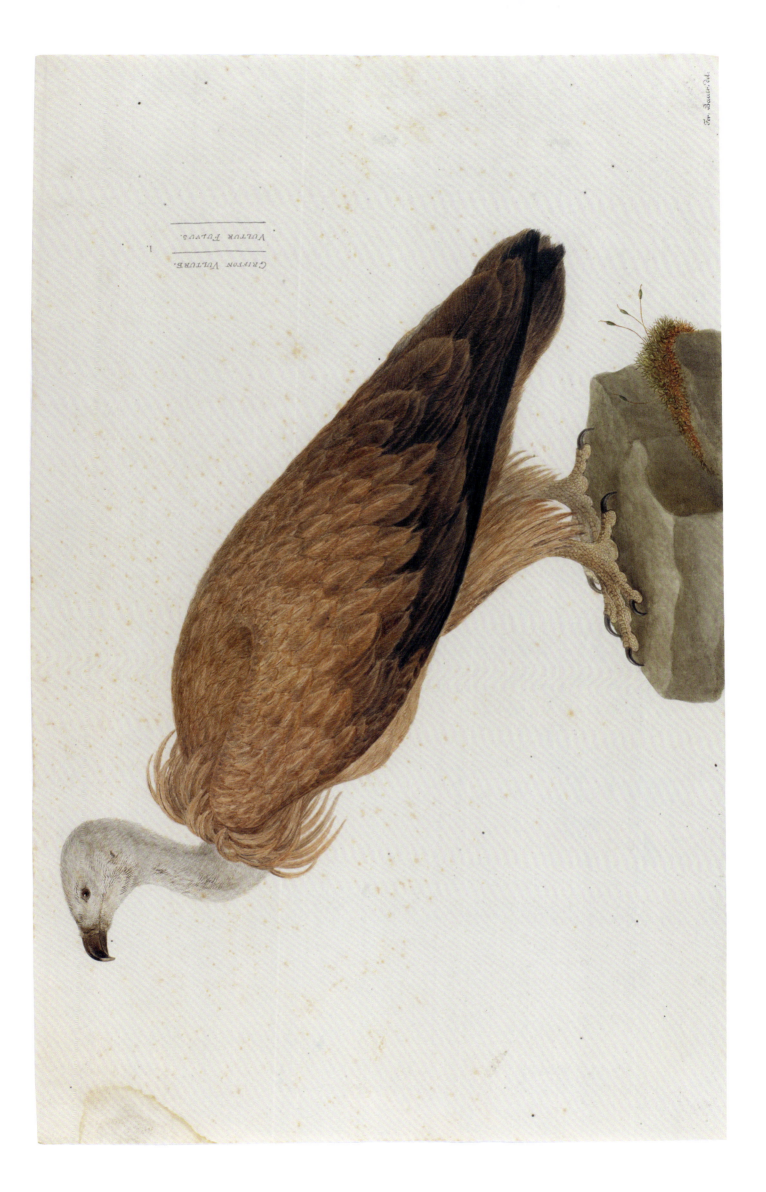

Western Marsh Harrier *Circus aeruginosus*

MARSH HARRIER *CIRCUS RUFUS*

This is one of the biggest of all harriers, a distinctive genus of sixteen species of medium-sized birds of prey with a global distribution apart from the polar regions. All have long wings and tails that are adapted for slow flying in search of prey (see Hen Harrier, *Circus cyaneus*, p. 130). Sibthorp noted in his diary for 19 November 1794, as the travellers rode along the plain near the town of Livadeia, in central Greece, that as they passed the marsh around Lake Copais they saw 'the Moor Buzzard ... pursuing the Scolopax [Woodcock], and other Grallae [an old grouping that included the waders]'. Moor Buzzard was at the time the 'official' name for the Marsh Harrier, with the 'moor' not having the same meaning as today, but being an alternative word for 'marsh', as in the still-used name of the Moorhen, *Gallinula chloropus*. Another old name is Bald Buzzard, but confusingly that name was sometimes also used for that unique raptor the Osprey, *Pandion haliaetus*, including by Sibthorp. The specific name *aeruginosus*, the Latin word for 'rusty', alludes to the colour of the male's body. The bird Bauer has painted is a female, distinguished from a male by her dark brown body and the lack of grey feathers in her wings and tail. Females are on average much larger and heavier than males.

Whereas all their relatives such as eagles and hawks normally nest in trees, cliffs or other above-ground sites, all but one species of harrier (an Australian and east Indonesian species that habitually nests in trees) almost always build their nests on the ground or among reeds or other aquatic vegetation. This probably evolved due to living in treeless habitats that provide the small mammals and aquatic birds that they specialize in catching. Unlike most other birds of prey, which are fiercely territorial, they may nest in loose association, and after breeding often roost together on the ground. Another distinctive behaviour is the aerial food pass. A spectacular sight for those lucky enough to witness it, this occurs during the period when the female is incubating eggs or caring for young and the male provisions her and their offspring. The female flies up below her mate as he arrives with prey in his talons and then with perfect coordination he drops it for her to stretch out her feet to receive it.

Western Marsh Harriers breed right across Europe and in Asia as far east as Mongolia. Most European populations migrate south to winter in Africa, although those in Britain, south-west Europe and the Mediterranean are mainly resident. At the time of Sibthorp and Bauer's trip, this impressive bird was generally flourishing across Europe, including Britain and Ireland, and it was a common bird in large areas of fen and marsh such as the Norfolk Broads and much of Ireland. But soon increased drainage and persecution by gamekeepers and egg and skin collectors began to take their toll. By the end of the nineteenth century it was effectively extinct in Britain and Ireland and had disappeared from much of western and central Europe. Recovery started in the 1980s and has been impressive in some places, including Britain.

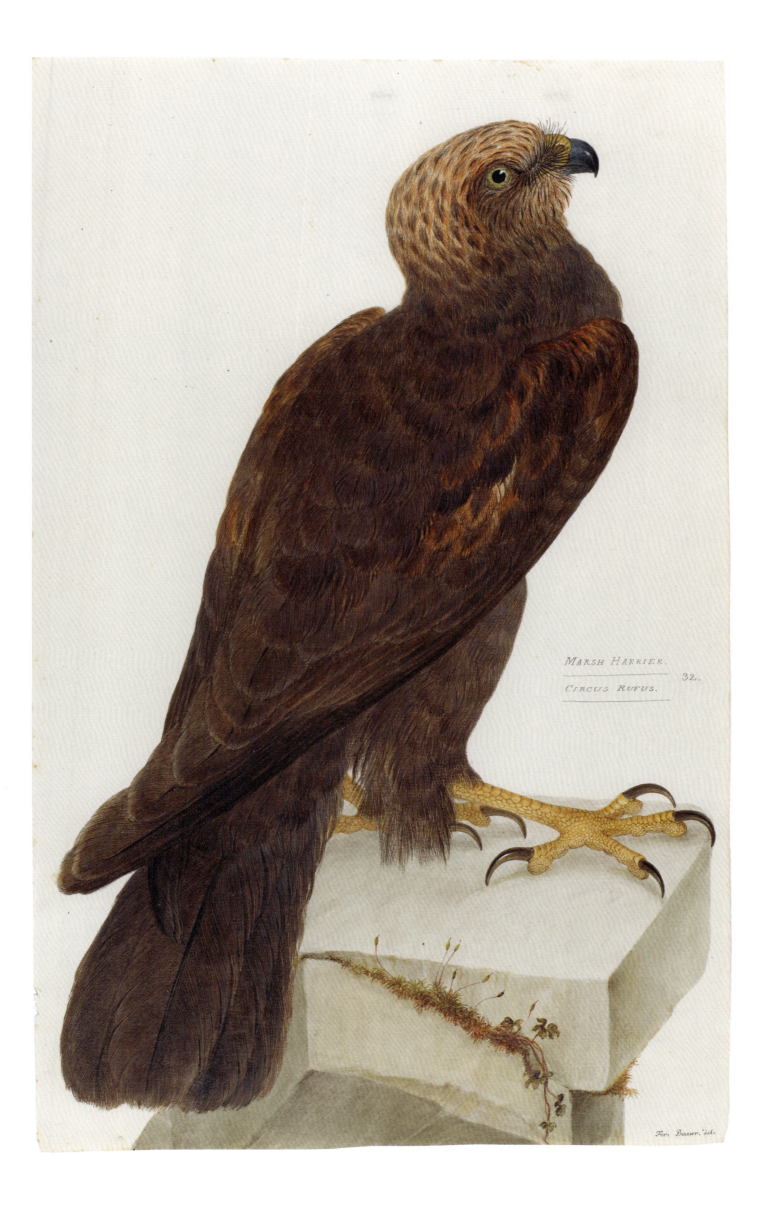

MARSH HARRIER. 32.
CIRCUS RUFUS.

Hen Harrier *Circus cyaneus*

The name of the harrier genus, *Circus*, is derived from the Greek *Kirkos* for a quasi-mythical hawk said to fly in circles (the word also means a circle). In fact, when hunting, which they spend much of the day doing, they typically follow a basically straight course up and down a regular beat, often above a hedgerow or ditch, where small mammals, birds or amphibians are more likely to be found. Hen Harriers may fly more than 100 km each day in search of food. Harriers hunt in a manner more akin to open-country owls, such as Short-eared Owls, *Asio flammeus*, than to other birds of prey, having evolved highly sophisticated aerodynamics. They are notable for their light 'wing loading' – the relationship between a bird's weight and its total wing area. This enables them to float along low over the ground for long periods, alternating gliding, holding their wings in a shallow but distinct V, with a few wingbeats, expending little energy. This allows them to fly slowly, and their long tails are used to help them as they make controlled stalls and sudden twists and turns when necessary to secure prey. They may also slow down their progress to maximize the chance of detecting prey by flying into the wind.

Another resemblance harriers show to owls is in having prominent 'facial discs' of short, stiff, probably movable feathers that act like reflectors to concentrate the slightest sound made by prey they cannot see in long grass or other vegetation into the large ear openings hidden beneath their plumage. They have lightning-quick reactions once they have located prey and can strike far as well as fast, with their long legs. Hen Harriers specialize in catching voles, although the range of prey recorded is wide, including other rodents, songbirds, wader and gamebird chicks by the males and also rabbits and young hares by the larger females. They occur in various open habitats, from grasslands, moorlands and peatlands to cultivated farmland, breeding in western and eastern Europe across to the far east of Asia. Eastern populations migrate south for winter.

Male Hen Harriers have beautiful pale blue-grey plumage, paler below and set off by a pure white rump and black wingtips. The larger females are dark brown above and pale buff below with brown streaks. Females and young of both sexes are known as 'ringtails' from their white rumps and banded tails. The note on Bauer's painting states that it is a young bird. Although the features that distinguish one from an adult female are subtle, the pale tips of some feathers of the greater coverts do suggest this is correct. The head looks disproportionately large and the facial ruff is not apparent; perhaps he painted this specimen from a badly prepared skin or from a hasty drawing in the field? Males do not acquire their beautiful plumage until they reach two to three years of age. Their chances of doing so are poor in much of the UK, especially in England, as they are still illegally shot, trapped or poisoned on grouse moors, to the extent that virtually none are able to breed there.

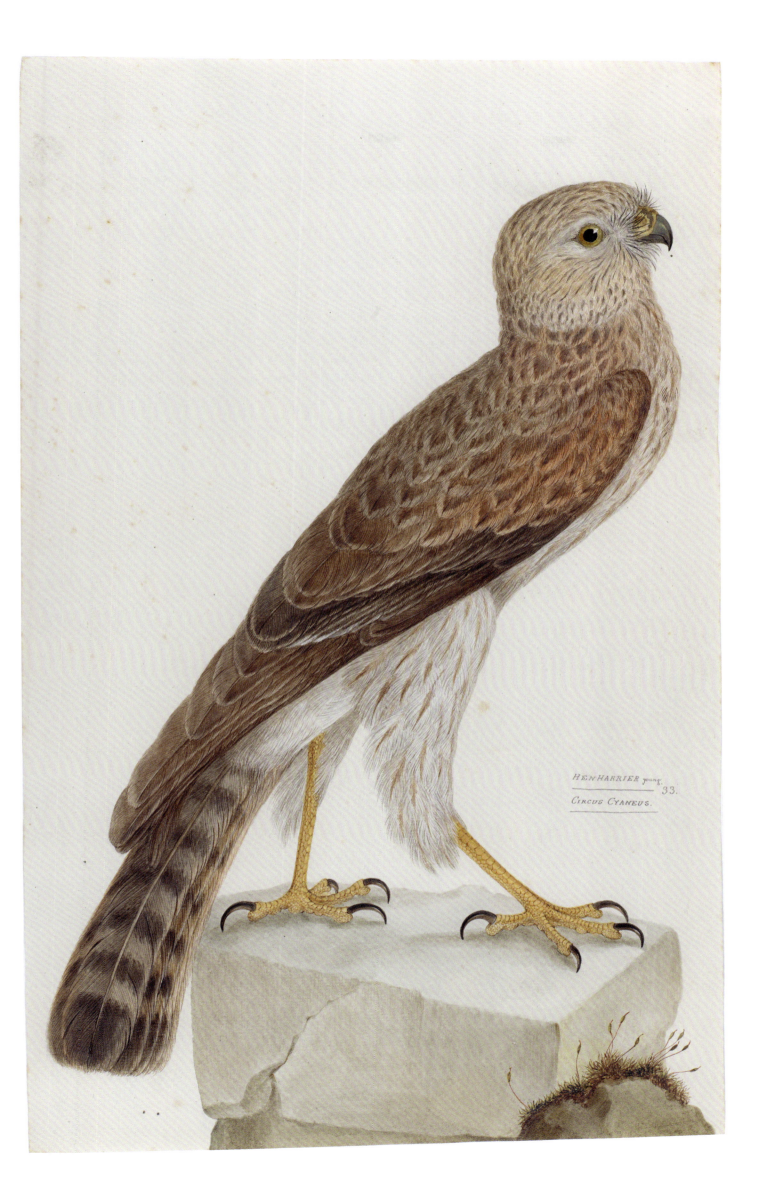

HEN HARRIER young. 33.
CIRCUS CYANEUS.

Hoopoe *Upupa epops*

Bauer and Sibthorp are likely to have seen this very easily identified, strikingly plumaged bird frequently on their travels. In his diaries, Sibthorp mentions seeing a migrant of this species on Heybeliada, one of the Kizil Adalar (Princes' Islands) just south of Istanbul in the Sea of Marmara. Travellers to the Mediterranean still often delight in an encounter with the Hoopoe. Even those who have not noticed one are likely to have heard its distinctive, far-carrying call, a repeated, soft, mellow *poop–poop–poop* resembling the sound of someone blowing across the top of a bottle. It is from this delightful aural backdrop to hot summer days that the bird acquired its common and scientific genus names.

This slim-bodied bird can be surprisingly difficult to spot on the ground, as its pinkish buff plumage blends into the surroundings and its black-and-white wing pattern acts as a disruptive camouflage by breaking up its outline. But when it takes to the air, it is startingly obvious. Floating and bounding on its broad, rounded, boldly patterned wings, it resembles a giant butterfly. The crest is not very noticeable much of the time, as it lies flat along the top of the head, when it gives the bird a curious hammer-head shape in profile. When fully unfurled, however – as in courtship or disputes with rivals, or momentarily as a flying bird alights – it is unmissable, looking like a Mohican haircut.

The global range of this lovely bird extends from the Canary Islands to the far east of China, and from France, Germany, Poland and southern Russia to much of Africa and southern Asia. It has declined in Europe in recent years, due mainly to agricultural intensification. Populations breeding in Europe and most of Asia are summer visitors, migrating south to Africa and southern Asia. Those in south-west Spain and Portugal, Africa and southern Asia are resident all year. Each year, as they return in spring to Europe from their winter quarters, up to a hundred or more Hoopoes overshoot their destination and end up in Britain or Ireland; some have even bred here.

The Hoopoe was important to the Ancient Greeks, who referred to it as *epops*. It plays an important part in their mythology, featuring in the gruesome story of Tereus, King of Thrace, whose wife Prokne and her sister Philomela kill Tereus and Prokne's son Itys in revenge for Tereus raping Philomela, and cook his flesh to serve as a meal for the unsuspecting Tereus. When Prokne answers her husband's question as to where Itys was, he attacks the sisters, but the gods intervene and turn all three into birds: Prokne, the swallow; Philomela, the nightingale; and Tereus, the hoopoe, who incessantly cries *Pou, pou, pou*, Greek for 'Where?, where?, where?' Tereus also appears in a far more light-hearted guise in Aristophanes' famous political satire *The Birds*, in which he was once human and thus is able to understand both men and birds; he also taught the birds to speak.

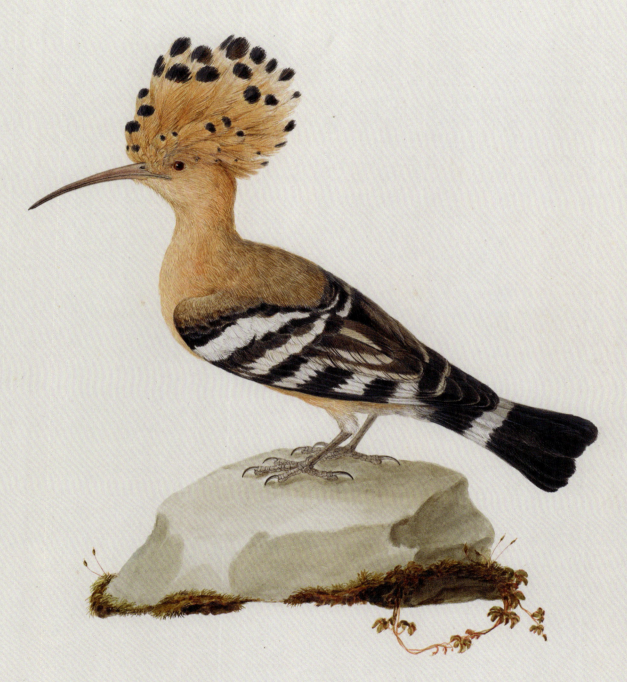

HOOPOE.
238.
UPUPA EPOPS.

European Bee-eater *Merops apiaster*

COMMON BEE-EATER *MEROPS APIASTER*

With its harlequin coloured plumage, this is one of Europe's most tropical-looking birds, along with the European Roller (see p. 136), the Common Kingfisher, *Alcedo atthis*, and Golden Oriole, *Oriolus oriolus* (see p. 148). As well as being so splendidly colourful, Bee-eaters have a graceful shape, being about the same length as a Blackbird, *Turdus merula*, but with a far more slender body and a long slightly decurved bill balanced by a long tail, made slightly longer by ending in a slender spike formed by the two middle projecting feathers. Males and females are similar, juveniles of both sexes rather less colourful. Their beauty has contributed to European Bee-eaters being depicted on the postage stamps of eighteen nations. It is no hyperbole that the common name of the Australian species, *Merops ornatus*, is Rainbow Bee-eater, or simply Rainbow Bird.

Bee-eaters are highly aerial. Approaching flocks are often heard before being seen (even when flying high, as they do on migration) with their distinctive and far-carrying contact calls creating a delightful, liquid, rippling sound. They have a characteristic flight action when chasing insects, ascending rapidly with bursts of rapid beats of their long, stiff wings, then stalling before making a slow, curving glide. They make a memorable spectacle for an observer as a flock fills the air, rising and falling in all directions, calling all the while. They also make use of bare tree branches and overhead wires as lookout perches from which to spot prey and then launch an attack. Bee-eaters target a wide range of aerial insect prey, from flies, wasps and bees to locusts, large beetles, dragonflies and butterflies. However, where they are available, honey bees make up the bulk of their prey, making them very unpopular with beekeepers. During the visit to Cyprus, Sibthorp records that the 'bee-bird' was not uncommon. And in another reference to the Bee-eater in his diary he states that 'The Merops invited by the bee-hives of Hymettus appears about Athens, at the latter end of summer.' Bee-eaters are highly sociable birds, not only when feeding, but on migration too, and they also breed colonially. Small groups of up to eight pairs excavate burrows up to 2 metres long in banks of hard sand, dry clay or soft sandstone, and also in level ground.

This is the only European member of a family of twenty-seven species found throughout the warmer parts of the Old World, mostly in Africa and Asia. It breeds across a huge range in Eurasia, from Portugal, Spain and north-west Africa in the west to the western edge of China in the east. Almost all migrate to winter in Africa. There is also a small isolated population in South Africa, which migrates north and south within Africa. Most probably due to climate change, this bee-eater is expanding its range northwards, especially in regions with a primarily continental rather than an oceanic climate, such as Germany, where it first bred in the early 1990s but now already boasts about 2,500 pairs.

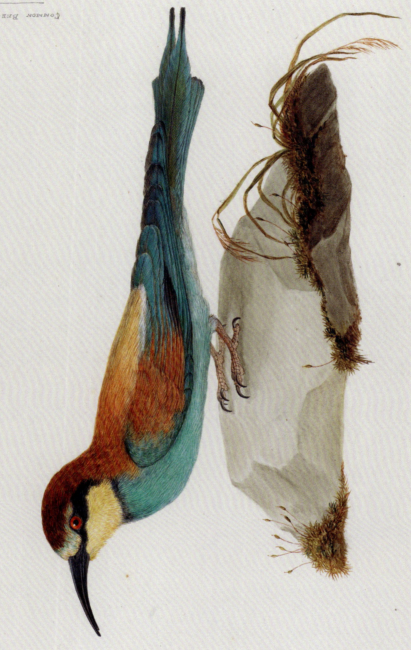

COMMON BEE-EATER.
MEROPS APIASTER.
59.

European Roller *Coracias garrulus*

Roller *Coracias garrulus*

This is the only European member of the small roller family (Coraciidae), whose thirteen species are spread across Europe, Asia, Africa (which contains most species), Madagascar and Comoros Islands. It is a summer visitor that is restricted to dry, warm, open country, with most European populations in the south, from the Iberian Peninsula and north-west Africa across the Mediterranean to as far east as south-west Siberia and western China. Small populations breed in eastern Europe, in Poland, the Baltic republics and Belarus, but these have declined, and some, such as those in Denmark, have disappeared.

Although rollers are not related to the corvids (crows and relatives), they have some features in common, including their harsh, guttural calls. In shape and size the European Roller is similar to a Jackdaw, *Corvus monedula*, but with a large head bearing a distinctly longer and more hook-tipped bill. In its buoyant flight, its broader, longer, more angled wings appear disproportionately large compared to its smaller, slimmer body and it has a narrow tail. The gorgeous blue, purple and chestnut plumage make it among the most colourful of all European birds. Like peacocks, kingfishers, parrots, hummingbirds and other brilliantly plumaged birds, European Rollers have for centuries provided splendid and challenging subjects for painters to portray. Many Renaissance paintings feature them, including the portrait of a detached European Roller's wing painted in 1512 by Albrecht Dürer.

The name 'roller' refers to the dramatic territorial display flight, with which a male challenges a rival. He suddenly shoots upwards almost vertically, beating his wings deeply, then almost stalls momentarily before tumbling over and hurtling down, flapping his wings strongly and tilting his body from side to side in a manner similar to the courtship display flight of a Lapwing, *Vanellus vanellus*, or the aerobatics of the domesticated breed of pigeons known as tumblers. As he performs these remarkable manoeuvres, the European Roller utters a crescendo of loud rattling sounds lasting a few seconds.

In its hunting behaviour, the Roller resembles a greatly oversized shrike, as it perches on an overhead wire to scan for prey below. Rollers feed almost exclusively on insects, especially large ones, including many beetles, crickets, grasshoppers and locusts, mantises and cicadas, and also flies, butterflies and their caterpillars. European Rollers nest in holes in trees and sometimes in the walls of old buildings, or in tunnels they dig in sandy banks. If the young are threatened by a predator, they can vomit, covering themselves in acids from their grasshopper prey and thus making themselves distasteful.

Pairs at their breeding sites drive away any intruders, both others of their own kind or different birds. However, before migration, they may assemble in loose flocks to take advantage of good feeding sites or to roost together. When they are migrating, they may follow one another, well spread out, in a steady stream. All populations winter in the savannahs of southern Africa. There they may gather at bush fires to feed on the insects fleeing the flames, or to gorge on swarming termites and locusts.

ROLLER.
CORACIAS GARRULUS.

Middle Spotted Woodpecker
Dendrocoptes medius

MIDDLE SPOTTED WOODPECKER *PICUS MEDIUS*

The Middle Spotted Woodpecker is far less abundant and widespread than the most familiar European species, the Great Spotted Woodpecker (*Dendrocopos major*). Its common and specific names are misnomers, for it is not halfway in size between the latter species and the smallest European woodpecker, the sparrow-sized Lesser Spotted Woodpecker (*Dryobates minor*). Indeed, it is only a little smaller than the Great Spotted Woodpecker, though it often looks more diminutive due to its distinctly shorter, more slender bill and more rounded pale head. Another striking difference is its extensively red crown, which it raises to form a spiky crest when alarmed or in dispute with a rival. Juvenile Great Spotted Woodpeckers also have a red crown, but this has a black rim, and they have a black moustache stripe reaching the base of the bill. The latest genetic comparison indicates that it is not, as was long thought, closely related to the other European pied woodpeckers, but instead to two south Asian species.

Unlike the Great Spotted Woodpecker, which feeds at various levels of its woodland habitat, the Middle Spotted (like the Lesser Spotted) remains mainly high in the canopy, where its restless movements make it hard to see, especially during the spring to autumn periods when the foliage obscures one's view.

Unlike its other black-and-white relatives, which drum rapidly with the bill on branches or trunks to proclaim ownership of their territory and attract mates, it rarely does so, though it taps loudly when at the nest hole. Vocal communications between pairs are distinctive and varied, including a nasal miaowing sound.

The Middle Spotted Woodpecker has a scattered distribution across western Europe, and does not occur in Britain or Ireland. It is most widespread across central and south-west Europe and parts of south-west Asia. Long before embarking on the tour of the Levant with Sibthorp, Bauer would likely have known this bird from the forests around Vienna, where it still occurs. The pair would have had opportunities to encounter it at various points in their expedition. In Greece the species is widespread and generally quite common, occurring in much of the mainland and also on the bird-rich island of Lesbos, where it is the only woodpecker to breed. It also occurs in western and northern Turkey. It is a habitat specialist generally dependent on extensive tracts of old forest, especially those with a preponderance of large, mature oak trees as well as hornbeam, beech and other species. Many populations have declined as ancient oak woodlands have become scarcer.

Like other woodpeckers, the Middle Spotted feeds mainly on insects. Compared to the other species, it does not bore deeply into the wood, preferring to concentrate on those living in the bark or on the leaves, including beetles, flies, aphids, ants and caterpillars.

In spring it often feeds on rising sap by girdling tree trunks with a series of holes, and in winter, when insect food is scarcer, it also eats nuts, acorns and a variety of fruit.

MIDDLE SPOTTED WOODPECKER.
230.
PICUS MEDIUS.

Lesser Kestrel *Falco naumanni*

LESSER KESTRIL *FALCO TINNUNCULOIDES*

This accurate portrait by Bauer shows an adult male. It differs from the male Common Kestrel, *Falco tinnunculus* (see p. 142) in having a pure, unspotted bright chestnut-brown back and inner forewings, and a broad blue-grey panel on its inner hind wings; also its cheeks are plain blue-grey without the dark moustachial stripe. Females (see Bauer's painting on p. 19) and immature birds are very similar to those of their larger relative, and sometimes even experienced birders cannot distinguish them by plumage alone. As their name indicates, they are smaller than Common Kestrels, but size is notoriously difficult to judge except in the unlikely event of seeing both species close together for comparison. As well as calls resembling those of their larger relative, they do have a distinctive contact call, though, a hoarse, rasping three-note *chay–chay–chay* sound.

Sibthorp notes in his diary on 2 July 1787 that several bird species inhabited the rocks of Delphi, including 'a small species of hawk, called Kirkenasi'. This Greek name was used for both the Lesser Kestrel and the Common Kestrel, but as Sibthorp also records that 'The Falco Tinnunculus breeds here' when writing about the birds of Cyprus, it is apparent that he recognized the distinction. Furthermore, he also records observations of what are certainly Lesser Kestrels: 'The Falco Kirkenasi, half domestic, arrives early in the spring with the storks, in immense numbers, joint inhabitant with them of the houses and temples of the Athenians, and retires with these birds at the latter end of August.' This speaks to the fact that unlike their larger relatives, and indeed most unusually for any raptor, these beautiful little falcons are highly communal, breeding close together and feeding in loose groups, mainly in flight, like overgrown swallows, snapping up flying insects such as locusts, crickets, grasshoppers and beetles, especially when these swarm, attracting large numbers of the little falcons. In pre-human times, they bred on cliffs, but since buildings became available many of them found more suitable sites on old buildings and ruins, where they nest in cavities in the walls or in the spaces between roof tiles.

Lesser Kestrels are summer visitors to southern Europe, with about half of the total breeding population of about 35,000 pairs in Spain. Other strongholds are in Italy, Greece and Turkey. Smaller numbers (several thousand) also breed across central Asia and discontinuously in Mongolia and northern China. All populations of the Lesser Kestrel migrate south in autumn to winter in areas where they can continue to find sufficient insect prey in winter. Some travel only as far as Spain, Malta, North Africa and Turkey, but most cross the Mediterranean Sea and the Sahara Desert to winter widely in sub-Saharan Africa, especially in the south. Since the 1950s there have been huge declines of up to 90 per cent in both numbers and range in much of Europe. This is mainly due to the intensification of agriculture, with changes in land use and increased use of insecticides resulting in major reduction of their staple prey. Demolition and rebuilding, especially the replacement or alteration of roofs on buildings, also remove many nesting sites.

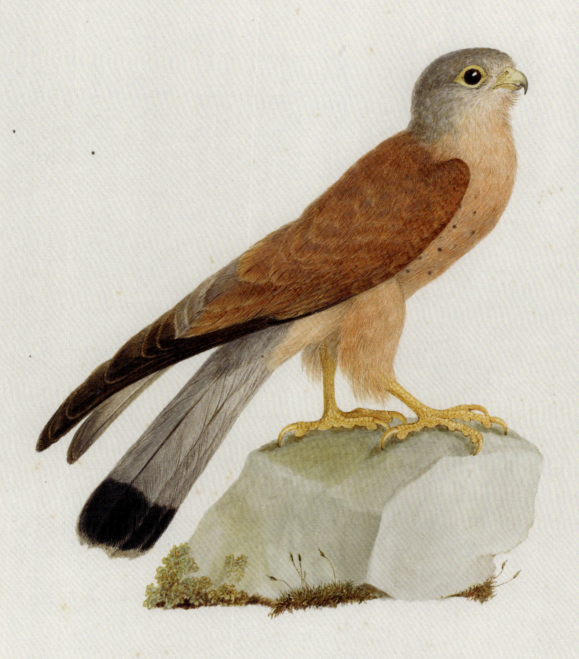

LESSER KESTRIL. male.
27.
FALCO TINNUNCULOIDES.

Common Kestrel *Falco tinnunculus*

COMMON KESTRIL *FALCO TINNUNCULUS*

This is one of those birds that most people can identify from its habit of hovering above roadside verges to spot its rodent prey. In the UK the Kestrel used to be the commonest bird of prey but the Buzzard, *Buteo buteo*, has replaced it in that top slot. The male shown here is distinguished from the female (also painted by Bauer, see p. 227) by his grey head and upper tail. Although other raptors sometimes hover, none do so as persistently or skilfully as this one. An old country name for this elegant, long-winged and long-tailed raptor is Windhover, reflecting the way in which the Kestrel saves energy by gliding into the wind while its head hardly moves, to maximize the chance of focusing on prey. In strong winds it will allow itself to be blown backwards a tiny amount while extending its neck so that its head remains in the same place, and then flaps its wings a few times, bringing its body forward so that it can glide again. This requires incredibly precise coordination.

For most populations, voles, mice and shrews constitute three-quarters or more of the biomass of prey. Other mammal prey include rats, rabbits and occasionally moles. Second in importance are usually birds, although these may sometimes make up the bulk of prey, for example on islands where rodents are scarce. Most of the birds taken are songbirds, such as pipits, larks, finches, sparrows and starlings, as well as young of larger birds, but they are capable of killing adult birds as large as ducks, gulls, small pigeons and coots. Other prey includes earthworms and big insects, especially beetles in northern Europe and crickets and grasshoppers farther south, where lizards are on the menu. Kestrels quite often steal food from other predators or scavenge from carrion, and regularly cache food to eat later, depositing it among grass tussocks, clods of earth or other memorable sites.

This is one of the best known and most studied of all the falcons and their relatives in the family Falconidae. Surprisingly, recent DNA research revealed that the falconids do not belong with all the other diurnal raptors such as eagles, buzzards and hawks, but are more closely related to parrots and songbirds. The genus name *Falco* derives from *falcis*, the genitive case of the Latin word, *falx*, for a sickle, referring to the shape of the wings. The specific name *tinnunculus*, the Latin name for the species, from *tinnulus*, shrill-sounding, was chosen for its harsh calls. The name 'Kestrel' is related to the French name for the bird, *Faucon Crécerelle*, the second word being a diminutive of *crécelle*, a rattle, and again refers to some of the Kestrel's calls.

The Kestrel has a vast range, across Eurasia and in much of Africa. There has been a long-term decline in Europe, especially in Britain and Ireland, where numbers have fallen by 44 per cent since 1970. Nesting sites include ledges on cliffs, large buildings or other structures such as pylons and bridges, hollows in trees, nest boxes, and the old nests of other birds, especially crows or other corvids.

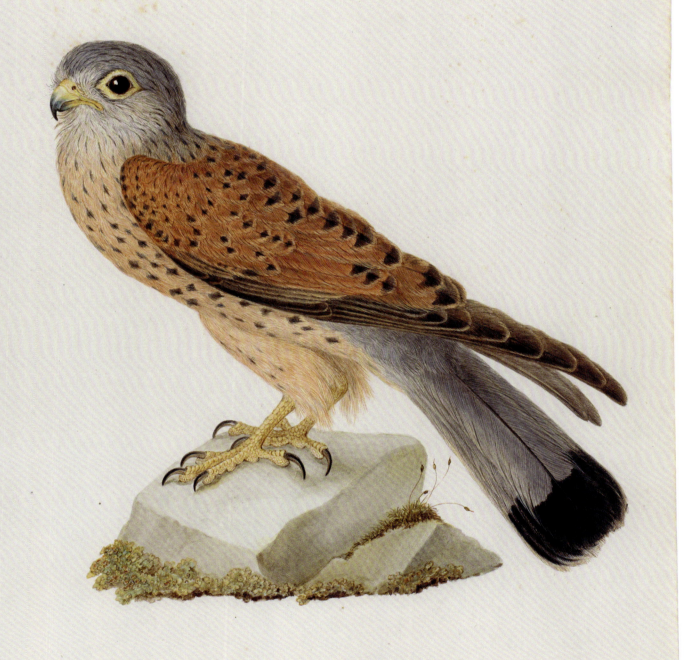

COMMON KESTRIL. male.
26.
FALCO TINNUNCULUS.

Eurasian Hobby *Falco subbuteo*

HOBBY *F. SUBBUTEO*

This elegant member of the falcon family (Falconidae) is one of the most agile and speedy of all raptors, capable of catching fast-flying swifts, swallows and martins in flight. As well as these, bird prey include other small birds, such as larks, pipits, starlings and small waders; occasionally it catches bats. Aerial insects, especially larger ones such as dragonflies, beetles, butterflies and moths, make up much of its prey.

Bauer has done full justice to this beautiful bird, depicting the details of its plumage with his usual consummate skill. One of the most distinctive features of the adult, shown well here, is the rusty red feathering of the thighs and undertail. Its graceful proportions are apparent in flight, when it appears far less stocky and full chested than the Peregrine Falcon, *Falco peregrinus* (see p. 146), although it shares the latter's anchor shape with its long scythe-shaped wings and relatively short tail, like a giant swift. When chasing a bird, a Hobby angles its wings backwards in dashing flight with powerful, stiff wingbeats alternating with short, rapid glides before seizing it in level flight. Often, it suddenly swoops down from above with wings almost closed and then suddenly turns or swoops upwards and extends its feet to snatch the victim with its talons. It usually takes bird prey to a perch to pluck and devour, but eats insects in flight, using a bicycling action to strip off the hard, indigestible chitinous exoskeleton, which falls to the ground as it transfers the soft body to its bill.

The name 'hobby' relates to the Medieval French verb *hober*, meaning 'to leap about', and reflects the bird's renowned agility. The French name to this day is *Faucon hobereau*. The specific name *subbuteo* is a Latin construction combining the elements *sub*, under, or less than, and *buteo*, a buzzard. This odd pairing was apparently due to a misunderstanding of a word used by Aristotle. There is a curious coda to this linguistic story. In 1947 a British games inventor, Peter Adolph, was looking for a catchy name for the new table-top football game he had designed. Adolph was a keen birdwatcher (and dealer in birds' eggs, illegal today) as well as a soccer fan and had chosen the name of his favourite bird of prey, the Hobby, with its punning quality, in his application for a patent. The Patents Office refused his request on the grounds that the name was far too general, so he changed it to Subbuteo, and this was accepted, with the game still being sold under that name today.

The Eurasian Hobby frequents lowland open country with scattered trees or small areas of woodland, including heaths and downs, but has adapted well to farmland and also taken advantage of conifer plantations in their early open stages. Proximity to wetlands is an advantage, as they often contain abundant swift, swallow, martin and dragonfly prey. This is a very widespread breeding bird, found across Europe and Asia to the North Pacific coast of Russia, and absent only from the treeless arid parts of central Asia.

Hobby.
22.
F. Subbuteo.

Peregrine Falcon *Falco peregrinus*

PEREGRINE FALCON

This creature of superlatives is renowned as the fastest of all animals, possibly capable of reaching speeds of up to 320 km/h (200 mph) in an often steep-angled 'stoop', as its power dive bringing death to its prey flying far below is known. This is just one of many terms that originated with the ancient practice of falconry, such as 'mantling', guarding prey from interlopers by spreading the wings over it; and 'waiting-on', the circling flight high in the air before the sudden rocketing swoop. Prey ranges from the smallest songbirds to birds as large as herons and geese, with a total of over 200 species recorded from some parts of continental Europe. Generally, though, the great majority of prey are medium-sized birds, with feral pigeons being especially important. In different habitats, the other most targeted prey include ducks (in North America the Peregrine was once known as the Duck Hawk), gamebirds, crows and other corvids, waders and seabirds, especially gulls and auks.

Bauer has, characteristically, done justice to this imposing bird in his painting of an adult. Male and female differ in only minor plumage details, but far more in bulk. A small male may weigh only 60 per cent as much as his partner. Juveniles are readily distinguished from their parents, as they have streaked rather than barred underparts (as depicted by Bauer in his painting opposite p. 1). The Peregrine is one of the most widespread of all the world's 10,000-odd bird species. Its immense range encompasses every continent except for Antarctica. Even in the latter region it breeds in the extreme south of South America, only 1,000 km from the Antarctic Peninsula, while at the other end of the world its range extends into the High Arctic tundra. Peregrines occupy a wide range of habitats, from sea coasts to mountains and semi-desert to tundra, requiring open country for hunting. Most breed on ledges on steep cliffs, though they have adapted to nesting on tall buildings, pylons, bridges and other artificial structures.

Over a couple of decades, from the 1950s to the 1970s, the Peregrine suffered huge declines, including local extinctions, as a result of breeding failure due to the effects of agricultural organochlorine pesticides used to dress seeds, such as Dieldrin and Aldrin. This not only killed many adults as they accumulated the poison from the bodies of seed-eating birds they caught, but also caused eggshell thinning, resulting in the eggs breaking when the parent birds incubated them. Fortunately, bans on the pesticides were instituted and the species made a good recovery, so that today populations in most parts of Europe have not only recovered but in many cases are probably at an all-time high, at least for as long as records of historic levels suggest. Furthermore, numbers have been swelled by city-dwelling Peregrines' enthusiasm for nesting on ledges high up on churches and other tall buildings.

Studies of prey remains at the Peregrines' nesting and roosting sites show that, as well as the rich supply of food in the form of urban pigeons, these city-dwellers catch a remarkable range of migrant birds in spring and autumn, both by day and (thanks to bright urban lighting) at night.

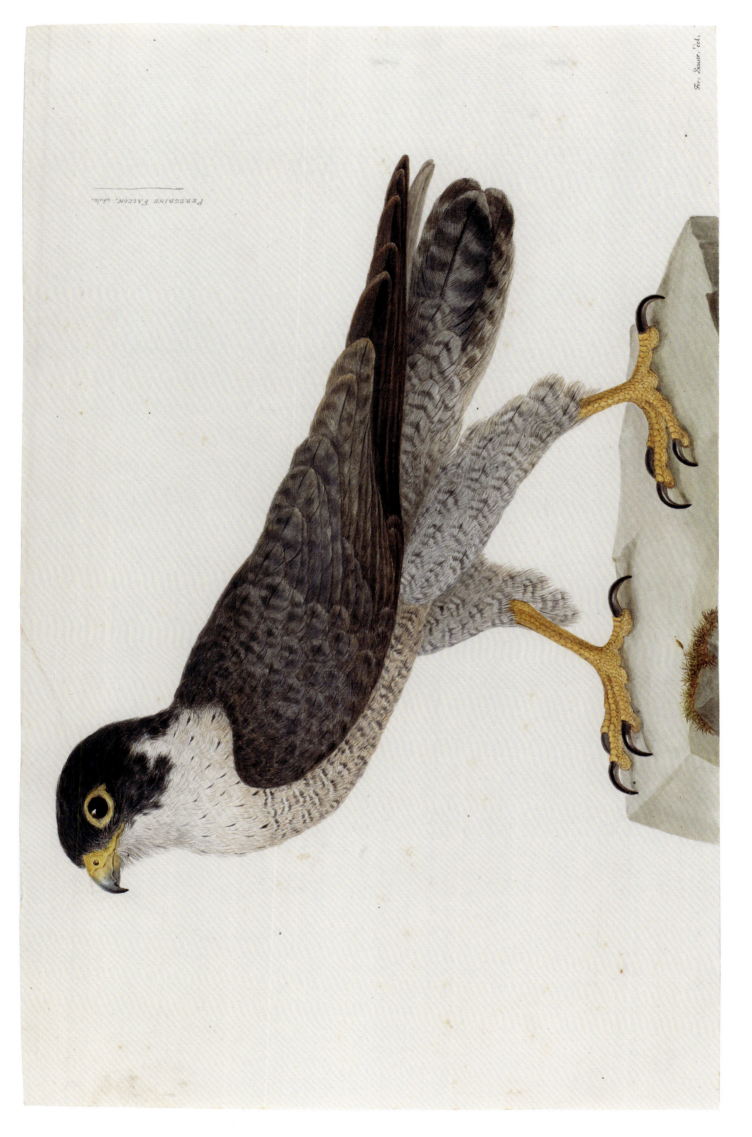

PEREGRINE FALCON, *male.*

Eurasian Golden Oriole *Oriolus oriolus*

Golden Oriole *Oriolus galbula*

This rather thrush-like songbird, about the size of a Blackbird, *Turdus merula*, but slimmer-bodied, is one of the most striking of all European species, with its bright plumage reminiscent of tropical birds. The male is especially flamboyant, with his buttercup-yellow body contrasting with jet-black wings and a black tail with yellow corners, a strong bright pinkish-red bill and grey legs. The female is yellowish green above with rather duller, brownish-black, wings and tail, but a bright yellow rump and undertail. Below, she is pale off-white, with varying amounts of yellow, marked with fine dark streaks, on her belly and flanks. Some females are much yellower and can be hard to distinguish from males.

Despite their colourful appearance, Golden Orioles are often hard to spot as they spend much of the day largely hidden from view, moving about among foliage high in the tree canopy. Here their bright plumage camouflages them against the dappled light and shade cast by the sunlight shining through the leaves. When they do show themselves, it is rarely for long, for they are restless creatures, making leaping hops or short flights through the canopy, or flying fast from tree to tree, in long, shallow undulations, ending with a distinctive upward sweep to land on a branch. This is a shy, wary bird that is often heard before it is seen. The mellow, lazy fluting *wheel-a-whee-o* song of males has something of the rich quality of Blackbird song, and, like the song of that far more familiar and approachable bird, is one of the most beautiful of all European bird sounds. Both sexes have a variety of mainly harsh calls. These include hoarse screeches, chattering sounds and caterwauling noises. The scientific name is from the Latin word *aureolus*, meaning 'golden coloured', and the English common name 'oriole' is from the similar name *oriol* in Old French.

In spring and summer, these summer visitors are mainly insectivorous, with caterpillars and beetle larvae among their favourite food. Autumn sees them gorging themselves on fruit, such as various berries and figs, which are also favoured in their African winter quarters. Their nests are shallow bowls of dry leaves, grasses and other vegetation, to which they often add pieces of paper, cloth, string or wool, binding these together with long strips of bark fibre and gluing them together with their own saliva. They are slung like miniature hammocks between the two halves of a horizontal fork in an upper branch of a tree.

The Eurasian Golden Oriole has a very wide distribution, across most of Europe, along the north-west coast of Africa and across central Asia as far east as Mongolia. All populations migrate to winter in central and southern Africa. The largest numbers in Europe are around the Mediterranean and in eastern Europe, in mature, broadleaved open woodland. Sibthorp mentions in his diary that the 'oriole' is not uncommon on Cyprus, where it still lives today. It is far scarcer in north-west Europe. It has occasionally bred in south-east England, and is a rare passage migrant, mainly in spring, to eastern and southern coasts.

Golden Oriole. male.
Oriolus Galbula.
71.

Fer. Bauer. del.

Red-Backed Shrike *Lanius collurio*

Shrikes are intriguing: although they are songbirds, like thrushes, sparrows, warblers and many others that mainly eat insects and other small invertebrates and/or seeds and fruit, they have evolved to follow a raptorial lifestyle, like miniature hawks. Their feisty fierceness is out of proportion to their size, in this species only about that of a Skylark, *Alauda arvensis*.

They typically scan their surroundings for suitable prey while perching upright motionless on a branch, post, wire or some other convenient vantage point. Once they have spotted a beetle, grasshopper, vole, small bird or other prey, they fly down swiftly to deliver the *coup de grâce*. They seize small mammals and birds on the ground, sometimes hovering briefly before striking with their hooked bill, equipped with a 'tooth-and-notch' arrangement probably capable of severing the spinal cord; this is also found in falcons. Unlike the unrelated diurnal raptors (such as hawks and eagles), though, shrikes do not use their feet to seize their prey on the ground. They do, however, use their feet when catching birds or insects in flight, as do some falcons. Aerial pursuit of prey and hovering are generally less often used as they require a lot more energy than ground capture.

Most of their local vernacular names in many languages (such as those translated as 'murderer', 'throttler' or 'destroying angel') reflect a negative image of shrikes as cruel and ruthless hunters. Bauer and Sibthorp are likely to have shared this attitude, which in some places still persists to this day. The name 'shrike' was used only by ornithologists until modern times, the old name for these birds being Butcher Birds. Its scientific name also reflects this: *Lanius*, the name for the genus to which this and all but four species of shrikes belong, is Latin for 'butcher'. This relates to their curious habit of impaling prey on thorns or barbed wire. A major function is to hold it securely while tearing up the flesh with the bill into easily swallowed, bite-sized pieces, since they lack the very strong feet that hawks and other raptors use to clamp their prey. They also store surplus prey in this way. The word 'shrike' is onomatopoeic, referring to the generally harsh calls of these birds, though they also have a quiet, sweet warbling song, often including mimicry of other small birds' calls and songs.

The male is a gorgeous sight, his plumage featuring a striking head pattern of a blue-grey crown, nape and rump above contrasting with the rich reddish brown of his back and a jet black bill and bandit mask and a white throat; the pale underparts have a delicate rose blush, and the tail is black with a narrow white border. Females and immature birds are far duller, with brown upperparts and pale underparts barred with darker crescents. When the bird is excited, its longish tail seems to take on a life of its own as it swings it from side to side, flicks it up and down, and fans it to reveal in the male flashes of white feathers.

This is by far the most abundant and widespread of the European shrikes, breeding right across Europe, though no longer in the UK.

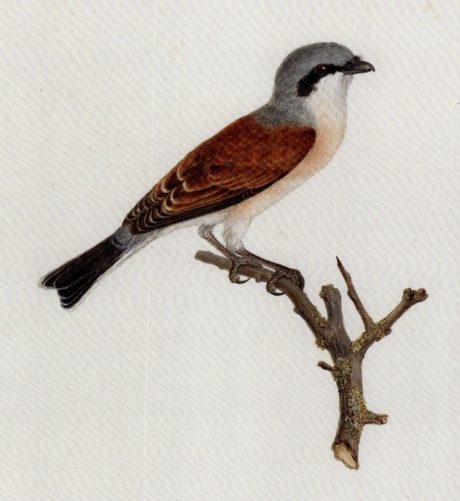

RED-BACKED SHRIKE. male.
69.
LANIUS COLLURIO.

The tail should be graduated instead of forked.

Great Grey Shrike *Lanius excubitor*

GREAT GREY SHRIKE *COLLURIO MERIDIONALIS*

At one time shrikes were regarded as diminutive birds of prey, or at least their close relatives. But despite their strong, hooked bills, predatory habits and fierce mien, they are songbirds, like warblers, finches, swallows or thrushes. DNA analysis has demonstrated that their closest relatives are the crows, jays, magpies and other corvids. As its common name suggests, this is one of the largest species in the shrike family, whose thirty-four members are found across much of the Old World and in North America. In southern Europe and Turkey the Great Grey Shrike is a winter visitor only, from its breeding range across northern and eastern Europe.

It is odd that the usually accurate Bauer has painted this and the other three species of shrikes collected on the expedition with a forked tail, rather than the graduated tail (with the central feathers longer than the outer ones) that is a feature of the family. Also, although he portrays accurately the proportionately large head, the body of this specimen looks rather too attenuated.

Like its relatives, the Great Grey spends much time upright scanning for prey from an exposed perch, such as the top of a tree, shrub or a fence post, or an overhead wire. This habit is celebrated in the specific name *excubitor*, from the Latin word for 'sentinel'.

Like its relatives, it is a formidable hunter of small mammals, birds, lizards and large insects. Usually the vertebrate prey of this species are small, such as voles and small songbirds such as tits and finches. But occasionally they include records of avian victims weighing as much as or rarely far more than the shrike itself, such as partridges and a Little Egret, and fierce mammals such as rats or stoats. Like that of the unrelated birds of prey in the falcon family, the stout, sharply hooked bill has a 'tooth' (a tomial tooth; that is, a sharp projection from the tomium, the cutting edge of the bill) near the end of the upper mandible. This fits snugly into a corresponding notch in the lower mandible as the shrike closes its bill. It works as a powerful cutting tool to dismember insects and probably also helps to sever the spinal cord of small birds or mammals. Adding to their reputation for fierceness, this and many other shrike species have a black 'bandit' mask around their eyes.

The Great Grey Shrike breeds mainly in Fennoscandia and eastern central Europe, and is only a winter visitor and migrant to Greece. A close relative, the Iberian Grey Shrike, *Lanius meridionalis*, was formerly regarded merely as a subspecies, but genetic analysis led to it being recognized as a distinct species breeding in Portugal, Spain and extreme south-east France. The two species have only minor differences in plumage, but where their range overlaps they choose different habitats and do not interbreed. Another relative, the Lesser Grey Shrike, *Lanius minor*, is more common than the Great Grey in Greece, and breeds there regularly. Sibthorp mentions it, as 'the small grey Butcher-bird', being 'one of three distinct species' of butcherbird seen frequently in the olive groves near Athens, though there is no painting of it by Bauer.

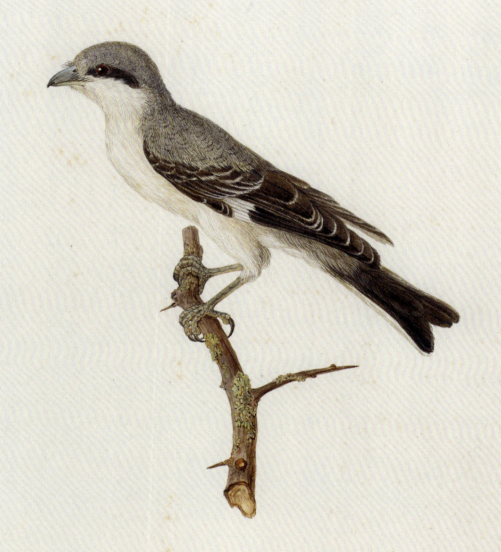

GREAT GREY SHRIKE. semi-adult.

67.

COLLURIO MERIDIONALIS.
or excubitor ?

Tail very inaccurate: should be longer, & graduated instead of forked.

Woodchat Shrike *Lanius senator*

WOODCHAT SHRIKE *LANIUS RUFUS*

Slightly bigger overall than the Red-backed Shrike, *Lanius collurio* (p. 150), and with a distinctly larger head, this is one of the most attractively patterned of the four species of shrikes that Bauer painted. Its most distinctive feature is its rich, glowing chestnut-red head, which accounts for the common names of this bird in almost every other European language except for English; for instance, *Rotkopfwürger* in German, *Pie-grièche à tête Rousse* in French, *Averla Capirossa* in Italian, and *Kokkinokefalas* in Greek. The specific name *senator* is also likely to refer to the Woodchat's striking cap colour, alluding to its resemblance to that of the band on the togas worn by Roman senators. By contrast, the origin of the English name 'woodchat' is cloaked in mystery. The earliest mentions appear to be by the two great natural historians Francis Willughby and John Ray in their *Ornithology*, published in 1678, though not in the section describing shrikes. The word 'shrike' was also used for the Mistle Thrush. A posthumously published work of Ray's in 1713 does however give a description of this shrike, calling it the wood-chat, and he and Willughby described specimens they found on their travels in Europe.

The female is typically duller than the male, with a slightly paler chestnut crown, duller greyish black back and pale fringes to the wing coverts, a larger pale buff batch at the base of the bill, and pale underparts marked with faint grey-brown crescentic bars on the breast and flanks. However, some individuals are very difficult to distinguish from males. Juveniles are similar to those of the Masked Shrike, *L. nubicus*, and Red-backed Shrike, *L. collurio* (see pp. 156 & 150).

As with the other shrikes encountered by Bauer and Sibthorp, the nest of the Woodchat Shrike, built mainly by the female, is a compact, cup-shaped nest of twigs and roots, lined with hair, wool, moss and lichen and bound with spiders' webs. This is well hidden in a tree or shrub. The Woodchat lives in a range of habitats, including open woodland with scattered trees, shrubs and ground vegetation, including olive groves. In his diary, Sibthorp refers to having seen this species frequently in the olive groves near Athens.

In more recent times the Woodchat Shrike has suffered from a smaller and more fragmented distribution, especially so since its major decline in the north and west of its breeding range over the past 100 or so years, with the recent extinction of populations in central and eastern Europe, from Germany to Poland and Slovenia. Nevertheless, it is still a relatively abundant breeder elsewhere, from the Iberian Peninsula and southern France eastwards to the Balkans, western and southern Turkey, and eastwards as far as Azerbaijan and Iran, as well as parts of North Africa and the Middle East. Even so, it is threatened in many places by agricultural intensification and some forestry developments. A small number of Woodchat Shrikes turn up as off-course passage migrants to delight birdwatchers in Britain and Ireland. This compares with just five Masked Shrikes in the UK, but greater numbers of the Red-backed and Great Grey species.

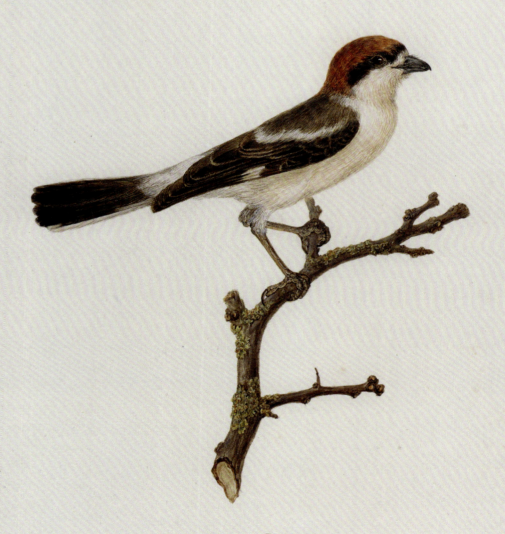

Woodchat Shrike. 70.
Lanius Rufus.

Masked Shrike *Lanius nubicus*

Lanius nubicus personatus

By contrast with the Great Grey Shrike, Lanius excubitor (p. 152), one of the largest members of the shrike family, this is one of the smallest, not much larger than a sparrow and about the same weight. The male shown here is a very attractive little bird, with his smartly pied head and upperparts contrasting with a white breast and delicate apricot-coloured flanks. Most females have a duller version of the male's plumage, with dark greyish brown markings on the head and upperparts where his are jet black (though some are more similar), and they have far less extensive apricot flank colour. Bauer's painting is by no means the first accurate representation of this shrike; an adult and an immature bird were depicted with astonishing accuracy in a wall in the tomb of the Egyptian official Khnumhotep II, which is a minimum of 3,800 years old.

The comment written on Bauer's illustration asserts that this species is a 'Native of Egypt and Nubia – hitherto unrecorded as European.' In fact, it has long been known to breed in various parts of south-east Europe, though it was not scientifically described until 1823, thirty-seven years after the start of Sibthorp and Bauer's expedition, by a German naturalist and explorer, Martin Lichtenstein, who gave it the specific name of *nubicus*. It was also described independently by a Dutch zoologist. Today, we know that the Masked Shrike is seen in Egypt, and also in the region of Nubia, now split between Egypt and Sudan, as a passage migrant only. Its breeding range extends from northern Greece (where it was formerly far more widespread and up to the 1860s said to be common in the vicinity of Athens), North Macedonia, Montenegro, Serbia and Bulgaria eastwards to Cyprus, western and southern Turkey, and south to parts of the Middle East; there is also an isolated population in Iran. The specimen that Bauer painted may have been obtained during his and Sibthorp's sojourn in Cyprus, at the crossroads of Europe, Asia and the Middle East, where it is generally the commonest of the four breeding shrike species, but they are also likely to have encountered it too in northern Greece and Turkey. Masked Shrikes migrate each autumn to spend winter in Arabia and subtropical Africa.

Compared to the other European shrikes, it generally avoids exposed habitats, preferring open woodland, where it tends to use a less isolated perch in a bush, hedge or tree to wait for prey. Its diet consists mainly of large insects, such as crickets, dragonflies and beetles. It also catches migrating songbirds, including warblers and swallows, especially when they are exhausted.

The Masked Shrike has suffered a moderate decline in its European populations, due mainly to habitat destruction and the effects of pesticides on insects, also on migration and in winter from shooting. It is persecuted in some places, including some parts of Greece (where it is thought to bring bad luck), often (as with other shrike species) because of being despised for its allegedly murderous habits.

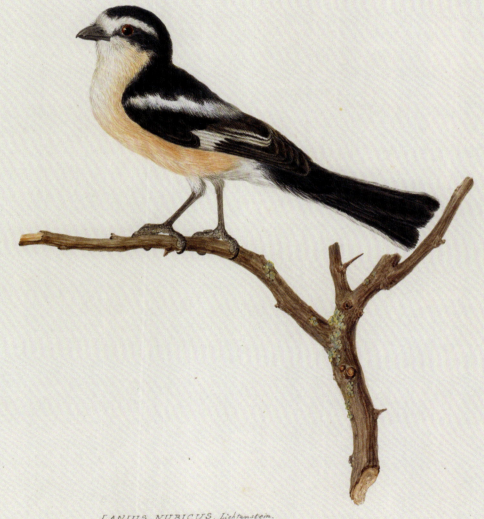

LANIUS NUBICUS. *Lichtenstein.*
——— PERSONATUS. *Temm. Pl. Col. 256. fig. 2.*

Native of Egypt & Nubia — hitherto unrecorded as European.

Red-billed Chough
Pyrrhocorax pyrrhocorax

Chough *Fregillus graculus*

This highly characteristic member of the crow family (Corvidae) is renowned for its exuberant and supremely aerobatic flight. Pairs or larger groups of these distinctive glossy black birds often wheel high above a sea cliff on their broad wings with fingered tips, like scraps of charred paper in the updraught from a bonfire, then perform spectacular turns and rolls, or suddenly hurtle down vertically with their wings folded and only spread them again at the last moment to pull up before they strike rocks or the water, and shoot back up skywards. When they return to earth, they are easily distinguished from their corvid relatives, Jackdaws (*Corvus monedula*), which often share the same habitat, by their brilliant red, slightly decurved bills and feet of the same colour. Hopping and walking about jauntily, they probe the clifftop turf and investigate cowpats and sheep droppings with their bill for the beetles, ants and other insects that form their diet.

Chough was formerly pronounced 'chow', in an approximate transcription of the wonderful, wild, ringing calls, often sounding more like *tschee-ow*, on a descending scale. The scientific name appended to Bauer's watercolour is an old synonym. Usually spelled with one *l* as *Fregilus*, the generic name was derived from the Mediaeval Latin name for the Chough's much larger relative Rook (*Corvus frugilegus*). *Pyrrhocorax*, from the Greek, is far more apt, meaning the 'fire-billed crow'. The former specific name on the painting, *graculus*, is from the Latin word for an unknown bird, later associated with the Jackdaw. The name 'chough' was for long applied indiscriminately to both the latter species and the Red-billed Chough. Local English names include Cornish Daw and Cornish Chough; Sibthorp mentions in his diary that when the party had attained the summit of Mount Parnassus, in central Greece 'the Cornix graculus, the Cornish chough, flew frequent among the rocks.'

The Red-billed Chough is a relatively scarce bird in continental Europe, found only in scattered areas, mainly in the south. It breeds mainly in mountains, but also along some coasts, from Portugal and Spain (the latter country containing about a third of the total European population) across the Alps, the central Appenines in Italy, in Crete and northern Greece and a few other areas in the Balkans, and across Turkey and the Caucasus. Its world range is far greater, extending eastwards discontinuously right across Asia as far as eastern China. There are also populations in North Africa and the Canary Islands.

In Britain and Ireland, until the early 1800s, it bred widely along cliff-girt coasts until the cumulative effects of persecution, egg and specimen collection and then agricultural changes drove it to the more remote western coasts, with small numbers breeding inland in high mountains and quarries in Wales. The agricultural changes include a reduction in grazing by farm animals and rabbits that maintains the short sward on the unimproved pastures where the birds feed, the treatment of livestock with antiparasite drugs that kill the dung-dwelling insects they eat, and ploughing to grow arable crops.

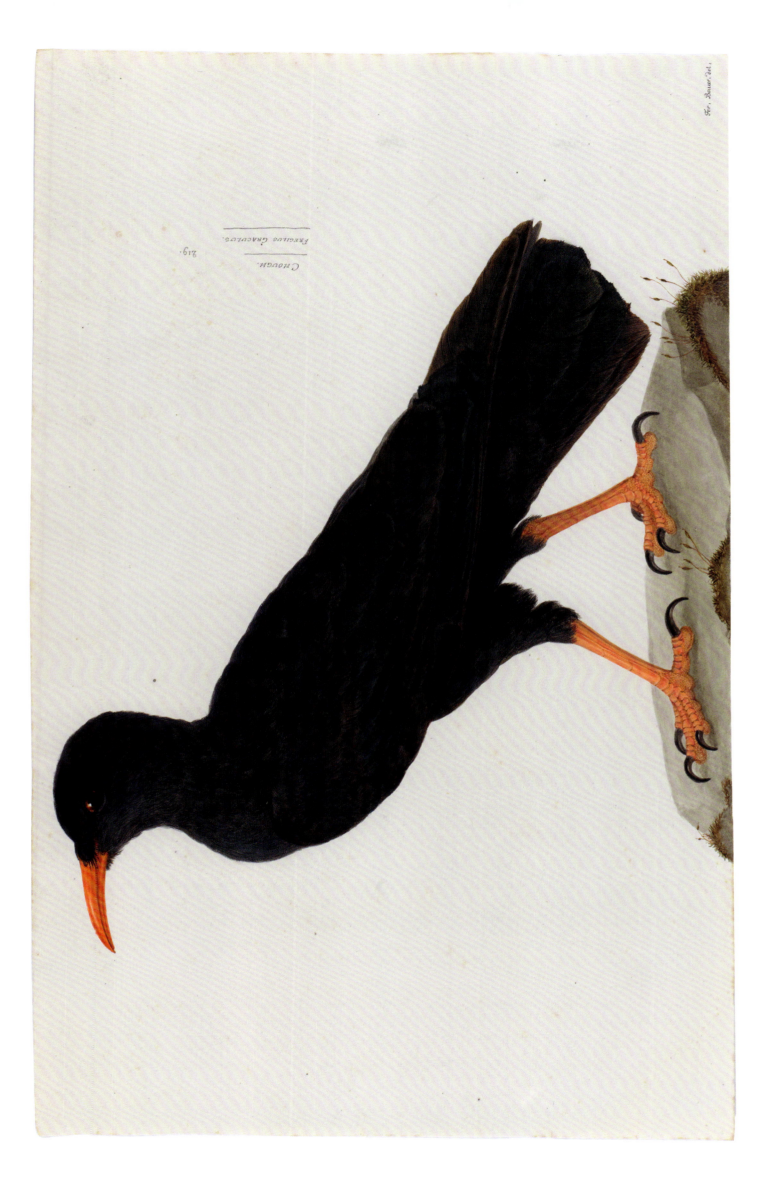

Chough.
Fregilus Graculus.

Coal Tit *Periparus ater*

Cole Tit *Parus ater*

In Latin, there are two words describing distinctions of the colour black, *ater*, for a matt black, which is used in the specific name of the Coal Tit, and *niger*, for a glossy black. The Coal Tit's black cap may actually show a slight bluish gloss in strong light, but is not as glossy as that of its much larger cousin the Great Tit, *Parus major*. The blackness of the cap is also celebrated in this tiny, rotund bird's common names in many languages across its vast range right from Europe and Asia to as far east as northern China, Japan and Kamchatka. In English, the original spelling was Cole Tit (as written on the label for Bauer's watercolour) and regional variants include Coley Tit or Coaly-Hood in Scotland, while in Yorkshire it was aptly called Little Blackcap: measuring just 11.5 cm from bill tip to the end of its short tail, it is even smaller than the more familiar Blue Tit, *Cyanistes caeruleus*. It weighs a mere 10 g or so, equivalent to 2½ teaspoons of sugar.

Coal Tits are widespread year-round residents in Greece, Crete, Cyprus and Turkey, and likely to have been frequently encountered by the two travellers when they were in woodlands, especially those consisting mainly or wholly of conifers, particularly spruce, which these little songbirds prefer for breeding. They also occur in broadleaved woodland, as in Britain and parts of southern Europe, where they live among oaks, beeches or birches, and in mixed woodland, where they often seek out various species of conifers.

Bauer and Sibthorp would have had little difficulty in recognizing any Coal Tits they encountered, as they have a prominent white patch on the nape. This distinguishes them from the other black-capped grey and brown tits that occur in the Levant. In young birds, the white of the nape patch, cheeks and underparts have a yellowish tinge. Coal Tits can also be identified by their various distinctive high-pitched calls and a persistent sweet piping song.

They have finer bills than their relatives, an adaptation for probing into dense clusters of conifer needles to tweezer out small insects and their larvae hiding among them. Coal Tits (and Blue Tits) are also adept at finding tiny moth larvae that burrow into the scales of young pine cones, where they feed on the developing seeds and then pupate. The birds do so by tapping on the cones; it is likely that those containing pupae produce a different sound, due to having been hollowed out by the insects. Coal Tits forage mostly among the needles and cones high up in large conifers, where they move with great agility, fluttering, hopping and hovering, and often hanging upside down. Sometimes they feed on tree trunks, probing among the bark. They nest in tree holes like other tits, but in coniferous forests these are often scarce, and they can make do instead with cavities among tree stumps, in earth banks, stone walls, or in the ground, especially in abandoned mouseholes or among tree roots.

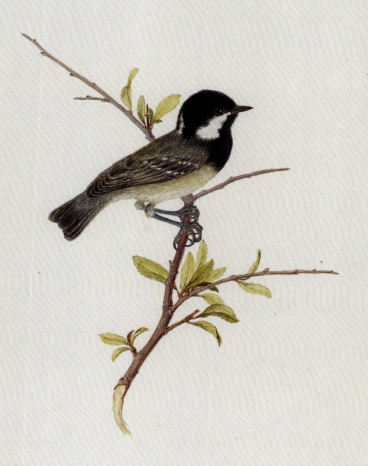

Cole Tit.
Parus Ater. 155.

Calandra Lark *Melanocorypha calandra*

CALANDRE LARK *ALAUDA CALANDRA*

Sturdily built with a plump body and a very short tail, and almost as large as a Starling, *Sturnus vulgaris*, this is one of the largest European larks, with a stout buff-coloured bill and a distinctive black patch across its breast of variable shape, width and extent. It has a striking and attractive appearance in flight when seen overhead as its long, pointed, blackish underwings, with a broad white trailing edge, contrast with its pale fawn body.

This is a bird of warm regions, in southern Europe found around the Mediterranean and the Black and Caspian seas. Farther afield, its range extends southwards to north-west Africa and parts of the Middle East, and eastwards via the Caucasus to as far as Mongolia and central Siberia. The northernmost and south-eastern Asian populations migrate south in winter, but those in Europe are year-round residents. In the Mediterranean, the Calandra Lark is found in Portugal, Spain, a few places in extreme southern France, Italy (including Sardinia and Sicily), the Balkans, Turkey and Cyprus. The largest populations are in Iberia (where it is especially common in the large plateaus in the centre of Spain), Turkey and Russia. Bauer and Sibthorp may well have encountered this distinctive songbird in many parts of their journeys, in Greece, Cyprus and Turkey.

Although it is not revered like the Skylark by poets and other writers, the male Calandra Lark has a very attractive song, which he broadcasts sometimes from the ground or from a bush or other low perch, but mainly high in the sky. Typically, after a long spiral ascent, singing as he goes, he reaches an impressive height that may even exceed that attained by Skylarks, before descending vertically, the last part of which is in silence. The whole process may take as long as half an hour. The song is a loud, continuous outpouring of sweet trilling, warbling, rattling and whistling sounds. It also includes imitation of the sounds made by many other birds of a wide variety of species, from other larks and finches to crows and waders. In contrast to the Skylark, which spreads its tail in its song flight, the Calandra Lark holds his tail closed; also, he holds his wings stiffly and straight out from his body, as he flaps them slowly.

In the past, these plump larks were hunted for food in many parts of their range and also trapped for cagebirds because of their fine song. Today, populations in many areas are declining, due to agricultural intensification of its grassland and steppe habitat.

Although some birds in much of their range in Ukraine and Kazakhstan, and in the eastern half of Turkey, migrate from their breeding grounds to winter farther south, others do not make regular movements of this kind, although they may wander quite extensively. At such times, they may form large, dense flocks of many hundreds that roam in search of water or food. They eat mainly insects in summer and seeds in winter.

CALANDRE LARK.

162.

ALAUDA CALANDRA.

Fer. Bauer del.

Greater Short-toed Lark
Calandrella brachydactyla

SHORT-TOED LARK *ALAUDA BRACHYDACTYLA*

This small, sparrow-sized bird is a bird of open, arid country, favouring sandy or clay soils, and areas with stones or gravel. It frequents waste ground, abandoned farmland and dusty tracks, and also visits fields of low-growing crops and stubble as well as sparse grassland and other natural habitats with short vegetation that provide it with plenty of seeds and insects.

Like the common English name, the specific name (from the Greek *brakhus*, short, and *daktulos*, toe) refers to the length of the hind toe (and its claw), which is in contrast to that of most larks, in which they are noticeably long, especially those species living on soft soil with dense, low vegetation. The short toes are an adaptation to fast and manoeuvrable running on hard, bare ground. The short, stout bill is suited for crushing hard seeds, which form a substantial part of the species' diet all year round. In spring and summer, Greater Short-toed Larks also eat large amounts of a wide range of insects, and feed their young exclusively on insects too. As its common name suggests, it has a relative called the Lesser Short-toed Lark (*Alaudala rufescens*). The two species are very difficult to distinguish, but Sibthorp and Bauer are less likely to have met with the Lesser species as it is only a passage migrant in the areas they visited.

Today, the Greater Short-toed Lark has a fragmented breeding range across southern Europe, where it is most abundant in Spain; it is also widespread across Turkey and parts of central Asia. Over the past twenty-five or so years it has suffered major declines across much of its range and is threatened everywhere, especially by intensification of agriculture. Also, as with other ground-living and nesting birds, and despite their streaked sandy buff to greyish ochre camouflaging plumage, Greater Short-toed Larks are very vulnerable to predators such as foxes, weasels, snakes or domestic animals, including dogs, and even livestock, including cattle and sheep, which may inadvertently trample nests containing eggs or nestlings; sheep, too, may eat them deliberately. Overall, predation rates at lark nests can be very high, in some cases up to 80 or 90 per cent.

Like most other larks, the Greater Short-toed Lark is mainly an aerial singer, although it does sometimes sing from the ground or from a low perch such as a rock or a mound of earth. Larks are birds of open country, where there are usually few or no suitable elevated song-posts such as trees or roofs of buildings and other structures that are available to many birds. Male larks are able to hover for prolonged periods at considerable height, enabling them to use an area of the sky as a song-post to broadcast their song over as wide an area as possible to attract females and deter rival males. In addition to the rapid ascent they make to reach their desired height, this energy-demanding flight is a good measure of fitness that females can use to choose the most suitable mates with which to rear a family.

SHORT-TOED LARK.
163.
ALAUDA BRACHYDACTYLA.

Crested Lark *Galerida cristata*

CRESTED LARK *ALAUDA CRISTATA*

This is slightly larger and has a longer bill than the more familiar Skylark (*Alauda arvensis*), and the crest that gives it its common name is far longer and more prominent than that which adorns that species (which when lowered merges into the crown). And whereas the Skylark's erect crest is short, neat and blunt-ended, that of the Crested Lark is long, rising at an acute angle or vertically in a spike; even when folded and flattened, it is visible as it projects behind the rear of the head. As with many other of the world's ninety-five species of larks, the Crested Lark is remarkably varied in its plumage colour across its range – a trait that is at least partly associated with being camouflaged against soils and other substrates of different colours. This can be complicated by the birds being stained by damp soil and later, after bathing, losing this extra acquired colour.

Crested Larks have loud, liquid three-note whistling calls with a mournful, rather ethereal quality. The male's song, which it often delivers from high in the air, and also from the ground or a perch, is long and highly varied, incorporating elements of the whistling calls with louder double notes, twittering and slurred sounds, and often including mimicry of many other birds, both songbirds and others such as partridges and waders. This performance is not so popularly renowned as that of the Skylark, one of the world's most celebrated songbirds, whose song is even more powerful. Also, the Crested Lark ascends silently, whereas the Skylark sings as soon as it rises and keeps singing, sometimes for up to thirty minutes. Nevertheless, its song does have a beauty of its own.

This ground-dweller favours open habitats, often with bare soil or other surfaces, or with only sparse growth of shrubs, such as waste ground, building sites, fields with low-growing crops or other vegetation, areas between railway tracks or along embankments, all places where it can find plenty of weed seeds, leaves and insects on which to feed.

In southern parts of its range, including Greece, Cyprus and Turkey, where Bauer and Sibthorp would have encountered it, the Crested Lark is at home in quite arid areas. It is a very characteristic bird there along roadsides between towns and villages, especially where these are rough and dusty, and can be very tame, allowing a close approach. Its tolerance of humans has been its undoing in many Mediterranean and other countries where small birds are hunted or trapped.

The Crested Lark has a world range that includes much of Europe, parts of Africa, and Asia east as far as Korea. It is an abundant resident breeder across southern Europe, and its range extends far more patchily to the centre and north, where it is steeply declining or extinct. The largest populations are in Spain and Turkey, with many also in southern Italy and the Balkans.

CRESTED LARK.

ALAUDA CRISTATA.

165.

Too pale in all the colouring.

Zitting Cisticola *Cisticola juncidis*

FANTAIL WARBLER? *SALICARIA CISTICOLA*

This tiny songbird is the sole European representative of a large group of species that was recently separated from the warblers in a family of its own, the Cisticolidae. Most of the other 157 species are found in Africa, which has by far the largest variety, and southern Asia. Almost a third of the total are included in the genus *Cisticola*, of which this species is by far the most widespread. Its vast range extends from southern Europe and Africa to Indonesia and northern Australia.

A compact bird with a short, rounded tail, its plumage is sandy brown with prominent dark streaks, resembling that of the reed warblers in the family Acrocephalidae, such as the Sedge Warbler, *Acrocephalus schoenobaenus* (see p. 172), to which the cisticolas are related. It is one of Europe's smallest birds, about the size of a Wren, *Troglodytes troglodytes*, and only slightly bigger than the smallest, the Goldcrest, *Regulus regulus*. Like its relatives, it is a bird of open, treeless country that provides cover, mainly in grassland of various types and cultivated crops. It spends much of its life hidden among the vegetation, where it finds its insect food. Here, males build as many as seven unlined 'courtship nests' from grass leaves bound together with spiderwebs or plant down, typically taking just a day or two to finish each one. If the female is amenable, she will line one of the nests with a snug layer of fine grass, spiderwebs and plant down, in which she lays her four to six eggs.

To attract females, the males come out of hiding to perform sky-dancing song flights. The sound is far removed from the glorious aerial song of the Skylark, *Alauda arvensis*, being a rapid, tuneless series of dry *dzit* notes, delivered as the male bounces up and down in a series of steep undulations as he circles round high above the ground, resembling a large insect as much as a bird. With each ascent, he spreads his tail to reveal its bright white outer feathers, a habit that is celebrated in the species' old name of Fan-tailed Warbler. The songs of its many African relatives are very varied, which has given rise to a gamut of inventive names, including Whistling, Trilling, Rattling, Chattering, Bubbling, Wailing, Tinkling, Croaking and Chirping Cisticolas.

About 90 per cent of the European population, currently roughly assessed at between 1 million and 2 million breeding pairs, lives in Spain, Portugal and Italy. In the east it is widespread in the mainland of Greece, as well in Crete and Cyprus, where numbers have recently increased. Unlike most of the warblers with which it was formerly grouped, this is resident year round or at most only a partial migrant. Although there is speculation that this is one of a number of birds that may spread northwards to the UK as a result of global warming, only a handful of individuals have so far been recorded in the UK, where cold winter weather is a barrier.

FANTAIL WARBLER? H.S.S.

SALICARIA CISTICOLA.

113.

Olive-tree Warbler *Hippolais olivetorum*

OLIVETREE WARBLER *SALICARIA OLIVETORUM*

This is one of the largest and most robust of the Old World warblers, with a long, strong, dagger-shaped bill, an elongated body and thick, relatively long legs. These features are well shown in Bauer's illustration. True to its common and specific names, this species favours olive groves as one of its habitats, along with pistachio and almond orchards, open woodland, mountain scrub and mixed grassland with scattered trees. It is most abundant in areas near the coast. This is one of those warblers that is often hard to spot, due to its skulking habits and dull grey-brown plumage, darker above than below, which makes it hard to distinguish from the leaves as it spends most of its time in dense foliage.

The Olive-tree Warbler breeds widely in the Balkans, where it has extended its range and population in Bulgaria, and along the Adriatic coasts as far as the Slovenian border. The largest populations are in Greece, Albania, Bulgaria and far across southern Turkey. It breeds in Crete and some of the Aegean islands but not in Cyprus. The Olive-tree Warbler has long wings, as befits such a long-distance traveller. Like the great majority of warblers breeding in Europe, this is a migrant, arriving in spring and departing in autumn for its winter quarters in Africa. It departs early, from mid-July to early September, for its passage across the Mediterranean, through the Middle East and onwards down the eastern side of Africa, where a few stop off to winter in Kenya and Tanzania, leaving the rest to continue on to southern Africa, chiefly from Zambia to northern South Africa.

In contrast to many warblers, such as the Blackcap, Garden Warbler or Willow Warbler, which have attractive songs, that of the Olive-tree Warbler is unmelodious. Compared to the songs of most warblers, it is markedly low in pitch, consisting of a complex series of throaty, contralto grating, chattering and squawking notes. These are separated rather than running on continuously.

It may have been this species that Sibthorp mentions in his diary as being one of the group of warblers and other songbirds collectively called to this day *beccafico* (or variants such as *beccafiche* and *beccafigo*) from the Italian words meaning 'a fig-pecker') which he shot in Greece, in this case near Athens. (In Ancient Rome the equivalent word was *ficedula*, and this has been conscripted by science as the generic name of some flycatchers; see Pied Flycatcher, *Ficedula hypoleuca*, p. 190). These small birds were traditionally trapped in large numbers by people in Italy (and still are on a worrying scale today in Cyprus, where the equivalent Greek collective noun is *ambelopoulia*; see Garden Warbler, p. 178), stuffed with breadcrumbs, herbs, raisins and pine-nuts and then baked. They are indeed fig-peckers, feeding on ripe figs and other fruit in autumn to build up fat reserves before embarking on their long migrations.

OLIVETREE WARBLER.

107.

SALICARIA OLIVETORUM.

Sedge Warbler *Acrocephalus schoenobaenus*

SEDGE WARBLER? *SALICARIA PHRAGMITIS*

Compared to the American birds that, confusingly, are also called 'warblers', 'wood warblers', or more precisely American or New World warblers, the Old World warblers are largely far less colourful and strongly patterned, most of them being plumaged in muted tones of greys, browns and olive, often with paler underparts. As a result, they have been described by ornithologists puzzling over their correct identification as the quintessential 'little brown or green jobs'. One of the specimens of a variety of warblers which the travellers obtained was this Sedge Warbler. It is one of the more abundant and best known of the fifty-odd species in the reed warbler family Acrocephalidae, distributed widely across much of the Old World. Some, like this one, are Eurasian, others African, one Australian, and many are restricted to tiny Pacific islands.

Like most warblers, Sedge Warblers leave their entire breeding range in autumn and are long-distance migrants, travelling by night and feeding en route at occasional stopovers by day. As with some of the other warblers Bauer and Sibthorp encountered on their Levant travels, they would only have been likely to have seen Sedge Warblers on spring or autumn passage. While the breeding range of this little bird extends from Ireland and France right across Europe and into central Siberia, in the south of its range it excludes Iberia, southern France and Italy, and the species is rare and sparsely distributed south of Hungary and Romania, with hardly any nesting in Greece, Cyprus or Turkey. Eastern European and Asian breeders are, however, encountered in the Levant as they stop off briefly to replenish food or rest on their impressive annual trans-Saharan journeys to and from their winter range in central and southern Africa.

There are several similar other members of this family that breed in the Levant which Sibthorp and Bauer may have seen, including the Eurasian Reed Warbler, Great Reed Warbler, Marsh Warbler, and Moustached Warbler. Like all other than the last of these, the Sedge Warbler's common name refers to its habitat, although it is by no means restricted to sedges or reeds, and can also be found in various other types of dense vegetation, usually with scattered bushes to provide song-perches, where it builds its deep cup-shaped nest low down in cover. Its specific name *schoenobaenus* is from the Ancient Greek words meaning 'reed-walker', and like its relatives it is highly skilled at travelling up, down and across at speed and with great agility as it grasps a reed stem or stems with its feet. The male's song is a loud, lively medley in which he jumbles together rapid, complex sequences of sweet, melodic notes and harsh, chattering ones, and sometimes inserts mimicry of many other birds. As well as delivering it from a prominent perch, he may launch himself into a song flight, spreading his wings and tail and parachuting down again. Sedge Warblers often sing at night, a habit earning this species an old local name of 'Irish Nightingale'.

SEDGE WARBLER? ♂.

110.

SALICARIA PHRAGMITIS.

Willow Warbler *Phylloscopus trochilus*

WILLOW WREN *SYLVIA TROCHILUS*

This little bird is one of the most abundant of all summer visitors to Europe, welcomed by those who know it when it arrives in spring to breed for its beautiful song – a sweet, wistful-sounding, warbling on a descending scale, ending in a little flourish. As many as 2.4 million pairs nest in Britain and Ireland each year (though it has suffered major long-term declines), and many more across its entire vast breeding range.

It belongs to the bird family known as leaf warblers, Phylloscopidae. This family name and the genus name *Phylloscopus* are derived from the Greek words meaning 'leaf seeker'. The specific name *trochilus* is taken from the Ancient Greek name of a small bird mentioned by Aristotle, and later linked by writers with the Wren, *Troglodytes troglodytes*. And until recent times, a popular English name for the species has been Willow Wren – which is the name used by Sibthorp and other naturalists of the time. Although it often breeds among willow scrub, it is also found in a wide range of other habitats, including young-growth woodland, both broadleaved and coniferous, especially birches and oaks, which are particularly good sources of accessible insect food, as well as hedges, gardens, rough tussocky grassland and bushy heathland. As with many of Bauer's stylized presentations of the bird perched on a rock, common in the ornithological art of his day, this does not reflect the typical habitat of this species.

This is one of the classic examples of a bird that is difficult to distinguish by sight from a close relative, in this case the Chiffchaff (*Phylloscopus colybita*, p. 176). Like it, the Willow Warbler has a pale stripe over the eye, but this is longer, more obvious and yellower. It also has a clearly marked dark stripe through the eye. The leg colour of the two is another useful distinction, that of the Willow Warbler usually being brownish pink (and not as bright reddish as Bauer has depicted), while a Chiffchaff's legs are usually dark brown or dark grey. Chiffchaffs have an odd habit of dipping their tail repeatedly, which the Willow Warbler does not share. Singing birds are instantly distinguishable, as the Willow Warbler's sweet silvery song could never be mistaken for its relative's repetition of its name.

Willow Warblers have longer wings than Chiffchaffs, with their tips projecting further over the tail. This is related to the much longer migratory journeys they make each year compared with their relatives, some of which stay put all year in parts of their more southerly range. This applies across their whole range, which extends from western Europe to the far east of Russia. All populations, even those in eastern Siberia, migrate to the southern half of Africa, undertaking prodigious return journeys for such a tiny bird that only weighs as much as three small grapes.

A very unusual feature of the species is that it moults all of its feathers twice a year, once when it is in its breeding area and again after it has reached its wintering site. The reason for this is not known for sure, but it may be related to the length of its migration.

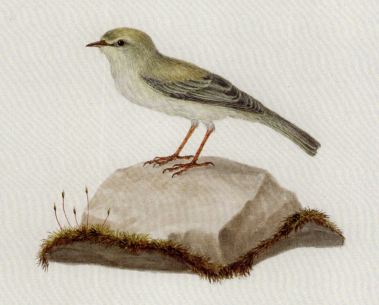

WILLOW WREN

SYLVIA TROCHILUS 131. 5.1

H.E.S

Chiffchaff *Phylloscopus colybita*

CHIFF CHAFF? SYLVIA RUFA?

Officially the Common Chiffchaff, since the very recent splits of Canary Island Chiffchaff and the Iberian, Siberian and Mountain Chiffchaffs, this close relative of the Willow Warbler, *Phylloscopus trochilus* (p. 174), is very similar. Indeed, it resembles its relative closely enough to have not been distinguished from it until the famous English parson-naturalist, the Reverend Gilbert White (1720–1793), did so. He declared that there were three British species of leaf warblers, as the birds in this genus are now called, and not two, as the pioneering ornithologist Francis Willughby (1635–1672) and his brilliant Cambridge tutor John Ray (1627–1705) observed in their encyclopaedic *Ornithology*, published in 1678. (The third species is the larger and more brightly coloured Wood Warbler, *P. sibilatrix*.) Despite their similar plumage, the songs of the three species are very different, as White had detected. That of the Chiffchaff is the simplest: a repetitive declaration of insistent high notes celebrated in its onomatopoeic common name, with the *chiff* pitched higher than the *chaff*. If you listen carefully, it becomes apparent that the pattern is usually more subtle, and not simply a *chiff* followed by a *chaff*, often an irregular sequence of notes on two or three pitches, such as *chiff, chaff, chiff, chaff, chaff, chaff, chiff, chiff, chaff...* Each verse often begins with a series of quiet, hard chattering notes. The specific name also refers to the song, *collybita* being the Latin word for a money-changer, fancifully comparing its song to the jingling of coins by such a trader. Some of the common names in other languages are similar to the English one, such as German *Zilpzalp*, Dutch *Tjiftjaf*, and Welsh *Siffsaff*.

Like the Willow Warbler, this is a very abundant and widespread summer visitor to Europe. Its European breeding range does not reach as far north as the Willow Warbler's (though it has achieved a modest expansion in that direction over the past few decades), but it does extend considerably farther south, reaching as far as Sicily, southern Greece and Crete, and also breeds in western and northern Turkey. Populations from much of Europe occur in these places as a passage migrant and winter visitor.

This is one of the first of our migrants to arrive in spring, when its presence is immediately apparent as the males sing more or less incessantly. Compared to the Willow Warbler, it is a shorter-distance migrant, a fact whose physical expression is seen in its shorter primary flight feathers of the outer part of the wing. Furthermore, in contrast to the Willow Warbler, many Chiffchaffs in the far west and south of Europe (including some in the south of Britain and Ireland) remain there all year round, while the rest leave after breeding. In Sibthorp and Bauer's time, Chiffchaffs were far less widely distributed in England, being absent or very scarce in south, south-west and northern England, Scotland and Wales, and they were also very rare in Ireland. From the 1850s onwards, though, the species spread north and west, its colonization especially rapid in Ireland, so that it thrived in suitable habitat throughout the country by the turn of the century.

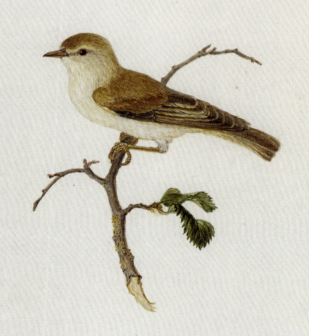

CHIFF CHAFF
SYLVIA RUFA. 131. 5 2
　　　　　　　Æ.E.S.

Garden Warbler *Sylvia borin*

This unlabelled portrait appears to be of a Garden Warbler, which Bauer and Sibthorp may have collected at various points on their journeys, during either spring or autumn, when it appears in Greece, Turkey and Cyprus as a passage migrant. It is renowned among birders for its absence of striking plumage features, being plain brown above and paler fawn below. It has a sturdier body than most similar warblers, a rounded head, a relatively short bill and large dark eyes, combining to give it a gentle 'expression'. The tail should appear shorter and the wings longer than in Bauer's painting.

Like most other European warblers, the Garden Warbler is a long-distance migrant, travelling across the Mediterranean and the Sahara each year to winter in Africa. It has a very large breeding range in Europe and western Asia, from Ireland, Britain and Spain in the west across most of the continent to as far east as western Siberia, and from northern Norway in the north to northern Turkey and the Caucasus in the south.

This is similar to the distribution of its close relative, the Blackcap, *Sylvia atricapilla*. Both are woodland birds, favouring tall trees for song-posts and dense undergrowth of shrubs and herbage where they can conceal their nests. Despite its common name, the Garden Warbler is not a garden bird, except in large and less managed gardens with plenty of trees and dense undergrowth. To the uninitiated, the songs of the males sound very similar. Both birds often deliver their beautiful, rich warbling performances from deep cover, hidden from view by foliage, when it is not possible to pair the singer to its song. This is especially true of the Garden Warbler, which rarely shows itself more than briefly. A good view of a male Blackcap shows the male's distinctive feature for which it is named (or, if it is a female, a reddish-brown cap). With experience, however, it is often possible to distinguish their songs. That of the Garden Warbler is more continuous, a relatively unvarying stream of sweet warbling notes, usually sustained for longer than the Blackcap's, which is richer, more melodic and varied, with distinct phrases and often ending in fluting notes. But to complicate matters, the Blackcap can mimic the Garden Warbler's song.

Bauer and Sibthorp may have heard the song of both species in Greece or western Turkey from migrants in spring on their way northwards, and in the case of the Blackcap into summer as well, as it is a common breeding bird there. They may well have also encountered both species served up on a plate, for this is one of the main species of warblers that for centuries have been eaten as delicacies. To this day, many millions are killed for this purpose both legally and illegally each year in the Mediterranean, including Cyprus, where they and various other small songbirds are known by the Greek name *ambelopoulia*, meaning 'vine-birds', and in Italy as *beccafico*, 'fig-peckers'.

Cyprus Warbler *Sylvia melanothorax*

SARDINIAN WARBLER? *CURRUCA MELANOCEPHALA*?

This is one of the most interesting of all Bauer's bird paintings from the Levant, considered by Strickland to possibly represent a Sardinian Warbler, *Sylvia melanocephala* (see p. 182). In fact it clearly represents a species of warbler that was not scientifically described until eighty-five years after Sibthorp and Bauer encountered it, on the island to which it is confined as a breeder.

Its formal zoological description was by one of the many eighteenth- and nineteenth-century clergymen naturalists, the strikingly red-bearded Canon Henry Baker Tristram (1822–1906). An indefatigable traveller to many parts of the world, a skilled field observer and amasser of a huge collection of bird skins, eggs and nests, Tristram spent much time on trips to the Middle East, and wrote a major book on the natural history of the Bible. He was the first ornithologist to support the theory of evolution by natural selection, citing evidence from his own study skins of desert chats and larks. Remarkably, it was not in Cyprus that he found the Cyprus Warbler, but on an expedition to Palestine. He distinguished a pair of unfamiliar warblers from among some Sardinian Warblers by their different calls, and after chasing them for a while was able to shoot them to study closely and proclaim this as a newly identified species. It was originally known as the Palestine Warbler, but as it is only a winter visitor to the Red Sea coastal strip and breeds only in Cyprus the name was changed.

The Cyprus Warbler belongs to a group of five species found around the Mediterranean. Though it is quite closely related to the Sardinian Warbler, its closest relative is Rüppell's Warbler, *Sylvia rupeli*, which Bauer and Sibthorp may have seen in Cyprus, where it is a passage migrant, or in southern Greece and Crete or other smaller islands, or western Turkey, all places where it breeds. The three species are similar in appearance, especially the females and immature birds, all having grey bodies, darker above. The males in their smart spring plumage are easiest to distinguish. All have black on the head; in the Sardinian Warbler the black cap contrasts with a white chin, whereas Rüppell's Warbler has the throat black too, separated from the cap by a neat white 'moustache' stripe; both these have a bright red eye ring. Male Cyprus Warblers have their throat and underparts peppered with bold dark spots and a dull reddish brown eye ring surrounded by a very narrow white ring. Their songs also differ; that of the Sardinian Warbler is a harsh, rattling affair, Rüppell's Warbler includes warbling notes and high-pitched whistles, and the Cyprus Warbler has a rather jerky, dry warble with few if any whistling notes.

Cyprus Warblers are widespread and common in various habitats, though they mostly prefer the evergreen scrub and heathland known as *maquis*, mainly on the coastal plains and mountains. They avoid the arid area of the island's central plain. In 1992 Sardinian Warblers started breeding in Cyprus, having been known only as passage migrants and winter visitors before that date. Since then they have spread rapidly across most of the island. Although some ornithologists thought that they might be competing with the Cyprus Warblers, this seems unlikely and they may coexist by having different niches.

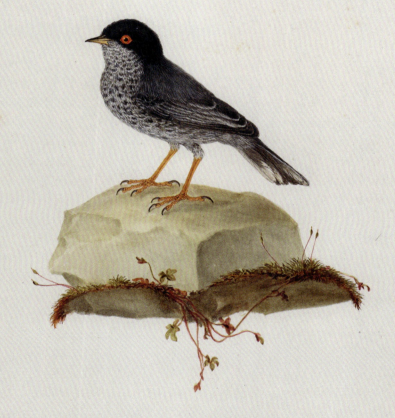

SARDINIAN WARBLER, juv.?
CURRUCA MELANOCEPHALA

N.E.S.

Sardinian Warbler *Sylvia melanocephala*

SARDINIAN WARBLER *CURRUCA MELANOCEPHALA*

Bauer's illustration shows a male of this attractive little bird; females have a grey head rather than the velvety black one of the male (though some have a blackish forecrown and ear coverts); their upperparts are brown rather than grey and they have greyish-brown rather than grey flanks. A prominent feature, which is shared with other Mediterranean warblers in the genus *Sylvia*, is the red or reddish eye-ring surrounding the orange, brownish or deep red iris, more conspicuous in males. Although its English common name links it to Sardinia, where it is abundant, this warbler is by no means restricted to that Italian island. It is a common and widely distributed songbird around the Mediterranean region, breeding throughout Portugal and Spain (including the Canary Islands and the Balearic Islands), southern France, Corsica, Italy, including Sardinia and Sicily, Malta, the Balkan Peninsula, Greece and most of its islands, including Crete, and the western half of Turkey. It has colonized Cyprus since being first recorded there in the 1990s, and has been thought by some ornithologists to compete with its relative that is endemic to the island, the Cyprus Warbler, *Sylvia melanothorax*, but this is now believed to be unlikely (see p. 180).

It is particularly abundant along or near coasts and on islands. It is a species that has benefited from a couple of human-induced changes: the neglect or abandonment of agricultural land, and the effects of global warming, which have enabled it to expand its range northwards. Outside Europe, it breeds in northwest Africa, Libya, Lebanon and Israel. Most populations are resident year-round, but those on the northern fringes where winters are colder migrate, generally for short distances within the breeding range.

This is a frequently encountered bird in open woodland with dense shrubs or in dry scrub throughout the mainland and islands of the Mediterranean region, where it is one of the most abundant birds. In several other European languages it is given names, such as the French *fauvette mélanocéphale* (meaning 'black-headed warbler'), echoed by its specific scientific name, *melanocephala*. The generic name *Sylvia* is from the Latin for woodland sprite.

The Sardinian Warbler is at ease living in close proximity to people, for instance in gardens and along roadsides in villages. It is a bold and inquisitive little bird, often cocking its tail and raising its black crown feathers when it emerges from cover briefly before darting back into the foliage after scolding the human observer with a torrent of rapid, rattling alarm calls that suddenly explode with great force. The male's song is a brief sequence of harsh rattling notes interspersed with musical warbling and a few brief whistling sounds, which he delivers from within the cover of a bush or on a more prominent perch, often when moving about and occasionally in a short, dancing song flight. This song, and the bursts of harsh calls, are among the most frequently heard sounds heard outdoors in spring and summer in the Mediterranean.

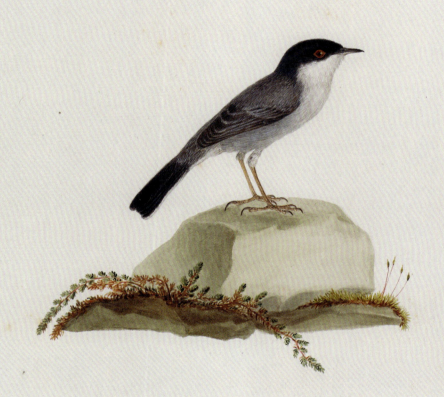

SARDINIAN WARBLER.
123.
CURRUCA MELANOCEPHALA.

Fer. Bauer del.

Western Rock Nuthatch *Sitta neumayer*

Dalmatian Nuthatch *Sitta syriaca*

A bird of the eastern Mediterranean, this is a less well-known relative of the far more familiar and widespread Eurasian Nuthatch, *Sitta europaea*, which often visits British gardens to take advantage of the peanuts provided by many people, dominating the various species of tits that share its habit. It is very similar to that species, but equipped with a rather longer bill and longer legs. It also has a paler buff breast and belly compared to the western races of the European Nuthatch, and is paler blue-grey above. Like that species, and most of the other twenty-seven species of nuthatch that live in Europe, North Africa, Asia and North America, it has a striking black eyestripe, often likened to a bandit's mask. The biggest difference, though, is that it is not a woodland bird.

Like the closely related Eastern Rock Nuthatch, *Sitta tephronota*, the Western Rock Nuthatch is found on rocky outcrops and cliff faces, especially of limestone, and also on slopes covered with low-growing, aromatic shrubs (known by the Greek name of *phrygana*) interspersed with rocks. It is often heard before it is seen, uttering a wide variety of whistling, piping and trilling sounds. Just as the other nuthatches are skilled tree-climbers, able – unlike the unrelated woodpeckers – to descend tree trunks head first just as fast as climbing up them, rock nuthatches scamper up and down rocks with great speed and agility. And unlike woodpeckers, which hold their feet more or less parallel as they climb in jerky hops, using their stiffened tail feathers as a prop, the nuthatches reach above them with one leg and use the sharp claws to grip onto the rock, supporting themselves on the other foot beneath the body, with their short, unstiffened tail held away from the surface.

Other nuthatches nest in trees, in natural holes, those abandoned by woodpeckers, or in some species holes they chisel out themselves in soft, rotting wood; some, including Eurasian Nuthatches, use nest boxes where people provide them. The two species of rock nuthatches nest in crevices and cavities in rocks, most commonly available in limestone country, as well as in old buildings and ruins. Most nuthatches reduce the size of the entrance hole by plastering round it with mud, sometimes mixed with other ingredients such as hair and animal dung. The mud sets to a brick-like hardness and, as well as serving to exclude larger hole-nesting birds from taking over the hole, helps to deter predators, such as starlings, woodpeckers, squirrels or weasels from gaining access to their eggs or nestlings. The two rock woodpeckers take more elaborate precautions still. They use mud to fashion a large flask-shaped structure over the nest cavity with an entrance tunnel that may be up to 10 cm long. This gives them a wider choice of nest sites, as they can nest safely lower down than other nuthatches. These fortifications are very durable, so that pairs may use them for several years.

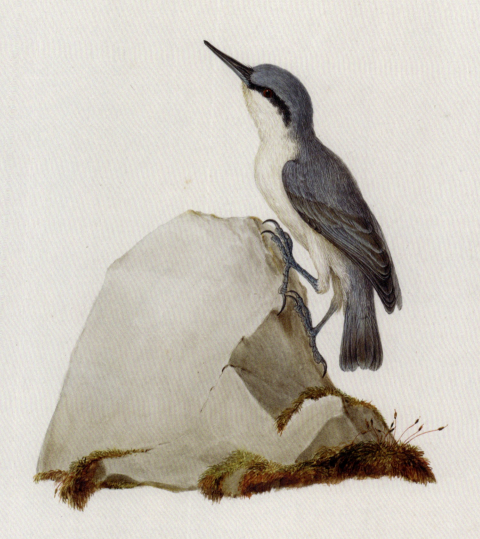

DALMATIAN NUTHATCH. immature.

235.

SITTA SYRIACA.

Ring Ouzel *Turdus torquatus*

RING-OUZEL *MERULA TORQUATA*

This strikingly patterned songbird is one of several species in the thrush family, Turdidae, that occur in Greece and Turkey, mainly as passage migrants and winter visitors, or in some places also as breeding birds. A wilder, far more elusive relative of the familiar Blackbird, *Turdus merula*, the Ring Ouzel breeds in uplands, favouring mountains, hills and heather moorlands with rocky outcrops, crags, boulders and scree slopes, and sparse, wind-stunted trees and shrubs (and in Europe also in conifer woods and shrublands). This choice of habitat is reflected in the old English name of Mountain Blackbird. The ouzel part of the common name originally also applied also to the closely related Blackbird, an old English name for which was ouzel (or ousel) and to a distant relative of the thrushes, the Dipper, *Cinclus cinclus*, once known as the Water Ouzel.

In young birds during their first winter, this diagnostic marking is only just discernible at best as a pale brown ghost of the adult males' boldly contrasting white crescent, and often impossible to make out in first-winter females. By summer, adults have acquired this feature that distinguishes them from Blackbirds, though it is narrower and much duller in females. Some Blackbirds develop white patches in their plumage, and are often incorrectly thought to be partial albinos, though these are rare and such birds are affected by a more common genetic condition called leucism. If one of these white patches is on the breast, it can lead wishful-thinking birdwatchers to claim they have seen a Ring Ouzel. A further feature that distinguishes the Ring Ouzel is the pale fringes to the wing feathers, forming a silvery panel on the closed wing and making the wings appear much paler than a Blackbird's. The Ring Ouzel has a far simpler song compared to the justly renowned one of its commoner relative, a halting, repeated series of fluting notes with a melancholy character suited to the loneliness of its surroundings.

There are three races. Birds belonging to the race *torquatus* breed in small and still dwindling numbers in Britain and Ireland, and far more abundantly in western and far-northern Scandinavia and Finland, as well as in the Kola Peninsula in Russia. They migrate to spend winter in the Mediterranean and north-west Africa. The race *alpestris* breeds in northern Spain, especially in the Pyrenees, and across the Alps and other mountains of central Europe eastwards to the Carpathians and the Balkans, including a few in northern Greece. They migrate mainly to North Africa but also to parts of southern Europe.

Bauer has accurately portrayed the distinctive feature of this race, the pale fringes to the belly feathers that give them a scaly appearance. The mainly yellow colour of the bill indicates it is a male, though its shape is rather too curved at the tip. A third race, *amicorum*, similar in appearance to *torquatus* but with a broader white crescent and a whiter wing panel, breeds in eastern Turkey, the Caucasus and Turkmenistan, wintering farther east than the other races, mainly in Iran.

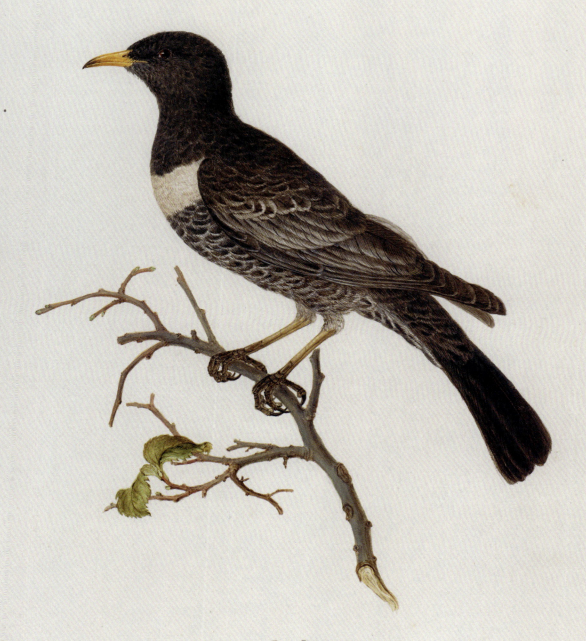

Ring-Ouzel.
73.
Merula Torquata.

Spotted Flycatcher *Muscicapa striata*

SPOTTED FLY-CATCHER *M. GRISOLA*

This small, slim, songbird with a disproportionately large head, long wings and short legs lacks any striking plumage features. It is greyish-brown above with subtle dark streaks on its forehead and dull white below, with diffuse brown streaks on its breast and often a buff wash to its flanks. The qualifying adjective 'Spotted' is a bit of a misnomer, as the adults have streaks but lack spots. Young birds do live up to their name, however, as they have copious pale buff spots on the head, nape and back.

It has a distinctive feeding method associated with its common name of 'flycatcher', a name also given to many other birds in the family, Muscicapidae, to which it belongs. Like the generic name *Muscicapa*, this family name derives from the Latin words for flycatcher. Sitting upright on a prominent perch such as a leafless tree branch, overhead wire or fence post, often in the dappled light directly beneath the foliage, a Spotted Flycatcher scans the surroundings for flying insects, often flicking its wings and tail. As soon as it spots one, it launches an attack, making a short, quick flight with a flurry of wingbeats alternating with a long, sweeping glide to seize its prey, with a clearly audible snap of its broad-based bill, then returns to the same or another nearby perch. It prefers larger insects, especially – as befits its name – flies, but also a wide range of others, including dragonflies, beetles and butterflies, and will twist and turn with great agility if necessary to secure prey. It also tackles wasps and bees but usually only if other prey is scarce, as it has to spend time rubbing their bodies against a perch to remove the sting. Like some other groups of birds, such as swallows and nightjars, flycatchers are equipped with highly modified stiff bare feathers called rictal bristles flanking the sides of the bill near its base, which Bauer has accurately drawn in his painting. These form a fringe around the gape that reduces the chance of mobile insect prey escaping as the bird opens its bill wide to seize them.

The Spotted Flycatcher's song is as unremarkable as its self-effacing plumage, consisting of a halting series of about three to half a dozen quiet, scratchy and squeaky notes with pauses between them. It sometimes mixes in a few soft trills. Its contact calls, too, are single thin, hoarse, high-pitched sounds, similar to those of many other small songbirds; the alarm call is more distinctive, a louder single note followed by a couple of short clicking notes.

This is one of the latest of all summer visitors to Europe from its winter home in sub-Saharan Africa, due to its dependence on plentiful insect prey. Although it breeds across virtually the entire subcontinent, and is especially abundant in north-east Europe, particularly in Scandinavia and Russia, this is one of those birds that have suffered catastrophic declines in parts of north-west Europe, especially Britain and Ireland.

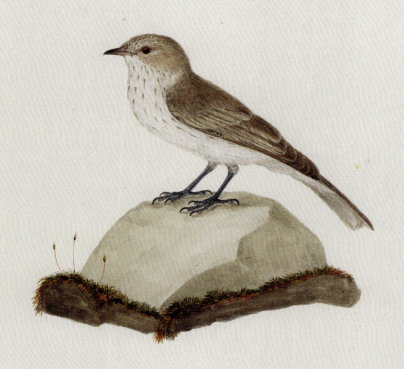

SPOTTED FLY-CATCHER.
65.
M. GRISOLA.

Pied Flycatcher *Ficedula hypoleuca*

Pied Fly-catcher *Muscicapa luctuosa*

Compared with the other flycatcher species painted by Bauer, the mainly dull grey-brown Spotted Flycatcher, *Muscicapa striata* (p. 188), this is a strikingly plumaged little bird. Males in particular are generally very dapper, living up to the species' common name, in the glossy black and bright white breeding plumage that they wear in spring and summer. A qualification is that from late summer to early autumn they moult into a winter plumage that renders them virtually indistinguishable from females, with greyish brown replacing the black. A further complication that can confuse anyone seeking to distinguish males is that some individuals resemble females in summer too, with varying degrees of brownish-grey instead of black, and some are almost identical to females. They do sport one distinctive feature of typical breeding males – a pair of little white spots on the forehead, or in the Spanish race a large single white patch.

As if that wasn't enough, two other close relatives that have similar plumage also occur in the area covered by Sibthorp and Bauer's travels, like the Pied Flycatcher, as frequent passage migrants, more often in spring than in autumn. All three of these species are summer visitors to Europe. The best known by far is the Pied Flycatcher, first described in 1764, which breeds from Britain and Iberia east across northern and central Europe to south-central Siberia. The Collared Flycatcher, *Ficedula albicollis*, not described until 1815, has a more easterly breeding range, while the Semi-collared Flycatcher, *Ficedula semitorquata*, described only in 1885, and sometimes since then regarded as a race of the Collared Flycatcher, is restricted as a breeder to the south-east, from the Balkans, including northern Greece, patchily across Turkey and into the Caucasus. All three species migrate south in autumn to winter in Africa. They pose further identification problems not just by having similar plumage, but also because Pied and Collared Flycatchers occasionally hybridize, and then closely resemble the Semi-collared species. What is puzzling about Bauer's illustration is that there is no trace of the distinctive white wing patch found in all three of these species. The males flaunt these in displays during the breeding season both to challenge rival males and to attract females to mate with them.

In contrast to Spotted Flycatchers, Pied Flycatchers spend more time hidden among foliage in trees (especially mature oaks in Britain and in both deciduous and coniferous woodland elsewhere), and move restlessly from one lookout perch to another when hunting flying insects rather than adopting a favourite one; they also take insects and caterpillars from leaves, branches and tree trunks while hovering briefly or clinging to the bark, and sometimes from the ground. They make their nests in tree holes, but where nest boxes have been provided they generally prefer these. This has enabled conservationists to achieve impressive increases in numbers in areas where there have been major declines, including in Britain. Such declines are thought to be linked to a mismatch between the availability of the food for their young and the timing of breeding, due to climate change.

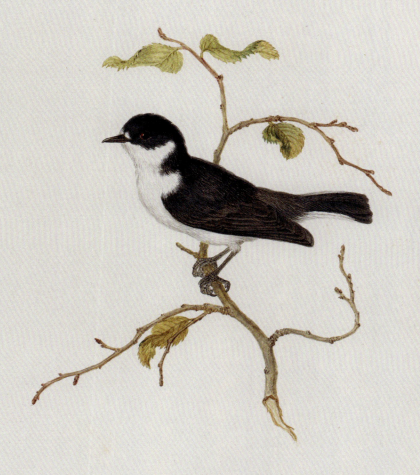

PIED FLY-CATCHER. male.
63.
MUSCICAPA LUCTUOSA.

Common Redstart *Phoenicurus phoenicurus*

Common Redstart *Phœnicura ruticilla*

The male is one of the most beautiful of all the songbirds that delight the eye as summer visitors to Europe, with his ash-grey upperparts, contrasting with a brilliant white forehead above the jet-black face, and his fiery orange-red breast. Bauer has painted this fine portrait of a male in the breeding season (when he is at his brightest, since by autumn, prior to migration, his bright colours are partly hidden by buff fringes to the feathers). Females are less flamboyantly plumaged, brown above and variably orange-buff to fawn below, but are subtly beautiful: Bauer painted a female too, and also an immature male, duller above and with an orange-mottled breast (see pp. 14–15).

The English name 'redstart' refers not to the male's fiery red breast but to the tail of a similar bright colour, a feature of both sexes; 'start' is from the Old English word *steort*, meaning 'tail'. Names with similar meaning are found in most other European languages, as well as the many dialect names in Britain. The scientific name, too, is derived from the Greek words with the same meaning.

This is one of the group of songbirds collectively known as chats. Until quite recently they were considered to belong to the thrush family (Turdidae), but DNA genetic analysis demonstrated that they belong within the Old World flycatcher family (Muscicapidae), where they make up most of the subfamily Saxicolinae. This contains other such familiar European birds as the wheatears (*Oenanthe*, see pp. 198 & 200) and, best known of all, the Nightingale (*Luscinia megarhynchos*) and (in a different subfamily) the European Robin (*Erithacus rubecula*). The Common Redstart is one of three species of redstart in Europe. The other two are the Black Redstart, *Phoenicurus ochruros* (which Bauer and Sibthorp are likely to have seen in Greece, as it is more widespread there today than the Common Redstart), and the White-winged (or Güldenstädt's) Redstart, *Phoenicurus erythrogastrus*, which breeds from the Caucasus and central Asia east to the Himalayas. The European range extends from Britain and Iberia east across most of the continent, and farther east in Asia it reaches Mongolia and southern Russia, while its southward limits are in North Africa and Iran. In autumn, all these birds leave to winter in Africa south of the Sahara, apart from a few that go no farther than the Arabian Peninsula.

Breeding populations declined in many parts of its European range between 1970 and 2000, and the largest numbers are found in Scandinavia, Finland and Russia, where there is plenty of suitable habitat. This is essentially a bird of open woodland. In Britain it favours broadleaved or mixed woodland, where it is especially numerous in sessile oakwoods in western England and Wales, as well as in northern England and Scotland. But elsewhere it often prefers conifer woods, as long as they are not too dense. The Common Redstart nests in holes in trees, walls, rocks or old buildings, and readily takes to nest boxes. As with most small songbirds, they do not have a long life; the average lifespan is about two years, and they usually breed at just one year old.

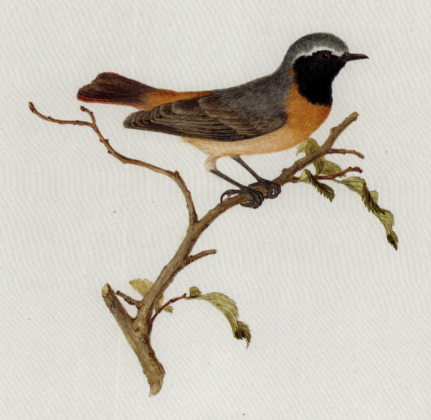

Common REDSTART, adult male.
95.
PHŒNICURA RUTICILLA.

Blue Rock Thrush *Monticola solitarius*

BLUE THRUSH *PETROCINCLA CYANEA*

The generic name of this striking bird, *Monticola*, is from the Latin meaning 'mountain dweller'. These birds do indeed inhabit mountainous country, on cliffs, in gorges or among boulder-strewn slopes, but they also live at lower altitudes, for instance along rocky shores, headlands and sea cliffs, and in quarries or open-cast mines. They are also found among ruins and other old buildings still in use, including churches, castles, houses with tiled roofs, bridges and dams, even in urban areas. This is especially true in areas where the Blackbird, a potential competitor for food, is scarce or absent.

Because of this striking bird's relatively wide habitat preferences, Bauer and Sibthorp may have encountered it at various places in their travels, perhaps among the ruins of Messina, or in the mountains, including the northern Apennines of Italy, the high mountains of Crete or the two different mountains then known as Olympus, one (now Olimbos) in Greece and the other (now Uludağ) in Turkey.

Females and young are brown, darker above and with a scaly pattern below. Bauer's portrait shows the handsome male, whose plumage, all blue save for the black wings and tail, accounts for the common name. The blue is a deep, dark blue, reminiscent of the colour of sloe berries. Relatively few birds have entirely or largely blue plumage. Blue colours in birds are not due to pigment. They result instead from the microscopic structure of the feathers causing the light falling on them to diffract and scatter. At a distance or in poor light male Blue Rock Thrushes can appear black, but once seen in a closer view and in bright light they are unforgettably blue. Distinctly smaller than a Blackbird at about the size of a starling, but with a longer tail and bill, Blue Rock Thrushes are often maddeningly hard to spot as they blend into the background of dark rocks.

The specific name *solitarius* too is apt: for much of the time Blue Rock Thrushes are seen only singly, or in pairs during courtship, although they may travel in small groups during migration. They are generally shy: typically, when one that has been spotted on a perch scanning for insect prey is approached, it flies off fast and low and is lost to view behind a rock.

In Europe the species favours dry, sunny areas with sparse vegetation in the Mediterranean climate zone, where it is most abundant in Spain, Italy and Greece. The major part of its extensive range is in Asia. The European race is a partial migrant, with some birds remaining year round in the breeding region and others migrating as far as North Africa. It is particularly widespread and abundant in Spain, Italy and Greece, though it has suffered local declines due to coastal tourist developments or other habitat degradation and disturbance.

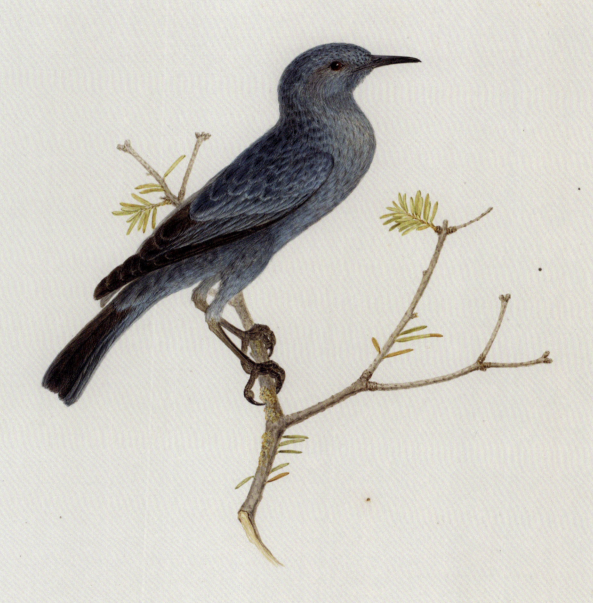

BLUE THRUSH. male.
PETROCINCLA CYANEA.
87.

Common Stonechat *Saxicola torquatus*

STONECHAT *SAXICOLA RUBICOLA*

The English name of this lively little relative of the wheatears, *Oenanthe* (see pp. 198 & 200), European Robin, *Erithacus rubecula*, and Nightingale, *Luscinia megarhynchos*, relates to its frequently repeated, scolding alarm call, a sharp, penetrating whistle followed by a double note like that made by two stones being knocked together. This speaks to the convoluted history of both the common and scientific names of this songbird and some of its relatives among the group called chats (a name which referred to these birds' short, harsh calls). The genus name *Saxicola* means 'stone-dweller', but although this bird's calls relate to stones the Common Stonechat is not especially found in stony country.

The common name of the other member of the genus found in Britain, Ireland and across Europe, the Whinchat *Saxicola rubetra*, adds to the confusion. Whin (or furze) are alternative names for gorse, a shrub that is often a feature (along with heather) of the coastal and moorland heaths the Stonechat favours, but is not generally associated with its relative. In another twist of the tale, both species were often known by the same vernacular name of Furze-chat. The Northern Wheatear, *Oenanthe oenanthe* (p. 198), was formerly also included within the genus *Saxicola*, and old British dialect names for it include stonechat, stonechacker and variants.

Although the 'official' name of this bird in ornithological literature is Common Stonechat, it is generally known in Britain and Ireland simply as *the* Stonechat (as no other stonechat species breed there, or indeed anywhere in its wide range across Europe and western Asia).

This is a very restless little bird, frequently flitting from one prominent perch, for instance at the top of a gorse bush or on a fence post or wire, to another. In its fast, direct, whirring flight it resembles an oversized bumble bee, especially the male in breeding plumage, with his black head and deep-orange breast.

Unlike most of its European relatives, such as the Whinchat, the Common Redstart, *Phoenicurus phoenicurus* (see p. 192), and the Northern Wheatear, *Oenanthe oenanthe*, which are summer visitors that migrate to winter in Africa, most of the Common Stonechats in western and Mediterranean Europe are year-round residents (in contrast to those breeding in northern and eastern Europe, which are mainly migrants). This brings benefits and costs to both groups. The migrants are able to avoid harsh winter weather and resultant food shortages, but undergo the hazards of migration, while the stay-at-homes have the advantage of getting off to an earlier start with breeding and can rear two or even three broods of young, though they are vulnerable to cold weather. There were serious declines in numbers in western Europe until about 1980, due in large part to increased mortality in a series of especially cold winters, resulting in fewer pairs surviving to breed, as well as more intensive agriculture. Following this, numbers recovered, as winters became milder due to global warming, and conservation measures on farmland, such as set-aside, were introduced. Most recently, numbers nosedived again following the severe winters of 2009–10 and 2010–11.

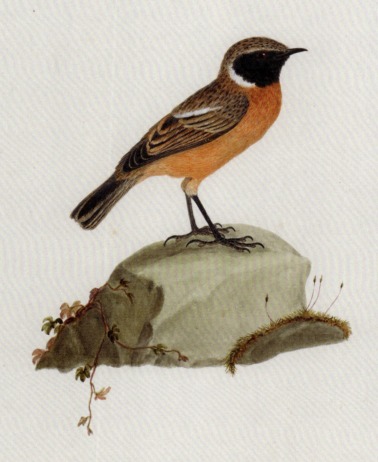

STONECHAT.

94.

SAXICOLA RUBICOLA.

Northern Wheatear *Oenanthe oenanthe*

Wheat-ear *Saxicola œnanthe*

This is one of thirty species of small songbirds in the genus *Oenanthe* known as wheatears. The English name, originally given to the best-known European species, the Northern Wheatear, *Oenanthe oenanthe*, has no connection whatsoever with ears of wheat, but is a polite Victorian renaming of the original folk name, 'White-arse', referring to the bird's prominent white rump that is especially apparent, even at long range, as it flashes brightly whenever the bird takes flight. This is emphasized by the inverted *T* pattern formed by the black outer tail feathers and terminal tail band in this and some other species.

The scientific name, given by Linnaeus in 1758, originated from the name given to an unidentified bird by Aristotle, formed from the Greek words *oinē*, vine, and *anthos*, bloom, celebrating the return of this migrant in spring at the time of flowering of the grape vines. It is unusual among scientific names given to animals in that the same name is also used for a widespread genus of plants, with the common names of water dropworts, water celeries and water parsleys. Some of the thirty-three species are notorious for being extremely poisonous. In this case, the name *oenanthe* appears to have been chosen in reference to their intoxicating effects.

Wheatears belong to a large group of insectivorous songbirds called chats, in the subfamily Saxicolinae, which also includes such well-known and iconic birds as the European Robin, *Erithacus rubecula*, and the Common Nightingale, *Luscinia megarhynchos*. Until recently they were included with the thrushes in the family Turdidae, but genetic research demonstrated that they were more closely related to the subfamily Muscicapinae, containing the Old World flycatchers and relatives, in the family Muscicapidae, one of the world's largest bird families, with some 350 species.

The Northern Wheatear is one of the world's champion bird migrants. It has one of the hugest breeding ranges of any songbird, spanning three continents and extending from the eastern Arctic region of Canada across Greenland, Europe and Asia and into Alaska. Moreover, birds from all these populations all migrate twice a year between their nesting area and their wintering grounds in northern sub-Saharan Africa. In the case of the Alaskan breeders this involves a trip of about 14,500 km each way, travelling up to 290 or more kilometres per day – a phenomenal feat for a little sparrow-sized bird with an average weight of just 25 g, just that of 6 teaspoons of sugar. They spend almost half of each year flying between their summer and winter homes. After rearing up to two broods of nestlings during the brief, bountiful Arctic summer, they depart across the Bering Strait and fly over Russia, Kazakhstan, the Caspian Sea, the Arabian desert and the Red Sea to Africa. For the Canadian breeders the journey involves crossing the Atlantic Ocean. It is remarkable that neither of these populations of North American birds have evolved the shorter journey made by all other songbirds that breed there, to the southern USA, the Caribbean, Central America or northern South America.

WHEAT-EAR young.
90.
SAXICOLA ŒNANTHE.

Cyprus Wheatear *Oenanthe cypriaca*

Pied Wheat-ear *Saxicola leucomela*

This boldly plumaged little bird (the smallest of all European wheatears) was until recently considered merely a distinctive isolated island subspecies of the Pied Wheatear, *Oenanthe pleschanka*. Along with the latter, it is one of many species of wheatears in which the males have very similar pied plumage, posing a challenge for birders attempting to distinguish them. The difficulty also extends to females and immature birds, which have duller, more subtly patterned plumage, and are even more difficult to identify. Furthermore, subtle differences between subspecies and the existence of variable forms (morphs) of the males of some species can also cause problems. Unlike those of the Pied Wheatear, females of the Cyprus Wheatear look very similar to the males, apart from being slightly duller with a brown tinge to their crown and upperparts.

The two wheatear species that are most widespread and numerous in Greece and Turkey are the Northern Wheatear, *Oenanthe oenanthe*, which is easy to distinguish (see p. 198), and the Black-eared Wheatear, *Oenanthe hispanica*. Today, the Pied Wheatear, which breeds from around the Black Sea and eastwards across Asia, is very scarce in extreme north-east Greece and adjacent Turkey. It is the only wheatear to breed there. The Cyprus Wheatear, by contrast, is endemic to the island after which it is named, where it is the only wheatear to breed, though seven other species occur as passage migrants in varying numbers; the Pied Wheatear is only a very rare vagrant to the island.

The Cyprus Wheatear, like its relatives, is a migrant spending winter in southern Sudan and Ethiopia. It returns to Cyprus from late March into April, and after breeding heads south-west to Africa from August to October. Although most abundant in the mountains and foothills, and least numerous in the hot central plain, it is common throughout much of the island, in a wide range of habitats. These include scrubland, rocky ground, open woodland, farmland and around houses and industrial sites. Although their numbers are stable, Cyprus Wheatears suffer from illegal bird trappers.

They are lively little birds that frequently bob up and down, flick their wings and spread or wag their tails. They use the branches of small trees, shrubs and tall plants such as thistles, as well as boulders or walls, to serve as lookouts from which to spot insect food, and also as song-posts. Bauer has painted this dapper male perched on a shrub from which it may start singing. Its song is utterly unlike that of other wheatear species, consisting of a rapid series of hoarse buzzing notes. Pairs build their untidy nest of dry grass and roots in a hole; this is often among rocks, in a stone or mud wall or an earth bank, but they are very adaptable and may choose a tree hole or a cave. They also use artificial sites such as empty cans, flowerpots or other containers, shelves in an outbuilding, or nest boxes.

PIED WHEAT-EAR. male.
89.
SAXICOLA LEUCOMELA.

Alpine Accentor *Prunella collaris*

BARRED WARBLER? *CURRUCA NISORIA?*

Although the common and scientific names inscribed in capital letters appended by Frederick Holmes to this painting suggest that it may represent a Barred Warbler, *Sylvia nisoria*, the question marks following it is fully justified. As the handwritten note beneath by H.E.S. (Hugh Edwin Strickland) indicates, the bird depicted is clearly not a Barred Warbler (and indeed not a warbler at all), but an Alpine Accentor, *Prunella collaris* (formerly *Accentor alpinus*), a member of a far smaller and unrelated family of songbirds, the accentors, Prunellidae. As to his comment 'the beak incorrect', the bills of both species are dark above and at the tip and mainly orange below, but that of the warbler is proportionately longer. The difference in the plumage of the two species is far more obvious; also the accentor's eyes are brown and its legs pink, quite unlike the warbler's yellow eyes and dark grey legs.

Most of the dozen species of accentor breed only or almost entirely in Asia, some are highly localized and all but two, like this species, dwell in wild, high mountain habitats. The exceptions are the Siberian Accentor, *Prunella montanella*, which lives in wooded and bushy tundra, and the Dunnock (*Prunella modularis*), formerly known as the Hedge Accentor and earlier by the misnomer Hedge Sparrow. This is a very common, widespread and familiar bird, found shuffling about, mouselike, in gardens as well as woodland and scrub in lowlands as well as in mountains in the south of its range across most of Europe and a small area of south-west Asia. The Alpine Accentor is a sturdier and more upright bird than the Dunnock, with more striking plumage, including a pale throat with dark markings, two white wing bars and bold red-brown streaks on its flanks – all clearly shown on Bauer's painting. As to where Bauer and Sibthorp encountered this unusual bird, it occurs in the mountains of Crete, Greece and Turkey, though today it is sparsely distributed there and more likely to be seen in other parts of its scattered range, farther north and west in the Pyrenees, the Alps and to the east in the Caucasus. It favours rocky habitats above the treeline with areas of grassland on high mountains with good snow cover and low temperatures in summer at altitudes of about 1,700 to 3,000 m, and is becoming scarcer as a result of global warming.

Like the Dunnock, it has a complex and hectic sex life. This involves a mating system known as polygynandry, with two or more females sharing a territory with a similar number of males, one of whom is dominant. This alpha male tries to keep fertile females to himself, to maximize his chance of passing on his genes, but the females compete to mate with every male, so as to ensure the most help with raising a family. This results in a very high copulation rate, and to supply the necessary sperm the males have huge testes, accounting for up to 8 per cent of their body weight. This is equivalent to a 70 kg man carrying around testes weighing over 5.5 kg!

BARRED WARBLER. female.

128.

CURRUCA NISORIA ?

more like Accentor alpinus (the beak incorrect) H.C.S.

Fer. Bauer del.

Rock Sparrow *Petronia petronia*

DOUBTFUL SPARROW *PYRGITA PETRONIA*

Bauer's painting of this relative of the familiar House Sparrow, *Passer domesticus*, shows its distinctive appearance, with its broader head and bigger bill, though this should be stouter still, with a deeper lower mandible. In life the head usually appears flatter, with the forehead merging with the top of the bill rather than at an angle as depicted. Also, the tail appears too long. But Bauer's illustration accurately depicts the thicker, stronger legs compared with those of the House Sparrow, well adapted for spending more time on the ground, where it finds more of its food, consisting mainly of seeds, supplemented in spring and early summer with insects (which also form almost the whole of the diet fed to its young) and in autumn with berries. This is a very active little bird, restlessly shuffling, hopping and jumping hither and thither from one food source to another.

In contrast to the House Sparrow, the sexes are alike in plumage. The combination of strong head stripes and white spots on the tip of the tail, shown well in Bauer's painting, is diagnostic of this species among European songbirds. The small lemon-yellow patch situated at the junction of the throat and the breast is not always apparent, being often hidden by overlying feathers, though it is more prominent (especially in males) when the plumage is worn, as on the specimen Bauer has portrayed, and especially when the male puffs out his breast while singing, as his throat vibrates and he opens his big bill wide to deliver a succession of long-drawn-out creaky and sibilant notes. Dark feathers at the base of the throat may form a smudged irregular dark line just above the yellow spot, as in this portrait. Although the underparts have darker feathers that can form a smudgily streaked pattern, this is not always apparent, especially in heavily worn plumage during summer, when they appear mottled brownish and dirty white, as on Bauer's painting.

The Rock Sparrow has an extensive world range, from Madeira and the Canary Islands across Iberia, southern France and much of the Mediterranean, across Turkey and much of central Asia to north-west China, and also in parts of North Africa. Its range was once more extensive, with populations surviving until the early years of the twentieth century far to the north of its present occurrence, in northern France and southern Germany. There have been further declines in range and numbers in recent years, particularly along the edges of its distribution in Portugal, Italy and the Balkans, including Greece.

It is most abundant in warm climates at altitudes of 500–1,500 m, in open country with low or sparse vegetation. True to its common name, it favours rocky habitats, including flat dry steppes, rocky outcrops, cliffs, screes and boulder-strewn mountainsides, olive groves, orchards and other cultivated land, where it can find the holes it needs to nest in, among rocks, stone walls, in earth banks, or in tree holes.

Doubtful Sparrow. 186.
Pyrgita Petronia.

White-winged Snowfinch
Montifringilla nivalis

SNOW FINCH *FRINGILLA NIVALIS*

Many birds called finches are not in fact members of the finch family Fringilidae; this subtly attractive bird is one example. It belongs instead to the Old World sparrow family, Passeridae, which includes one of the most familiar and ubiquitous of all the world's birds, the House Sparrow (*Passer domesticus*). Although the 'finch' part of its common name is a misnomer, the reference to 'snow' is accurate, since this bird is adapted for life at high altitudes. Bauer and Sibthorp must have encountered the species in high mountain country, perhaps in late June 1787 when they climbed to the summit of Mount Parnassus, towering above Delphi, which at 2,457 m (8,061 ft) is one of the highest of all Greek mountains.

This is a distinctly larger, bulkier and longer-winged bird than a House Sparrow, and Bauer's depiction of its body is rather too attenuated. Its breeding plumage is a mixture of grey, black, brown and white. The male's bill is almost entirely black, as in the specimen depicted by Bauer, in contrast to that of the female's, which is usually yellowish at the base. But the mottling on the chin and throat is very sparse in females (in males it forms a distinct mottled black-and-white bib). In winter both sexes have a mainly yellowish bill with black just at the tip.

At all times, the large areas of white in the wings and tail are especially striking when a restless nomadic flock flies off swiftly, with a bounding action, uttering a volley of sharp nasal calls. Aptly for birds of the snowfields, the flickering of white in large flocks as they rise and fall make them look like wind-blown snowflakes when seen at a distance. Unlike the naked nestlings of most songbirds (including sparrows), those of the White-winged Snow Finch are clothed in dense down, helping the tiny creatures to withstand the cold as they huddle together in the nest.

Today, White-winged Snowfinches are still relatively common in high mountain regions of Europe and Asia. They have benefited from the establishment of ski resorts and other tourist developments in alpine regions, visiting them and also mountain houses or villages after the breeding season to take advantage of waste food or deliberate handouts. They live in pairs or small family groups when breeding, but may form quite sizeable flocks in winter.

Seven distinct geographical races (subspecies) are currently recognized by ornithologists, which are geographically isolated from one another. Due to the lack of gene flow between these populations, several of these subspecies appear to be well on the way to achieving full species rank. The bird or birds Bauer and Sibthorp encountered would have belonged to the nominate race *nivalis*, which lives in the mountains of southern Europe, from Spain and the Alps east to Greece. The other six races are all in Asia.

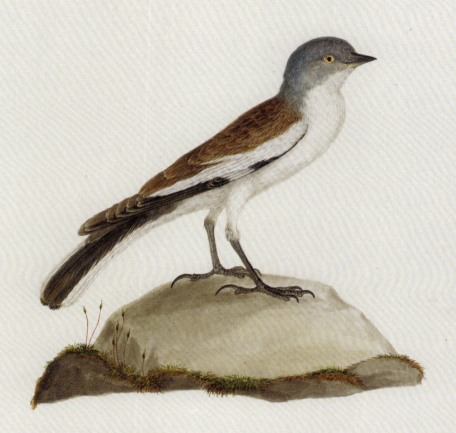

Snow Finch.

Fringilla Nivalis.

189.

Tawny Pipit *Anthus campestris*

CRESTED LARK? TAWNEY PIPIT? *ANTHUS RUFESCENS?*

The bird Bauer has painted is clearly not a lark, but one of the seven pipit species that breed in Europe (out of about forty species worldwide). These less flamboyantly plumaged, shorter-tailed, close relatives of the wagtails are classified with them in the family Motacillidae. The most likely candidate for the identity of this species is, as the annotation suggests, a Tawny Pipit, *Anthus campestris*, a relatively common bird during the spring and summer breeding season in Greece, Cyprus and Turkey. It is larger and slimmer than the Meadow Pipit, *Anthus pratensis* (see p. 210), which does not breed in the Levant but spends winter there and across the rest of southern Europe. Adults have brownish coloured upperparts contrasting with pale underparts, and have very little or none of the dark streaking on the breast that is a feature of most other species of pipits found in Europe. It should have a distinctive head pattern, with a pale stripe above the eye and a distinct dark stripe from the base of the bill to the eye, which is not apparent on Bauer's illustration.

The scientific name mentioned in the annotation, *Anthus rufescens*, is that of a different species, the Buff-bellied Pipit, which breeds in east Asia and also in North America (where it is known as the American Pipit) and Greenland, and is only an extremely rare wanderer to Europe. Furthermore, it has a distinctly streaked breast, lacking in this illustration.

Like all members of the pipit family, Tawny Pipits are open-country birds, feeding mainly on insects and other invertebrates, supplemented by small amounts of seeds. In common with most other pipits (and larks) they have long legs, and the hind claws on their toes are elongated, features helping them to run at speed. They can be very approachable, and so were often shot by hunters – as well as naturalists wishing to obtain specimens.

The name 'pipit' is onomatopoeic, being derived from the flight calls of many of the species. As with other pipits (and larks), males perform undulating song flights during the breeding season. The vast range of the Tawny Pipit extends from north-west Africa and Iberia across Europe and Asia to north-west Mongolia. It has an almost continuous distribution across southern Europe, and also breeds in parts of central and north-east Europe, but over the past thirty years or so it has largely disappeared from north-west Europe as a result of negative environmental impacts.

Closer to home, the Tawny Pipit had a starring role in an eponymous British wartime film. The plot of the 1944 comedy drama *Tawny Pipit* involves the rare event of a pair of Tawny Pipits breeding in England (something that has never happened, although a few individuals are recorded annually). The film's propaganda message symbolized a safe place of freedom from Nazi oppression. The renowned bird photographer Eric Hosking was asked to provide material, but his footage of the birds was actually of Meadow Pipits, because he could not travel to occupied Europe to film the real thing.

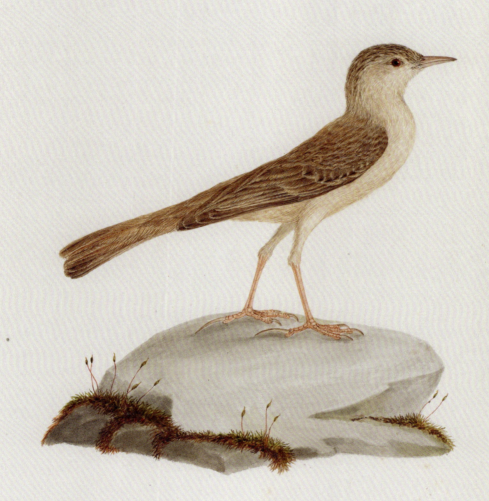

CRESTED LARK immature?

TAWNEY PIPIT?

ANTHUS RUFESCENS?

H.6.S.

Meadow Pipit *Anthus pratensis*

This species is the epitome of the 'little streaked brown bird' (or 'little brown job'), a very abundant member of the group of pipits, *Anthus*, that form a subfamily of the family Motacillidae, which also includes the far more colourful and distinctive wagtails. Because it is so widespread the Meadow Pipit is the default species that birders need to be able to identify as a yardstick with which to compare other pipit species, especially those that turn up only rarely as migrants. Their similarity has been the cause of much vexation, not least because the fine details separating them can also be variable within species as well as between them. This was neatly summarized in a humorous poem, titled 'Pipititis', written by Beryl Patricia Hall, who was a renowned curator and contributor to the bird collections of the British Museum (Natural History), later known as the Natural History Museum. In the first verse she wrote: 'It's a pity pipits have / No diagnostic features / Specifically they are the least / Distinctive of God's creatures.' And in reference to the Meadow Pipit, the poem ends: 'And when you've marshalled all the facts, / No matter what their sense is, / If the bird was caught in Europe / It is, ten to one, *pratensis*.'

At the time Sibthorp and Bauer were exploring the Levant, the Meadow Pipit and several of its relatives were often referred to by British ornithologists as well as country people by their traditional name of 'tit lark'. This referenced their superficially lark-like appearance, with the 'tit' qualifier being used in the same way as for the various species of titmouse, such as the Blue Tit, *Cyanistes caeruleus*, and Coal Tit, *Periparus ater* (see p. 160), to signify small size compared to the more familiar Skylark, *Alauda arvensis*. By the middle of the nineteenth century, following the earlier separation of the pipits from the larks, most ornithologists stopped calling them tit larks, not least because it was sometimes used indiscriminately for all three of the pipit species commonly occurring in Britain, the other two being the Tree Pipit, *Anthus trivialis*, and the Rock Pipit, *Anthus spinoletta*. In recent times, in the way devotees of any passionate pursuit have of creating a private language for the objects of their attention, these three are referred to as 'mipit', 'tripit' and 'ripit'.

The word 'pipit', of French origin, refers to the high-pitched, piercing, thin *tseep* calls, which in the case of Meadow Pipits are often for long periods the only bird sounds heard by hill walkers on moorlands, where these birds are especially numerous, as they ascend from the ground in a jerky flight. Like the unrelated larks, they perform parachuting song flights, incorporating both the call notes and a rapid trill. This is one of a depressingly large number of bird species that have for so long been extremely widespread and numerous but in recent times have been suffering serious declines of more than 50 per cent across much of their range. The Tawny Pipit, *Anthus campestris* (see p. 208), has also experienced losses but not over such a wide area as the Meadow Pipit, which breeds from Britain and Ireland to as far east as western Siberia.

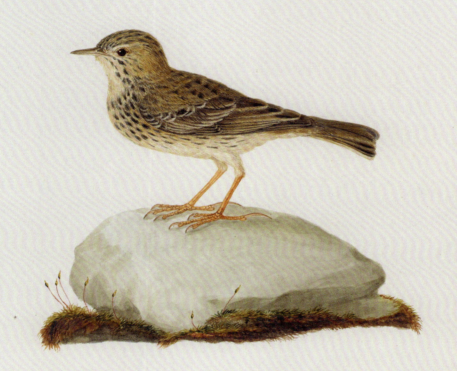

MEADOW PIPIT. 136.
ANTHUS PRATENSIS.

Western Yellow Wagtail
Motacilla flava feldegg

BLACK-HEADED WAGTAIL *BUDYTES MELANOCEPHALA*

This graceful and exquisitely coloured bird is a very distinctive subspecies (geographical race) of a species, the Western Yellow Wagtail, *Motacilla flava* (the specific name *flava* celebrating its rich golden yellow underparts). The species as a whole has an immense breeding range, being found, albeit in varying and fluctuating numbers, almost everywhere from the western margins of Europe eastward to Siberia, and from northern Russia south to the Mediterranean. Western Yellow Wagtails are found in various open habitats, including lush grassland, farmland, the fringes of marshes and steppe. Like other wagtails, they seem to be in perpetual motion, their heads bobbing and tail pumping up and down as they search on the ground for food. These dainty birds often accompany cattle, darting in between their hoofs to snap up the flies and other insects that form the bulk of their diet, and if necessary flying up in the air to seize their prey.

All populations make long migrations to winter in sub-Saharan Africa. With a complicated evolutionary history, the Western Yellow Wagtail has been divided into many different subspecies, or geographical races. Currently, eleven such races are recognized by most taxonomists. This already complex picture of the distribution of different races is made still more complicated by hybridization between some of them. The best-known race *flavissima* (its specific name referring to its most intense yellow underparts) breeds in coastal western Europe, including in Britain and Ireland, where it has suffered a major decline of almost 50 per cent over the past twenty-five years, due mainly to agricultural intensification and maybe also to deterioration in conditions in their African winter quarters.

The various races share a greenish back and yellow on the underparts, brightest and most extensive in males in their breeding plumage. The main difference between them is their distinct head patterns. Other more minor distinctions include differences in overall size and bill length. The race *feldegg* is particularly striking, with its glossy black crown contrasting strikingly with the rich golden yellow throat and underparts. It is often referred to informally as the Black-headed Wagtail (or Black-headed Yellow Wagtail).

The note on the painting 'So marked by Gould – the species is not on record as European' is incorrect, as it is widespread in the eastern Mediterranean region, breeding in the Balkans, eastwards to the Caucasus, and south to Greece, Cyprus and European Turkey. Beyond Europe it occurs right across Turkey, and east into central Asia and south to parts of the Middle East. It is a rare wanderer to western Europe, with only a few records to Britain and Ireland. This strikingly patterned race was distinctive enough in Bauer and Sibthorp's time – and at various other times since it was first described, including recently – to be regarded as a separate species. The scientific name ascribed to it on Bauer's painting is just one of very many (at least forty-five). Sibthorp and Bauer saw and collected this specimen in summer 1787 when they were visiting Cyprus.

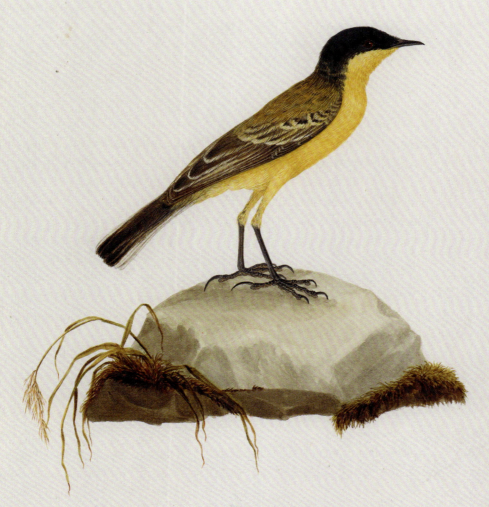

BUDYTES MELANOCEPHALA.

BLACK-HEADED WAGTAIL.

So marked by Gould — the species is not on record as European
It is described by Tem. as a var. of B. flava - Man. Orn. pt. 1. p. 623.

Brambling *Fringilla montifringilla*

MOUNTAIN FINCH *FRINGILLA MONTIFRINGILLA*

This is a close relative of the Chaffinch, replacing that generally far more familiar species as a breeding bird in northern Europe, to the north of a zone where both species occur together. Sibthorp knew it as the Mountain Finch (and this is echoed in its common name in many European languages), though it is not characteristic of mountains, and the French *Pinson du Nord* (Northern Chaffinch) is more accurate. The name Brambling (and formerly Bramlyng or Bramlin), by which it has long been officially known in English, is puzzling, since it has no connection at all with brambles. Some etymologists have suggested it is a corruption of 'Brandling', referring to the brindled upperparts of its winter plumage. The rich orange, brown, grey, black and white pattern provides superb camouflage from predators in autumn and winter against the dead leaves and dappled light of the woodland floor, where it spends most of its time feeding.

One of the most abundant of all landbirds in this region, the Brambling nests most abundantly in subarctic birch woods and in open conifer forests directly to the south, but pairs are also found in willow scrub to the north. It has a far greater range to the east than its relative, breeding right across Russia to the Pacific coast. All European breeders migrate south to spend winter, right across western, central and southern Europe, mainly in areas with beech trees, as their favourite winter food consists of the angular dark brown nuts of beech trees, encased in a prickly case, known as beechmast. The Brambling is well adapted to dealing with this hard food; compared with the Chaffinch, it has a slightly deeper and stronger bill, with sharper cutting edges.

Where beechmast is abundant, Bramblings can build up huge numbers, and form immense winter roosts. They gather together in the bare treetops from mid-afternoon onwards, then as dusk falls perform wheeling flights above the roosting trees like the murmurations of Starlings before dropping down to sleep for the night. Numbers vary greatly from year to year as well as from place to place, depending largely on variation in the productivity of beechmast. They include some of the largest flocks of any of the world's bird species, with estimates of up to tens of millions of individuals in some years. The largest of these were recorded in Switzerland in years when the beech crop was particularly good compared with other areas: in the winter of 1946/7, when two roosts were estimated to hold 11 million and 50 million birds, and even more spectacularly in the 1951/2 winter, when a vast gathering likely to contain as many as 70 million birds built up in a roost in conifers adjacent to beechwoods near the town of Hünebach, in central Switzerland. During the same period, other huge flocks were found elsewhere, such that the total number of Bramblings in this small country could well have represented the entire European breeding population.

Mountain Finch.
188.
Fringilla Montifringilla.

Black-headed Bunting
Emberiza melanocephala

The male Black-headed Bunting is a real dandy, his jet black hood contrasting strikingly with a bright canary-yellow body and chestnut nape and back, and his black wing feathers are set off with neat buff edges. He is hard to miss during the early part of the breeding season, as he perches on the branch of a tree, the top of a bush, or on an overhead wire to broadcast his song to attract females and deter rival males. This is a brief, rather harsh but melodious warbling introduced by a series of hard staccato notes. Sometimes a male will deliver this overture from mid-air, launching himself into a level flight with shallow, quivering wingbeats and dangling his legs, or occasionally in a rising and parachuting flight reminiscent of the song flights of pipits. Confusingly, the Reed Bunting, *Emberiza schoeniclus*, was sometimes known by the alternative English name of Black-headed Bunting, males sharing that feature with those of this species; but, although dapper and strikingly patterned, they are far less brightly coloured.

Female Black-headed Buntings in summer breeding plumage have a far duller plumage than the males, with a dark grey hood and duller grey-brown back with little or no chestnut colour, while in winter they are duller still, as are immature birds. This makes them very difficult to distinguish from a close relative breeding to the east across central Asia, the Red-headed Bunting, *Emberiza bruniceps*, especially as they are also very similar in behaviour and their songs are indistinguishable too. The two species hybridize where their ranges meet in the south-eastern Caspian region. Both these attractive songbirds are popular cagebirds, and the few sporadic records of their occurrence in western Europe, including Britain and Ireland, are probably of escapes from captivity, although a handful may represent genuine wild vagrants.

The Black-headed Bunting is restricted in Europe as a summer visitor, mainly to the south-east Mediterranean region; its breeding range outside Europe extends from northern and southern Italy across the Balkans, throughout Turkey and east as far as Ukraine and south-west Russia and south to Israel, Jordan, Iraq and Iran. It migrates south-east in autumn to spend winter in western and central India. Although it has experienced declines in various southern parts of its range, especially in southern Italy, Greece and Turkey, due to habitat loss, the species is currently expanding its range northward, and Turkey still holds about 80 per cent of the world total.

Bauer and Sibthorp would have encountered the conspicuous males in spring and summer in many places on their travels, throughout Greece (including many Aegean islands but not Crete), Cyprus and Turkey. To this day, Black-headed Buntings live in a variety of open, dry habitats, from coasts to mountain slopes where there are scattered trees and shrubs, fences or overhead wires to serve as song-posts for the males, and dense clumps of vegetation such as thistles for nesting. They are most abundant in low-intensity agricultural land, such as vineyards, citrus orchards and fields of sunflowers, the last echoing the male's striking plumage.

172. BLACK-HEADED BUNTING. male.
EMBERIZA MELANOCEPHALA.

Corn Bunting *Emberiza calandra*

COMMON BUNTING *EMBERIZA MILIARIA*

The nineteenth-century ornithologist and aviculturalist Lord Lilford (1833–1896) wrote of the Corn Bunting while visiting Cyprus in 1875 that it was 'tediously common', justifying the name given to it below Bauer's painting. During the time of his travels with Sibthorp, it would have been a very common bird of open grassland and arable farmland throughout Italy, Greece, Cyprus and Turkey. This is still the case today, as well as in much of the rest of Europe, especially in countries where there is less agricultural intensification, notably in Spain (which holds almost half of the entire European population), eastern Europe and Turkey. But the picture is very different in parts of north-west Europe, especially in Britain and Ireland, Belgium, the Netherlands, western Germany, Austria and Switzerland. Here there have been huge population losses over the last thirty or so years and serious retractions in range.

Ornithologists in Britain have witnessed a decline of 90 per cent from 1970 to 2010, with many gaps in distribution in England, where the species is now largely restricted to the south-east, and almost complete losses from Wales and Scotland. In Ireland, at the beginning of the twentieth century the Corn Bunting bred throughout almost the whole island and was a common sight, especially in coastal counties. By the 1950s its range had contracted hugely, restricting it as a breeding bird to cultivated headlands and islands; today it is effectively extinct throughout the whole island of Ireland. The reasons for such precipitous declines include the increasing use of herbicides and fertilizers that reduce the amount of wildflower seeds, and in winter the scarcity of stubble fields due to the change from spring-sown to autumn-sown cereals.

The Corn Bunting is unusual among songbirds for the considerable difference in size between males and females, the former averaging about 10 per cent heavier; also the males' wings are about 10 per cent longer. Some females breed with already mated polygynous males, and these females have better reproductive success than monogamous ones. Some broods are attended by 'helpers', especially juvenile females that fledged earlier and assist the parents in feeding the chicks; these are usually half-siblings from a polygynous father.

With its streaky brown plumage it looks rather like the similarly sized Skylark, *Alauda arvensis*, even though it is often heavier and plumper and its bill is conical in shape and far stouter (much more so than in Bauer's portrayal). It has a curved cutting edge and prominent bony 'tooth' in the lower mandible of its bill that works together with a similar smaller projection in the upper mandible to crush the seeds of cereals and other plants, which form much of its diet. Also, unlike the famously soaring singing lark, the Corn Bunting is far more earthbound, rarely ascending to any great height. Its song has no pretensions to musicality, though it is distinctive, being a short sequence of simple, repetitive, metallic notes that is often likened to the jingling of a bunch of keys. This the male delivers with great frequency during the breeding season from a perch, such as a fence post or wire, a telephone wire or the branch of a bush, or in a short song-flight, with his legs dangling.

Common Bunting.

171.

Emberiza Miliaria.

Ortolan Bunting *Emberiza hortulana*

This is a summer visitor patchily distributed across Europe, from northern Portugal and Spain across the northern Mediterranean to the Levant; it also breeds throughout Turkey and the Caucasus and across southern Russia as far as south-central Siberia and Mongolia, also on the coast of Algeria and in northern Iraq and Iran. In the east and north it breeds mainly in eastern Germany, Poland, eastern Sweden and Finland. It occurs in a very wide range of habitats, including hot dry upland plains, steep ravines and shrub-covered mountain slopes, non-intensive mixed farmland with scattered trees and shrubs, and clearings or edges in woodland. Overall, it prefers continental climates with drier conditions, and higher altitudes. In southern and eastern Europe it has benefited from higher temperatures resulting from climate change. Both its common name (often contracted to Ortolan) and specific name *hortulana* come from the Late Latin word *hortulanus*, related to the diminutive *hortulus*, from the Latin *hortus*, or garden. In fact, it is not often found in gardens, and tends to shun human settlements. In spring and summer, males deliver their simple song from an elevated perch, such as a tree, shrub, boulder or overhead wire. It consists of a few rich ringing notes followed by even fewer, lower-pitched, wistful-sounding ones (or in southern birds just a single longer one). It has been described as melancholy but tuneful. It can also have a ventriloquial quality, with the second part sounding as if it comes from a second bird. Some people have likened it to the opening notes of Beethoven's Fifth Symphony.

This attractive little bird has suffered a huge decline throughout Europe since the 1950s; this was especially marked during the past thirty years, when numbers dropped by almost 90 per cent. Its breeding range has become dramatically fragmented, with few remaining in many areas of western and northern Europe, and a complete absence from some countries, such as the Netherlands, Belgium and Hungary. There are two main causes. The first and more recent is the intensification of agriculture, as the drenching of farmland with insecticides and herbicides greatly reduces its supply of insects and wild flower seeds. Conversion of breeding areas to grow crops for biofuels is another threat.

The second reason for the decline is the now unsustainable hunting pressure, which has been going on for centuries. Sibthorp's diary records that on Cyprus 'immense flights of Ortolans appear at the time of the vintage; these are taken in great quantities, preserved in vinegar, and exported as an object of commerce.' Regrettably, Ortolans are still trapped in huge numbers in western Europe and North Africa, as they are regarded as a supreme culinary delicacy in France and command a high price (up to 150 euros each) despite hunting and eating them being illegal. After being caught, the birds are placed in fattening sheds where they are kept in darkness or even blinded to ensure they concentrate solely on overconsumption of oats, millet and water, so that they double or treble their weight, becoming succulent balls of fat. Before serving they may be drowned in Armagnac to enhance the taste.

ORTOLAN BUNTING. male.
176.
EMBERIZA HORTULANA.

Cretzschmar's Bunting *Emberiza caesia*

The painting Bauer made of this strikingly attractive songbird is of a male. The orbital ring (a ring of bare skin around each eye) should be a contrasting white or pale buff, not reddish orange like the plumage, and the throat should not be entirely rufous, but with a very narrow stripe on each side of the same blue grey as on the head, mantle and chest. The few small errors such as this one that Bauer made are not surprising, considering he did not produce some of the final paintings until up to seven years after having made the original drawing.

This is one of a number of songbirds that Sibthorp and Bauer encountered that have a restricted world range, in this case virtually all of it in the eastern Mediterranean. It breeds in south-eastern Greece, some Aegean islands, in western, southern and central Turkey and on Cyprus, where it is particularly abundant, and in smaller numbers to as far south as Palestine, northern Israel and possibly north-west Iraq. Most live at or near coasts, favouring open country with sparse or no vegetation; they are also found on cultivated land, boulder-strewn hillsides or islands. All populations migrate south to spend winter in southern Egypt, Sudan, Eritrea and western Arabia, where they occupy steppe grassland and savannah.

The common name commemorates the German medical doctor and naturalist Philipp Cretzschmar (1786–1845), who in 1826 published the scientific description of the type specimen collected by his better-known contemporary, the fellow German explorer-naturalist Eduard Rüppell (1794–1884), who made pioneering expeditions to Egypt, the Sinai desert and Abyssinia, collecting birds and other animals, including many species new to science. The two collectors had maintained cordial relations and cooperated on the description of various new species discovered by Rüppell and described by Cretzschmar. While Rüppell was engaged on a long and particularly challenging expedition to Egypt that included being captured at sea by Greek pirates, Cretzschmar prepared a book of his friend's travels, based on Rüppell's notes, outlining the latter's discoveries and giving descriptions of the birds, together with fine illustrations he commissioned. On his return Rüppell angrily criticized the standard of both descriptions and artwork, and their relationship never recovered.

The closely related and very similar Ortolan Bunting (*Emberiza hortulana*, p. 220) has a very much wider distribution, which overlaps this species' range. Here they often compete for breeding territory, with Cretzschmar's Bunting occupying lower altitudes, up to about 1,300 m (4,300 ft) above sea level, and more areas on islands, forcing the Ortolan Bunting to higher ground.

CRETZSCHMAR'S BUNTING.

181.

EMBERIZA CESIA.

Yellowhammer *Emberiza citrinella*

YELLOW BUNTING *EMBERIZA CITRINELLA*

Today, this attractive songbird is known in English as the Yellowhammer. The 'hammer' part has nothing to do with the tool, but may have been derived from the Old English word *amer*, and the name *Goldammer* is used for the species in German to this day. It was originally referred to by ornithologists as Yellow Bunting (and still is so in northern England), which has the merit of reminding one of which family of birds it belongs to, that of the Old World buntings, Emberizidae.

There was time not that long ago when every country child would have known the mnemonic celebrating the male's song: *A little bit of bread and (no) cheese...* The syllable represented by the *no* is usually missed out in the actual song. It is such an evocative sound, reminiscent of hot, still summers among heaths or scrubby farmland. The male's beautiful egg-yellow plumage matches the colour of gorse flowers (the Welsh name for the bird is *Melyn yr Eithin*, 'yellow of the gorse'). Other old English rural names include many referring to the yellow or gold in the plumage, and 'Scribble Lark', from the female's strikingly patterned eggs, which do look as though someone has scribbled all over them with a pencil with a mixture of thick and thin dark strokes.

Bauer's painting shows a female, with a subdued version of the male's plumage, the yellow on the head, throat and underparts being duller and far less intense, and just a subdued version of the chestnut wash that forms a distinct band on his streaked chest and flanks. There is considerable variation in female plumage, though, and some females are brighter.

Bauer has given a good idea of the stout chest, but the long tail should be strongly forked at the end. He has also not revealed a diagnostic feature, the unstreaked chestnut rump covered here by the wings (especially important in distinguishing females of this species from those of the Cirl Bunting, *Emberiza cirlus*).

The Yellowhammer's world range extends from northern Iberia, France and Ireland east right across Europe and far into Asia, as far east as Siberia, northern Kazakhstan and Mongolia, and from northern Scandinavia, Finland and Russia south to Italy and Greece. It is generally resident year-round but birds from the far north of its range migrate south.

The densest populations are across the lowlands of western and central Europe, but there has been a long-term decline in breeding numbers over most of the continent. This has been especially marked in Britain and Ireland, which have both lost more than half their populations over the last fifty years; in Ireland there has been a precipitous contraction in range from the west. Reasons for this include ploughing of stubble to grow more crops, depriving the birds of seeds.

The Yellowhammer is one of a whole suite of songbirds that were introduced into New Zealand by settlers during the second half of the nineteenth century, where they received protection. These were brought there by 'acclimatization societies' in various parts of the islands. It is possible to alight today from an aeroplane at a New Zealand airport and the first half dozen or more birds you see are all European imports.

YELLOW BUNTING. female.

173.

EMBERIZA CITRINELLA.

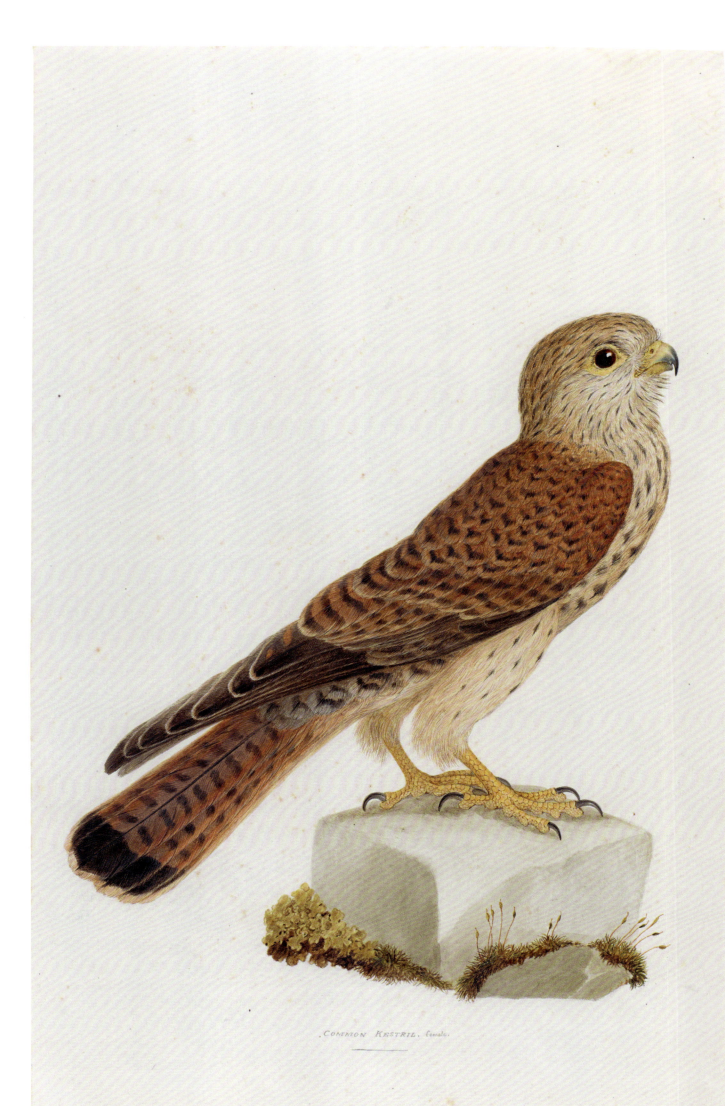
COMMON KESTRIL. female.

Appendix

Shown here are Bauer's paintings of females or young of bird species whose males or adults are included in the previous section, and paintings in which species are uncertain.

COMMON KESTRIL *female*

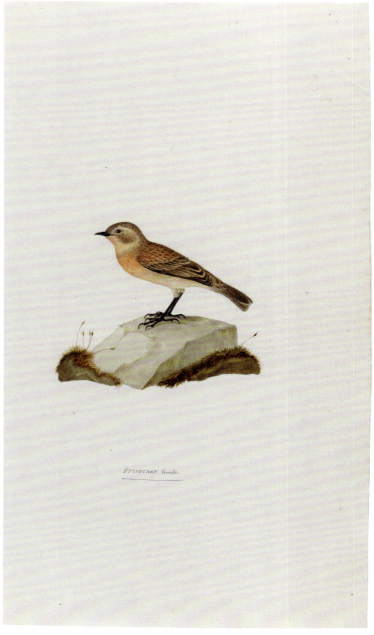

Reed Bunting *young?* E. Schoeniclus. cannot be E. Schoeniclus H.E.S.

This must be an immature Ortolan Bunting (*Emberiza hortulana*), see p. 220; its buff eye-ring distinguishes it from otherwise very similar immature Cretzschmar's Bunting (*Emberiza caesia*), see p. 222.

Stonechat *female*

The head pattern makes it look like female autumn Whinchat (*Saxicola rubetra*), but in that species the wings should be longer and the tail should have white patches at base. It has narrow pale outer tail feathers like a Stonechat – it could be an Eastern Stonechat (*Saxicola maurus*). Also, its body looks over-attenuated.

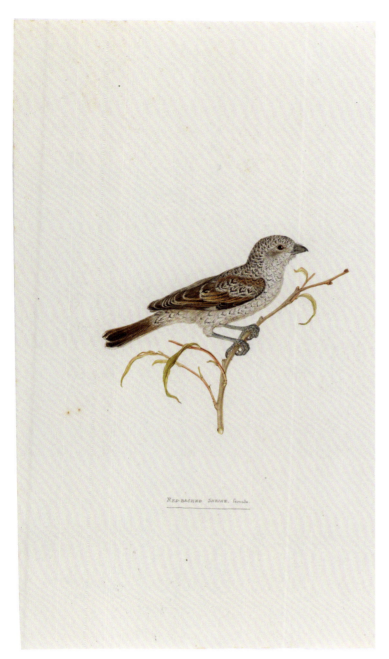 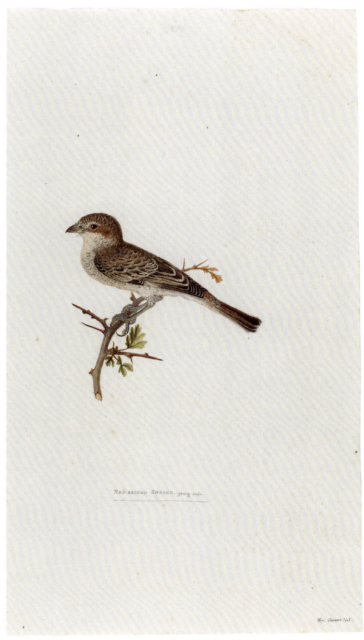

Red-backed Shrike *female* Red-backed Shrike *young male*

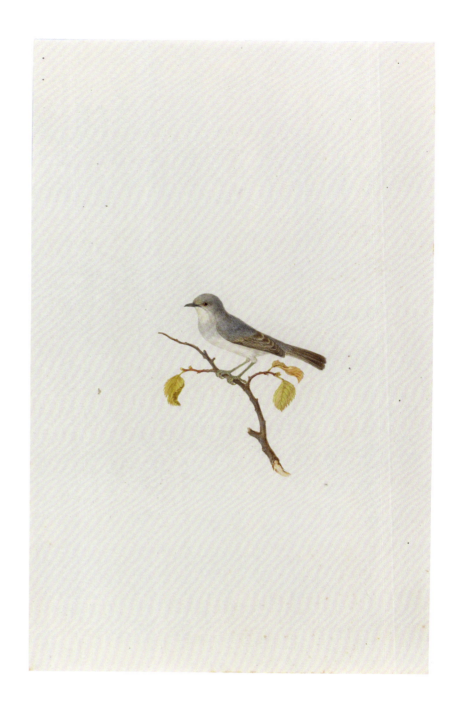

Lesser Whitethroat? The dark reddish iris and lack of blackish mask don't agree with that species, and as it is larger with a longer, sturdier bill. It is possibly an immature Eastern Orphean Warbler (*Sylvia crassirostris*).

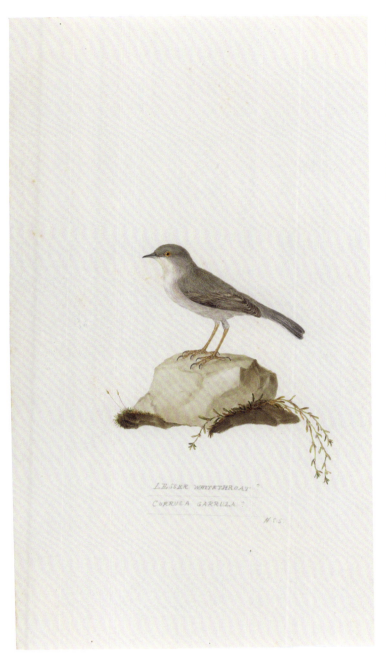

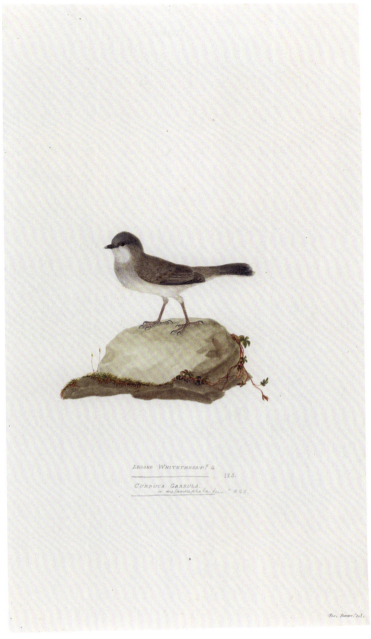

Lesser Whitethroat? *Curruca garrula*? H.E.S.

Not a Lesser Whitethroat; it looks most like a female Sardinian Warbler.

Lesser Whitethroat? *Curruca garrula* or *melanocephala*, fem? H.E.S.

This could be a Lesser Whitethroat, but the all-dark head and reddish iris don't fit that species; it looks too dark and brown above for a female Sardinian Warbler (*Sylvia melanocephala*), see p. 182.

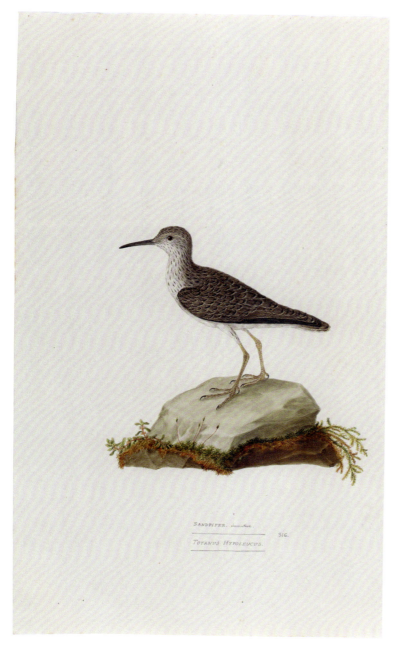

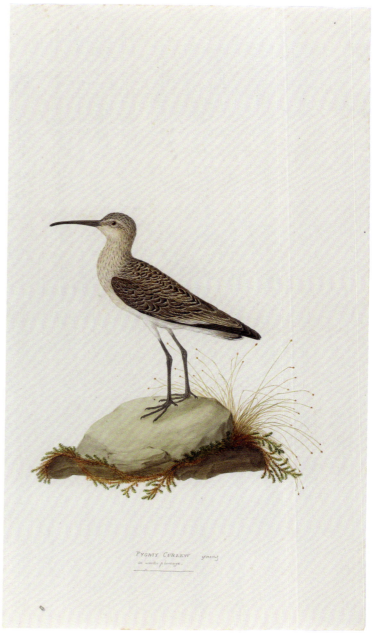

SANDPIPER. *immature*.
TOTANUS HYPOLEUCUS

This surely isn't a Common Sandpiper; it looks more like a juvenile Wood Sandpiper (*Tringa glareola*).

PYGMY CURLEW
young in winter plumage

Now called Curlew Sandpiper (*Calidris ferruginea*), see p. 100.

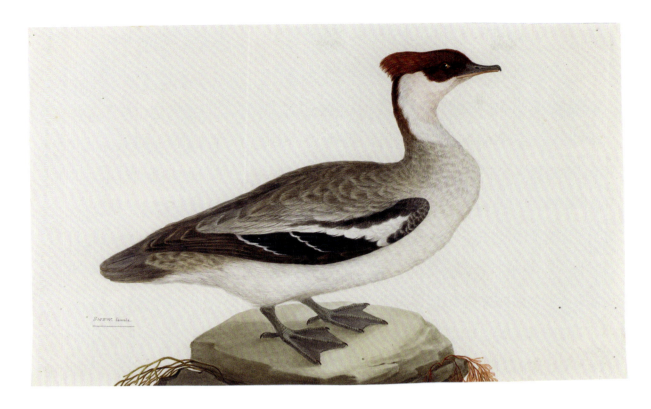

Smew *female*

Lesser Black-backed Gull *immature*

Further reading

Arnott, W.G., *Birds in the Ancient World from A to Z*, Routledge, London, 2007.

Bannerman, D.A., and W.M. Bannerman, *Birds of Cyprus*, reprint edn, Rustem Brothers, Nicosia, 1989.

Beolens, B., and M. Watkins, *Whose Bird? Men and Women Commemorated in the Common Names of Birds*, Christopher Helm, London, 2003.

Birkhead, T., *The Wisdom of Birds: An Illustrated History of Ornithology*, Bloomsbury, London, 2008.

Cocker, M., and D. Tipling, *Birds and People*, Jonathan Cape, London, 2013.

Cooper, P.M., *The Bauer Brothers: Images of Nature*, Natural History Museum, London, 2015.

Cramp, S., K. Simmon and C. Perrins, *Handbook of Birds of Europe, the Middle East and North Africa: The Birds of the Western Palearctic*, vols 1–9, Oxford University Press, Oxford, 1977–95.

Desmond, R., *Great Natural History Books and Their Creators*, British Library, London, 2003.

Elphick. J., *Birds: The Art of Ornithology*, Natural History Museum, London, 2017.

Elphick, J., *Bird Families of the World*, Natural History Museum, London, 2019.

Elphick, J., *Birds: A Complete Guide to Their Biology and Behaviour*, Natural History Museum, London, 2024.

Elphick, J., and D. Tipling, *Great Birds of Britain & Europe*, Duncan Baird, London, 2008.

Gibbons, B., *Greece: Travellers' Nature Guide*, Oxford University Press, Oxford, 2003.

Grove, A.T., and O. Rackham *The Nature of Mediterranean Europe: An Ecological History*, Yale University Press, New Haven CT and London, 2003.

Harris, S., *The Magnificent Flora Graeca: How the Mediterranean came to the English Garden*, Bodleian Library Publishing, Oxford, 2007.

Jobling, J.A., *The Helm Dictionary of Scientific Bird Names: From Aalge to Zusii*, Christopher Helm, London, 2010.

Keller, V., S. Herrando, P. Voříšek et al., *European Breeding Bird Atlas 2: Distribution, Abundance and Change*, European Bird Census Council and Lynx Edicions, Barcelona, 2020.

Lack, H.W., *The Bauers: Joseph, Franz & Ferdinand, Masters of Botanical Illustration*, Prestel, London, 2015.

Mabberley, D.J., *Painting by Numbers: The Life and Art of Ferdinand Bauer*, NewSouth Publishing, Sydney, 2017.

Mearns, B., and R. Mearns, *Biographies for Birdwatchers: The Lives of Those Commemorated for Western Palearctic Bird Names*, Academic Press, London, 1988.

Mynott, J., *Birds in the Ancient World*, Oxford University Press, Oxford, 2018.

Pollard, J., *Birds in Greek Life and Myth*, Thames & Hudson, London, 1977.

Potter, S., and L. Sargent, *Pedigree: Words from Nature*, Collins, London, 1973.

Reedman, R., *Lapwings, Loons and Lousy Jacks: The How and Why of Bird Names*, Pelagic Publishing, Exeter, 2016.

Tregaskis, H., *Beyond the Grand Tour: The Levant Lunatics*, Ascent Books, London, 1979.

Walpole, R., (ed.), *Travels in various countries of the East: being a continuation of memoirs relating to European and Asiatic Turkey &c.*, Longman, Hurst, Rees, Orme & Brown, London, 1820.

Acknowledgements

At Bodleian Library Publishing I shall be forever grateful to Samuel Fanous, head of publishing, for inviting me to write this book and for shepherding it through its long incubation and fledging period. I thank editor Janet Phillips, picture editor Leanda Shrimpton, managing editor Susie Foster and designer Lucy Morton of illuminati for their hard work, skill and patience, and Dot Little for her cover design.

I am most grateful to Professor Stephen Harris of Oxford University Department of Biology for sharing his deep knowledge of Bauer and Sibthorp, as well as showing me Ferdinand's exquisite watercolours. I also benefited hugely from the great fount of information contained in the publications of the two great biographers of Bauer, Hans Walter Lack and David Mabberley.

I also thank for advice and encouragement a host of colleagues and friends, especially Mark Cocker, Jeremy Mynott and Tim Birkhead.

PICTURE CREDITS

FIG. 1 Bodleian Library, Sherardian Library of Plant Taxonomy, MS. Sherard 240, vol. 3, plate 5.

FIG. 2 University of Oxford, Department of Biology.

FIG. 3 Bodleian Library, Sherardian Library of Plant Taxonomy, MS. Sherard 215, fol. 86v.

FIG. 5 Bodleian Library, Sherardian Library of Plant Taxonomy, MS. Sherard 408, plate 41.

FIG. 6 Bodleian Library, Sherardian Library of Plant Taxonomy, Sherard 763, vol. 6, frontispiece.

FIG. 7 Bodleian Library, Sherardian Library of Plant Taxonomy, MS. Sherard 240, vol. 3, plates 36 and 37.

FIG. 8 Bodleian Library, Sherardian Library of Plant Taxonomy, MS. Sherard 240, vol. 3, plate 91.

FIG. 9 Bodleian Library, Sherardian Library of Plant Taxonomy, MS. Sherard 240, vol. 3, plate 11.

FIG. 10 Bodleian Library, Sherardian Library of Plant Taxonomy, MS. Sherard 240, vol. 3, plate 2.

FIG. 11 Bodleian Library, Sherardian Library of Plant Taxonomy, MS. Sherard 247, vol. 2, Fasc. 4, 201.

FIG. 12 Bodleian Library, Sherardian Library of Plant Taxonomy, MS. Sherard 247, vol. 2, Fasc. 4, 201 verso.

FIG. 13 Bodleian Library, Sherardian Library of Plant Taxonomy, MS. Sherard 247, vol. 2, Fasc. 2, 210.

FIG. 14 Bodleian Library, Sherardian Library of Plant Taxonomy, MS. Sherard 240, vol. 3, plate 32.

FIG. 15 Bodleian Library, Sherardian Library of Plant Taxonomy, MS. Sherard 247, vol. 2, Fasc. 4, 209.

FIG. 16 Archivo Histórico del Real Jardin Botanico, CSIC, Madrid.

Index of birds by scientific name

The first column shows the current scientific name;
the second the current common name; and the third the page number in this book.

| | | |
|---|---|---|
| *Acrocephalus schoenobaenus* | Sedge Warbler | 172 |
| *Alectoris graeca* | Rock Partridge | 36 |
| *Anas crecca* | Common Teal | 50 |
| *Anthus campestris* | Tawny Pipit | 208 |
| *Anthus pratensis* | Meadow Pipit | 210 |
| *Ardea alba* | Great White Egret | 82 |
| *Ardea cinerea* | Grey Heron | 78 |
| *Ardea purpurea* | Purple Heron | 80 |
| *Athene noctua* | Little Owl | 118 |
| *Aythya fuligula* | Tufted Duck | 42 |
| *Burhinus oedicnemus* | Eurasian Thick-knee | 88 |
| *Buteo buteo* | Common Buzzard | 124 |
| *Calandrella brachydactyla* | Greater Short-toed Lark | 164 |
| *Calidris ferruginea* | Curlew Sandpiper | 100 |
| *Calidris pugnax* | Ruff | 98 |
| *Calonectris diomedea* | Scopoli's Shearwater | 68 |
| *Caprimulgus europaeus* | European Nightjar | 62 |
| *Charadrius alexandrinus* | Kentish Plover | 94 |
| *Ciconia ciconia* | White Stork | 72 |
| *Circus aeruginosus* | Western Marsh Harrier | 128 |
| *Circus cyaneus* | Hen Harrier | 130 |
| *Cisticola juncidis* | Zitting Cisticola | 168 |
| *Columba livia* | Rock Dove | 54 |
| *Coracias garrulus* | European Roller | 136 |
| *Dendrocoptes medius* | Middle Spotted Woodpecker | 138 |
| *Egretta garzetta* | Little Egret | 84 |
| *Emberiza caesia* | Cretzschmar's Bunting | 222 |
| *Emberiza calandra* | Corn Bunting | 218 |
| *Emberiza citrinella* | Yellowhammer | 224 |
| *Emberiza hortulana* | Ortolan Bunting | 220 |
| *Emberiza melanocephala* | Black-headed Bunting | 216 |
| *Falco naumanni* | Lesser Kestrel | 140 |
| *Falco peregrinus* | Peregrine Falcon | 146 |
| *Falco subbuteo* | Eurasian Hobby | 144 |
| *Falco tinnunculus* | Common Kestrel | 142 |
| *Ficedula hypoleuca* | Pied Flycatcher | 190 |
| *Francolinus francolinus* | Black Francolin | 34 |
| *Fringilla montifringilla* | Brambling | 214 |
| *Galerida cristata* | Crested Lark | 166 |

| | | |
|---|---|---|
| *Gelochelidon nilotica* | Gull-billed Tern | 106 |
| *Glareola pratincola* | Collared Pratincole | 104 |
| *Gyps fulvus* | Griffon Vulture | 126 |
| *Haematopus ostralegus* | Eurasian Oystercatcher | 90 |
| *Himantopus himantopus* | Black-winged Stilt | 92 |
| *Hippolais olivetorum* | Olive-tree Warbler | 170 |
| *Ixobrychus minutus* | Little Bittern | 76 |
| *Lanius collurio* | Red-Backed Shrike | 150 |
| *Lanius excubitor* | Great Grey Shrike | 152 |
| *Lanius nubicus* | Masked Shrike | 156 |
| *Lanius senator* | Woodchat Shrike | 154 |
| *Larus canus* | Common Gull | 112 |
| *Larus fuscus* | Lesser Black-backed Gull | 114 |
| *Larus melanocephalus* | Mediterranean Gull | 110 |
| *Larus michahellis* | Yellow-Legged Gull | 116 |
| *Larus ridibundus* | Black-headed Gull | 108 |
| *Mareca penelope* | Eurasian Wigeon | 48 |
| *Melanocorypha calandra* | Calandra Lark | 162 |
| *Mergellus albellus* | Smew | 40 |
| *Merops apiaster* | European Bee-eater | 134 |
| *Monticola solitarius* | Blue Rock Thrush | 194 |
| *Montifringilla nivalis* | White-winged Snowfinch | 206 |
| *Motacilla flava feldegg* | Western Yellow Wagtail | 212 |
| *Muscicapa striata* | Spotted Flycatcher | 188 |
| *Neophron percnopterus* | Egyptian Vulture | 122 |
| *Oenanthe cypriaca* | Cyprus Wheatear | 200 |
| *Oenanthe oenanthe* | Northern Wheatear | 198 |
| *Oriolus oriolus* | Eurasian Golden Oriole | 148 |
| *Otis tarda* | Great Bustard | 66 |
| *Otus scops* | Eurasian Scops Owl | 120 |
| *Oxyura leucocephala* | White-headed Duck | 38 |
| *Periparus ater* | Coal Tit | 160 |
| *Petronia petronia* | Rock Sparrow | 204 |
| *Phalacrocorax carbo* | Great Cormorant | 86 |
| *Phoenicurus phoenicurus* | Common Redstart | 192 |
| *Phylloscopus colybita* | Chiffchaff | 176 |
| *Phylloscopus trochilus* | Willow Warbler | 174 |
| *Plegadis falcinellus* | Glossy Ibis | 74 |
| *Podiceps cristatus* | Great Crested Grebe | 52 |
| *Prunella collaris* | Alpine Accentor | 202 |
| *Pterocles orientalis* | Black-bellied Sandgrouse | 60 |
| *Puffinus yelkouan* | Yelkouan Shearwater | 70 |
| *Pyrrhocorax pyrrhocorax* | Red-billed Chough | 158 |
| *Saxicola torquatus* | Common Stonechat | 196 |
| *Sitta neumayer* | Western Rock Nuthatch | 184 |
| *Spatula clypeata* | Northern Shoveler | 46 |
| *Spatula querquedula* | Garganey | 44 |
| *Streptopelia risoria* | Barbary Dove | 58 |
| *Streptopelia turtur* | European Turtle Dove | 56 |
| *Sylvia borin* | Garden Warbler | 178 |
| *Sylvia melanocephala* | Sardinian Warbler | 182 |
| *Sylvia melanothorax* | Cyprus Warbler | 180 |
| *Tachymarptis melba* | Alpine Swift | 64 |
| *Tringa nebularia* | Greenshank | 102 |
| *Tringa ochropus* | Green Sandpiper | 16 |
| *Turdus torquatus* | Ring Ouzel | 186 |
| *Upupa epops* | Hoopoe | 132 |
| *Vanellus spinosus* | Spur-winged Lapwing | 96 |

Index of birds by common name

The first column shows the current common name; the second the current scientific name; the third the plate number in the *Fauna Graeca* (MS. Sherard 240, vol. III); and the final column the page number in this book.

| | | | |
|---|---|---|---|
| Accentor, Alpine | *Prunella collaris* | *FG65* | 202 |
| Bee-eater, European | *Merops apiaster* | *FG18* | 134 |
| Bittern, Little | *Ixobrychus minutus* | *FG82* | 76 |
| Brambling | *Fringilla montifringilla* | *FG58* | 214 |
| Bunting, Black-headed | *Emberiza melanocephala* | *FG61* | 216 |
| Bunting, Corn | *Emberiza calandra* | *FG64* | 218 |
| Bunting, Cretzschmar's | *Emberiza caesia* | *FG43* | 222 |
| Bunting, Ortolan | *Emberiza hortulana* | *FG59* | 220 |
| Bustard, Great | *Otis tarda* | *FG77* | 66 |
| Buzzard, Common | *Buteo buteo* | *FG4* | 124 |
| Chiffchaff | *Phylloscopus colybita* | *FG38* | 176 |
| Chough, Red-billed | *Pyrrhocorax pyrrhocorax* | *FG66* | 158 |
| Cisticola, Zitting | *Cisticola juncidis* | *FG46* | 168 |
| Cormorant, Great | *Phalacrocorax carbo* | *FG105* | 86 |
| Dove, Barbary | *Streptopelia risoria* | *FG72* | 58 |
| Dove, European Turtle | *Streptopelia turtur* | *FG71* | 56 |
| Dove, Rock | *Columba livia* | *FG70* | 54 |
| Duck, Tufted | *Aythya fuligula* | *FG100* | 42 |
| Egret, Great White | *Ardea alba* | *FG80* | 82 |
| Egret, Little | *Egretta garzetta* | *FG81* | 84 |
| Falcon, Peregrine | *Falco peregrinus* | *FG6* | 146 |
| Falcon, Peregrine (*immature*) | *Falco peregrinus* | *FG5* | 1 |
| Flycatcher, Pied | *Ficedula hypoleuca* | *FG20* | 190 |
| Flycatcher, Spotted | *Muscicapa striata* | *FG21* | 188 |
| Francolin, Black | *Francolinus francolinus* | *FG74* | 34 |
| Garganey | *Spatula querquedula* | *FG99* | 44 |
| Grebe, Great Crested | *Podiceps cristatus* | *FG104* | 52 |
| Greenshank | *Tringa nebularia* | *FG90* | 102 |
| Gull, Black-headed | *Larus ridibundus* | *FG107* | 108 |
| Gull, Common | *Larus canus* | *FG112* | 112 |
| Gull, Lesser Black-backed | *Larus fuscus* | *FG109* | 114 |
| Gull, Lesser Black-backed (*immature*) | *Larus fuscus* | *FG95* | 233 |
| Gull, Mediterranean | *Larus melanocephalus* | *FG108* | 110 |

238

| | | | |
|---|---|---|---|
| Gull, Yellow-Legged | *Larus michahellis* | *FG111* | 116 |
| Harrier, Hen | *Circus cyaneus* | *FG13* | 130 |
| Harrier, Western Marsh | *Circus aeruginosus* | *FG12* | 128 |
| Heron, Grey | *Ardea cinerea* | *FG78* | 78 |
| Heron, Purple | *Ardea purpurea* | *FG79* | 80 |
| Hobby, Eurasian | *Falco subbuteo* | *FG7* | 144 |
| Hoopoe | *Upupa epops* | *FG69* | 132 |
| Ibis, Glossy | *Plegadis falcinellus* | *FG89* | 74 |
| Kestrel, Common | *Falco tinnunculus* | *FG1* | 142 |
| Kestrel, Common (*female*) | *Falco tinnunculus* | *FG8* | 227 |
| Kestrel, Lesser | *Falco naumanni* | *FG10* | 140 |
| Kestrel, Lesser (*female*) | *Falco naumanni* | *FG11* | 19 |
| Lapwing, Spur-winged | *Vanellus spinosus* | *FG86* | 96 |
| Lark, Calandra | *Melanocorypha calandra* | *FG55* | 162 |
| Lark, Crested | *Galerida cristata* | *FG53* | 166 |
| Lark, Greater Short-toed | *Calandrella brachydactyla* | *FG54* | 164 |
| Nightjar, European | *Caprimulgus europaeus* | *FG16* | 62 |
| Nuthatch, Western Rock | *Sitta neumayer* | *FG68* | 184 |
| Oriole, Eurasian Golden | *Oriolus oriolus* | *FG27* | 148 |
| Ouzel, Ring | *Turdus torquatus* | *FG29* | 186 |
| Owl, Eurasian Scops | *Otus scops* | *FG14* | 120 |
| Owl, Little | *Athene noctua* | *FG15* | 118 |
| Oystercatcher, Eurasian | *Haematopus ostralegus* | *FG88* | 90 |
| Partridge, Rock | *Alectoris graeca* | *FG75* | 36 |
| Pipit, Meadow | *Anthus pratensis* | *FG49* | 210 |
| Pipit, Tawny | *Anthus campestris* | *FG57* | 208 |
| Plover, Kentish | *Charadrius alexandrinus* | *FG87* | 94 |
| Pratincole, Collared | *Glareola pratincola* | *FG76* | 104 |
| Redstart, Common | *Phoenicurus phoenicurus* | *FG35* | 192 |
| Redstart, Common (*immature*) | *Phoenicurus phoenicurus* | *FG36* | 14 |
| Redstart, Common (*female*) | *Phoenicurus phoenicurus* | *FG37* | 15 |
| Roller, European | *Coracias garrulus* | *FG19* | 136 |
| Ruff | *Calidris pugnax* | *FG93* | 98 |
| Sandgrouse, Black-bellied | *Pterocles orientalis* | *FG73* | 60 |
| Sandpiper, Curlew | *Calidris ferruginea* | *FG94* | 100 |
| Sandpiper, Curlew (*immature*) | *Calidris ferruginea* | *FG95* | 232 |
| Sandpiper, Green | *Tringa ochropus* | *FG91* | 16 |
| Shearwater, Scopoli's | *Calonectris diomedea* | *FG113* | 68 |
| Shearwater, Yelkouan | *Puffinus yelkouan* | *FG114* | 70 |
| Shoveler, Northern | *Spatula clypeata* | *FG97* | 46 |
| Shrike, Great Grey | *Lanius excubitor* | *FG23* | 152 |
| Shrike, Masked | *Lanius nubicus* | *FG26* | 156 |
| Shrike, Red-Backed | *Lanius collurio* | *FG28* | 150 |
| Shrike, Red-Backed (*female*) | *Lanius collurio* | *FG24* | 229 |
| Shrike, Red-Backed (*immature*) | *Lanius collurio* | *FG25* | 229 |
| Shrike, Woodchat | *Lanius senator* | *FG22* | 154 |
| Smew | *Mergellus albellus* | *FG102* | 40 |
| Smew (*female*) | *Mergellus albellus* | *FG103* | 233 |
| Snowfinch, White-winged | *Montifringilla nivalis* | *FG63* | 206 |
| Sparrow, Rock | *Petronia petronia* | *FG56* | 204 |
| Stilt, Black-winged | *Himantopus himantopus* | *FG85* | 92 |

| | | | |
|---|---|---|---|
| Stonechat, Common | *Saxicola torquatus* | *FG33* | 196 |
| Stonechat, Common (*female*) | *Saxicola torquatus* | *FG34* | 228 |
| Stork, White | *Ciconia ciconia* | *FG83* | 72 |
| Swift, Alpine | *Tachymarptis melba* | *FG17* | 64 |
| Teal, Common | *Anas crecca* | *FG98* | 50 |
| Tern, Gull-billed | *Gelochelidon nilotica* | *FG106* | 106 |
| Thick-knee, Eurasian | *Burhinus oedicnemus* | *FG84* | 88 |
| Thrush, Blue Rock | *Monticola solitarius* | *FG30* | 194 |
| Tit, Coal | *Periparus ater* | *FG52* | 160 |
| Vulture, Egyptian | *Neophron percnopterus* | *FG3* | 122 |
| Vulture, Griffon | *Gyps fulvus* | *FG1* | 126 |
| Wagtail, Western Yellow | *Motacilla flava feldegg* | *FG50* | 212 |
| Warbler, Cyprus | *Sylvia melanothorax* | *FG51* | 180 |
| Warbler, Garden | *Sylvia borin* | *FG45* | 178 |
| Warbler, Olive-tree | *Hippolais olivetorum* | *FG44* | 170 |
| Warbler, Sardinian | *Sylvia melanocephala* | *FG41* | 182 |
| Warbler, Sedge | *Acrocephalus schoenobaenus* | *FG39* | 172 |
| Warbler, Willow | *Phylloscopus trochilus* | *FG40* | 174 |
| Wheatear, Cyprus | *Oenanthe cypriaca* | *FG31* | 200 |
| Wheatear, Northern | *Oenanthe oenanthe* | *FG32* | 198 |
| Wheatear, Northern (*immature*) | *Oenanthe oenanthe* | *FG32* | 28 |
| White-headed Duck | *Oxyura leucocephala* | *FG101* | 38 |
| Wigeon, Eurasian | *Mareca penelope* | *FG96* | 48 |
| Woodpecker, Middle Spotted | *Dendrocoptes medius* | *FG67* | 138 |
| Yellowhammer | *Emberiza citrinella* | *FG60* | 224 |